Digital Compositing for Film and Video

Second Edition

Digital Compositing for Film and Video

Second Edition

Steve Wright

AMSTERDAM • BOSTON • HEIDELBERG • LONDON
NEW YORK • OXFORD • PARIS • SAN DIEGO
SAN FRANCISCO • SINGAPORE • SYDNEY • TOKYO

Focal Press is an imprint of Elsevier

Acquisitions Editor: Amy Jollymore
Project Manager: Paul Gottehrer
Assistant Editor: Cara Anderson
Marketing Manager: Christine Degon Veroulis
Cover Design: Cate Barr
Interior Design: Julio Esperas

Focal Press is an imprint of Elsevier
30 Corporate Drive, Suite 400, Burlington, MA 01803, USA
Linacre House, Jordan Hill, Oxford OX2 8DP, UK

∞ Recognizing the importance of preserving what has been written, Elsevier prints its books on acid-free
paper whenever possible.

Library of Congress Cataloging-in-Publication Data
Application submitted

British Library Cataloguing-in-Publication Data
A catalogue record for this book is available from the British Library.

ISBN 13: 978-0-240-80760-7
ISBN 10: 0-240-80760-X
ISBN 13: 978-0-240-80761-4 (DVD)
ISBN 10: 0-240-80761-8 (DVD)

For information on all Focal Press publications
visit our website at www.books.elsevier.com

06 07 08 09 10 10 9 8 7 6 5 4 3 2 1

Printed in China

Contents

Preface

This book is about hands-on digital compositing techniques in the quest for photo-realism in feature film and video digital effects. Of course, artistic training is an essential ingredient to achieving photo-realism, as it is in the art class that you learn how things are supposed to look. But the other requirement is mastery of your tools and the technology. Knowing what the picture should look like will do little good if you can't bend the images to your vision. Reading the owner's manual will teach you how to operate your compositing software, but it will not teach you how to pull a good matte from a badly lit bluescreen or what to do when banding erupts in a digital matte painting. It is the difference between the owner's manual for a car and driving school. The first teaches you where the knobs are and the second teaches you how to use them to actually get somewhere.

While very suitable for beginners, this is not an introductory book. It assumes that the reader already knows how to operate the compositing software, what a pixel is, and what RGB means. It is intended for the digital artist sitting in front of a workstation with a picture on the monitor wondering why there are edge artifacts in a bluescreen composite and how to get rid of them. The attempt was to present the topics with sufficient background detail so that they will be of value to the beginner while including advanced concepts and production techniques that will also be of interest to the senior compositor.

This is also a "software independent" book. It carefully avoids the specifics of any particular brand of software and uses procedures and operations that are common to all software products, such as add, maximum, and color curves. You will be able to perform all of the procedures in this book regardless of the brand of software that you are using, including Adobe Photoshop. I like to think of Photoshop as a single frame compositing package with extended paint capability. Adobe Photoshop has become an important tool for previsualizing digital effects shots so it would be very useful to know how to use it to pull a color difference matte and perform the despill for a bluescreen shot.

Each topic has two thrusts. The first is understanding how things work. It is much more difficult to solve a problem when you don't know what is causing it, and a large part of time spent in production is problem solving. There is a great deal of information on how different matte extraction methods work, how despill works, and what goes on inside of a compositing node. The purpose of all of this information is to provide a sufficient understanding of the issues that conspire to spoil your fine work so that when you encounter a production problem you will be able to stab your finger in the

air and declare "I know what's wrong here!" and then turn around and fix it straight away.

The second thrust is production technique. How to help your keyer pull a better bluescreen matte, how to create a more photo-realistic depth of field effect, and when to use a "screen" operation instead of a composite are but a few examples. The different film formats are not just listed in a table, but described in terms of the client's artistic intent in filmmaking, how to work with them, and how to combine images from two different formats. There are also several step-by-step procedures for accomplishing particular effects. A great deal of effort was put into alerting you to the potential problems likely to be encountered when working with less than perfect real-world elements along with suggested solutions and workarounds.

While the information and techniques described herein apply equally to film and video work, the focus of the book's presentation is feature film simply because it is the most demanding application of digital effects. The much greater resolution and dynamic range of film make it more challenging to achieve satisfactory results so it is the "gold standard." Video is, of course, extremely important so it gets its own special chapter. As a result, the issues unique to video, such as the effects of interlaced scanning, nonsquare pixels, and Hi-Def, are collected together in one chapter so as not to muddle the general discussion of digital effects.

By virtue of gaining a deeper understanding of how things work, my hopes for the reader of this book are threefold: that you will not only finish your shots faster, but that they will also look better and that you will have more fun in the process. Let's face it. What could be more rewarding than putting together a beautiful shot to be admired by millions of viewers? Enjoy.

SECOND EDITION CHANGES

The second edition was inspired by two developments. First, cost improvements in the color printing process have made it feasible to print the entire second edition in full color. Second, new material has been added to respond to requests from readers and the inevitable march of technology. Most importantly, the accompanying DVD accesses real-world Production Exercises and contains almost 4 Gigabytes of high resolution film scans and Hi-Def video images. There are DVD icons throughout the book to identify which sections have production exercises. There is also much more support for Adobe Photoshop users, complete with their own icon sprinkled throughout the text to mark Photoshop-specific information. As a further aid to the reader there are "TIP!" icons scattered throughout the book to mark those parts of the text that are production tips you can use on the job.

Acknowledgments

Many thanks go to Glenn Kennel, who helped to develop the original Cineon log film digitizing system and film recording for Kodak, and is one of the smartest people that I have ever met. His patience and understanding while explaining the complexities of log film data were absolutely essential to those chapters. I would also like to thank Serena Naramore for taking the time to read the very rough drafts of the chapters and offering her very helpful suggestions and clarifications. Ken Littleton also gets a big thank you for reviewing the glossary and helping me to eschew obfuscation. I would also like to thank the three lovely ladies who grace the bluescreen and greenscreen pictures: Valerie McMahon, Kandis Leigh, and Chelene Nightingale (yes, that's her real name!).

Printing the second edition in full color provided the opportunity to sweeten up the graphics throughout the book. I am extremely grateful to Jeff Jasper who put in many long hours to not only contribute to the design of the graphic look of the book (such as the spiffy chapter heading above) but also to provide several 3D renderings used in the illustrations. Jeff also spent many hours testing the Production Exercises to make sure they were as clear and correct as possible.

A special word of thanks has to go to Sylvia Binsfeld of DreamWeaver Films who provided many beautifully shot film scans from her lovely 35mm short film "Dorme." She graciously provided the high resolution 2k film scans for the DVD, including several greenscreens. I would also like to thank the indomitable Alex Lindsay and the gang at Pixel Corps for providing the superb HiDef video production footage that appears on the DVD. Pixel Corps provides production training for digital artists around the world.

A special thanks to my darling wife Diane, who's loving support and patient assistance in the effort to write this book were essential to its timely completion while still maintaining harmony in our lives. Not to mention that she personally photographed many of the pictures in the book, of course. Nicely done, honey!

The ultimate artistic objective of a digital composite is to take images from a variety of different sources and combine them in such a way that they appear to have been shot at the same time under the same lighting conditions with the same camera. To do all of this well it is important to have a substantial understanding of the technology because many of the obstacles that you will encounter are, in fact, not artistic obstacles. They stem from underlying technical issues that are not at all obvious to the casual observer but create problems in the shot.

The designers of digital compositing software have tried mightily to create a software tool that hides the technology so that it can be used by artists, and to a large degree they have succeeded. However, no amount of artistic training will help you pull a good matte from a bad bluescreen or smooth motion track jitter caused by grain content. Problems of this sort require an understanding of the underlying principles of the digital operations being used to create the shot and a library of techniques and different approaches to the problem.

It takes three distinct bodies of knowledge to be a good digital effects artist: the art, the tools, and the technique. The artistic knowledge is what allows you to know what it should look like in the first place in order to achieve photo-realism. The knowledge of your tools is simply knowing how to operate your particular compositing software package. The third body of knowledge, which is technique, comes with experience. Eventually you become a seasoned veteran where you are seeing most problems for the second or third time and you know exactly what to do about them. The beginner, however, is continually confronting problems for the first time and it takes time to run through all the bad solutions to get to the good ones. This book contains years of production experience.

While digital artists are invariably smart people, being artists they undoubtedly paid more attention in art class than in math class. But math is occasionally an indispensable part of understanding what's going on behind the screen. What I did in this book was, first, avoid math wherever possible. Then, in those situations where math is utterly unavoidable, it is presented as clearly as I know how with lots of visuals to smooth the path for artists that are, ultimately, visual thinkers. I hope that as a result you will find the light smattering of math relatively painless.

1.1 SECOND EDITION SPECIAL FEATURES

There are three new special features designed into the second edition of the book, each identified by its own icon. They provide tips for Adobe Photoshop users (we are *all* Adobe Photoshop users), mark production tips, and identify the Production Exercise on the accompanying DVD that goes with that section of the text.

1.1.1 Adobe Photoshop

Adobe Photoshop Users—This icon is for you. It marks tips on how to achieve the objectives in the text using Adobe Photoshop. While this is a book on digital compositing, the vast majority of the topics are also quite valuable to a Photoshop artist even though they might be implemented somewhat differently or given a different name. Those differences are documented wherever you see the Photoshop icon. There are even three Production Exercises designed specifically to be done in Photoshop.

1.1.2 Production Tips

The production tips scattered throughout the book are designed to show good technique for various types of real-world production problems. The "Tip!" icon at the left marks the text both to alert the reader that this is a production tip and to make it easy to find later when the need arises. There are almost 200 production tips marked in this book.

1.1.3 DVD Production Exercises

Ex. 1-1

The icon at the left means that there is a Production Exercise for the section that you just finished reading. It is complete with test pictures and step-by-step procedures for trying out the techniques described in the text. This will give you real-world production experience creating effects and solving production problems that reading a book alone cannot do. Plus, it's more fun.

The Production Exercises are accessed with the DVD and are organized into folders, one folder for each chapter of the book. When you load a Production Exercise it will tell you where the images are on the DVD and guide you through a challenging production experience. The caption under the icon tells you the name of that particular exercise. The sample caption here, "Ex. 1-1," means "Production Exercise chapter 1, number 1." Take a minute

now to put in the DVD and follow the instructions to get to the Chapter 1 folder and load Exercise 1-1. There you will learn more about how the Production Exercises work.

The images provided on the DVD for the Production Exercises are typically 1 k resolution feature film proxies (1024 × 778) which is half resolution for 2 k feature film scans (2048 × 1556). Half-resolution proxies are normally used in feature film compositing to set up a shot, and full-resolution 2 k film scans would have been an undue burden on the DVD and your workstation for very little added benefit. The 1 k film scans were selected as a good compromise to be useful to both feature film and video compositors. The half-resolution proxy is large enough for film work but not too large for folks working in video. When the topic is video, of course, video-sized frames are provided, complete with interlacing when appropriate. There are even full-resolution HiDef video frames to work with.

Most of the images are tiff file format, as that is the most ubiquitous file format and is supported by virtually every digital imaging program in the known universe. For the exercises that specifically require log images, DPX files are provided, as DPX is becoming more prevalent than the Cineon file format for log film scans. They contain the same log data as a Cineon file so the file format does not affect the results, but more readers will be able to read a DPX file than a Cineon file.

1.2 HOW THIS BOOK IS ORGANIZED

This book is organized in a task-oriented way rather than in a technology-oriented way. With a technology-oriented approach, all topics relating to the blur operation, for example, might be clustered in one chapter on convolution kernels. But blurs are used in a variety of work situations—refining mattes, motion blur, and defocus operations, to name a few. Each of these tasks requires a blur, but trying to put all of the blur information in one location is counter to a task-oriented approach when the task is refining a matte. Of course, scattering the blur information across several chapters introduces the problem of trying to find all of the information on blurs. For this situation a robust index will come to the rescue.

Part I—Making the Good Composite
The first part of this book is organized in the work-flow order of the process of pulling a matte, performing the despill, and compositing the layers.

Chapter 2—How to pull mattes. There are lots of different kinds of matte for lots of different situations. There is extensive coverage of the all-important color difference matte that is fundamental to bluescreen compositing.

Chapter 3—Methods of refining mattes. Regardless of how a matte is extracted, it will usually need some "sweetening" to soften the edges, expand or erode the perimeter, or refine the rolloff of the matte edges.

Chapter 4—The all-important despill operations. How they work and the various artifacts they can introduce. Several approaches for creating your own custom despill operations are given to help solve troublesome discoloration artifacts.

Chapter 5—How the compositing operation works. What goes on inside of the composite node and how to deal with premultiplied and unpremultiplied images. How to composite premultiplied four channel CGI images is given special attention.

Chapter 6—Image blending operations. There are a myriad of ways to blend two images together other than the composite. Without using a matte, two images can be blended with a variety of mathematical operations, each with its own unique visual result.

Part II—The Quest for Realism

After we have a technically excellent composite we turn our attention to color correcting the layers to make them look like they are in the same light space, matching the camera attributes, and then matching the action.

Chapter 7—Matching the light space between the composite layers. Some background on the nature of color and the behavior of light is offered and then on to the subject of getting the different layers to appear to have been photographed with the same lighting. A checklist of things to look for in the finished composite is included.

Chapter 8—Matching the camera attributes between the composite layers. The camera, lens, and film stock affect the appearance of the layers and must be made to match so that the different layers appear to have been photographed by the same camera.

Chapter 9—Matching the action between the composite layers. An extensive look at motion tracking plus the effects of geometric transforms and their filters on images are explored. How to make more realistic motion blurs and quick image lineup procedures are offered.

Part III—Things You Should Know

At this juncture we have completed the basic composite so the topics turn to a broad range of issues beyond compositing that affect the results of the job overall.

Chapter 10—The wacky world of gamma. Not just the gamma command for altering the brightness of images, but also how gamma works on images and in your monitor and with film, plus its effects on the display of images.

Chapter 11—Coping with video. The complexity of video images and why they are the way they are. Procedures for removing the 3:2 pulldown, deinterlacing, and how to deal with the nonsquare pixels are addressed, plus how to incorporate video into a film job. Both Standard Definition and High Definition are covered.

Chapter 12—Film and film formats. Definitions for the different film apertures, what they are for, and how to mix images between them are covered, along with how to work with Cinemascope and Imax images, the workings of film scanners and film recorders, and an overview of the Digital Intermediate process.

Chapter 13—Log vs linear film data. How film captures images and what the heck is log film data anyway. Why log is the best digital representation for film and what happens to your pictures when you go linear anyway.

Chapter 14—Working with log images. How to convert log images to linear and back to minimize the picture losses with Cineon film scans. For the brave souls that work with log images and those that want to try, the procedures for doing digital effects in log space are explained.

1.3 TOOL CONVENTIONS

The slice tool, flowgraphs, and color curves are used extensively throughout this book to analyze images, show procedures, and modify pixel values. Because they are essential to the telling of the story, this section describes each of them in order to develop a common vocabulary and to overcome any terminology differences with your software. Your software may not have a slice tool so it will be a new concept to some, but I'm sure you will quickly appreciate why it is such an important tool for revealing what's happening inside an image. Who knows, you may want your engineering department to whip one up for you after you see what it can do. While the flowgraph is becoming the standard interface for compositing software, terminology differences and its absence in a few compositing packages warrant a quick review of how it is used in this book. While all software packages have color curves, we will be putting it to some new and interesting uses.

1.3.1 The Slice Tool

The slice tool is a very important image analysis tool used extensively throughout this book to illustrate pixel events. Not many software packages have such a cool tool, so an introduction to its operation and why it is so helpful is in order. Use of the slice tool starts with drawing a single straight line across the region

of interest of a picture, shown in Figure 1-1 as a diagonal white line. The second step is to plot the pixel values under the slice line on a graph, shown in Figure 1-2. We start with a grayscale image because it is easier to follow and then we will see it in action on a three-channel RGB image.

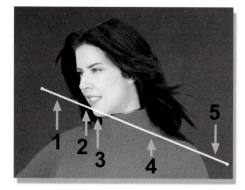

Figure 1-1 Slice line on image.

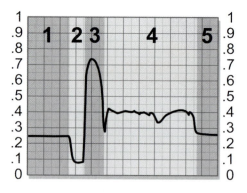

Figure 1-2 Slice graph of image.

Starting at the left end of the slice line in Figure 1-1, the graph in Figure 1-2 plots the pixel values under the line from left to right. In this introductory example, each region of the image that the slice line crosses is numbered to help correlate it to the graph. Region 1 crosses the bluescreen backing region, which results in a pixel brightness of around 0.25 in the graph. Region 2 crosses the black hair so the graph dips down to below 0.1 there. Region 3 has a bright spike where it crosses the chin, and region 4 is the long section of the medium gray sweater. Finally, region 5 ends up back on the bluescreen. Interestingly, even though regions 1 and 5 are both on the bluescreen, the graph is a bit higher in region 5, suggesting that the bluescreen is a bit brighter on the right side of the picture.

Now that the operation of the slice tool has been established for a one-channel grayscale image we can compare it to an example of the same image in full color in Figure 1-3. Here the pixel values of all three channels are plotted in the colored slice graph in Figure 1-4. Over the bluescreen backing regions the blue record is much greater than either the red or the green, as we would expect in a well-exposed bluescreen. The brightness levels and color proportions of the hair and skin tones are also easy to see. The red sweater can even be seen to have a blue bias. These graphs of the absolute level of each color record across the image also reveal their levels relative to each other, which provides invaluable insights for pulling mattes, despill operations, and a myriad of other digital effects tasks.

Another very important application of the slice tool is to graph edge transitions as shown with the close-up in Figure 1-5 and Figure 1-6. Here a short

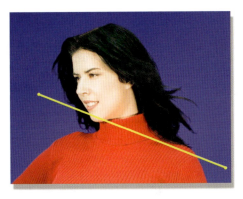

Figure 1-3 Slice line across an RGB image.

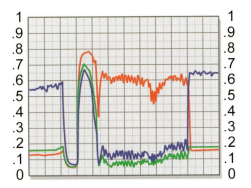

Figure 1-4 Graph of RGB values under slice line.

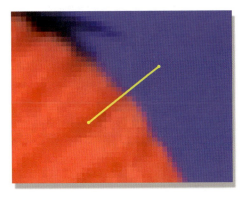

Figure 1-5 Slice line across edge transition.

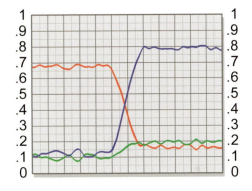

Figure 1-6 Graph of RGB values across edge transition.

slice line starts on the red sweater and crosses over to the bluescreen. The actual transition pixel values between the two regions can now be seen and studied. By striking a short line on the image that spans relatively few pixels, the resulting graph in effect "zooms in" to the image to show more detail.

The slice graph is much more revealing of what's happening in your color space than a point sample tool because it displays the pixel values across entire regions of the picture. With a slice line across an entire bluescreen, for example, the graph will reveal the uneven lighting and which way it rolls off and by how much. Appropriate correction strategies can then be developed to compensate. Being able to characterize the pixel values across broad regions of a regular image such as the sky can also be very helpful. You will also undoubtedly find it more intuitively helpful to see the RGB values plotted on a graph than just the RGB numbers from a pixel sample tool.

1.3.2 Flowgraphs

Flowgraphs are used extensively throughout this book to illustrate the sequence of operations needed to achieve a particular effect because of their clarity and universality. Most of the major compositing software packages have settled on a flowgraph gui (Graphical User Interface) as the logical presentation of the compositing data flow to the user. The flowgraph is even useful to users that do not have a flowgraph gui, such as Adobe Photoshop, because it clearly shows the sequence of operations in a way that can be translated to any software package, including those with a command line interface. Even for someone that has never seen a flowgraph before it is intuitively clear not only what operations are to be done, but their specific order, including any branching and combining.

Figure 1-7 shows an example of a generic flowgraph, which is read from left to right. Each box is called a "node" and represents some image processing operation, such as a blur or color correction. Reading the flowgraph in Figure 1-7, the first node on the left, labeled "image," can represent the initial input operation where the image file is read from disk or simply the initial state of an image to which the operations that follow are to be attached. The node labeled "op 1" (operation 1) is the first operation done to the image and then the processing "forks" to the nodes labeled "op 2" and "op 3." The output of "op 3" is then combined with "op 1" to form the two inputs to the last node labeled "op 4."

Figure 1-7 A generic flowgraph example.

Digital compositing is in actuality an example of what is referred to as "data flow programming," a computer science discipline. The reason that the flowgraph works so well is that it is a straightforward graphical representation of the "flow" of data (the images) from operation to operation, which results in a "program" (the compositing script) that produces the desired results: an outstanding composite, in this case. The clarity and intuitiveness of the flowgraph have earned it a permanent place in the man–machine interface for digital compositing.

 Adobe Photoshop Users—Photoshop does not use flowgraphs. However, the flowgraph is a "blueprint" for the sequence of operations to achieve an effect and you can implement a sequence of operations in Photoshop. Whenever you see a flowgraph, use it as a road map for creating a layer for each operation.

1.3.3 The Color Curve

The color curve is another important convention used throughout this book to adjust RGB and grayscale color values. Beyond its original intent as a color correction tool it has a myriad of other uses such as scaling mattes, altering edge characteristics, clamping, and more, all of which are encountered in this book. Some software packages may refer to it as a LUT (Look-Up Table) node, or perhaps even by some other names. By whatever name it is known in your software, this operation is present in virtually every compositing package known to man, as well as Adobe Photoshop. The convention in this book is to label the pixel values in floating point format from zero to 1.0, which is also common practice in most software packages.

The short form of the color curve story is that it simply maps the pixel values of the input image to a new set of output pixel values. The input image pixel values are indicated along the bottom edge of the graph, marked "in" on Figure 1-8, and the new output values are read along the right edge marked "out." The graph in Figure 1-8 is an identity curve, meaning that it gives the same value out as the value in, making no change to the image. Arrows point to an input value of 0.5 mapping to an output value of 0.5. In Figure 1-9, however, the color curve has been "curved" and now an input value of 0.5 results in an output value of 0.8. This would brighten the midtones of any image that it was connected

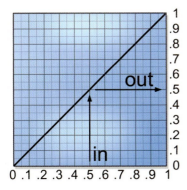

Figure 1-8 An "identity" curve.

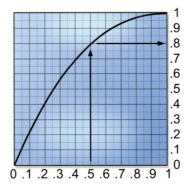

Figure 1-9 Mapping an input value to a new output value.

to. The color curves can be drawn in virtually any desired shape, and from this comes its great flexibility and multiple applications.

Here are just a few of those multiple applications. Figure 1-10 shows two color curves: one that scales the pixel values up and one that scales them down. For the "scale up" curve, an input pixel value of 0.6 becomes an output pixel value of 1.0, which is a scale factor of (1.0 ÷ 0.6 =) 1.67 on all pixel values. In other words, it is performing the same operation that a "scale RGB" node set to 1.67 would do. Note also that it is clipping all input data above 0.6 just like a scale RGB node would do. The "scale down" curve maps an input pixel value of 1.0 to an output pixel value of 0.6, which scales all pixel values by, well, 0.6. These scale operations assume that the color curve is a straight line, of course. Figure 1-11 illustrates the color curve used to clamp an image to limit its brightness values. Because the color curve is an identity curve up to an input value of 0.7, all pixels between 0 and 0.7 are unchanged. All input pixel values above 0.7, however, become clamped to the value 0.7 upon output.

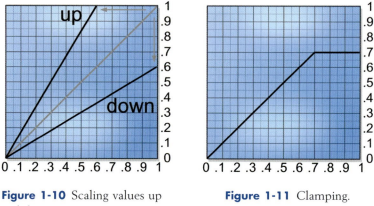

Figure 1-10 Scaling values up and down.

Figure 1-11 Clamping.

Moving to more elaborate configurations, Figure 1-12 represents using a color curve to create a "notch" filter. Input pixel values between 0.4 and 0.6 become an output value of 1.0 while all other pixel values are clamped to zero. Figure 1-13 shows an "exotic" curve meaning a complex nonlinear curve. This particular example would increase the contrast of an image without clipping it in the blacks or whites like a typical contrast operation would.

Of course, the color curve works on three-channel RGB images as shown in Figure 1-14. In this example the red channel is scaled down by 0.6, the green channel has the midtones brightened, and the blue channel is clamped to 0.7. We will see later that this ability to tweak each of the three channels

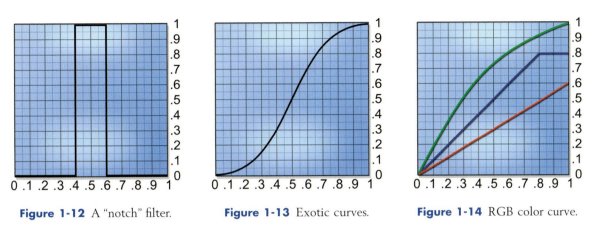

Figure 1-12 A "notch" filter. **Figure 1-13** Exotic curves. **Figure 1-14** RGB color curve.

individually comes in very handy when trying to preprocess a bluescreen plate to extract a better matte.

1.3.4 Data Conventions

A major modern compositing package today can work in a variety of data formats such as 8- or 16-bit integer or floating point. This can be troublesome when trying to give an example in the text, as a bright color in 8 bits might have a code value of 220 but in 16 bits it is 56,320. To avoid cluttering the story by listing all possible versions for each example, floating point data will normally be used throughout. This means that in 8- and 16-bit data the value zero is also zero in floating point, but the maximum 8-bit code value of 255 and the maximum 16-bit code value of 65,535 maps to the floating point value of 1.0. A floating point value of 0.5 would be 128 in 8-bit and 8268 in 16-bit code values and so on.

The first step toward any composite is to pull a matte. While your software probably has one or two excellent keyers such as Ultimatte, there are many occasions where they don't work well or are not applicable at all. This chapter describes several alternate methods of creating mattes, some of which work with bluescreens and some of which work with arbitrary backgrounds. The purpose here is to provide you with as many different methods as possible for creating a matte for either compositing or element isolation—to put as many arrows in your quiver as possible. No single matte extraction procedure is good for all situations, so the more different approaches at your disposal, the better the chances are that you can pull a good matte quickly. Subsequent chapters will address the topics of refining the matte, despill methods, and the actual compositing operation itself.

A very important point to keep in mind is that pulling a matte from an image, even a perfectly shot bluescreen, is in fact a clever cheat—it is not mathematically valid. It could be characterized as a fundamentally flawed process that merely appears to work fairly well under most circumstances, so we should not be surprised when things go badly, which they do frequently. Technically, a matte is supposed to be an "opacity map" of the foreground object of interest within an image. It is supposed to correctly reflect semi-transparencies at the blending edges and any other partially transparent regions. We will see in the color difference matte section why even the best bluescreen matte is a poor approximation of this definition. Because the matte extraction process is intrinsically flawed, to be truly effective it is necessary to understand how it works in detail in order to devise effective work-arounds for the inevitable failures of the process. Hopefully the following techniques will provide you with a wide range of approaches to help you navigate through the perverse terrain of your personal workspace.

2.1 LUMA-KEY MATTES

First up on the matte extraction hit parade is the ever popular luma-key. Luma-key mattes get their name from the world of video where the video signal is naturally separated into luminance and chrominance. The luminance (brightness) part of the video is commonly used to create a matte (or "key," in video-speak) in order to isolate some item for special treatment. In digital compositing we might refer to the same process as a luminance matte; however, most compositing packages will label this node as a luma-key node.

Regardless of what you call it, it works the same way in both worlds. Some portion of the luminance of an image is used to create a matte. This matte (luma-key) can then be used in any number of ways to isolate some item of interest for selected manipulation.

Luma-key mattes are simple to create and flexible in their use because the item of interest is often darker or lighter than the rest of the picture. This section describes how they work, their strengths and weaknesses, and how to make your own customized versions to solve special problems.

2.1.1 How Luma-Key Mattes Work

A luma-keyer takes in an RGB image and computes a luminance version of it, which is a monochrome (one-channel grayscale) image. A threshold value is set, and all pixel values greater than or equal to the threshold are set to 100% white and all pixel values less than the threshold are set to black. Of course, this produces a hard-edged matte, which is unsuitable for just about everything, so some luma-keyers offer a second threshold setting to introduce a soft edge to the matte.

My favorite visualization of a luminance key is to imagine the luminance image laid down flat on a table and the pixels pulled up into mountains. The height of each "mountain" is based on how bright the pixels are. Bright pixels make tall mountain peaks, medium gray makes low rolling hills, and dark pixels make valleys like those shown in Figure 2-1. This three-dimensional representation of two-dimensional images is a very useful way of looking at RGB images in general that we will use a lot in this book.

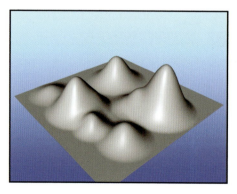

Figure 2-1 Monochrome image visualized as brightness "mountains".

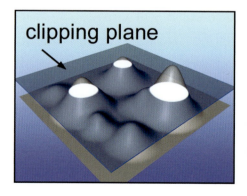

Figure 2-2 Clipping plane clips the tallest (brightest) mountain peaks.

You can now imagine the threshold point as a clipping plane that slices off the peaks of the mountains like Figure 2-2. White areas are the intersection of the clipping plane with the mountain peaks and form the resulting luminance mask.

This metaphor provides a number of interesting insights to the luminance matte. The first and most obvious issue is how there are several different mountain peaks sliced off by the threshold point clipping plane, not just the one we may be interested in. This means that the luminance matte will have "snared" unwanted regions of the picture. Some method will have to be devised to isolate just the one item we are interested in. Another point is how the clipped regions will get larger if the threshold point (clipping plane) is lowered, and smaller if it is raised, which expands and contracts the size of the matte.

There are two approaches to the problem of snaring more regions than you want. The first is to garbage matte the area of interest. This is crude, but effective, if the garbage mattes do not require too much time to make. The second approach entails altering the heights of the mountain peaks in the luminance image so that the one you are interested in is the tallest. This is covered in Section 2.1.2, "Making Your Own Luminance Image."

Simply binarizing the image (separating it into just black and white pixel values) at a single threshold value creates a very hard edged matte, while most applications require a soft edge. The soft edge issue is addressed by having two threshold values in the luma-keyer settings. One setting is the inner, 100% density edge, and the other is the outer 0% density, with a gradient between them. Switching to a cross-sectional view of one of the "mountain peaks" in Figure 2-3 shows how the inner and outer settings create a soft-

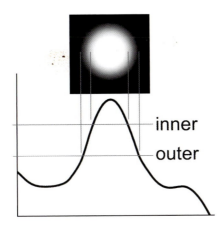

Figure 2-3 Inner and outer thresholds for soft edge matte.

edged matte. Everything that is greater than the inner threshold value is pulled up to 100% white. Everything below the outer threshold value is pulled down to a zero black. The pixels in between these two values take on various shades of gray, which creates a soft edge matte shown in the inset above the mountain peak.

2.1.2 Making Your Own Luminance Image

There are two important things to be aware of about the luminance image itself that is generated internally by the luma-keyer. The first is that there are a variety of ways to calculate this luminance image, and some of these variations might isolate your item of interest better than the default. The second thing to be aware of is that it does not have to be a luminance image at all. Your luma-keyer will most likely accept monochrome images in addition to RGB images as inputs. We can take serious advantage of this fact by feeding it a customized monochrome image that better isolates the item of interest. If it doesn't accept monochrome inputs, then we will make our own luma-keyer.

2.1.2.1 Variations on the Luminance Equation

The normal idea of a luminance image is to convert a three-channel color image to a monochrome image such that the apparent brightness of the monochrome image matches the apparent brightness of the color image. As usual, this is more complicated than it first seems. The obvious approach of simply taking one-third of each of the three channels and summing them together doesn't work because the eye's sensitivity to each of the three primary colors is different. The eye is most sensitive to green, so it appears much brighter to the eye than equal values of red or blue.

Figure 2-4 shows how the eye responds differently to the three primary colors as luminance by taking as an example a set of three color chips made up of 80% of one primary color and 10% of the other two. The chip labeled red is made of the RGB values 0.8 0.1 0.1 and, when converted to luminance, results in a gray value of 0.30. The green chip has the exact same RGB values (except for green being the dominance color, of course) but its gray value is 0.51, much brighter than the red. The poor blue chip hardly makes any brightness at all with a paltry 0.18.

Figure 2-4 Color converted to luminance.

Here's the point: if you do not create the luminance version with the proper proportions of the red, green, and blue values that correctly correspond to the eye's sensitivities, the resulting luminance image will look wrong. A simple one-third averaging of all three colors would result, for example, in a blue sky looking too bright because the blue would be overrepresented. A green forest would appear too dark because the green would be underrepresented. One standard equation that mixes the right proportions of RGB values to create a luminance image on a color monitor is

$$\text{Luminance} = 0.30R + 0.59G + 0.11B \qquad (2\text{-}1)$$

This means each luminance pixel is the sum of 30% of the red plus 59% of the green plus 11% of the blue. Be advised that the exact proportions differ slightly depending on what color space you are working in so they may not be the exact values used in your luma-keyer. And, of course, these percentage mixes are different for media other than color monitors. If your software has a channel math node, then you can use it to create your own luminance images using Equation 2-1.

But making a luminance image that looks right to the eye is not the objective here. What we really want is to make a luminance image that best separates the item of interest from the surrounding picture. Armed with this information you can now think about "rolling your own" luminance images that better separate your item of interest. Some luma-keyers allow you to juggle the luminance ratios. Try different settings to make your target item stand out from the background better. If your luma-keyer does not permit you to tweak the luminance equation, then feed it a luminance image you created externally with some other method, such as a monochrome node that does allow you to adjust the mix ratios.

 Adobe Photoshop Users—You too can create your own custom luminance images by making a custom grayscale image with the Channel Mixer. Go to Image > Adjustments > Channel Mixer, check the "Monochrome" box at the bottom of the dialogue box (Output Channel goes to "Gray"), and then dial up your custom mix of colors to make your very own luminance image.

 If your monochrome node does not permit you to change the RGB mix proportions, then another way you can "roll your own" luminance image is with a color curve node. The flowgraph in Figure 2-5 shows the operations. The RGB image goes into the color curve node where each color channel is scaled to the desired percentage mix value as shown in Figure 2-6. The three-channel output goes to a channel split node so the R, G, and B channels can be separated and then summed together to create a custom luminance image with the attributes you need. This luminance image is then connected to the luma-key node to pull the actual matte.

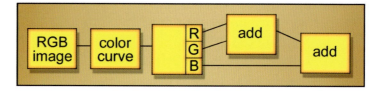

Figure 2-5 Flowgraph for generating a custom luminance image.

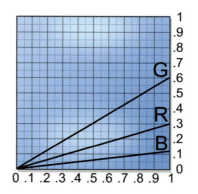

Figure 2-6 RGB scaling in the color curve.

Adobe Photoshop Users—The luminance image is referred to as a "grayscale" image. You can mix your own grayscale image using the Channel Mixer (Image > Adjust > Channel Mixer). Click the monochrome button on and dial up the percentage mix of each color channel.

2.1.2.2 Nonluminance Monochrome Images

Another approach is to not use a luminance image at all. The luma-key process is simply based on the brightness values in a monochrome image. This one-channel image is usually created by making a luminance version of the color image, but it is not against the laws of man or nature to make the one-channel image in other ways. For example, just separate the green channel and pipe it into the luma-keyer. Perhaps the blue channel has a better separation of your item of interest from the rest of the picture or maybe a mix of 50% of the red channel plus 50% of the green channel will work best. It totally depends on the color content of your target and the surrounding pixels. Unfortunately, the RGB color space of an image is so complex that you cannot simply analyze it to determine the best approach. Experience and a lot of trial and error are invariably required. Fortunately, the iterations can be very quick and a good approach can usually be discovered in a few minutes.

2.1.3 Making Your Own Luma-Key Matte

Perhaps you are using some primitive software that does not have a luma-keyer or you don't want to use your luma-keyer for political or religious reasons. Maybe you just want to demonstrate your prowess over pixels. Fine. You can make your own luma-keyer using a color curve node, which every software package has. The first step is to make your best monochrome image that separates the item of interest from the background using one of the techniques described earlier and then pipe it to a color curve node to scale it to a "hicon" (high contrast) matte.

How to set up the color curve is demonstrated in Figure 2-7. The item of interest is the white letter "A" in the target image on the left, a deliberately easy target for demonstration purposes. The color curve labeled "hard clip" uses a single threshold value, but this results in a hard matte with jaggy edges (effect exaggerated for demo purposes). The color curve labeled "soft clip" shows a slope introduced to the color curve to create a soft edge for the matte. The gentler the slope of the line, the softer the edge. Of course, nothing says

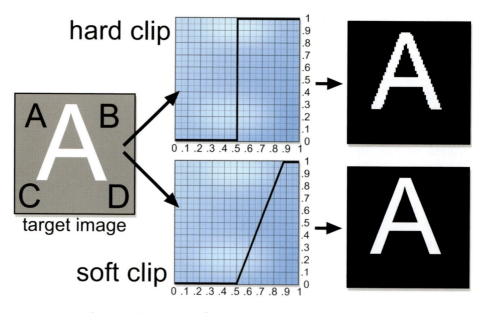

Figure 2-7 Using a color curve to make a luma-key matte.

that the target object will be the white object. If a black object is the target, the color curve would be set to pull all pixels *lighter* than the black target pixels up to 100% white. This produces a black matte on a white background, which can be inverted later if needed. Alternately, the color curve could pull the black pixels up to 100% white and all others down to black to produce a white matte on a black background directly.

Very often the target object is a middle gray, like the one shown in Figure 2-8. The pixel values of the target object are pulled up to 100% white with the color curve, and all pixel values greater *and* less than the target are both pulled down to black. The sloped sides ensure a nice soft edge to the matte. Occasionally the luma-key is pulled on the darkest or lightest element in the

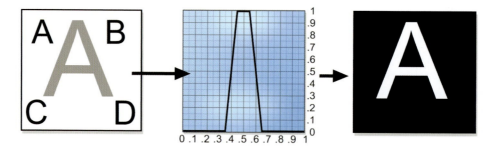

Figure 2-8 Luma-key matte for a middle gray target.

frame so the simple soft clip shown in Figure 2-7 can be used, but most often it will be some middle gray like this example where you have to suppress pixels that are both lighter and darker than the target.

Figure 2-9 shows the details of shaping the matte with a curve in the color curve node. The "center" represents the average luminance value of the target. The "tolerance" is how wide a range of luminance will end up in the maximum density region of the resulting matte. The "softness" reflects the steepness of the slope between black and white; the steeper the slope, the harder the matte edges. Only four control points are needed to adjust the tolerance and softness. Measuring a few pixel values will give you a starting point, but you will probably end up adjusting the four control points visually while watching the resulting matte in order to see the effects of the changes to the tolerance and softness.

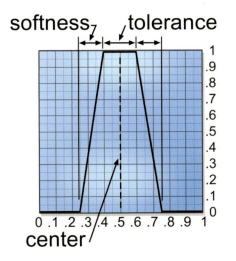

Figure 2-9 Details of a luma-key scaling operation.

To summarize the home-made luma-key process, Figure 2-10 shows a flowgraph of the operations described earlier. The RGB image is piped into a "monochrome" node, which makes a luminance version of color images. Hopefully yours has internal settings that can be tweaked for best

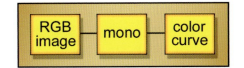

Figure 2-10 Flowgraph of luma-key operations.

Ex. 2-1

results. The mono image is then piped to a color curve to scale it up to the final hicon matte. Alternately, instead of the mono node, a single channel of the RGB image might be used or perhaps some mix of two channels as described earlier for making your own luma-keys.

2.2 CHROMA-KEY MATTES

Chroma-key mattes also get their name from video work where, again, the video signal is naturally separated into luminance and chrominance. The chrominance (color) part of the video is used to create a matte (key) in order to isolate some item for special treatment. The same principles are used in digital compositing. Because the chroma-key is based on the color of an object, it can be more selective and hence more flexible than the simple luma-key. The chroma-key also comes with a list of limitations and liabilities, which are explored in this section along with some workarounds and how to make your own chroma-key type mattes.

2.2.1 How Chroma-Key Mattes Work

The chroma-keyer node takes in the RGB image and converts it to an HSV (Hue, Saturation, Value or, if you prefer, color, saturation, brightness) or HSL type of representation internally. The reason why the original RGB version is not used internally is because the keyer needs to distinguish between, say, levels of saturation, which is not an RGB attribute, but is an HSV attribute. A starting RGB value is set that represents the "center" of the chroma-key matte and then additional tolerances are set that permit the addition of saturation and value (brightness) ranges to be included in the matte. A good chroma-keyer will also permit some sort of "tolerance" settings to allow for a graceful transition with soft edges.

The chroma-key is very flexible for two important reasons. First, it allows you to go after any arbitrary color. It does not have to be a carefully controlled bluescreen, for example. Second, it accommodates the natural variations in the color of real surfaces by having saturation and value ranges to expand its window of acceptance. If you examine the color of skin, for example, you will find that the shadow regions not only get darker, but also have lower saturation. To pull a matte on skin, therefore, you need something that will not only select the RGB color you picked for the main skin tone, but also follow it down into the shadows with lower saturation and value.

Figure 2-11 Flowgraph for combining multiple chroma-keys.

Having said all that, let me also say that the chroma-key is not a very high-quality matte. It is prone to creating mattes with hard edges that require blurring, eroding, and other edge processing to try and clean up. It also does not do semitransparent regions very well at all. You must also never use it for bluescreen work, except to pull garbage mattes in preparation for more sophisticated matte extraction processes. For bluescreen work it is terrible with edge-blended pixels—those wisps of blonde hair mixed with the bluescreen, for example.

Some of the shortcomings of the chroma-key can be compensated for by pulling several chroma-key mattes and "maxing" them together. That is to say, use a maximum operation to merge several chroma-key mattes together, as shown in the flowgraph in Figure 2-11. Each chroma-key pulls a matte from a slightly different region of color space so that, when combined, they cover the entire item of interest.

Ex. 2-2

Adobe Photoshop Users—The "Magic Wand Tool" is in fact a manually operated chroma-key tool.

2.2.2 Making Your Own Chroma-Keyer

Here is an interesting and flexible variation on the chroma-keyer theme that you can make at home. While it is based on utterly different principles than the classic chroma-keyer, which converts the image to an HSV type of representation to manipulation, it is still based on the specific color of the item of interest, not simply its luminance. Because it is based on making a matte for any arbitrary color, I have tossed it into the chroma-key category. It is actually a three-dimensional color keyer that uses a much simplified version of the operating principles of Primatte.

As you probably know, any given pixel can be located in RGB color space by its RGB value. If we imagine a normal three-dimensional coordinate system labeled RGB instead of XYZ, we can imagine any given pixel being located somewhere in this "RGB cube" by using its RGB values as its XYZ location coordinates. We could then take a greenscreen plate like the one in Figure 2-12 and plot the location of just the green backing pixels in this RGB cube. Because all of the pixels in the green backing part of the picture have very similar RGB values, they would all cluster together into a fuzzy green blob like the one shown in the RGB cube of Figure 2-13.

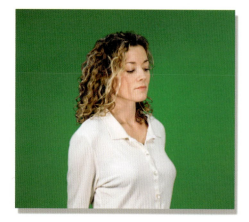

Figure 2-12 Greenscreen plate. **Figure 2-13** Green backing pixels plotted in RGB color cube.

Now, what if we could isolate this little constellation of green pixels? Suppose we picked a point right in the center of the green pixel constellation by choosing the appropriate RGB value and then measured the distance between this center point and all of the pixels in the image. Because the green backing pixels all hover in the vicinity of the center point, the distance to them would be zero or close to it. All other pixels would be located much further from the center point, giving them distances much greater than zero.

Suppose, further, that we created a new version of the greenscreen image that showed the distance each pixel is from this center point—call it a distance map. Pixels very close to the center point would be black because their distance to the center point is at or near zero. The entire green backing region

Figure 2-14 Distance map of greenscreen plate.

Figure 2-15 Hicon version of distance map.

would therefore be black, while the skin pixels, being further away, would have some shade of gray. What we wind up with is a grayscale image of the same picture with the brightness of each pixel indicating its distance from the target color, like the distance map in Figure 2-14. The closer a pixel is to the center point RGB value, the blacker it is. By using a color curve to separate the black "near" pixels from the gray "far" pixels, a hicon matte can be made like the one in Figure 2-15.

This three-dimensional color matte can be created for any arbitrary RGB value, not just a greenscreen or bluescreen, which is what makes it as flexible as the chroma-key. The RGB value of the target color is used as the center point and then the distance map is created relative to it. If the skin tones were used for the center point, the skin would have been black and all other pixels shifted in gray value to reflect their "RGB distance" from this new center point in the color cube.

Now the icky part—the math. It is simply based on the trigonometry equation for calculating the distance between two points in three-dimensional space. You remember from your favorite trig class that for point 1 located at x_1, y_1, z_1 and point 2 located at x_2, y_2, z_2, the distance between point 1 and point 2 is

$$\text{Distance} = \text{square root}((x_1 - x_2)^2 + (y_1 - y_2)^2 + (z_1 - z_2)^2) \qquad (2\text{-}2)$$

To apply this equation to our matte, point 1 becomes the center point RGB value and point 2 becomes the RGB value of each pixel in the image, with

all RGB values normalized to between 0 and 1.0. This means that the smallest distance value we can get is 0 and the largest is 1.0, which results in a grayscale image with pixel values ranging between 0 and 1.0. To reformat the trig equation for RGB color space, it becomes

$$\text{Gray value} = \text{square root}((R_1 - R_2)^2 + (G_1 - G_2)^2 + (B_1 - B_2)^2) \quad (2\text{-}3)$$

where $R_1G_1B_1$ is the normalized value of the center point, i.e., the color you

want to isolate, and $R_2G_2B_2$ is the normalized value of each pixel in the image. This equation can be entered in a math node or some other expression format that your software supports and you can

Ex. 2-3 create your own three-dimensional color mattes. Good hunting!

Adobe Photoshop Users—Unfortunately, Photoshop does not support this ability to write your own math equations. Lucky you.

2.3 DIFFERENCE MATTES

Difference mattes are one of those things that sound really great until you try it. They don't work very well under most circumstances and have nasty edges in almost all circumstances. Their most suitable application is usually garbage matting. However, for those occasional situations where it might be helpful, the difference matte is herein presented.

2.3.1 How Difference Mattes Work

Difference mattes work by detecting the difference between two plates: one plate with the item of interest (the "target") to be isolated and the other a clean plate without the item of interest, e.g., a scene with the actor in it and the same scene without the actor. This obviously requires the scene to be shot twice with either a locked off camera or, if the camera is moving, two passes with a motion control camera. In the real world this rarely happens, but under some circumstances you can create your own clean plate by pasting pieces of several frames together. However it is done, a clean plate is required.

A target over its background is illustrated with the monochrome image in Figure 2-16. This simplified example will make the process much easier to follow than a color image with complex content. The background is the speckled region and our target is the dark gray circle, which is standing in for the actor. Figure 2-17 represents the clean plate. To create the raw difference

Figure 2-16 Target plate.

Figure 2-17 Clean plate.

matte, the difference is taken between the target and clean plates. For those pixels where both plates share the common background, the difference is zero. Those pixels within the target have some difference compared to the clean plate. That difference may be small or large, depending on the image content of the target relative to the clean plate.

In the real world, the background region in the target and clean plates are never actually identical due to film grain plus any other differences in the clean plate, such as a small change in lighting, a leaf blown by the wind, or a camera that has been bumped. This will show up as contamination of the black background region.

The raw difference matte produced by the difference operation can be seen in Figure 2-18. Note that it is not a nice 100% white clean matte ready to go. It has all kinds of variations in it due to the fact that the background pixels are of varying value; the foreground pixels are also of varying value so the results of their differences will also be of varying values. To convert the low-density raw difference matte into a solid hicon matte like Figure 2-19 it is typically "binarized" around a threshold value. To binarize an image simply

Figure 2-18 Raw difference matte.

Figure 2-19 Binarized hicon difference matte.

means to divide it into two (binary) values, zero and 1.0, at some threshold value. All pixels at or above the threshold go to 100% white while those below go to zero. Of course, this single threshold approach will produce a jaggy hard-edged matte. A difference matte node worth its pixels will have two threshold settings that you can adjust to select the range of differences that appear in the matte versus the background in order to introduce a softer edge.

Now for the bad news. Remember those pixels in the target mentioned earlier that were close in value to the pixels in the clean plate? They and their close associates spoil the difference matte. Why this is so can be seen in Figure 2-20, which represents a slightly more complex target. This target has pixels that are both lighter and darker than the background and some that are equal to it. When the raw difference matte is derived in Figure 2-21 there is a black stripe down the center because those pixels in the target that are close to the pixel values in the background result in differences at or near zero. Both the left and the right ends are brighter because they are much darker and lighter than the background, resulting in greater difference values.

When the raw difference matte is scaled up to create the solid hicon version shown in Figure 2-22 there is a serious "hole" in the matte. This is also the problem with difference mattes. The target object will very often have pixel values that are very close to the background, resulting in holes in the matte. The raw difference matte normally must be scaled up hard to get a solid matte for these small difference pixels, which produces a very hard matte overall. However, there are occasions where the difference matte will work fine, so it should not be totally dismissed.

Figure 2-20 Complex target.

Figure 2-21 Raw difference matte.

Figure 2-22 Hicon difference matte.

2.3.2 Making Your Own Difference Matte

For reasons that are now all too obvious, many software packages do not offer a difference matte feature, but you can make your own. To create the difference matte, the target and clean plates are subtracted twice and the two results are summed together. Two subtractions are required because some of the target pixels might be greater than the background and some less than the background. In "pixel math," negative pixel values are normally not permitted. If you tried to subtract 100 – 150 you will get 0 as an output, not –50. We want this –50 pixel for our matte, but the pixel math operation clipped it to zero. Unless your software has an "absolute value" operator, it will take two subtractions to get both sets of pixels into the matte. So our math operation would look like this:

Raw difference matte
 = (target plate – clean plate) + (clean plate – target plate) (2-4)

Target pixels that are *greater* than the background pixels in the clean plate will be found with the first subtraction (target plate – clean plate). Target pixels that are *less* than the background pixels in the clean plate will be found with the second subtraction (clean plate – target plate). These two sets of pixels are then summed together to make the raw difference matte. As shown earlier, any target pixels that are equal to the background will show up as holes in the matte. As for the background surrounding the target, theoretically, these pixels are identical in the two plates so their differences become zero. Theoretically.

You will undoubtedly be performing this operation on three-channel color images instead of the monochrome examples shown earlier. You can perform the two subtractions and one addition operation shown in Equation 2-4 on the full color images with just add and subtract nodes as shown in the flowgraph in Figure 2-23. When the two subtractions are summed together, however, you will have a three-channel image that needs to become a one-channel image. Just separate the three channels, sum them together to make the monochrome raw difference matte, and use a color curve to scale it up to a hicon matte.

If you have a channel math node, the entire operation can be put into one node with the following equation:

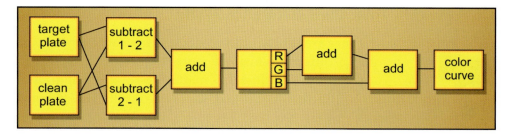

Figure 2-23 Flowgraph of home-made difference matte.

Raw difference matte
$$= (abs(R_1 - R_2)) + (abs(G_1 - G_2)) + (abs(B_1 - B_2)) \qquad (2\text{-}5)$$

where "abs" means absolute value and $R_1G_1B_1$ are the RGB values of one plate

and $R_2G_2B_2$ are the RGB values of the other plate. It matters not which is plate one and which is plate two. And, of course, this raw difference matte must then be scaled with a color curve to make

Ex. 2-4 the final hicon matte. Good luck.

Adobe Photoshop Users—You can add and subtract color channels using the Calculations command (Image > Calculations). The "Difference" blending mode does not use the same math as described here so it does not produce as robust a difference matte. It might occasionally work well enough to be worth a try, however. In Photoshop you only have to worry about one frame rather than a sequence of moving frames so the magic wand is your best friend here.

2.4 BUMP MATTES

Here is a sweet little number that you will find indispensable perhaps only one or two times a year, but when you need it, there is no other game in town. The situation is that you want to pull a matte on the bumps of a rough surface—a stippled ceiling, the textured grass of a lawn, the rough bark on a tree, etc. You want to isolate and treat the bumpy bits, perhaps to suppress or highlight them. The bump matte will give you a matte of just the bumps, and here is the really sweet part, even when they are on an uneven surface. A luminance matte will not do. Because of the uneven brightness, many of the bump tips are darker than the brighter regions of the surface. You need a method that just lifts out the bumps, regardless of their absolute brightness. Because the bump matte is based on the *local* brightness of the region

immediately surrounding each bump, it adapts continuously to the local brightness everywhere in the picture.

The idea is to make a luminance version of the target plate that makes the bumps stand out as much as possible. A blurred version of the target plate is then generated, and this blurred version is subtracted from the luminance version. Wherever the bumps stick up above the blurred plate you will get a matte point. This is an entirely different result from performing an edge detect. Edge detection would actually draw circles around all the bumps, while the bump matte actually gets the bumps themselves.

Figure 2-24 represents a generic bumpy surface. Note how the left edge is a medium brightness, it gets brighter toward the center, and then gets much darker toward the right edge. This is not a flat, evenly lit surface. Figure 2-25 shows the blurred version of the original bumpy plate in Figure 2-24, and Figure 2-26 shows the resulting bump matte. Note how each bump became a matte point even though the surface was unevenly lit. It is as if the bumps were "shaved off" the main surface in Figure 2-24 and laid down on a flat surface.

Figure 2-24 Target bumpy surface.

Figure 2-25 Blurred bumpy surface.

Figure 2-26 The resulting bump matte.

The action can be followed in the slice graph in Figure 2-27 where a slice line has been drawn horizontally across the bumpy target image in Figure 2-24. The bumps in the image create the bumpy slice line. After the image is blurred, the bumps are all smoothed down, but the overall contours of the surface are retained in the slice line labeled "blurred." The blurred surface will, in fact, be the average of the bumpy surface. When the blurred plate is subtracted from the bumpy plate, all of the bumps that stick up above the blurred version are left as the bump matte at the bottom of Figure 2-27.

Figure 2-28 shows an important refinement of the matte where the matte points have been increased by first lowering the blurred plate a bit before the plate subtraction. Simply subtracting a small constant value (such as 0.05)

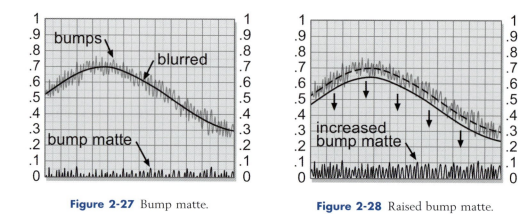

Figure 2-27 Bump matte. **Figure 2-28** Raised bump matte.

from the blurred plate "lowers" it so that the remaining bumps stick up higher. The resulting matte has both larger and "taller" (brighter) matte points. Increasing and decreasing the amount of blur is another refinement. The greater the blur, the larger the bumps trapped in the bump matte.

Figure 2-29 illustrates a flowgraph of the blur matte operations. Starting with the target image on the left, the luminance version is created. Next it is blurred and then a small constant such as 0.05 may be subtracted from it

Ex. 2-5

to increase the size of the bumps in the map. If you want to decrease the size of the bumps, you would add a constant instead. The adjusted blurred image is then subtracted from the luminance image of the target plate.

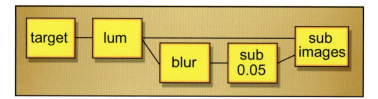

Figure 2-29 Flowgraph of bump matte procedure.

2.5 KEYERS

There are several high-quality, third-party "keyers" on the market, such as Ultimatte, Primatte, and Keylight. What they all have in common is that they offer a turnkey solution to bluescreen compositing. You connect the foreground and background plates to the keyers node, adjust the internal param-

eters for matte and despill attributes, and they produce a finished, despilled composite. Ultimatte and Keylight both work on color difference principles, whereas Primatte is a very sophisticated three-dimensional chroma-keyer. Why not just use one of these all the time and not worry about pulling your own mattes?

There are several possible reasons. You may be working with problem elements that are giving the keyer problems, so you may have to assist the keyer by preprocessing the bluescreen plate to set it up for a better matte extraction. Another issue is when the despill operation goes wrong. A surprising number of edge discoloration artifacts are from the despill operation. Because it is internal to the keyer, when you cannot adjust the problem away you have no way to substitute a different despill operation. If you cannot use the despill in the keyer, then you cannot use the keyer. You will have to pull the matte separately, use some other despill operation (see Chapter 4) that does not introduce the artifact, and do the final composite yourself.

Sometimes the built-in color correction will not solve the color correction problem. Another problem may be that the built-in color correction capability may not be adequate for certain cases. You may also have other operations to do to the foreground that must come after the despill but before the composite. You should not color correct the raw bluescreen plate before giving it to the keyer, for several reasons. The first big problem is that if the color correction has to be revised later, all of the keyer settings have to be completely redone. Second, the color-corrected version may disturb the relationships between the channels, which can degrade the matte extraction, the despill operations, or both.

 Should you find that your favorite keyer is not doing the job, it still may be useful for pulling the original matte and then do the despill and composite externally. Virtually all keyers will output the matte that they develop internally for their own composite. This matte can be refined further if needed and used with a regular comp node to perform the actual composite. While this approach may

 be necessary to solve a problem, be sure to always try to do the comp in the keyer first, as they usually do an excellent job and are much quicker to set up than creating your own color difference
Ex. 2-6 mattes.

2.6 COLOR DIFFERENCE MATTES

The color difference matte (not to be confused with the plain "difference matte") is one of the best matte extraction methods for bluescreens because

of its superior edge quality and reasonable semitransparency characteristics. As mentioned earlier, the Ultimatte method is in fact a sophisticated color difference matte extraction and compositing technique. This section shows how to "roll your own" color difference mattes. While originally conceived for bluescreen matte extraction, the color difference matte technique can often be used to pull a matte on an arbitrary object that has a single dominant color, such as a red shirt or a blue sky, for example.

The importance of this section is twofold. First, by understanding the color difference matte process you will be able to "assist" your favorite keyer when it is having trouble. Second, if you can't use a keyer, either because your software doesn't have one or because it is having problems with a bluescreen plate, you can always make your own color difference matte. The methods outlined here can be used with any compositing software package or even Adobe Photoshop because they are based on performing a series of simple image processing operations that are available universally.

This color difference matte section is extensive for two reasons. First, it is the single most important matte extraction procedure because it does the best job in the most common and critical application—bluescreen and greenscreen matte extraction. Second, it is also more complex and harder to understand than other matte extraction methods. While the general term for this type of shot is a "bluescreen" shot regardless of the actual backing color, most of the examples in this section use greenscreens simply because it is becoming the most common backing color used. The astute reader will be able to easily see how the principles apply equally to the other two primary colors, blue and red. Yes, you can shoot redscreens as well as bluescreens and greenscreens, with equally good results, assuming the foreground objects do not have the same dominant primary color as the backing color, of course.

2.6.1 Extracting the Color Difference Matte

This first section is about how to extract or "pull" the basic color difference matte using simplistic test plates designed to avoid problems. After the basic principles of how the matte extraction works are clear, the sections that follow are concerned with fixing all the problems that invariably show up in real world mattes.

2.6.1.1 The Theory

Referring back to Figure 2-12, a greenscreen plate consists of two regions: the foreground object to be composited and the backing region (the green-

screen). The whole idea of creating a color difference matte from a green-screen is that in the green backing region the *difference* between the green record and the other two records (red and blue) is relatively large, but zero (or very small) in the foreground region. This difference results in a raw matte of some partial density (perhaps 0.2 to 0.4) in the backing region, and zero (or nearly zero) density in the foreground region.

The different densities (brightness) of these two regions can be seen in the raw color difference matte in Figure 2-30. The dark gray partial density derived from the greenscreen backing color is then scaled up to 1.0, a full density white, as shown in the final matte of Figure 2-31. If there are some nonzero pixels in the foreground region of the matte, these are pulled down to zero to get a solid foreground matte region. This results in a matte that is a solid black where the foreground object was and solid white where the backing color was. Some software packages need this reversed, with white for the foreground region and black for the backing, so the final matte can simply be inverted if necessary.

Figure 2-30 Raw color difference matte.

Figure 2-31 Final color difference matte.

2.6.1.2 Pulling the Raw Matte

The first step in the process is to pull the raw matte. This is done with a couple of simple math operations between the three-color channels and can be done by any software package using simple math operators. We will look at a simplified version of the process first to get the basic idea and then look

at a more realistic case that reveals the full algorithm. Finally, there will be a messy real world example to ponder.

2.6.1.3 A Simplified Example

Figure 2-32 is our simplified greenscreen test plate with a gray circle on a green backing. We will refer to the green part of the plate as the backing region because is contains the green backing color and the gray circle as the foreground region because it is the "foreground object" we wish to matte out for compositing. Note that the edges are soft (blurry). This is an important detail because in the real world all edges are actually soft to some degree, and our methods must work well with soft edges. At video resolution a sharp edge may be only one pixel wide, but at feature film resolutions "sharp" edges are typically three to five pixels wide. Then, of course, there are actual soft edges in film and video, such as with motion blur and depth of field (out of focus), plus partial coverage, such as fine hair and semitransparent elements. It is these soft edges and transitions that cause other matte extraction procedures to fail. In fact, it is the superior ability of the color difference matte to cope with these soft transitions and partial transparencies that makes it so important.

Figure 2-33 is a close-up of the greenscreen plate in Figure 2-32 with a slice line across it, which has been plotted in Figure 2-34. The slice line in Figure 2-33 starts at the left on the gray circle and crosses the edge transition and then over a piece of the greenscreen. The slice graph in Figure 2-34 graphs the pixel values under the slice line from left to right also. Reading

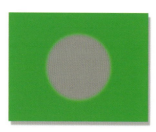

Figure 2-32 Gray circle on green backing.

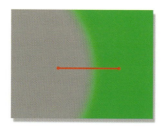

Figure 2-33 Close-up of slice line on edge transition.

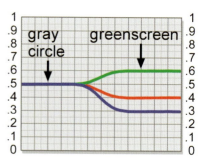

Figure 2-34 Slice graph of gray circle edge transition.

the slice graph from left to right, it first shows that on the gray circle the pixel values are 0.5 0.5 0.5 (a neutral gray), so all three lines are on top of each other. Next, the graph transitions toward the greenscreen backing colors, so the RGB values can be seen to diverge. Finally, the samples across the green backing region show that the backing color has RGB values of 0.4 0.6 0.3. The green backing shows a high green value (0.6), a lower red (0.4) value, and a somewhat lower blue value (0.3), just what we would expect from a saturated green.

To make our first simplified color difference matte, all we have to do is subtract the red channel from the green channel. Examining the slice graph in Figure 2-34, we can see that in the foreground region (the gray circle) the RGB values are all the same, so green minus red will equal 0, or black. However, in the green backing color region the green record has a value of 0.6 and the red record has a value of 0.4. In this region, when we subtract green minus red, we will get 0.6 − 0.4 = 0.2, not 0. In other words, we get a 0 black for the foreground region and a density of 0.2, a dark gray, for the backing region—the crude beginnings of a simple color difference matte. Expressed mathematically, the raw matte density is

$$\text{raw matte} = G - R \qquad\qquad (2\text{-}6)$$

which reads as "the raw matte density equals green minus red." The term "density" is used here instead of "brightness" simply because we are talking about the density of a matte instead of the brightness of an image. For a matte, the item of interest is its density, or how transparent it is. The exact same pixel value dropped into an RGB channel would suddenly be referred to as brightness.

The raw color difference matte that results from the green minus red math operation is shown in Figure 2-35 with another slice line. We are calling this the "raw" matte because it is the raw matte density produced by the initial color difference operation and needs a scaling operation before becoming the final matte. In the green backing region, subtracting red from green gave a result of 0.2, which appears as the dark gray region. In the foreground region the same operation gave a result of 0, which is the black circle in the center. We get two different results from one equation because of the different pixel values in each region. In Figure 2-36 the slice graph of the raw matte shows the pixel values where the red slice line is drawn across the raw matte. The raw matte density is 0.2 in the backing region, 0 in the foreground region, and a nice gradual transition between the two regions. This gradual transition is the soft edge matte characteristic that makes the color difference matte so effective.

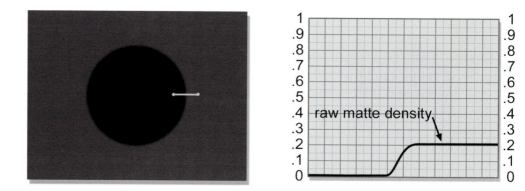

Figure 2-35 Raw color difference matte with slice line.

Figure 2-36 Slice graph of raw color difference matte.

Figure 2-37 is a flowgraph of the simple G-R raw color difference matte operation. From the greenscreen plate (GS), the red and green channels are connected to a subtract node. The output of the subtract node is the one-channel raw color difference matte in **Ex. 2-7** Figure 2-35.

Figure 2-37 Flowgraph of simple raw matte.

2.6.1.4 A Slightly More Realistic Case

Real images obviously have more complex colors than just gray, so let's examine a slightly more realistic case of pulling a matte with a more complex foreground color. Our next test plate will be Figure 2-38, which is a blue circle on a greenscreen backing with a slice graph next to it in Figure 2-39. As you can see by inspecting the slice graph, the foreground element (the blue circle) has an RGB value of 0.4 0.5 0.6, and the same green backing RGB values we had before (0.4 0.6 0.3). Clearly the simple trick of subtracting the red channel from the green channel won't work in this case because the green record in the foreground region (the blue circle) is *greater* than the red record. For the foreground region the simple rule of green minus red (0.5 − 0.4) will result in a matte density of 0.1, a far cry from the desired 0 black.

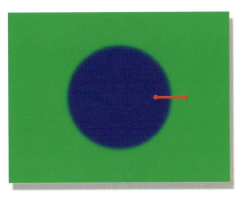

Figure 2-38 Blue circle with slice line.

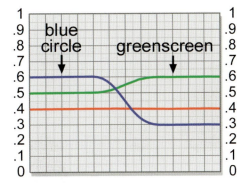

Figure 2-39 Slice graph of blue circle.

If anything, from this example, we should subtract the blue record from the green record. In the foreground region, green minus blue (0.5 − 0.6) will result in −0.1, a negative number. Because no negative pixel values are allowed, this clips to 0 black in the foreground region, which is good. In the backing region, green minus blue (0.6 − 0.3) gives us a nice raw matte density of 0.3, even better than our first simple example. The problem with simply switching the rule from green minus red to green minus blue is that in the real world the foreground colors are scattered all over color space. In one area of the foreground red may be dominant, but in another region blue may be dominant. One simple rule might work in one region but not in another. What is needed is a matte extraction rule that changes and *adapts* to whatever pixel value the foreground regions happen to have.

Here's a rule that adapts to those elusive scattered pixel values—the green channel minus *whichever is greater*, red or blue or, put in a more succinct mathematical form,

$$\text{raw matte} = G - \max(R,B) \tag{2-7}$$

which reads as "the raw matte density equals green minus the maximum of red or blue." If we inspect the slice graph in Figure 2-39 with this rule in mind, we can see that it will switch on the fly as we move from the foreground region to the green backing region. In the foreground (blue circle) region, blue is greater than red so the raw matte will be green minus blue (0.5 − 0.6), which results in −0.1, which clips to 0 black. So far so good, we get a nice solid black for our foreground region. Following the slice graph lines in Figure 2-39 further to the right we see that the blue pixel values dive under the red pixel values in the edge transition region so the

maximum color channel switches to the red channel as it transitions to the backing region. Here the raw matte density becomes green minus red (0.6 − 0.4), resulting in a density of 0.2. There you have it. An adaptive matte extraction algorithm that switches behavior depending on what the pixel values are.

Figure 2-40 shows the new and improved flowgraph that would create the more sophisticated raw color difference matte. The red and blue channels go to a maximum node that selects whichever channel is greater on a pixel-by-pixel basis. The subtract node now subtracts this maximum(R,B) pixel value from the green channel, which creates the raw matte. It is called the raw matte at this stage because it is not ready to use yet. Its density, currently only 0.2, needs to be scaled up to full opacity (white, or 1.0) before it can

be used in a composite, but we are not ready for that just yet. This procedure can be implemented easily in Adobe Photoshop, providing that you know that they call the maximum operation "lighten" and the minimum operation "darken."

Ex. 2-8

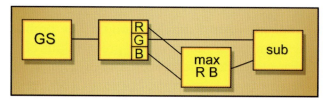

Figure 2-40 Flowgraph of raw color difference matte.

Adobe Photoshop Users—In Photoshop the maximum operation is known as the "Lighten" blending mode. You can pull an excellent color difference matte in Photoshop just like a compositing program. Exercise 2-9 will show you how.

Ex. 2-9

2.6.1.5 And Now, the Real World

When we pick up a real live action greenscreen image such as Figure 2-41 and graph a slice across the foreground to the greenscreen (Figure 2-42), we can immediately see some of the differences between real live action and our simple test graphics. First of all, we now have grain, which has the effect of

Figure 2-41 Real world picture.

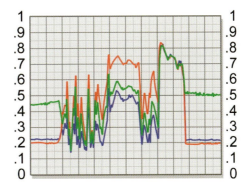

Figure 2-42 Graph of real world picture.

degrading the edges of the matte we are trying to pull. Second, the green-screen is unevenly lit so the color difference matte will not be uniform across the entire backing area. Third, the foreground nonbacking colors (red and blue) cross the green backing color at different values in different locations at the edges, which results in varying widths of the transition region (edges). Fourth, the green record in the foreground object can, in fact, be slightly greater than the other two colors in some areas, resulting in contamination in the foreground region of the matte. Each of these issues must ultimately be dealt with to create a high-quality matte.

2.6.1.6 Matte Edge Penetration

There is another real world issue to be aware of, and that is that the matte normally does not penetrate as deeply into the foreground as it theoretically should. Figure 2-43 represents a slice graph taken across the boundary between the foreground and the backing region of a greenscreen—foreground on the left, green backing on the right, with the resulting raw matte included at the bottom. The two vertical lines marked A and B mark the true full transition region between the foreground and the background. The foreground values begin their roll-off to become the greenscreen values at line A and don't become the full backing color until they get to line B.

Theoretically, the new background we are going to composite this element over will also start blending in at line A and transition to 100% background

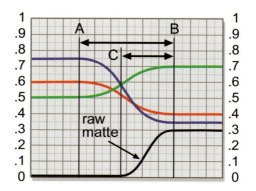

Figure 2-43 Matte edge shortfall.

by line B. Obviously, the matte should also start at line A and end at line B, but as you can see, the raw matte does not start until much later—at line C.

The reason for this shortfall is readily apparent by inspecting the RGB values along the slice graph and reminding ourselves of the raw matte equation. Because it subtracts green from the maximum of red or blue, and green is less than both of them until it gets to line C, the raw matte density will be 0 all the way to line C. How much shortfall there is depends on the specific RGB values of the foreground and backing colors. When the foreground colors are a neutral gray, the matte does in fact penetrate all the way in and has no shortfall at all. In fact, the less saturated (more gray) a given foreground color is, the deeper the matte will penetrate. You might be able to figure out why this is so by inspecting the slice graph in Figure 2-33, which shows a gray foreground blending into a green backing. Just step across the graph from left to right and figure the raw matte density at a few key points and see what you get.

However, for foreground RGB values other than neutral grays, there is always a matte edge shortfall like the one in Figure 2-43, and it can easily be the true width of the transition region, sometimes even more. Further, the amount of shortfall varies all around the edge of the foreground element depending on the local RGB values that blend into the green backing. In other words, line C above shifts back and forth across the transition region depending on the local pixel values, and is everywhere wrong, except for any neutral grays in the foreground.

The good news is that it usually does not create a serious problem (note the use of the evasive words "usually" and "serious"). The color difference matte process is very "fault tolerant." Later we will see how to filter the raw matte, and one of the things this filtering does is to pull the inner matte

Ex. 2-10

edge deeper into the foreground region to help compensate for the shortfall.

Other sections will also show how to move this transition edge in and out, which will solve many problems.

2.6.2 Scaling the Raw Matte

When the raw matte is initially extracted it will not have anywhere near enough density for a final matte. The criterion for the final matte is to get the backing region to 100% white and the foreground region to zero black. This is done by scaling the density of the raw matte. We have to scale the raw matte density in two directions at once: both up and down. The basic idea is to use the color curve tool to pull up on the whites to full transparency and down on the blacks to full opacity. It is very common to have to scale some dark gray pixels out of the black foreground region to clear it out as there will often be some colors in the foreground where the green channel is slightly greater than both of the other two. Let's see why this is so.

Figure 2-44 illustrates a greenscreen plate with two foreground contamination regions: A and B. Area A has a green highlight in the hair and there is some green light contamination on the shoulder at area B. The rise in the green record in these two regions can be seen in the slice graph in Figure 2-45. Because the green record is noticeably greater than *both* of the other two records in these areas, it will leave a little raw matte density "residue" in the foreground region that we do not want. This residual density contamination is clearly visible in the resulting raw matte shown in Figure 2-46. The gray residues in the foreground area are regions of partial transparency and

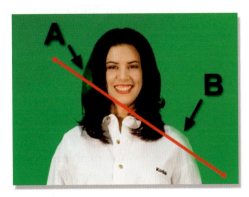

Figure 2-44 Problem greenscreen plate.

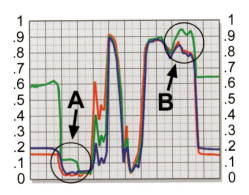

Figure 2-45 Slice graph over problem areas.

will put "holes" in our foreground at composite time. They must, therefore, be terminated with prejudice.

The first step is to scale the raw matte density up to full transparency, which is a density of 1.0 (100% white). Again, the matte can be inverted later if needed. Figure 2-46, the contaminated raw matte extracted from the problem greenscreen in Figure 2-44, shows the raw matte starting point. Move the "white end" (top) of the color curve graph to the left as shown in Figure 2-47 a bit at a time and the raw matte density will get progressively more dense. Stop just as the density gets to a solid 1.0 as shown in Figure 2-48. Be sure to pull up on the whites only as much as necessary *and no more* to get a solid white because this operation hardens the matte edges, which we want to keep to an absolute minimum. In the process of scaling up the whites, the nonzero black contamination pixels in the foreground will also have gotten a bit denser, which we will deal with in a moment. We now have the backing region matte density at 100% white and are ready to set the foreground region to zero black.

Figure 2-46 Raw matte.

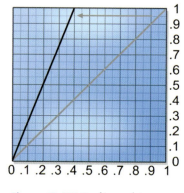

0 .1 .2 .3 .4 .5 .6 .7 .8 .9 1

Figure 2-47 Scaling whites up.

Figure 2-48 White scaled matte.

To set the foreground region to complete opacity, slide the "black end" (bottom) of the color curve to the right as shown in Figure 2-49 so it will "pull down" on the blacks. This scales the foreground contamination in the blacks down to zero and out of the picture like Figure 2-50. This operation is also done a little at a time to find the *minimum* amount of scaling required to clear out all the pixels because it too hardens the edges of the matte. As you pull down on the blacks you may find that a few of the white pixels in the backing region have darkened a bit. Go back and touch up the

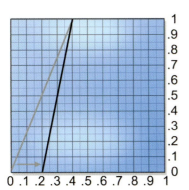

Figure 2-49 Color curve moved to scale down blacks.

Figure 2-50 Blacks scaled down.

whites just a bit. Bounce between the whites and the blacks, making small adjustments until you have a solid matte with the least amount of scaling.

It is normal to have to scale the whites up a lot because we are starting with raw matte densities of perhaps 0.2 to 0.5, which will have to be scaled up by a factor of 2 to 5 in order to make a solid white matte. The blacks, however, should only need to be scaled down a little to clear the foreground to opaque. If the foreground region of the raw matte has a lot of contamination in it then it will require a lot of scaling to pull the blacks down, which is bad because it hardens the edges too much. Such extreme cases will require heroic efforts to suppress the foreground pixels to avoid severe scaling of the entire matte. Figure 2-51 shows a new flowgraph with a color curve node for the scaling operation added to our growing sequence of operations.

Ex. 2-11

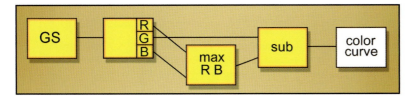

Figure 2-51 Flowgraph with color curve scaling operation added.

2.6.3 Refining the Color Difference Matte

So far we have seen the basic technique for extracting or "pulling" a color difference matte, but when used in the real world on actual bluescreens all kinds of problems will surface in both foreground and backing regions, not to mention the edges. This section shows how to refine the basic color difference matte to control the ever-present artifacts and finish with the best possible matte ready for compositing.

2.6.3.1 Preprocessing the Greenscreen

As a broad strategy, you can almost always improve your raw matte results with some kind of preprocessing of the greenscreen to "set it up" for a better color difference matte. By the by, all of these preprocessing techniques can also be used to help Ultimatte, as it is basically a color difference matte technique too. What works for your own color difference mattes will work for Ultimatte too. The basic idea is to perform some operations on the greenscreen plate *before* the matte is pulled that improves the raw matte density in the backing region, clears holes in the foreground region, improves edge characteristics, or all of the above. There are a number of these operations, and which ones to use depends on what's wrong.

Figure 2-52 shows a flowgraph of how the preprocessing operation fits into the overall sequence of operations. The key point here is that the preprocessed greenscreen is a "mutant" version kept off to the side for the sole purpose of pulling a better matte, but not to be used in the actual composite. The original untouched greenscreen is used for the actual foreground despill, color

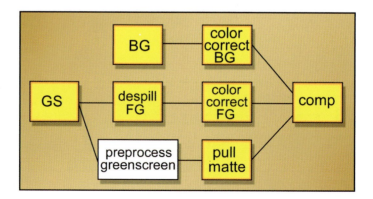

Figure 2-52 Preprocessed greenscreen.

correction, and final composite. This section explores several preprocessing operations that can help in different circumstances. Which techniques will work on a given shot depends entirely on the actual colors present in the greenscreen plate. These, then, are some of the "heroic" rescue techniques alluded to at the beginning of this chapter. You can use one or all of them on a given greenscreen.

2.6.3.2 Local Suppression

As we know, problem areas in the foreground region are caused by the green record climbing above the other two records in a local region. As another overarching strategy, we would like to avoid "global" solutions to the problem (such as scaling the blacks down harder) because they affect the entire matte, which can introduce problems in other areas. A surgical approach that just affects the problem area is much preferred. Ideally, we would just push the green record down a bit in the problem area, solving the problem without disturbing any other region of the greenscreen plate. This is sometimes both possible and easy to do.

Use a chroma-key tool to create a mask from the original greenscreen plate that covers the problem area. Use this chroma-key mask and a color adjusting tool to lower the green record under the mask just enough to clear (or reduce to acceptable) the problem area from the foreground. Perhaps the subject has green eyes, which will obviously have a green component higher than the red and blue in that area. Make a chroma-key mask for the eyes and suppress the green a bit. Perhaps there is a dark green kick on some shiny black shoes that also punches holes on the foreground region of the matte. Mask and suppress. A flowgraph of the general sequence of operations is shown in Figure 2-53. If the target item is too close to the backing in color then some of the backing may show up in the chroma-key matte.

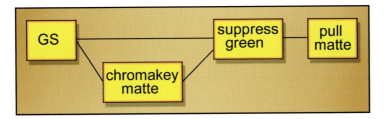

Figure 2-53 Flowgraph of chroma-key used for local suppression.

A traveling garbage matte may be required to isolate the target item from the backing.

2.6.3.3 Channel Clamping

Let's explore a more sophisticated solution to the problem green-screen in Figure 2-44, which is the green highlight in the hair and some green spill on the shoulder. Reexamining the slice graph in Figure 2-45, the graph area marked A shows the green record rising about 0.08 above the red record, which is the result of the green highlight in the hair. The graph area marked B shows that the green record has risen above the red channel due to the green spill on the shoulder. It has reached a value as high as 0.84, while the average value of the backing green channel is down near 0.5. What we would like to do is shift the color channels so that the green record is at or below the red record in these two regions without disturbing any other parts of the picture. We can either move the green record down or move the red record up. In this case, we can do both.

Referring to the color curve in Figure 2-54, the red curve has been adjusted to clamp the red channel *up* to 0.13 so no red pixel can fall below this value. As a result, the red channel in the hair highlight in area A has been "lifted" up to be equal to the green record, clearing the contamination out of this area of the raw matte. The resulting slice graph in Figure 2-55 shows the new relationship between the red and the green channels for area A. Similarly, the problem in area B has been fixed by the same color curve in Figure 2-54 by putting a clamp on the green record that limits it to a value of 0.75. This has pulled it down below the red record, which will clear this area of contamination.

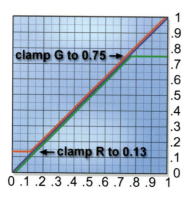

Figure 2-54 Color curve used to clamp channels.

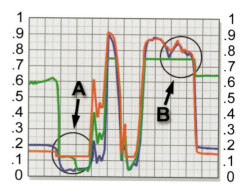

Figure 2-55 Red and green channels clamped by color curve.

Again, we just need to get the green record below (or nearly below) either the red *or* blue records to clear the foreground matte. This means either lowering the green record or raising one of the other two. Either one will work. The key is to shift things as little as possible and then check the raw matte for the introduction of any new problems in other areas. Keep in mind that other parts of the picture could also get caught in this "net" that could introduce other problems. Make small changes and then check the raw matte.

2.6.3.4 Channel Shifting

 Here is a nifty technique that you will sometimes be able to use, again, depending on the actual color content of the greenscreen. By simply raising or "lifting" the entire green record you can increase the raw matte density, resulting in a better matte with nicer edges. Starting with the slice graph in Figure 2-56, the difference between the green channel and the maximum of the red and blue channels in the backing region is about 0.3. We can also see that the green record is everywhere well below both the red and the blue records in the foreground region. If the green record were raised up by 0.1, as shown in Figure 2-57, it would increase the raw matte density from 0.3 to 0.4, a whopping 33% increase in raw matte density! As long as it is not raised up so much that it climbs above the red or blue records, no holes in the foreground will be introduced. Of course, in the real world you will rarely be able to raise the green record this much, but every little bit helps.

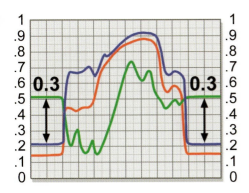

Figure 2-56 Original raw matte density.

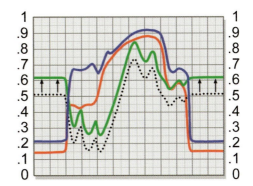

Figure 2-57 Green channel shifted to increase raw matte density.

The procedure is to raise the green record a bit by adding a small value (0.1 in this example) to the green channel and then pull the raw matte again to look for any new contamination in the foreground. If all seems well, raise the green record a bit more and check again. Conversely, you can try lowering the red and blue records by subtracting constant values from them. These techniques can sometimes solve big problems in the matte extraction process, but sometimes at the expense of introducing other problems. The key is an intelligent tradeoff that solves a big, tough problem while only introducing a small, soluble problem. For example, if only a few holes are introduced, you can always pound them back down with local suppression techniques or perhaps with a few quick rotos.

In addition to adding or subtracting constants from the individual records to push the channels apart for better raw mattes, you can also scale the individual channels with the color curve tool. It is perfectly legal to have "creative color curves" to push the color records around in selected regions to get the best matte possible. Always keep in mind that the color difference matte extraction works on the simple *difference* between the green record and the other two records so raising or scaling up the green can increase the difference, but so can scaling down or lowering the red or blue records. Push them around, see what happens.

2.6.3.5 Degraining

All film has grain. Even video shot with a video camera has "video noise" that acts like grain. When film is transferred to video in telecine there will still be grain. It is important to know how the grain will affect the matte extraction process and what to do about it to reduce its impact on your results. While the grain degrades all matte extraction processes, its most important impact is in bluescreen matte extractions because that is normally the most frequent and demanding scenario.

Figure 2-58 is a close-up of a greenscreen plate showing the grain with a slice line crossing the transition region between the foreground and the backing. The grain "noise" can be seen easily in its slice graph in Figure 2-59. Regardless of the matte extraction method, the first thing that is generated by a keyer or your own matte extraction procedure is the raw matte. This is the initial color difference density before it is scaled up to full density for use, and the grain has a big impact at this point.

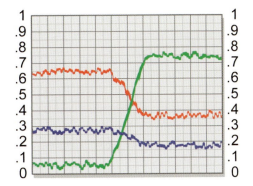

Figure 2-58 Close-up of greenscreen grain.

Figure 2-59 Slice graph of greenscreen noise.

Figure 2-60 represents the raw matte created from the greenscreen close-up in Figure 2-58. As you can see, the grain from the film has become "embossed" into the raw matte as "noise." It is called noise because it is no longer really grain because it is now the interaction between the grain of two or more color records of the film. The good news is that the resulting raw matte "grain noise" is no greater than the noise (grain) in any one of the three-color channels. In other words, the grain does not build up or accumulate in any way. Anywhere in a matte extraction process that incorporates the blue channel in its calculations will end up embossing the grain of the blue channel into the raw matte, and the blue channel has much more grain than the green or red (which are similar to each other). The blue grain is both larger in diameter and greater in amplitude than the red or green grains.

Figure 2-60 Raw matte.

Figure 2-61 Scaled matte.

Another issue is that the density of the raw matte must be scaled up from the typical value of 0.2 or 0.3 to a full density value of 1.0, which is a scale factor of 3 to 5. This will obviously also scale up the matte noise by a factor 3 or 5. In addition to that, if the raw matte density was an average of, say, 0.2, then we would scale it up by a factor of 5 to get a density of 1.0, but the 0.2 was an *average* value, so when the matte is scaled up some of the pixels don't make it to 100% white. This leaves some "salt and pepper" contamination in the backing region, as shown in the scaled matte in Figure 2-61.

We are therefore forced to scale the brightness up by *more* than the original factor of 5 to get all the noise out of the backing region. Scaling the matte up more hardens the edges, increases "edge sizzle"—chatter at the edges of the composite on moving pictures caused by this "grain noise"—and destroys edge detail. Making a degrained version of the frames to pull the matte will solve a great many of these problems.

If grain from the blue channel is causing most of the grain grief, then it is often very effective to degrain just the blue record before pulling the matte. If a quality degrain operation is not available, then either a median filter or a gentle blur will have to do. The key is that it is done on the blue record *only*. This takes advantage of the following two important film facts.

Important Film Facts

1. Most of the grain noise comes from the blue channel.
2. Most of the image detail is in the red and green channels.

By taking advantage of this fortuitous juxtaposition, most of the noise reduction can be achieved with the least loss of matte detail by smoothing just the blue channel.

The blue record grain affects bluescreens and greenscreens differently. With bluescreens it is the primary color of the matte so all of the matte calculations are based on it. As a result, its excessive grain is embedded into the matte edges, making bluescreen mattes "sizzle." However, because the despill operation of the bluescreen is based on comparisons to the red and green channels, the despill is not badly affected. With greenscreens the blue record is part of the color difference matte calculations only in certain areas. For those areas the grain of the blue record will be present,

but for the majority of the matte it is not a participant. As a result, the green-screen matte will have "quieter" edges than the bluescreen. However, the despill for a greenscreen will reference the blue channel, and the heavier blue grain often becomes "embossed" into the red or green records. Of course, this invariably happens on smooth flesh tones on the face, just what you don't need.

Ex. 2-12

2.6.4 Poorly Lit Greenscreens

The entire purpose of the DP (Director of Photography) is to ensure that each scene is lit properly and exposed correctly (oh, yes—fabulous com-position and exciting camera angles too!). The entire purpose of the green-screen is to be lit evenly, exposed correctly, and the right color—you know—green! Not cyan, not chartreuse, but green. Somehow this all too often collapses on the set and you will be cheerfully handed poorly lit off-color greenscreen shots and are expected to pull gorgeous mattes and make beau-tiful composites from these abused plates. As digital compositors, we are victims of our own wizardry. Digital effects have become so wondrous of late that no matter how poorly it is shot on the set, the "civilians" (nondigital types) believe that we can fix anything. The problem is that all too often we can, and as a result we are encouraging bad habits on the part of the film crew.

The standard lecture to the client is "poorly lit greenscreens degrade the quality of the matte that can be extracted. Extra work will be required in an attempt to restore some of the lost matte quality, but this will both raise pro-duction costs and degrade the results." Unfortunately, you may never be given the chance to deliver this lecture or supervise the greenscreen shoot. All too often the first time you will know anything about the shot is when the dig-itized film frames are handed to you and then it's too late. Now you must cope. Poorly lit greenscreens are, in fact, the most difficult and common problem. There are several different things that can be wrong with the lighting, so each type of problem will be examined in turn, its effect on the resulting matte, and potential workarounds discussed. But it is not a pretty sight.

2.6.4.1 Too Bright

In film work it is rare for the greenscreen to be too "hot" (bright) simply because it requires either a great amount of light (which is expensive) or

overexposure due to excessive aperture (a rare mistake for all but the most inept DPs). The dynamic range of film is so great that it can take an enormous amount of light and still maintain separation between the color records, unless, of course, you are *not* working with the full dynamic range of film, which, surprisingly, most studios are not.

When film is digitized to the Cineon 10-bit log format the full dynamic range of the film is retained. If the Cineon log image is later converted to linear, then both the whites and the blacks get clipped. When film is digitized to 8 bits linear either on a film scanner or on a telecine the picture is again clipped in both the whites and the blacks. See Chapter 13 for the full story on this fascinating topic. In the meantime, suffice it to say that since the picture is clipped in the whites, an overbright greenscreen can become clipped.

Figure 2-62 represents a greenscreen with a "hot spot" in the middle that was overexposed with the brightness of the green channel greater than the white clip point, not uncommon in film to video transfers. The green record got clipped in the flat region in the center. The slice graph in Figure 2-63 shows what's happening. While the red and blue records peaked around point A, the green record was clipped flat. This is lost data which cannot be restored. Most importantly, note the difference between the green and the red records at point A in the clipped region and point B in the normally exposed region. Clipping the green record has reduced the green–red color difference so the raw matte values in this region will be significantly less than in the unclipped regions. Now the matte density will be thinner in the clipped region.

Figure 2-62 Clipped greenscreen.

Figure 2-63 Slice graph of clipped greenscreen.

 What to do? The problem with this problem is that critical data has been lost. Not compressed, abused, or relocated in some way that can be recovered, but gone. In the case of a Cineon log image converted to linear, the only real fix is to reconvert the original film scan, adjusting the white point to slightly above the brightest green value. This will darken the overall image somewhat, which will have to be color corrected back later at composite time. But in a greenscreen shot the matte's the thing, so we must have a full data set to pull a good matte. The rest can be fixed later. If the greenscreen plate was film transferred to video, then the telecine must be redone, if at all possible. If it was shot in video, then the original video is clipped and you are stuck with what you got.

Now here's a nifty trick for the film folks converting Cineon log images to linear, assuming the foreground object is not clipped along with the backing color. Keep the original clipped version to use as the foreground element in the composite, but pull the matte from the reconverted version. That way you keep the best of both. The folks working with film transferred to video with a telecine have a tougher problem. The film can be transferred to video a second time with color adjustments to lower the greenscreen values so they are no longer clipped, but unless both versions (the darker one to pull a good matte and the "overbright" one to use the foreground element for the composite) are transferred with a pin-registered telecine, the two sets of frames will have "gate weave" and will not stay registered to each other.

2.6.4.2 Too Dark

The greenscreen is too dark because it was underexposed. After vowing to purchase new batteries for the DP's light meter, we can examine the deleterious effects of underexposure on the raw color difference matte.

Figure 2-64 shows a greenscreen nicely exposed on the left and underexposed on the right with a slice line across the two regions. As you can see in the slice graph of Figure 2-65, on the correctly exposed (left) side of the greenscreen, the color difference between green and red channels will be a healthy 0.30 (0.7 − 0.4), whereas on the underexposed side the color difference will be an anemic 0.15 (0.35 − 0.2). In other words, the underexposed side has *half* the raw matte density of the properly exposed side! The reason is apparent from the slice graph. As the exposure gets lower, the RGB records not only get lower, but they also move *closer together*. Moving closer together reduces their difference, hence a lower raw matte density. As a result,

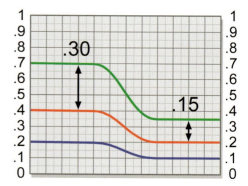

Figure 2-64 Normal and underexposed greenscreen.

Figure 2-65 Slice graph of normal and underexposed greenscreen.

the "thinner" raw matte will have to be scaled much harder to achieve full density.

Pausing for a lecture, this is a tempting situation to engage in what I call "pushing the problem around." What I mean by this is putting a fix on a problem that in fact only appears to help, but doesn't really. Here is an example of "pushing the problem around" in this case: Let's try solving our underexposed greenscreen problem by cleverly increasing the overall brightness of the greenscreen plate before pulling our raw matte. That is to say, we will scale the RGB values up by a factor of 2.0 and voila! The raw matte density jumped from 0.15 to 0.30, just like the properly exposed side. We can now scale the new and improved raw matte density by a modest factor of 3.3 to achieve our desired density of 1.0 and go home feeling quit clever. But are we? Let's take a closer look.

The original raw matte density was 0.15, which will need to be scaled up by a factor of 6.6 to achieve a full density of 1.0. However, if we scaled the original RGB channels up by a factor of 2 to get an improved raw matte density of 0.3 and then scaled that up by a factor of 3.3 to full density, we have still simply scaled the original density of 0.15 by a factor of 6.6 (2 × 3.3). We have wasted some time, some nodes, and had a fine exercise in the distributive law of multiplication, but we have not helped the situation at all. This is what I mean by "pushing the problem around," but not actually solving it. This is a chronic danger in our type of work, and understanding the principles behind what we are doing will help avoid such fruitless gyrations (end of lecture).

Returning again to the actual problem, one thing is clear: we are going to get a pretty thin raw matte density, and this thin raw matte density will also

have lots of grain in it because the apparent grain increases in low exposure parts of the picture. We now have to scale up this grainier version of the raw matte much more than one from a properly exposed greenscreen. As a result, we get a very noisy matte with hard edges. The tragedy in this problem is that data are simply not there for our raw matte. But wait, it's not there in the digital data you are trying to work with, but it *is* there in the film negative!

 Yes! The film negative has *several* times the amount of information compared to the digital file from a video telecine or the linear conversion of the original log film scan. Like the overexposed greenscreens in the previous section, we can go back to the original log data file and convert it to linear again, this time lowering the white point and adjusting the gamma to get a brighter greenscreen. This "pumped" version can be used to pull the mattes, discarded, and the foreground element from the original scan used for the actual composite. Rest assured that we are not "pushing the problem around." We are actually getting more data to work with by resampling the original log scan and recovering previously discarded data. It was on the film negative and in the 10 bit log data all the time, but was discarded when converted from log to linear. The underexposed film will still be grainier than properly exposed film, however.

Again, folks working with film transferred to video with a telecine have a tougher problem. As mentioned earlier, the film can be telecined a second time with better color correction, but only if it is a pin-registered transfer to prevent gate weave.

2.6.4.3 Impure Greenscreens

The entire idea of how a greenscreen works is based on a pure, saturated primary color. As shown from the math used to pull a color difference matte, to get the maximum raw matte density the green record must be as far above the red *and* blue records as possible. This is, by definition, a saturated color. However, in the real world, the red or blue records may not be very low values. Excessive red or blue records can cause the green to be "impure" and take on a yellow tint (from high red), a cyan tint (from high blue), or a faded look (from high red *and* blue). This lack of separation of the color records reduces the quality of the matte dramatically.

Figure 2-66 shows four side-by-side greenscreen strips, with Figure 2-67 plotting the matching slice graph across all four regions. Region A is a nice saturated green, and its slice graph shows a healthy color difference value

Figure 2-66 Impure greenscreens.

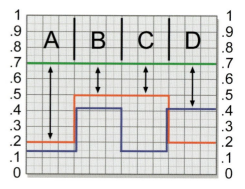

Figure 2-67 Slice graph of impure greenscreen.

(black arrow) that would make a fine raw matte density. Region B is an unsaturated greenscreen example, and its slice graph clearly shows high red and high blue values with a resulting low raw matte density. Region C is too high in red, and because the color difference equation subtracts green from the *maximum* of the other two channels, red becomes the maximum and the resulting raw matte density is also very low. Region D simply shifts the problem over to the blue channel with similarly poor results.

 What can be done? While the situation is dire, it is not hopeless. There is one possibility that may help: the channel shifting technique we learned earlier. Choosing the most offensive channel (let's say it's the red channel that is too high), you can start gently subtracting values from the red channel of the greenscreen before pulling the color difference matte. This will lower the red record overall, which will help the matte, but will also eventually start to introduce nonblack pixels into the foreground region if you go too far. Lower the red record a bit and then check the matte for foreground pixels. Lower it a bit more and check again. Some amount of nonzero pixels in the foreground is a common occurrence anyway and is not the end of the world. Once you have found the limits of the red channel, repeat the process with the blue channel. With luck (and this depends on the actual RGB color content of the foreground) you will be able to add significantly to the overall raw matte density while only adding a little to the foreground black. If the foreground is contaminated in only one or two places, this is a candidate for some local suppression. When broad areas start to increase density, you have reached the limits of the process.

2.6.4.4 Uneven Lighting

This is both the most common and the most insidious of the bad greenscreen curses. The reason it is the most common is simply because it is very difficult to get the lighting both bright and uniform across a broad surface. The human eye is so darn adaptable that it makes everything look nice and lit uniformly, even when it is not. Film is not so accommodating. Standing on the set looking at the greenscreen it looks like a perfectly uniform brightness left to right, top to bottom, but when the film comes back from the lab there is suddenly a hot spot in the center and the corners roll off to a dingy dark green and now you have to pull a matte on this chromatic aberration. Let's see what might be done.

First of all, here's a rare bit of good news. Even though the greenscreen gets noticeably darker at, say, the left edge, when you pull your color difference matte it will be less uneven than the original film plate! How can this be, you marvel? This is one of the magical virtues of the color difference matte technique compared to, say, chroma-key. To see how this is so, let's refer to Figure 2-68, which shows a greenscreen with a dark left edge, and Figure 2-69, which shows the slice graph of the unfortunate greenscreen.

Figure 2-68 Uneven greenscreen.

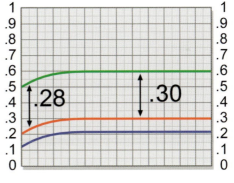

Figure 2-69 Slice graph of uneven greenscreen.

As shown in the slice graph, the greenscreen brightness drops off dramatically on the left edge. The RGB values at the left edge of the graph can be seen dropping almost 20% compared to the properly lit region. But look closely at the *difference* between the red and the green channels. All three channels drop together, so their *difference* does not change so dramatically. In the properly lit region the raw matte density is about 0.30 and in the dark region it is about 0.28, only a little less. While the green channel dropped off

Figure 2-70 Uneven greenscreen.

Figure 2-71 Uneven raw matte.

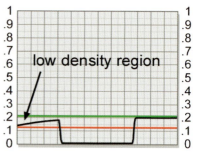

Figure 2-72 Slice graph of raw matte.

dramatically, so did the red channel. In fact, they largely drop off *together* so their difference is affected only slightly. More than any other matte extraction method, the color difference matte is fairly forgiving of uneven greenscreens. That is the end of the good news for today, however. Next, we will take a look at how the uneven greenscreen affects the matte and then what might be done about it.

Figure 2-70 shows an unevenly lit greenscreen and foreground element, both getting darker on the left. Next to it in Figure 2-71 is the resulting uneven raw matte (before scaling) using our standard color difference matte extraction procedure (G – max(R,B)). A low-density region can be seen along the left edge of the raw matte, which will become a partially opaque region if we don't do something about it. The slice graph of the uneven matte in Figure 2-72 shows the lower density in the backing region on the left edge (exaggerated for clarity). There is also a red and a green reference line added to the slice graph. The green line represents the desired point that would normally be pulled up to 100% white by the scaling operation. If this were done, the backing region at the left edge would remain partially opaque in the process, as it won't make it to 100% white. We can solve this problem by scaling the matte up harder from the much lower point indicated by the red line until this becomes the 100% white point. However, this will clip out some of the edge detail of the matte and harden the edges, neither of which we want to do. What is needed is some way to even up the greenscreen plate.

Ex. 2-13

2.6.5 Screen Leveling

Screen leveling is one of my favorite techniques. It has many more applications than just straightening out uneven greenscreens, but this is a fine place to describe the process. Imagine turning a greenscreen plate up and looking at it edge on. You might visualize the

three color channels as three "planes" of colored plastic. The green backing of a uniformly lit greenscreen would be seen as a nice flat surface of green. This "edge on" visualization is very useful for understanding screen leveling and is also the "point of view" of the slice graph.

Here is a conceptual model that will help you visualize how screen leveling works. Figure 2-73 shows a perfectly flat "greenscreen" surface with a "foreground object" sitting on it. It would be trivial to cleanly separate the foreground object from the greenscreen surface with a single threshold number; 0.45 in this case. Anything below 0.45 is the greenscreen, and anything above it is the foreground object. This threshold number represents the point that is scaled up to 1.0 to give the raw matte full transparency in the backing region.

However, in the real world the greenscreen is never perfectly flat. It is invariably lit unevenly with a "slope" to it like Figure 2-74 (getting darker toward the right in this example). As a result, the raw difference matte will not have a uniform value across the screen, despite the tolerance of the color difference matte to uneven lighting. Now try and separate the foreground object from the greenscreen with a single threshold value. It cannot be done. Whatever threshold you select will either leave some pieces of the foreground object behind, include pieces of the greenscreen, or both.

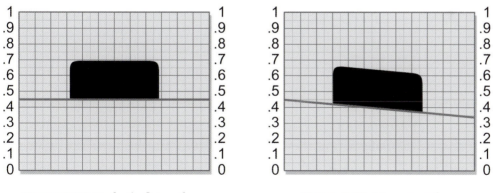

Figure 2-73 Perfectly flat surface. **Figure 2-74** Uneven surface.

But what if we could "straighten up" the greenscreen, making it flat? Figure 2-75 shows a "slope" at the bottom of the graph with the sloped surface as a compensating gradient that starts at 0 on the left and goes to 0.1 on the right. If this gradient is summed with (added to) the greenscreen plate, it will raise the low end of the backing and the foreground object together to restore a "flat" surface like the one in Figure 2-76, which can now be separated with

Figure 2-75 Compensating gradient. **Figure 2-76** Corrected surface.

a single threshold value. If the color difference matte is extracted from the "leveled" greenscreen, the raw difference matte will now be much more uniform. You cannot use this technique with the raw matte after it is pulled. The reason is that the gradient you add to level out the raw matte would also be added to the zero black region of the foreground, introducing a partial transparency there. It must be done to the greenscreen plate *before* pulling the matte.

To apply this to a simplified test case, let's say that we have a greenscreen plate that gets dark from top to bottom. The procedure is to measure the RGB values at the top and bottom and subtract the two sets of numbers, which will tell us how much the RGB values drop going down the screen. We would then make a "countergradient" that is zero black at the top and whatever value the difference was at the bottom. We would then add the countergradient plate to the greenscreen plate to level it out.

An example is shown in Figure 2-77. The left-most square represents a greenscreen plate with RGB values at the top of 0.2 0.6 0.2 and at the bottom of 0.1 0.4 0.2. Subtracting the two sets of RGB numbers, we find that the bottom is RGB 0.1 0.2 0 darker than the top. We now create a countergra-

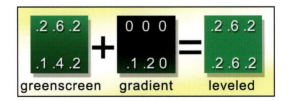

Figure 2-77 Leveling a greenscreen.

dient that is black (0 0 0) at the top and 0.1 0.2 0 at the bottom. Note that the difference between the RGB values will not be the same for all channels, so it is not a gray gradient but a three-channel colored one with different values in each channel. When we add these two plates together the new green-screen will have equal values from top to bottom—it will now be "level." We can now pull a much cleaner matte. Because the compensating gradient was green dominant and was also added to the foreground region, it will slightly raise the green record in the foreground region. This will sometimes add a bit of contamination to the foreground depending on its color composition, but it is well worth the gains of the improved backing uniformity. We have traded the large problem of an uneven greenscreen backing for the much smaller problem of a little possible foreground contamination.

Meanwhile, back in the real world, you will not have unevenly lit greenscreens that vary neatly from top to bottom like the little example just given. They will vary from top to bottom and left to right and be bright in the center and have a dark spot just to the left of the shoulder of the actor, making a much more complex irregularly "warped" greenscreen. Your software package may or may not have tools suitable for creating these complex gradients. The key is to do what you can to level the screen as much as possible, knowing that whatever you can do will help and that it does not have to be perfect,

Ex. 2-14

just better. When it comes to raw matte density, every little bit helps because the raw matte is going to be scaled up by many times, so even a 0.05 improvement could add 10 or 20% improvement to the final results.

2.6.6 Screen Correction

One of the most difficult problems to solve for greenscreen matte extraction is defects in the backing material. There can be seams, folds, tears, patches, tape, and other irregularities in the backing material that deviate wildly from the pure, uniform green they are supposed to be. These backing defects become matte defects and are particularly troublesome when the foreground object crosses in front of them, which they invariably do. Figure 2-78 illustrates a greenscreen with a big fat fold across the backing material, and Figure 2-79 shows the resulting matte with a matching defect in the backing region from the fold. Scaling up the whites in the matte will clear the defect from the backing region of course, but at the expense of severely hardening the edges of the entire matte.

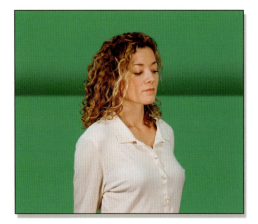

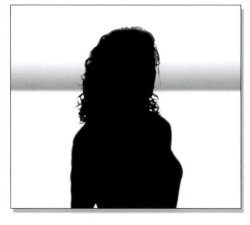

Figure 2-78 Original greenscreen. **Figure 2-79** Resulting defective matte.

Ultimatte devised an almost magical solution to this problem that they call *screen correction*. The basic idea is that in addition to the original greenscreen, a clean pass of the backing material is shot *without* the foreground object, which is used as a reference to correct the defects in the original greenscreen. An example of this clean greenscreen is shown in Figure 2-80. When a matte is extracted from the clean greenscreen (Figure 2-81), it will have all of the defects of the original greenscreen, including those that were hidden by the foreground object. The clean greenscreen and its matte are used to create a "defect map" of the original greenscreen backing material, which is then used to fill in its "potholes" to make it a uniform green. Beyond its use

Figure 2-80 Clean greenscreen. **Figure 2-81** Clean greenscreen matte.

with Ultimatte, you can also perform your own screen correction to be used with other keyers or for pulling your own mattes.

2.6.6.1 Screen Correction with Ultimatte

Ultimatte cheerfully advises you to simply connect your clean greenscreen plate to the screen correction input of the Ultimatte node. All you need is a clean greenscreen plate, of course. Meanwhile, back in the real world, you will almost never be given a clean plate. There wasn't the time, the money, or no one thought of it. Furthermore, it would only have been helpful for locked off camera shots, which most directors today prefer to avoid. If the camera is moving, the only way to shoot a matching clean pass of the greenscreen is with a motion control rig. Yah, that's going to happen.

So why even bring up the subject of screen correction and extol its virtues only to say you probably can't use it? There are a couple of reasons. First, now that you know about it you may be able to request that clean plates of the greenscreen be shot for your next job. You never know, it could happen. The second reason for bringing it up is that it is entirely possible to create your own clean greenscreens for screen correction, and it is well worth the hassle for particularly troublesome shots.

 To create your own clean greenscreen plate you may be able to select one frame of the original greenscreen shot and paint out the foreground object. Alternately, you might be able to cut pieces from several plates and paste them together. If the camera is moving, then the situation is more complicated. An oversized clean plate will have to be created that covers the entire exposed area of the greenscreen over the course of the shot and then motion tracked to make a match move with the camera. Lens distortions limit this approach because the defects in the static clean plate can drift relative to the moving frames. Obviously these heroic measures are only worth the time and money when you have some very serious problems to solve on a really important shot.

2.6.6.2 Doing Your Own Screen Correction

Assume that, by hook or by crook, you have come to possess a clean green-screen plate and are ready to use it to screen correct a defect riddled green-screen shot. This is a nontrivial procedure, so in addition to the step-by-step

Figure 2-82 Pictographic flowchart of screen correction procedures.

procedure here we also have the pictographic flowchart in Figure 2-82 and the flowgraph in Figure 2-83 to help keep us on track. The flowgraph shows which operations to use, whereas the pictographic flowchart shows the progression of images that you will see. This procedure will ultimately create a new version of the original greenscreen called the *corrected greenscreen* that has all of the backing defects removed. A clean matte is then pulled from the corrected greenscreen using the keyer of your choice or your own matte extraction methods. The corrected greenscreen is made by first creating a *correction frame*, which is an RGB image that holds all of the pixels required to fill in those pesky potholes in the original greenscreen. The correction frame is then summed with the original greenscreen to make it smooth and uniform. Let's see how it is done, again referring to Figure 2-82 and Figure 2-83.

Step 1. GS matte: pull a matte from the original greenscreen plate using your best method. Of course, it will have the defects from the original greenscreen. Invert the matte if necessary to get a black on white matte as shown.

Step 2. Clean GS matte: pull a matte from the clean greenscreen plate using *exactly* the same methods and settings as the original greenscreen matte. This matte must be everywhere identical to the GS matte with the only difference being the presence of the foreground object. This matte must also be a black on white version.

Figure 2-83 Flowgraph of screen correction procedure.

Step 3. Solid GS: this is just a solid color node filled with the original backing color and represents a perfectly uniform greenscreen. Pixels in the original backing will eventually all be brought up to this level. Because the RGB values of the original backing will vary all over, be sure to set the solid GS to the brightest (maximum) RGB values found in the original greenscreen.

Step 4. Defect map: subtract the clean GS from the solid GS to make the defect map. It represents the difference between the actual backing and a uniform one and is normally quite dark. Before it can be used, however, the region of the foreground object must be cleared to zero black.

Step 5. Correction matte: use a math node to divide the original GS matte by the clean GS matte. Their matching defects will magically cancel out, leaving a uniform backing region while the foreground object will stay zero black. Again, both input mattes must be black over white for this step to work.

Step 6. Correction frame: multiply the correction matte by the defect map to make the correction frame. What this operation does is "punch out" the foreground object from the defect map by scaling it to zero. This correction frame will be used to fill in the defects in the original greenscreen.

Step 7. Corrected GS: simply add the correction frame from step 6 to the original greenscreen to create the corrected greenscreen. Now use any keyer or the matte extraction method of your choice on the corrected greenscreen to pull a clean matte.

While a keyer must obviously be given the corrected greenscreen so it can pull its own matte, if you are pulling the matte yourself you might be

Ex. 2-15

able to just use the correction matte created at step 5. The correction matte is a very good matte with edge characteristics very similar to the clean matte you would get from the final corrected greenscreen.

Adobe Photoshop Users—There is no divide operation in Photoshop so you are forever barred from using this technique. However, you don't need to because you can always just paint out any defects, an option not really available when compositing 500 frames.

ADOBE AFTER EFFECTS COLOR DIFFERENCE MATTE

Adobe After Effects has a very nice color difference keyer that uses a somewhat different approach to creating a matte. While it does have some limitations compared to the classical methods outlined in this chapter, it is very simple and easy to set up and works surprisingly well in most situations. Interestingly, where the classical method is weak the After Effects method is strong, and where the After Effects method is weak the classical method is strong. This suggests that using them in combination would be a very effective strategy. To see how, be sure to check out the After Effects Color Difference Matte in Appendix A.

Regardless of the method used to pull a matte, a variety of operations can be applied to refine the quality of any matte. This chapter explores several operations that, among other things, reduce grain noise, soften the edges, and expand or contract the matte size to get a better composite.

3.1 THE MATTE MONITOR

 Before we begin, this is a good time to introduce the matte monitor, which you can make with your own color curve tool. Many of the various matte extraction processes result in a raw matte that has to be scaled up to full density. When scaling raw mattes up to full density there can be stray pixels in both the white and the black regions of the matte that are hard to see, but will suddenly become very visible in the composite. This can also happen with the mattes from keyers, such as Ultimatte. You need a way to see that both your whites and blacks are solid with no contamination. Here is a little tool you can make with your color curve tool that will make those pesky pixels pop out for you to see--and pound down.

Figure 3-1 shows a supposedly "clean" matte that has hidden bad pixels in both the white and the black areas. Figure 3-2 shows how to set up the color curve tool to make a matte monitor. Connect a color curve node to the fully scaled matte or the matte output of a keyer in order to monitor the results. Next, add the two new points shown in Figure 3-2, moving them very close to the left and right margins as shown and voila! The bad white and black pixels will suddenly become visible like those in Figure 3-3. The zero black and 100% white pixels must stay undisturbed so make certain that both of the end points stay at exactly zero and one.

What this color curve does is find any pixels in the whites that are very nearly white but hard to see and push them down sharply away from the pure white pixels to make them light gray. Similarly, in the blacks the color curve will push any nonzero pixels up sharply from the true zero black pixels and make them visible. You can leave this node hanging right after a matte scaling operation to make sure you have cleared out all suspect pixels. Of course, the output image is for diagnostic viewing only and is not used in the actual composite. If you are working with proxies, this is an operation that needs to be done at full resolution. "Proxies" are the low-resolution copies of the full-resolution frames that film compositors create to speed up shot

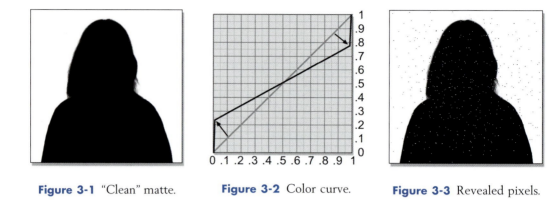

Figure 3-1 "Clean" matte. **Figure 3-2** Color curve. **Figure 3-3** Revealed pixels.

development by avoiding working with the larger (and much slower) full-size frames.

3.2 GARBAGE MATTES

One of the first preprocessing operations to be done on virtually any bluescreen matte extraction process is to garbage matte the backing color. The basic idea is to replace the backing area all the way out to the edges of the frame with a clean, uniform color so that when the matte is extracted the backing region will be clean and solid all the way out to the edges of the frame. There are two important criteria to this operation. First, it must replace the bluescreen a safe distance away from the edges of the foreground object. You must make sure that it is the matte extraction process that takes care of the foreground object edges, not the garbage matte. The second criterion is that it not take too much time.

Figure 3-4 shows the original bluescreen plate with an uneven backing color getting darker toward the top of the frame. Figure 3-5 is the garbage matte to be used, and Figure 3-6 is the resulting garbage-matted bluescreen. The backing region is now filled with a nice uniform blue, prepped for matte extraction. Note also that the garbage matte does not come too close to the edges of the foreground.

There are basically two ways to generate the garbage matte: procedurally (using rules) and by hand (rotoscope). Obviously, the procedural approach is preferred because it takes very little time. As an opening gambit try using a chroma-key node to pull a simple chroma-key matte on the backing color. If a chroma-key is not a viable solution for some reason, you can always use the second method: draw the garbage mattes by hand, which will obviously be

Figure 3-4 Original bluescreen.

Figure 3-5 Garbage matte.

Figure 3-6 Garbage-matted bluescreen.

more time-consuming. Because we are trying not to get too close to the edges of the foreground object, the rotos can be loosely drawn and perhaps spaced out every 10 frames or so. The two methods can also be combined by using a chroma-key matte for most of the backing region plus a single garbage matte for the far outer edges of the screen, which are often badly lit or have no bluescreen at all.

However you wound up creating it, once the garbage matte is ready, simply composite the foreground object over a solid plate of blue. But what blue to use? The RGB values of the backing differ everywhere across its surface. As you can see in the garbage-matted bluescreen of Figure 3-6, the color of the filled area is darker than the remaining bluescreen in some areas and lighter in others. You should sample the actual bluescreen RGB values near the most visually important parts of the backing region, typically around the head if there is a person in the plate. This way the best matte edges will end up in the most visually important part of the picture.

Garbage mattes can be used in another way. Instead of applying them to clean up the bluescreen backing region directly, they can be used to clean up the matte after it has been extracted. Again, these can be hand-drawn roto mattes, procedural mattes, or a mix. Figure 3-7 shows the starting matte with problems in both the backing region and the core area of the matte. Instead of being a nice clean black all around, the backing region has some contamination due to poor uniformity in the original bluescreen. The core matte also has some low density areas that will result in the background plate showing through the foreground object. This we must fix.

Figure 3-8 is a garbage matte created procedurally using a simple chroma-key on the backing region. The chroma-key was made with tight settings so that only the bluescreen is keyed. It was also dilated to pull it away from the

Figure 3-7 Orginal matte.

Figure 3-8 Backing region garbage matte.

original matte so that it does not touch any of its edges and accidentally trim them away. Figure 3-9 shows the results of clearing the backing region with its garbage matte. One way to do this is to use a brightness operation that is masked by the garbage matte so that only the backing region is scaled to black. Can you think of another way?

With the backing region well under control in Figure 3-9 we can turn our attention to cleaning up the core matte. Figure 3-10 shows a core garbage matte that can be used a couple of ways. We can either invert and shrink the backing region garbage matte or pull a new chroma-key with wider settings to "eat" into the core image. This garbage matte must be well inside the original core matte and also not touch its edges. The name of the game in compositing is edges, so we do not want to do anything that will damage the edge quality of our final matte.

Figure 3-9 Backing region cleared.

Figure 3-10 Core garbage matte.

Figure 3-11 Core of matte cleared.

The core garbage matte is then combined with the matte in Figure 3-9 using a "maximum" operation to fill in the low-density regions. Everywhere the matte has dark spots the pure white regions of the core garbage matte will fill them in with white. We now have a clean backing region plus a solid core matte with excellent edges in Figure 3-11.

Ex. 3-1

3.3 FILTERING THE MATTE

This section explores filtering of the matte with a blur or a median filter. There are two main reasons to apply a filter to a matte. First, it smoothes down the inevitable grain noise. This allows us to reduce somewhat how hard the matte has to be scaled up later to eliminate any "holes" in the finished matte. Second, it softens the edges of the matte. The tendency for all mattes extracted from images is to have too hard an edge. This we can fix, but first let us look into how filtering helps our cause. Always remember—blur kills (detail, that is).

3.3.1 Noise Suppression

Even if a bluescreen is degrained before matte extraction there will still be some residual grain noise. If the grain noise needs further suppression, the *raw* matte can be filtered before it is scaled to full density. The filtering operation helps reduce the amount of scaling required to get a clean matte in the first place, and minimal scaling is always desirable.

Figure 3-12 is a slice graph of a noisy (grainy) raw matte. The noise causes the pixel values to "chatter" both up and down, which tends to close the

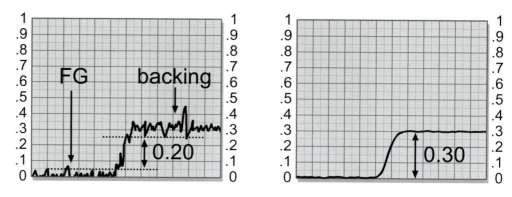

Figure 3-12 Slice graph of noisy raw matte.

Figure 3-13 Raw matte after the filter operation.

usable gap between the foreground region (around 0.3) and the backing region (near 0) to a usable gap of only about 0.2. This 0.2 region is all that is available for the final scaled matte if you are trying to eliminate the noise by scaling alone.

Figure 3-13 shows the effects of a filtering operation. It has smoothed out the noise in both the backing and the foreground regions. As a result, the gap has opened up to 0.3, increasing the available raw matte density range by 50%. (All numbers have been exaggerated for demo purposes; your results may vary.) If you pull a matte on a nicely shot greenscreen with a minimum amount of noise, you may not have to perform this operation on the raw matte, so feel free to skip it when possible. Remember, filtering operations destroy fine detail in the matte edges, so use it sparingly. Figure 3-14 shows a flowgraph of a generic matte extraction operation with a blur operation for grain suppression inserted before the matte scaling operation.

Ex. 3-2

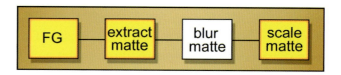

Figure 3-14 Blur operation on raw matte to suppress grain noise.

3.3.2 Softer Edges

When softer edges are needed the blur operation is performed on the final matte *after* it has been scaled to full density. The blur softens the composited edge transition two ways: (1) it mellows out any sharp transitions and (2) it widens the edge, which is normally good. It is important to understand what is going on, however, so that when it does introduce problems you will know what to do about them.

Figure 3-15 shows a slice graph of the edge transition of a matte between the white and the black regions. The dotted line represents the matte before a blur operation, with the short arrow at the top of the graph marking the width of the edge transition. The steep slope of the dotted line indicates that it is a hard edge. The solid black line represents the matte after a blur operation, and the longer arrow at the bottom marks the new width of the edge transition. The slope of the solid line is shallower, indicating a softer edge. In addition to the softer edge it is also a wider edge.

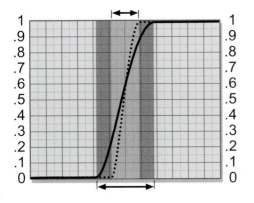

Figure 3-15 Slice graph of blurred final matte.

Figure 3-16 Edge width before and after blur operation.

The blur operation has taken some of the gray pixels of the transition region and mixed them with the black pixels from the backing region, pulling them up from black. Similarly, the white pixels of the foreground region have been mixed with the gray transition pixels, pulling them down. As a result, the edge has spread both inward and outward, equally shrinking the core of the matte while expanding its edges.

This edge spreading effect can be seen very clearly in Figure 3-16. The top half is the original edge, and the bottom half is the blurred edge. The "borders"

of the edge have been marked in each version, and the much wider edge after the blur is very apparent. This edge expansion often helps the final composite, but occasionally it hurts it. You need to be able to increase or decrease the amount of blur and shift the edge in and out as necessary for the final composite—and all of this with great precision and control. Not surprisingly, the next section is about such precision and control.

Figure 3-17 shows a flowgraph with the blur operation added after the matte scaling operation for softening the edges of the final matte. Remember, blur kills.

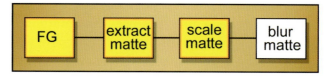

Figure 3-17 Blur operation on final matte to soften edges.

3.3.3 Controlling the Blur Operation

In order to apply the gentlest possible blur operation that will fix the grain problem it is important to understand how blur operations work. There are typically two parameters (controls) used to adjust the effects of a blur operation: the blur "radius" and the blur "percentage." And now, we digress to the nomenclature game. While most software packages refer to the blur radius as the "radius" (a few may call it "kernel size"), the parameter I am calling the blur "percentage" can go by many names. Your particular package may call it the "blur factor," "blur amount," or something else even less helpful like "more blur." Let us take a look at each of these two parameters, radius and percentage, and see how they affect the blur operation and how to set them for best results. The main problem we are addressing here is how to knock down the grain without knocking out other important matte details we want to keep. This requires a delicate touch.

3.3.3.1 The Blur Radius

A blur operation works by replacing each pixel in the image with an average of the pixels in its immediate vicinity. The first question is what is the immediate vicinity? This is what the blur radius parameter is about. The larger the radius, the larger the "immediate vicinity." To take a clear example, a blur of a

radius of 3 will reach out 3 pixels all around the current pixel, average all those pixel values together, and then put the results into the location of the current pixel. A blur of radius 10 will reach out 10 pixels in all directions, and so on. Not all blur operations use a simple average. There are a number of blur algorithms, each giving a slightly different blur effect. It would be worthwhile to run a few tests with your blur options to see how they behave.

Those packages that refer to "kernel size" are talking about a square region of pixels with the current pixel at the center like those in Figure 3-18. For example, a 7 × 7 kernel will have the current pixel in the center of a 7 × 7 grid and will "reach out" 3 pixels all around it. In other words, it is equivalent to a radius of 3. Note that since the kernel always has the current pixel in the center and gets larger by adding another pixel all around the perimeter, it will only come in odd sizes (3 × 3, 5 × 5, 7 × 7, etc.). While it is technically possible to create kernels of non-odd integer dimensions (i.e., a 4.2 × 4.2 kernel), some packages don't support it.

Figure 3-18 Blur radius vs blur kernel.

So what is the effect of changing the radius (or kernel size) of the blur and how will it affect our noisy mattes? The larger the blur radius, the larger the details that will get hammered (smoothed). Because the grain is a small detail, we need a small blur radius. If you are working in video, the "grain" size will probably be down to only one pixel or so, so look for floating point blur radius options such as 0.4 or 0.7. Working at film resolutions the grain size can be in the range of 3 to 10 pixels in size so the blur radius will be proportionally larger.

Figure 3-19 shows a slice of an image with the results of various blur radiuses. Each version has been shifted down the graph for readability. The top line represents a raw matte with noise. The middle line shows the results of a small radius blur that smoothed out the tallest small "spikes" but left some local variation remaining. With a larger blur radius the lower line would result in the local variation being smoothed out and just a large overall variation left.

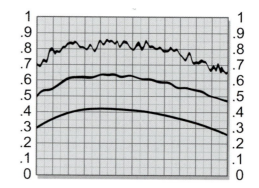

Figure 3-19 Smoothing effects of increasing the blur radius.

The problem is that there is usually desirable matte edge detail that is at or near the same size as the grain we are trying to eliminate, so as the grain is eliminated, so is our desirable detail. We therefore need the smallest blur radius that will attack the grain problem and hopefully leave the desirable detail.

3.3.3.2 The Blur Percentage

The second blur parameter, which I call the blur percentage, can be thought of as a "mix-back" percentage. It goes like this: Take an image and make a blurred copy. You now have two images: the original, and the blurred. Next, do a dissolve between the blurred image and the original image, say a 50% dissolve. You are mixing back the original image 50% with the blurred image, hence a "mix-back" percentage. That's all there is to it. Now, if your package does not offer a "percentage" parameter (by this or some other name) you now know how to make your own. Use a dissolve operation to create your own "percentage" parameter as shown in Figure 3-20. It will add an extra node, but gives you an extra control knob over the strength of the blur, and control is the name of the game here.

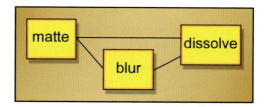

Figure 3-20 Creating your own blur percentage feature.

 If you do not have a dissolve operation, then scale the RGB values of the unblurred version by (say) 30% and the blurred version by 70% and then sum them together with an add node to make 100%. Changing the ratios (so they always total 100%, of course) allows any range of blur percentage.

3.3.4 Blurring Selected Regions

Even the minimum amount of blurring will sometimes still destroy the fine detail in the matte edge. The only solution now is to perform a masked blurring operation that protects the regions with the fine detail from the blur operation. If the hair, for example, was getting blended away by the blurring operation, a mask could be created to hold off the blur from around the hair. The mask could be created either by hand (roto mask) or procedurally (chroma-key, as one example). Now the entire matte is blurred except for the hair region. There is another possibility. Instead of blurring the entire matte except for the holdout mask region, you might do the inverse by creating a mask that only enables the blur in one selected region. For example, let's say that composite tests have shown that the grain is only objectionable in the edges around a dark shirt. Create a mask for the dark shirt and only enable the blur in that region.

What if your package does not support maskable blur operations? No problem. We'll make our own using a compositing substitute. Let's take the holdout mask for the hair as an example of the region we want to protect from a blur operation. First, make a blurred version of the entire matte. Then, using the hair mask, composite the unblurred version of the matte over the blurred version. The result is the region within the hair mask is unblurred while the rest of the matte is blurred.

3.4 ADJUSTING THE MATTE SIZE

Very often the finished matte is "too large" around the perimeter, revealing dark edges around the finished composite. The fix here is to erode (shrink) the matte by moving the edges in toward the center. Many software packages have an "erode" (or shrink) and "expand" (or dilate) operation. Use them if you got them, but keep in mind that these edge processing nodes destroy edge detail too. These nodes are edge processing operations that "walk" around the matte edge adding or subtracting pixels to expand or contract the region. While these operations do retain the soft edge (roll-off) characteristics of the

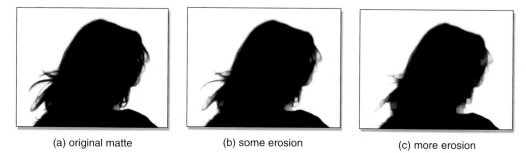

| (a) original matte | (b) some erosion | (c) more erosion |

Figure 3-21 Progressive loss of edge detail as the matte is eroded.

matte, keep in mind that the edge details will still get lost. Figure 3-21 illustrates the progressive loss of edge detail with increasing matte erosion. Note especially the loss of the fine hair detail.

 If you don't have these edge processing nodes or if they only move in unacceptably large integer (whole pixel) amounts, the following work-arounds may help. They show how to expand or contract a soft-edged matte with very fine control. Figure 3-22 represents a finished matte that needs some refinement, either to expand or to contract. The edge has been made very soft in order to make the results more visible. The following techniques show how to convert the gray edge pixels into either black transparency or white opacity regions, thus expanding or eroding the matte.

3.4.1 Shrinking the Matte with Blur and Scale

Figure 3-23 shows how to adjust the color curve to erode (shrink) the soft-edged matte shown in Figure 3-22 with the results in Figure 3-24. By pulling "down" on the blacks, the gray pixels that were part of the edge have become black and are now part of the black transparency region. By moving the color curve only slightly, very fine control over the matte edge can be achieved. The foreground region has shrunk, tucking the matte in all the way around the edges, but the edges have also become harder. If the harder edges are a problem, then go back to the original blur operation and increase it a bit. This will widen the edge transition region a bit more, giving you more room to shrink the matte and still leave some softness in the edge—at the expense of some loss of edge detail. Note the loss of detail in Figure 3-24 after the erode operation. The inner corners (crotches) are more rounded than the original, which is why the minimum amount of this operation is applied to achieve the desired results.

Figure 3-22 Soft matte.

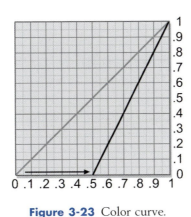

Figure 3-23 Color curve.

Figure 3-24 Shrunk matte.

To see the difference between using an edge processing operation or the color curve tool to erode the matte, Figure 3-25 shows a slice graph of the edge of a soft matte that has been shifted by an edge processing operation. Note how the edge has moved inward but has retained its slope, which indicates that the softness of the original edge was retained. Compared to Figure 3-26, the same edge was scaled with a color curve as described earlier. While the matte did shrink, it also increased its slope and therefore its hardness increased. Normally, only small changes are required so the increase in edge hardness is usually not a problem. However, if an edge processing operation is available and offers the necessary fine control, it is the best tool for the job.

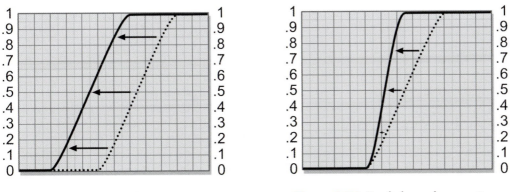

Figure 3-25 Erode by edge processing operation.

Figure 3-26 Erode by scale operation.

3.4.2 Expanding the Matte with Blur and Scale

Figure 3-28 shows how to adjust the color curve to expand the soft-edged matte in Figure 3-27 (the same matte as in Figure 3-22) with the results

shown in Figure 3-29. By pulling "up" on the whites, the gray pixels that were part of the inner edge have become white and are now part of the foreground white opacity region. The opaque region has expanded, and the edges have become harder. Again, if the harder edges are a problem, go back and increase the blur a bit. And yet again, watch for the loss of detail. Note how the star points are now more rounded than the original.

Figure 3-27 Soft matte.

Figure 3-28 Color curve.

Figure 3-29 Expanded matte.

The aforementioned operations were described as eroding and expanding the matte, while in fact they were actually eroding and expanding the whites, which happened to be the foreground matte color in this case. If you are dealing with black mattes instead, such as when pulling your own color difference mattes, then the color curve operations would simply be reversed or the matte inverted.

Ex. 3-3

When an object is filmed in front of a greenscreen, green light from the brightly lit green backing screen contaminates the foreground object in a variety of ways. Because the edges of the foreground object are not perfectly sharp due to lens limitations, the edges become blended with the green backing. There may also be semitransparent elements, such as smoke or glass, and the ever-present wisps of hair. There can be shiny elements that reflect the green backing regardless of how much dulling spray is used. Then there is the ubiquitous flare and spill.

Flare is seen as a green "haze" that covers everything in the frame, including the foreground object you are trying to isolate from the green backing. It is caused by the flood of green light entering the camera and bouncing around inside, lightly exposing the negative all over to green. The second contamination is spill. This stems from the fact that the green backing is, in fact, emitting a great deal of green light, some of which shines directly on areas of the foreground object that are visible to the camera.

The example in Figure 4-1 shows a close-up of a greenscreen and some blonde hair. The next example, Figure 4-2, reveals the contamination that the greenscreen has left on the foreground layer when it is composited over a neutral gray background without any spill removal. All of this contamination must be removed for the composite to look right, and it is the despill operation that does this job. This chapter explains how despill operations work and, equally important, how they introduce artifacts. In addition to under-

Figure 4-1 Close-up of greenscreen.

Figure 4-2 Remaining green spill without despill.

standing the inner operations of the despill nodes in your software, you will also see how to "roll your own" despill operations in the event that you don't have any or to solve special problems, which you are sure to have. Again, throughout this chapter we will be using the greenscreen to represent bluescreen as well.

The despill process is another example of a cheat that is not mathematically valid. A theoretically correct despill process would require a great deal of separate information about every object in the scene and the light sources that are shining on them, a totally impractical prospect. What we do have is a few simple techniques that work fairly well under most circumstances and introduce serious artifacts under some circumstances.

Even the very powerful off-the-shelf keyers such as Ultimatte will sometimes introduce despill artifacts. Even though they have very sophisticated algorithms that have been tested and refined over many years, they can still have problems. Your only recourse in this situation is to have as many despill methodologies as possible at your disposal so that you can switch algorithms to find one that does not introduce artifacts with your particular scene content.

 Adobe Photoshop Users—You can perform all of the despill operations described in this chapter. This is especially useful for Photoshop artists preparing bluescreen and greenscreen test composites in a digital effects studio to establish the look of the effects shots.

4.1 THE DESPILL OPERATION

In broad strokes, the despill operation simply removes the excess green from the greenscreen plate based on some rule, of which there are many to chose from. The despilled version of the greenscreen is then used as the foreground layer of the composite.

The sequence of operations can be seen starting with the original greenscreen plate in Figure 4-3 After the despill operation in Figure 4-4 the green backing has been suppressed to a dark gray and the green flare has been removed. The despilled version is then used as the foreground layer in the final composite shown in Figure 4-5.

A simplified flowgraph of the entire sequence of operations is illustrated in Figure 4-6. The greenscreen layer (labeled as "GS" in the flowgraph) is split into two branches. One branch is used to pull the matte and the other is despilled and used for the composite.

Figure 4-3 Greenscreen plate.

Figure 4-4 Despilled greenscreen.

Figure 4-5 Composited plate.

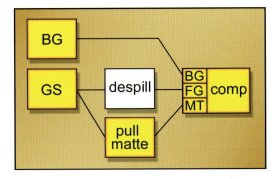

Figure 4-6 Flowgraph of the composite with despill operation.

There are three ways the despill operation might be introduced to the composite. With an off-the-shelf keyer the despill operation, as well as the matte extraction operations, is internal to the keyer. The artist will be able to adjust the despill parameters to tweak it in. The problem with this arrangement is that the despilled foreground layer will invariably need color correcting, and the keyer may not offer this option. You really don't want to color correct the greenscreen before it goes into the keyer because it will seriously disturb both matte extraction and despill operations. The second way to add the despill operation to the composite is if your software has a despill node. The third way is to develop your own despill operations with discrete nodes, which we discuss in detail.

4.2 DESPILL ARTIFACTS

The despill is done with some rule, and this despill rule can be very simple or very complex. The best rule is not necessarily the most complex. The

best rule is the one that gives the best results with the least artifacts. The problem is that the rule that removes the spill is necessarily much more simple-minded than the rules of optics that created it in the first place. As a result, any simple spill removal rule will be wrong everywhere in the plate to some degree. Depending on the scene content, it may only be a little bit wrong everywhere, so the results are quite acceptable. In other cases it can be seriously wrong in key areas and introduce such severe artifacts that something must be done.

There are primarily two color related despill artifacts: hue shifts and brightness drops. The hue shift is caused by the fact that only one color channel, the green channel, is being modified, and changing one value in any RGB color triplet will cause a hue shift. Sometimes the hue shift is so visually slight as to go unnoticed. Other times the amount of green removed relative to the other two channels is enough to shift the hue dramatically, ruining the shot. The brightness drop comes from the fact that green is being removed from the image and green is the majority component of the eye's perception of brightness. When the green is removed from around the edge, so is some brightness. In this regard, bluescreens may have a slight advantage because blue is the lowest contributor to the eye's perception of brightness, so dropping the blue channel will not cause anywhere near the apparent drop in brightness that green does.

Another artifact that despill operations can introduce with film elements is increased graininess. The blue channel of film is *much* grainier than the red or green channels, and this extra graininess even survives the telecine transfer to video. Some despill algorithms will use this grainy blue channel as a limiter for the green. As a result, the blue grain can become "embossed" on the green channel, adding an appalling, blotchy "chatter" to skin tones. There are solutions to this problem, of course, but it requires the artist who would fix it to understand what causes it in the first place. Tragically, video has its own "blue grain" problem in the form of video noise. Of the three video colors, like film, blue is also the noisiest.

4.3 DESPILL ALGORITHMS

The problem with despill operations is that color space is vast and the despill operation is a simple image processing trick. This means that no single despill algorithm can solve all problems. If you are using the despill operation within a keyer, you normally cannot change the despill algorithm. All you can do is tweak the settings. This will sometimes fail to fix the problem, and heroic measures will be required. This section describes a variety of different despill

algorithms, but perhaps more importantly, it lays the foundations for you to develop custom solutions to your unique problems.

4.3.1 Green Limited by Red

This is the simplest of all possible despill algorithms and yet it is surprising how often it gives satisfactory results. The rule is simply "limit the green channel to be no greater than the red channel." Simply put, for each pixel, if the green channel is greater than the red channel, clip it to be equal to the red channel. If it is less than or equal to the red channel, then leave it alone.

Figure 4-7 illustrates a slice graph of just the red and green channels of a section of a greenscreen plate that spans a transition between a foreground (FG) object and the greenscreen (GS) green backing region (the blue channel is not involved in this case). In the foreground region the red channel is greater than the green channel as we might expect for a skin tone; for example, then the green channel becomes dominant as the graph transitions into the green backing region. Results of the "green limited by red" despill operation can be seen in Figure 4-8. Everywhere that the green channel was greater than the red channel it was clipped to be equal to the red channel (the green line is drawn above the red line for clarity—they would actually have the same values).

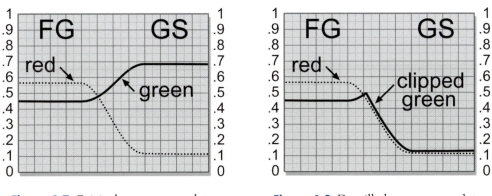

Figure 4-7 Original greenscreen plate. **Figure 4-8** Despilled greenscreen plate.

A real world example of a despill operation in action can be seen starting with Figure 4-9, which adds a slice line crossing from the greenscreen backing well into the blonde hair. The resulting slice graph in Figure 4-10 shows all three color records and how the green channel is the dominant color even

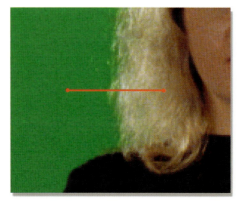

Figure 4-9 Slice line on original greenscreen.

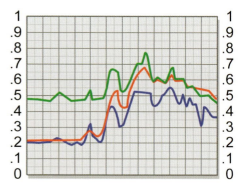

Figure 4-10 Slice graph showing original green channel.

well into the hair. Of course, this is what we expected based on the green spill example from Figure 4-2.

After the despill operation, however, the hair in Figure 4-11 is free of the excess green and its slice graph shown in Figure 4-12 shows how the green channel is now "trimmed" to the level of the red channel. In those locations where the green channel was already less than the red channel it was un-affected. The despilled green channel is drawn just underneath the red channel for comparison. In actuality it would lay right on top of it, covering it up except where it actually drops below it.

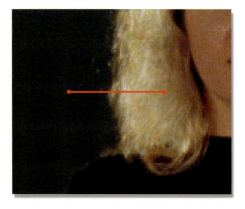

Figure 4-11 Slice line on despilled greenscreen.

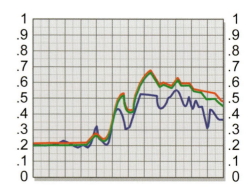

Figure 4-12 Slice graph showing despilled green channel.

4.3.1.1 Implementing the Algorithm

There are two ways you could implement this despill algorithm in your software. You can use a channel arithmetic node or build it out of simple discrete math operation nodes. If you have a channel math node and are on good terms with it, the equation would look like this:

$$\text{despilled green} = \text{if } G > R \text{ then } R: \text{ else } G \qquad (4\text{-}1)$$

which reads "if green is greater than red, then use red, else use green." The red and blue channels are left untouched. It simply substitutes the red pixel value for the green if it finds that the green pixel value is greater. Of course, you will have to translate this equation into the specific syntax of your particular channel math node.

Some of you may not have a channel math node or may not like using it if you do. Fine. The equivalent process can be done with a couple of subtract nodes instead. Because flowgraph nodes don't support logic tests such as "if/then," the discrete node approach requires a few more steps.

Figure 4-13 shows the flowgraph setup for this despill operation. Starting at the left, the greenscreen (GS) plate goes to a channel splitter. The first subtract (sub) node subtracts G-R, creating the "spill map," a channel that contains all of the green spill—any green that exceeds the red. More on this spill map in a moment. The next subtract node subtracts this spill map from the original green channel. This removes all of the excess green from the original green channel, clipping it to be equal to the red channel. The output of this subtract node is the despilled green channel. The last node merely recombines the despilled green channel with the original red and blue channels to create the final despilled greenscreen plate, then off you go to color correct and composite.

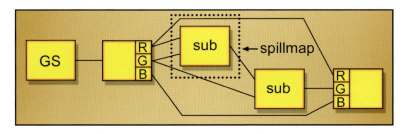

Figure 4-13 Despill flowgraph: green limited by red.

4.3.1.2 The Spill Map

The spill map is a monochrome image that contains all of the excess green from the original greenscreen plate. Simply subtracting the spill map from the green channel will produce the despilled image. In fact, the various despill methods discussed later really boil down to different ways of generating the spill map. Once you have a map of all of the excess green in a spill map, however it is created, you have the key to a despill operation. Of course, those folks that elect to use the channel math node or a keyer do not generate a separate spill map, and in that regard they are at a bit of a disadvantage. There are several very cool things that you can do with a spill map, which will be explored a bit later.

The slice graph in Figure 4-14 shows the transition from the skin tones of the subject to the green backing region. The shaded region shows the excess green that will be lifted out and placed into the spill map from the G-R subtraction operation. In the FG region the skin tones are red dominant so there is no excess green. As a result the spill map will have zero black in this region. When this part of the spill map is subtracted from the skin it will not remove any green. In the greenscreen backing region (GS) the green channel is much larger than the red so the results of the G-R subtraction produce a large residue of excess green for the spill map.

Figure 4-15 shows the actual spill map for the despilled greenscreen in Figure 4-4. As expected, the green backing area has a great deal of excess green. However, there is something else. It also shows some excess green in the hair and on the sweater. Green spill in the hair we can do without, so

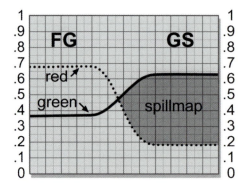

Figure 4-14 Slice graph of the spill map region.

Figure 4-15 Spill map from greenscreen in Figure 4-3.

removing this will actually be an improvement, but what about the sweater? It also showed up in the spill map even though it is not part of the green spill we are trying to fix. It showed up simply because it is a light yellow with its green channel greater than its red channel. Unfortunately, when this spill map is subtracted from the original greenscreen plate, the sweater color will also lose some green, resulting in a hue shift toward orange that you can see easily by comparing Figure 4-3 to Figure 4-4. This is exactly the kind of artifact described earlier in Section 4.2.

Whether or not this is a serious problem that has to be fixed totally depends on the circumstances. This could be just an actress in a scene and the color of her sweater doesn't really matter or it might be a sweater commercial and the color of the sweater is the entire point of the spot. If it has to be fixed, there are two approaches. One is to mask off the afflicted region and protect it from the despill operation. The second approach is to select a different despill equation that does not disturb the sweater. Of course, it may disturb something else, but that something else may be totally acceptable. Inspecting the spill map to find where the nonzero pixels are will reveal what parts of the picture are going to be affected by the despill operation.

The spill map slice graph in Figure 4-14 reveals another artifact of despill operations that you should be aware of. In the middle third of the slice graph you can see the entire transition region where the FG blends into the GS part of the graph. The spill map, however, starts near the middle of that transition region where the red and green channels actually cross. To be totally correct, it should start at the beginning of the transition region, further to the left. In other words, the spill map does not penetrate far enough into the true edge of the transition region. In some other part of the picture the spill map will penetrate deeper, and in other parts much less deeply. This means that the excess green will only be removed from the most outer edges of the foreground region, and

how "outer" that is will change around the perimeter of the foreground object based on the local RGB values. This is usually not a noticeable problem, but occasionally it will be so it is important
Ex. 4-1 to have alternatives at your disposal.

4.3.2 Green Limited by Blue

This, of course, is identical to the green limited by red described earlier—it simply substitutes the blue channel for the red channel as the green limiter. For use in a channel math node the equation becomes

$$\text{despilled green} = \text{if } G > B \text{ then } B: \text{ else } G \qquad (4\text{-}2)$$

When implemented with discrete nodes in a flowgraph (Figure 4-13), it is simply the blue channel instead of the red that is connected to the two subtract nodes. However, switching the despill rule like this gives spectacularly different results.

With film frames, the blue channel has much heavier grain then the other two. It is both larger in diameter and greater in amplitude. When using the blue channel as the green limiter, the green channel will wind up following the variations in the blue channel caused by its grain. It is as if the blue grain becomes "embossed" into the green channel. The workaround for this is to degrain the blue channel, which is covered in Section 4.4.4, "Refining Despill".

Figure 4-16 is a special greenscreen test plate that has three vertical foreground color strips on it. The left strip is a typical skin tone, the middle one is yellow, and the right is a light blue. The green backing also has three horizontal regions that are slightly different shades of green. All three green backing strips have the same high green level, but the top strip has more red, the bottom strip has more blue, and the middle strip has equal amounts of red and blue. Let's see what happens when we compare the red and blue limiting despill operations on the three color strips and the three green backing colors.

Figure 4-17 was despilled with green limited by red. The skin tone and yellow strips were unharmed, but the blue strip has lost some green, making it darker and bluer—both a hue and a brightness shift. Note also how the three green backing stripes fared after the despill operation. The top stripe had extra red so the green was limited to this higher red value. The despilled backing took on this residual color because it has equal red and green and a lower blue content, making it an olive drab. The center section is an even gray because the red and blue were equal so the despilled version has equal amounts of red, green, and blue—a gray. The bottom section had extra blue, but the green was still brought down to the red level. Now this backing region has equal red and green, but higher blue content, turning it a dark blue.

Figure 4-18 is the test plate in Figure 4-16 again despilled with green limited by blue. The skin tone and yellow strips got totally hammered with a massive hue shift, while the blue strip came through untouched. Two of the three green backing color regions also wound up with different residual colors compared to the red limited despill. The top strip with extra red has the green brought down to the blue level, but the red is greater than both of them, resulting in a dark maroon. The bottom section had the higher blue

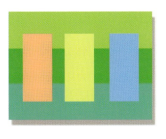

Figure 4-16 Test greenscreen plate.

Figure 4-17 Despill green by red.

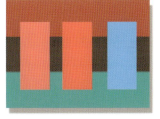

Figure 4-18 Despill green by blue.

content so blue and green are equal and red is lower then either of them, which creates a dark cyan color. The middle section, however, is unchanged. This is because the red and blue channels are the same and it does not matter which rule we use, we still get equal red, green, and blue here. The reason for showing what happens with the different shades of green in the backing color is because it will tint the edges of the foreground object during composite, and you need to know where it comes from in order to fix it. Later, we will see how to turn these residual backing colors to our advantage.

The purpose of this little demonstration was not to depress you. I know that it makes it look like both of these despill operations hopelessly destroy the color of the greenscreen plate, but this was a carefully crafted worst-case scenario. It was designed to demonstrate two important points. First, the despill operation does indeed introduce artifacts. Second, changing despill algorithms changes those artifacts dramatically. The good news is that the

Ex. 4-2

simple green limited by red despill works surprisingly well in many situations, there are many more sophisticated despill algorithms at our disposal, and there are some refining operations we can bring to bear on the situation.

4.3.3 Green by Average of Red and Blue

The first two despill algorithms were very simple, so let's crank up the complexity a bit with the next method: limiting the green by the *average* of the red and blue channels. As shown earlier, the all red or all blue method can be severe, but what about averaging them together first? This reduces the artifacts in both the red and the blue directions and, depending on your picture content, might be just the thing. For you channel math fans, the new equation is

$$\text{despilled green} = \text{if } G > \text{avg}(R,B) \text{ then avg}(R,B): \text{ else } G \qquad (4\text{-}3)$$

which reads "if green is greater than the average of red and blue, then use the average of red and blue, else use green." By averaging the red and blue channels together rather than picking one of them as the green limiter essentially spreads the artifacts between more colors, but with a lesser influence on any particular color. Implemented in a flowgraph with discrete nodes, it would look like Figure 4-19.

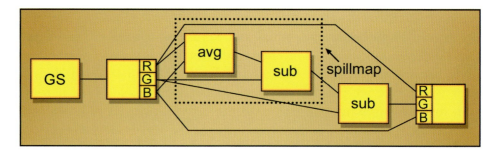

Figure 4-19 Despill flowgraph: green limited by the average of red and blue.

Starting at the left, the greenscreen (GS) goes to a channel splitter node and then the red and blue are connected to a node (avg) to be averaged together. Several methods for performing this averaging operation are described later. In the first subtract node (sub) the average is subtracted from the green record, forming the spill map. In the second subtract node (sub) the spill map is subtracted from the green channel, forming the despilled green channel. The despilled green channel is merged back with the original red and blue channels in the channel-combining node at the end to form the complete despilled foreground plate.

There are several ways to perform the averaging operation indicated in the flowgraph. A brightness node can be used to scale the red and blue channels by 50% and then they can be added together to make the average. A color curve node could be used to scale the red and blue channels by 50% and then added together. The coolest way is to use a cross-dissolve node, which virtually any software will have. It takes two inputs (the red and blue channels in this case) and then allows you to set the degree of mix between them. If you set the mix percentage to 50%, you will get the same average that the previous methods achieved. However, now you can easily try different mix percentages to see how it affects the despill results. Perhaps a 20/80 mix is better,

or maybe a 60/40 mix will eliminate those pesky artifacts. Set to one extreme you have the green by red despill, and the other extreme will give you the green by blue. You now have an adjustable despill procedure.

4.3.4 Green Limited by Other Formulations

Because the despill operation is in fact logically invalid, perfect results are guaranteed never to happen. Fortunately, the residual discolorations are usually below the threshold of the client's powers of observation (the hero's shirt is a bit more yellow than on the set, for example). When the discolorations are objectionable, we are free to explore utterly new despill formulations, as we know that they are all wrong. It is just a matter of finding a formulation that is not noticeably wrong in the critical areas on the particular shot you are working on at the moment. Here are a couple of arbitrary examples that illustrate some different alternatives.

1. Limit green to 90% of the red channel.

This is a simple variation of the green limited by red despill flowgraph shown in Figure 4-13 and illustrates how easy it is to create infinitely varied despill operations. Again, the name of the game is to create a spill map such that, when subtracted from the green channel, will produce the results we want. If we want to limit the green to 90% of the red channel instead of the full red channel, then the red channel needs to take a bigger "bite" out of the green channel. We can do this simply by scaling the red channel by 0.9 before subtracting it from the green record to make the spill map. This will make a 10% "thicker" spill map, which will in turn take a 10% bigger "bite" out of the green record when it is subtracted, which limits the green channel to 90% of the red channel.

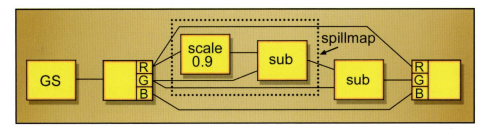

Figure 4-20 Despill flowgraph: green limited to 90% of red.

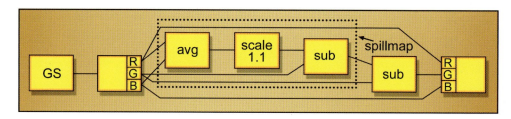

Figure 4-21 Despill flowgraph: green limited to 10% above the average of red and blue.

Figure 4-21 shows the complete flowgraph for the new and improved despill. One node has been added within the spill map area (scale 0.9) that scales the red channel down to 90% of its original value. When this lower red value is subtracted from the green channel in the next sub node, it results in a "thicker" spill map. In the following sub node this thicker spill map is subtracted from the original green channel, lowering it 10% more than simply limiting it to the red record.

2. Limit green to exceeding the average of the red and blue by 10%.

This is a minor variation of the green limited by the average of red and blue despill shown in Figure 4-19. Keep in mind that even minor variations in the despill operation can produce large changes in the appearance of the despilled image. In this case, we want a spill map that will let the green channel rise 10% above the average of the red and blue channels. This means that the spill map needs to be 10% "thinner" than the simple red and blue average. If we scale the red and blue average up by 10% before subtracting it from the green channel, results of the subtraction will be less, producing the "thinner" spill map we want.

Figure 4-21 shows the complete flowgraph for the fancy new despill. One node has been added within the spill map area (scale 1.1) that scales the red/blue average up by 10%. When this greater value is subtracted from the green channel in the next sub node, the result is the "thinner" spill map we need. In the following sub node this thinner spill map is subtracted from the original green channel, raising it 10% above the average of the red blue channels.

The despill algorithms discussed so far are by no means the end of the list. Ultimatte doesn't say much about their green despill algorithm, but they do have an elaborate formulation for their blue despill. It is based on the observation that very saturated blues are rare in nature. Their blue despill "rule" goes like this:

"If green is equal to or less than red, hold blue to the level of green. If green is greater than red, let blue exceed green only by the amount green exceeds red."

Having done it myself, I can assure you that even this convoluted despill algorithm can be implemented in a channel math node or by discrete nodes in a flowgraph. The point of this arcane example is to point out that there is actually an unlimited number of possible despill algorithms and to encourage you to explore and experiment. The spill map is the key. Come up with a novel way of creating your own spill map and then subtract it from the green channel to create your own custom despill algorithm.

Ex. 4-4

Adobe Photoshop Users—You can implement all of the despill algorithms described in this chapter in Photoshop, including the green limited by the average of red and blue despill operation described earlier. Exercise 4-4 will show you how.

4.4 REFINING THE DESPILL

Once you have discovered the despill algorithm that gives the best results for a given picture content, there is another layer of operations that can be performed to refine and improve the results even further. Here is a collection of refinement procedures that you can try when the need arises, keeping in mind that they can all be used in combination with each other.

4.4.1 Channel Shifting

Shift the limiting channel (red or blue) up or down by adding or subtracting small values such as 0.05. This has the effect of not only increasing and decreasing the brightness of the spill map, which increases and decreases how much spill is pulled out, but it also expands and contracts it in and out of the edges.

4.4.2 Spill Map Scaling

Using a scale RGB node or a color curve, scale the spill map up or down to increase or decrease its spill removal. This will have a similar but somewhat different effect than channel shifting.

4.4.3 Mixing Despills

Set up two completely different despill operations and then use a cross-dissolve node to mix them together. You can then juggle the mix percentage back and forth to find the minimum offensive artifact point.

4.4.4 Matting Despills Together

You cannot find one despill operation that works for the whole picture. One despill operation works great for the hair, but a different one works for the skin. Create a traveling matte to split the two regions and composite the usable part of one and the usable part of the other. Divide and conquer.

4.4.5 Blue Degraining

As mentioned earlier, any green limiting that uses the blue record will "emboss" the oversized grain of the blue channel into the green channel. This seems to happen most often on the smooth skin of beautiful women for some reason. Simply degrain the blue channel to use in the spill map calculations. Don't use the degrained blue channel in the final composite, of course. If you don't have a real degrain operation available, a median filter or a small radius gaussian blur might help.

4.5 UNSPILL OPERATIONS

In all of the examples so far the strategy has been to create a green spill map and then subtract it from the green channel to pull the excess green out of the greenscreen plate. This approach obviously removes some green from the image, which we want, but removing green also darkens, which we don't want. It also causes hue shifts, which we really don't want. Subtracting the excess green certainly gets the green out, but there is another way—we could just as well add red and blue. Either approach gets the green out. Because subtracting green is called despill, I call adding red and blue "unspill" in order to distinguish the two. This technique can solve some otherwise insoluble despill problems.

4.5.1 How to Set It Up

The basic idea is to create your best green spill map, scale it down somewhat, subtract it from the green channel as usual, but also add the scaled spill map

to the red and blue channels. In fact, the spill map is scaled appropriately for each channel. Because we are adding some red and blue, we do not want to pull as much green out as before so we can't use the original spill map at "full strength" on the green channel. For example, it might be scaled to 70% of its original brightness to be subtracted from the green channel, then scaled to 30% to be added to the red channel, then scaled to 20% to be added to the blue channel. The exact proportions totally depend on the picture content and the method used to create the spill map.

Figure 4-22 shows a flowgraph for the unspill operation. Starting at the left, the greenscreen plate goes into a channel splitter node. The separated channels are used to create the spill map, using your method of choice, which is represented by the "spill map" node. The resulting one-channel spill map is then fed into all three inputs of a channel, combining the node to create a three-channel version of the spill map. We now have a three-channel image with the same spill map replicated in all three channels. This is just a convenience to feed the "three-channel spill map" into a single "scale maps" node where each channel can be scaled individually. The scaling can be done with a scale RGB node or a color curve. The "unspill map" is then split into three separate channels again with the next channel splitter node so that each channel of the original greenscreen can get its own separate add or subtract operation with its own scaled version of the "unspill map." The "unspilled" channels are then recombined in the last node to make the final three-channel unspilled version of the greenscreen plate.

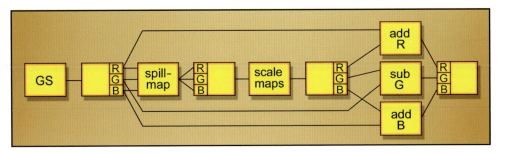

Figure 4-22 Flowgraph of unspill operation.

While this may look like a lot of nodes for a despill operation (excuse me—unspill operation), you will think it well worth the trouble when you cannot get rid of those pink edges on the blonde hair. You might be able to use the unspill method for the entire plate or you may find it more effective to mask off just the troublesome region of the picture for this special treatment.

4.5.2 Grading the Backing Color

How many times have you composited a picture only to find an ugly-colored "fringe" around the foreground object? Perhaps you had a light gray fringe that "glowed" when you composited the foreground over a dark background or a dark fringe when compositing it over a light background. You probably started eroding the matte to trim away the colored fringe only to find important edge detail disappearing along with the fringe. There is another approach that may help. It may be possible to change the color of the fringe to something that blends better with the background—perhaps a lighter or darker gray or maybe some particular color, for example.

Remember Figure 4-16 discussed in Section 4.3.2 "Green Limited by Blue" where the three colored strips were placed over three slightly different green backing colors? When the despill operation was performed the three slightly different green backing colors suddenly became three very different backing colors and the backing colors were different again depending on the despill method used (Figure 4-17 and Figure 4-18). Those "residual" backing colors blend with the edges of the foreground objects and "contaminate" it with their hue. If the greenscreen is brightly lit, the edge will be light, whereas if it is dark, the edges will be dark. This is the fringe that you see after your composite. If we could change the residual color of the backing, we would change the color of the fringe.

You can change the residual backing colors to whatever you want with the unspill method. This is because the unspill method both lowers the green and raises the red and blue channels in the backing region. By scaling the

spill map appropriately for each channel, the red, green, and blue channels in the backing region can be set to virtually any color (or neutral gray) that you want, which is another arrow for your quiver.

Ex. 4-5

We have pulled our finest matte, refined it, and despilled the foreground layer. Now it is time to bring everything together in the composite. This chapter examines the three steps within the compositing operation itself in detail with an eye toward what goes on inside the typical compositing node. After a clear understanding of the compositing operation, there are production tips on how to refine and improve the overall appearance of all composites with edge blending and light wrapping. A soft comp/hard comp technique is described that can elegantly solve edge problems from difficult matte extraction situations.

When compositing computer-generated images (cgi), some special issues surface when performing color correction operations. The cgi comes to you "premultiplied," which is an unnatural state for color correcting. Understanding what this is and how it affects the process is essential to understanding the fix, the "unpremultiply" operation, and its associated issues.

The matte has been around a long time and is used by several different professional disciplines. Of course, each group had to give it their own name. In deference to the different disciplines involved in compositing, the following conventions have been adopted. If we are talking about a matte used to composite two layers together such as with a bluescreen shot, it is called a matte. If we are talking about the matte that is rendered with a four-channel cgi image for compositing, it is called an alpha channel (or just the "alpha"). If we are talking about the matte used to composite two layers in a video context, it is called a key. The names have been changed but the functions are the same. It still arbitrates the relative proportions of the foreground and background in the composited image.

 Adobe Photoshop Users—Your "alpha" channel is created in the Layers palette with the Add Layer Mask operation. After using your best method to generate a matte, click on the Add Layer Mask icon to add an "alpha channel" to the selected layer. Copy and paste your matte into the layer's Mask channel. Photoshop actually already has a matte hidden in every single layer. When you create a new layer and then paint on it in "Normal" mode there is a matte generated to composite the new layer over the one below using exactly the equations shown in this chapter. It's just that Photoshop hides these mattes from the artist to make

your life easier. When you load the transparency of a layer into a selection you are actually loading the matte of that layer.

5.1 THE COMPOSITING OPERATION

The compositing operation is the fundamental image combining operation of, well, digital compositing. The process is essentially the same, even when done optically—there is a foreground layer, a background layer, a matte to identify which region is which, and the final composited results. In addition to defining where the foreground and background appear in the frame, the matte also controls the degree of foreground transparency. The key elements of a basic composite are illustrated in Figure 5-1.

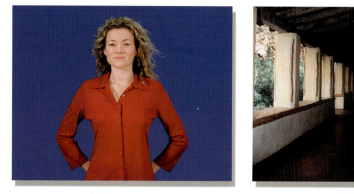

(a) foreground (b) background

(c) matte (d) composited results

Figure 5-1 Elements of a composite.

The compositing operation consists of three steps. The foreground is scaled (multiplied) by the matte, the background is scaled by the inverse of the matte, and then the results are summed together. Each of these operations is

explored in detail. The fact that these operations are performed digitally today offers an unprecedented level of control and quality.

5.1.1 Inside the Compositing Operation

This section "peers inside" a typical compositing node to understand its internal behavior. When you understand the math and operations that go on in the process you will be much better equipped to quickly troubleshoot problems and develop work-arounds. By the end of this section you will be able to make your own compositing node from simple discrete arithmetic nodes. Not that you will ever need to, of course, but it would be an interesting exercise of your command of the process if you did.

 A word to the folks who are working with log images. The compositing operation is one of the operations that must be done in linear space. You must convert both the foreground and the background layers to linear (but not the matte, as it is already a linear element) and then convert the composited results back to log space. This applies to cgi images as well.

5.1.1.1 Scaling the Foreground Layer

The foreground layer needs to be made transparent in the regions where the background is to be seen and partially transparent in any semitransparency regions, including the blending pixels that surround the foreground object (the woman, in the case of Figure 5-1). The pixels that are to become "transparent" are simply scaled to zero, and the semitransparent pixels are partially scaled toward zero. This is achieved by multiplying each of the three channels of the foreground layer by the one-channel matte. This assumes a "positive" matte—a white region where the foreground is to be opaque—and normalized pixel values, where white is 1.0 instead of 255. Multiplying the foreground layer by the matte channel scales each pixel in the foreground by the value of its matching matte pixel. Let's take a closer look at some pixels to see how they behave when scaled by the matte channel.

Figure 5-2 illustrates the three matte pixel cases, which are 100% opacity, partial transparency, and 100% transparency. The matte pixels are 1.0 for 100% opaque, 0.5 for 50% transparent, and 0 for 100% transparent. When a pixel in the RGB layer is scaled by the matte channel, all three channels are multiplied by the one matte pixel value.

The foreground in Figure 5-2 is represented by three identical pixels representing a skin tone with RGB values of 0.8 0.6 0.4. What starts out as three

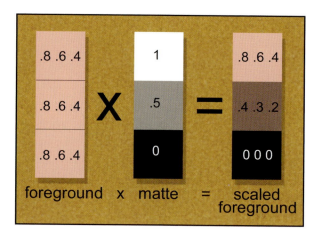

Figure 5-2 Multiplying the foreground by the matte.

identical skin pixels will end up as three totally different scaled foreground values based on the values of the matte pixels. The resulting three foreground skin pixels are scaled to three different values: 0.8 0.6 0.4 for the 100% opaque skin (no change), 0.4 0.3 0.2 for the 50% transparent skin (all values scaled by 0.5), and 0 0 0 for the completely transparent skin (all zero pixels). It is the process of scaling the foreground pixel values toward black that makes them appear progressively more transparent.

Figure 5-3 illustrates the matte multiply operation on the foreground layer to produce the scaled foreground image. A raw bluescreen plate is shown here for clarity, while in the real world this would be a despilled foreground. Where the matte channel is zero black the scaled foreground layer will also be zero black. Where the matte channel is 1.0 the foreground layer is unchanged.

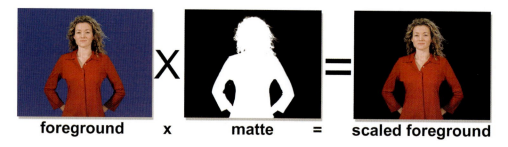

Figure 5-3 Multiplying the foreground layer by the matte to produce the scaled foreground image.

Any matte pixels that are between zero and 1.0 scale the foreground pixels proportionally.

5.1.1.2 Scaling the Background Layer

The foreground layer now has black where the background is going to be seen so the background now needs to have black where the foreground is to be seen. You can think of it as punching a "black hole" in the background where the foreground object is to go. A similar scaling operation needs to be done on the background to suppress the pixels to black behind the foreground object. The difference is that the matte must be inverted before the multiply operation in order to reverse the regions of transparency.

Figure 5-4 illustrates how the background layer is multiplied by the *inverted* matte to produce the scaled background layer. The background layer now has a region of zero black pixels where the foreground is going to go.

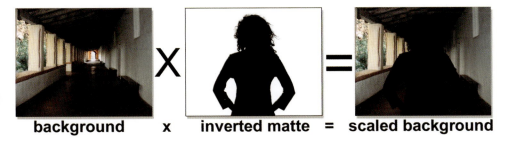

background x inverted matte = scaled background

Figure 5-4 Multiplying the background layer by the *inverted* matte to produce the scaled background image.

5.1.1.3 Compositing the Foreground and Background

Once the foreground and background layers have been scaled properly by the matte channel, they are simply summed together to make the composite, as shown in Figure 5-5.

Figure 5-6 shows a flowgraph for building your own compositing operation from simple discrete nodes. The despill operation is omitted for clarity. The foreground layer (FG) is multiplied by the matte, again, assuming a white matte, to make the scaled foreground. The background layer (BG) is

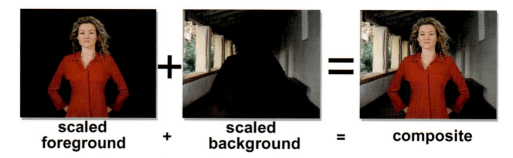

scaled foreground + **scaled background** = **composite**

Figure 5-5 Summing the scaled background and foreground to create the composite.

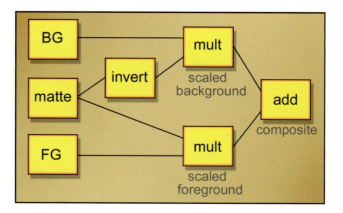

Figure 5-6 Flowgraph of discrete compositing nodes.

multiplied by the *inverted* matte to make the scaled background. The scaled background and scaled foreground are then simply summed together in the add node.

The complete sequence of operations can also be seen by inspecting the official mathematical formula for a composite shown in Equation 5-1.

$$\text{composite} = (\text{matte} \times \text{FG}) + ((1 - \text{matte}) \times \text{BG}) \tag{5-1}$$

In plain English it reads "multiply the foreground by the matte, multiply the background by the inverted matte, and then add the two results together." Equation 5-1 could be entered into a channel math node and the composite performed that way.

Ex. 5-1

5.1.2 Making a Semitransparent Composite

There is often a need for a semitransparent composite, either to do a partial blend of the layers or to perform a fade up or fade down. To achieve a partial

transparency, the matte simply needs to be partially scaled down from 100% white. The further away from 100% white the matte becomes, the more transparent the composite. Simply animating the matte scaling up or down will create a fade up or fade down.

Note that the foreground scaled matte in Figure 5-7 appears as a 50% gray in the white region. You can see how this partial density is reflected in the partially scaled foreground and background, which in turn shows up in the final composite as a semitransparency.

Figure 5-8 shows how the flowgraph would be modified to introduce semitransparency or a fade operation. The "scale" node is added to bring the white

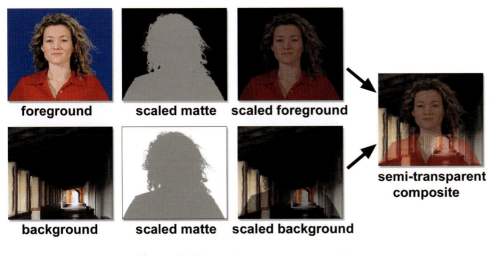

Figure 5-7 A semitransparent composite.

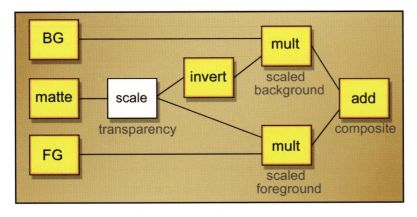

Figure 5-8 Flowgraph of semitransparent composite.

level down on the matte, which controls the degree of transparency. The scaled matte is then used to scale both the foreground and the background in the multiply nodes.

$$composite = ((Z \times matte) \times FG) + ((1 - (Z \times matte)) \times BG) \qquad (5\text{-}2)$$

Equation 5-2 has a transparency scale factor added that is represented by the letter "Z." When Z is zero, the foreground is completely transparent. When it is 1.0 the foreground is completely opaque, and a number between zero and one will produce a partial transparency.

5.2 THE PROCESSED FOREGROUND METHOD

The previous section demonstrated the classical method of compositing: multiply the foreground layer by the matte, multiply the background layer by the inverse of the matte, and sum the results together. But there is another way, a completely different way that might give better results under some circumstances. It is called the processed foreground method because it is modeled after Ultimatte's method of the same name. Its main virtue is that it produces much nicer edges under most circumstances compared to the classic compositing method. Its main drawback is that it is more sensitive to unevenly lit bluescreens.

5.2.1 Creating the Processed Foreground

The processed foreground method is essentially a different way of scaling the foreground by the matte to clear the surrounding backing color pixels to zero. With the classical compositing equation, this is done by multiplying the foreground layer by its matte to produce the scaled foreground. With the processed foreground method, a separate plate, called the backing plate, is created that is the same color as the backing color. The matte is used to clear the area where the foreground object is located to black and then it is subtracted from the original foreground layer, which in turn clears the backing region to black. Here is how it works.

Referring to Figure 5-9, the first step is to create a "backing plate," which is nothing more than a plate of solid color with the same RGB value as the blue (or green) backing color of the foreground layer. The backing plate is

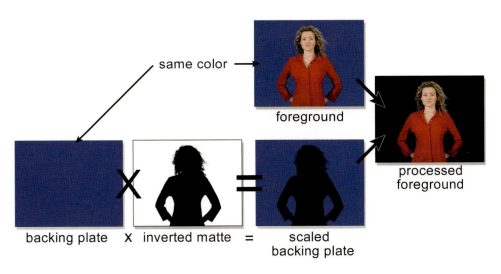

Figure 5-9 Creating the processed foreground.

then multiplied by the inverted matte to create the *scaled backing plate*. The scaled backing plate represents a frame of the backing color with zero black where the foreground element used to be. When this is subtracted from the original foreground layer, the backing region of the foreground layer collapses to zero black, leaving the foreground object untouched. The processed foreground now appears to be identical to the scaled foreground created in Figure 5-3, but appearances can be deceiving.

If you were to use the exact same matte to make a scaled foreground and a processed foreground and then compared the two, you would find that the processed foreground version has a kinder, gentler edge treatment. The edge pixels in the scaled foreground version will be darker and show less detail than the processed foreground version. The reason for this can be understood by taking an example of an edge pixel with a matte value of 0.5. With the scaled foreground, the RGB value of the edge pixel will be multiplied by 0.5, reducing the pixel value by half. With the processed foreground method, the same 0.5 matte value will be used to scale the backing plate color in half and then this RGB value is subtracted from the original foreground RGB value. In all cases this will reduce the foreground RGB value by less than the scaling operation, which results in a brighter pixel value for the processed foreground method, leading to less dark edges.

Figure 5-10 shows the flowgraph for creating a processed foreground. Starting with the foreground (FG), a matte is pulled using your best method and then it is inverted. A backing plate is created simply by filling a solid

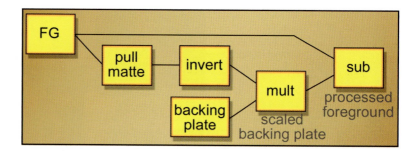

Figure 5-10 Flowgraph for creating a processed foreground.

color node with the RGB value of the backing color. The backing plate is then multiplied by the inverted matte and the results are subtracted from the foreground.

5.2.2 Compositing the Processed Foreground

When using the processed foreground method, the compositing operation itself must be modified. With the classical compositing method the comp node is given the original foreground layer, which is scaled within the comp node to create the scaled foreground. With the processed foreground method the foreground layer is already "scaled" and we do not want to scale it again in the comp node. This means that the foreground scaling operation must be turned off in the comp node.

Another issue is where to put the despill operation. The processed foreground will have much of the edge contamination removed, but there is still spill and veiling to deal with. The despill operation is placed after the processed foreground and before the comp node, as shown in Figure 5-11. Again, be sure to turn off the foreground multiply operation in the comp

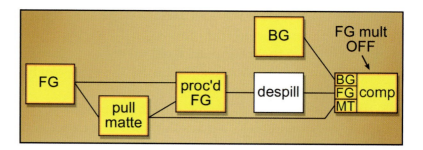

Figure 5-11 Flowgraph of processed foreground compositing.

node to avoid double-scaling the foreground layer and introducing some very nasty dark edges.

5.2.3 Some Issues

While the processed foreground method has the advantage of softer edges, it also has its problems and limitations. One of its problems is that it will introduce some residual grain over the background plate that is "inherited" from the backing region of the foreground layer. Another limitation is that it is less tolerant of unevenly lit bluescreens. The classical scaled foreground method is immune to these problems because the entire backing region is scaled to zero based on the value of the matte, regardless of the pixel values of the backing region in the foreground layer. With the processed foreground method the pixel values of the backing region do affect the results.

5.2.3.1 Residual Grain

The slice graph in Figure 5-12 shows why residual grain from the backing region will end up on the background plate after the composite. The jaggy line labeled "A" represents the typical grain pattern of the backing region of a foreground plate. The flat line labeled "B" represents the backing plate that was created for it. The average RGB value of the foreground plate was sampled in the backing region and then these values were used to fill a constant color node with a matching color. However, the synthesized backing plate has no grain, hence the perfectly flat line "B." Any grain

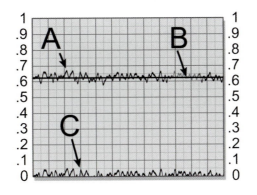

Figure 5-12 Residual grain.

pixels in the foreground layer (A) that are greater than the backing plate (B) will be left over after the scaled backing plate is subtracted from the foreground. These residual grain pixels are represented by line "C" in Figure 5-12.

The residual grain pixels will be lurking in what appears to be the zero black region of the processed foreground and will become quite visible after the composite. They will end up "on top" of the background plate everywhere the backing region used to be in the foreground layer. Ultimatte also exhibits this behavior, and for the same reason. A reasonable amount of this residual grain is not a problem. If the residual grain becomes a problem, the RGB values of the backing plate can be tapped up a bit so that they will subtract more from the foreground plate, leaving less residual grain. Because the blue channel has the most grain, it will be the one needing the most tapping. Be sure to only raise the RGB values by the least amount necessary to lower the residual grain to an acceptable level. The more you raise the backing plate RGB values, the more it degrades the edges.

5.2.3.2 Uneven Backing Colors

Another problem that can occur with the processed foreground method is backing region residuals due to uneven bluescreens. An example would be where the backing region is lit unevenly or made up of several panels that are not all the same color. The slice graph in Figure 5-13 illustrates a situation where there is a lighter panel on the left. The slice line "A" shows the two levels of brightness of the backing region, whereas "B" again shows the flat RGB value of the backing plate. When the scaled backing plate is subtracted from the foreground plate, the lighter region will leave a major

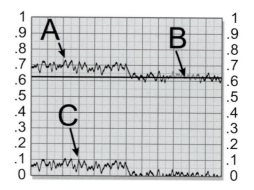

Figure 5-13 Uneven backing residual.

residual shown by the slice line at "C." This residual will also end up being added to the background layer of the final composite. This is also a trait of the Ultimatte process.

There are a couple of fixes for this. One fix is to garbage matte the backing region. This sets that backing region to a constant RGB color that can perfectly match the backing plate color. Of course, the region close to the foreground object that is not garbage matted will still show a bit of the grain. The other fix is to use screen correction, which was covered in Chapter 2.

Ex. 5-3

5.3 THE ADD-MIX COMPOSITE

The add-mix composite is a variation on the normal compositing algorithm that can be especially helpful when compositing thin wispies such as smoke and light emitters such as laser beams and to clear up those pesky dark edges around someone else's composite. The add-mix compositing operation is identical in all regards to the normal composite except when it comes to scaling the foreground and background by the matte that was described in the previous section. With the normal composite the same matte is used to scale the foreground layer, which is then inverted before scaling the background layer. With the add-mix composite, color curves are used to make two different versions of the matte: one for the foreground and one for the background layers.

So how does the add-mix composite work and when should you use it? How it works is difficult to visualize. The color curves do not affect the matte in either the 100% transparent or 100% opaque regions. It only affects the partial transparency pixels of the matte, which means it affects the composite in two areas: the semitransparent regions and the anti-aliased pixels around the edge of the matte. The effect of that is to alter the mixing of the foreground and background partial transparency pixels depending on how the color curves are adjusted. Instead of being exact reciprocals of each other (such as 50/50 or 80/20), variable mixes can be generated (such as 50/40 or 80/50).

5.3.1 When to Use It

One of the occasions to use the add-mix method is when compositing a wispy element, such as smoke or thin fog. Figure 5-14 shows a smoke element that was self-matted then composited over a night city. The smoke is barely seen. In Figure 5-15 an add-mix

composite was used to thin the matte on the smoke element but not the city element to give the smoke layer more presence. Again, this is an entirely different result than you would get just by tweaking the matte density in a normal composite.

Figure 5-14 Normal composite of a smoke plate over a night city.

Figure 5-15 Add-mix composite causes the smoke layer to have more presence.

Another occasion where the add-mix method can be helpful is when compositing "light emitters," such as laser beams or explosions. The example in Figure 5-16 shows an example of another dastardly laser attack by the demonic planet Mungo on our precious rock resources. Whether the beam element was rendered by the cgi department or lifted from another plate, the add-mix method can be used to adjust the edge attributes to give the element a more interesting and colorful appearance such as in Figure 5-17. Note that the edges have not lost their transparency or hardened up in any way.

Figure 5-16 Normal composite of beam element over background plate.

Figure 5-17 The add-mix composite gives the beam more "life."

A more prosaic application of the add-mix method is cleaning up those pesky dark edges often found lurking around a composite. While there are many causes and cures for them, which are visited in later sections, one of those cures can be the add-mix composite. Figure 5-18 shows a close-up of a dark edge between the foreground and the background, whereas Figure 5-19 shows how the add-mix composite can clean things up nicely.

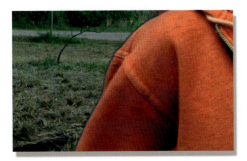

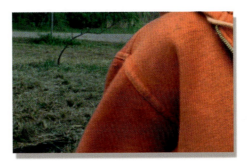

Figure 5-18 Close-up of dark edge between foreground and background layers.

Figure 5-19 The add-mix composite melts away the offending outline.

5.3.2 Creating the Add-Mix Composite

To create the add-mix composite, color curve nodes are added to the matte just before it is used to do the multiply on the foreground and background, as shown in Figure 5-20. Compare this to the flowgraph for the normal composite back in Figure 5-6. The key here is that the matte can be adjusted *differently* for the foreground and background. That is the whole secret. With the conventional compositing operation, a color curve can be added to the matte before the scaling operations, but it is the same matte used for scaling both the foreground and the background. Here, the matte is different for the foreground and the background scaling operations.

The problem you will have is that these color curves must be inserted *inside* the compositing operation, and you undoubtedly have a compositing node that you cannot get into to modify. A few compositing systems do have an add-mix compositing node, and if yours does you are doubly blessed. If not, then you can use the flowgraph in Figure 5-20 to "roll your own."

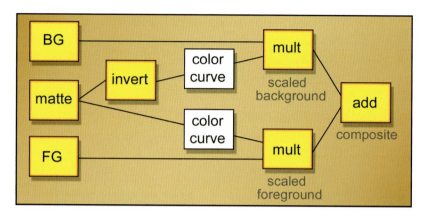

Figure 5-20 Flowgraph of the add-mix compositing operation.

 A word of caution here and the word is "clipping." The math used in the add-mix composite can permit composited pixel values greater than 100% white, which will be clipped and look awful. This cannot happen with the standard composite because even when two 100% white things are being composited, if a matte pixel value is, say, 40%, then the scaled foreground RGB value will become 40% and the scaled background RGB value will become 60%. When they are summed they will total no more than 100%, so no clipping.

With the add-mix method, however, the original matte pixel value might be 40%, but after it goes through the color curve it may come out as 60%, so the scaled foreground RGB value becomes 60%. That same 40% matte pixel now goes to the other color curve and comes out as, say, 70% so the scaled background RGB value becomes 70%. Now when they are summed, 60% plus 70% results in a composited pixel RGB value of 130%, which is not permitted—so it is clipped. This means that you must not only check for clipping on the frame that you use to set up an add-mix composite, but you must check every frame in the shot lest some of them get brighter than the one you are looking at.

Ex. 5-4

5.4 REFINING THE COMPOSITE

This section explores some processes that can be done during and after the composite operation to refine the quality further. Even after the best matte extraction and matte refinement efforts, the final composite will often have less than beautiful edge transitions between the composited foreground and the background. Performing a little edge blending after the final composite will better integrate the composited layers and improve the look

of the finished shot. The light wrap technique is also revealed to help integrate the foreground into the background even further. The soft comp/hard comp technique is a double compositing strategy that dramatically improves edge quality and density for troublesome mattes. It takes advantage of two different mattes: one that has best edges and one that has best density while retaining the best of both worlds without introducing any artifacts itself.

5.4.1 Edge Blending

In film compositing a "sharp" edge may be three to five pixels wide, whereas soft edges due to depth of field or motion blur can be considerably wider. A convincing composite must match its edge softness characteristics to the rest of the picture. Very often the matte that is pulled has edges that are much harder than desired. This is especially true of cgi composites over live action. While blurring the edges of a matte is done very often, it has the downside of blurring out fine detail in the matte edge. A different approach that gives a better look is "edge blending," which blends the edges of the foreground object into the background plate *after* the final composite. It can result in a very natural edge to the composited object that helps it blend into the scene. Of course your fine artistic judgment must be used for how much the edge should be blended, but you will find that virtually all of your composites will benefit from this refinement, especially feature film work.

The procedure is to use an edge detection operation on the original compositing matte (or cgi alpha channel) to create a new matte of just the matte edges like the example in Figure 5-21. The width of the edge matte must be

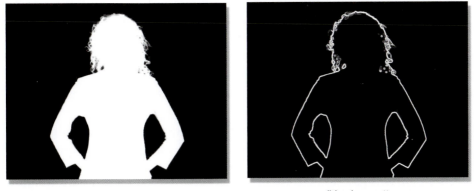

(a) original matte (b) edge matte

Figure 5-21 Edge blending matte created from original compositing matte.

Figure 5-22 Original composited image.

Figure 5-23 Edge matte straddles composite edge.

Figure 5-24 Resulting blended edge.

chosen carefully, but typically three or four pixels wide will work for high-resolution shots such as 2k film or Hi-Def video, but obviously much thinner is needed for video work. As with the amount of blur, the width of the edge matte is also an artistic judgment.

The edge matte itself needs to have soft edges so that the blur operation does not end with an abrupt edge. If your edge detection operation does not have a softness parameter, then run a gentle blur over the edge matte before using it. Another key point is that the edge matte must *straddle* the composited edge of the foreground object like the example in Figure 5-23. This is necessary so that the edge blending blur operation will mix pixels from both the foreground and the background together rather than just blurring the outer edge of the foreground.

Figure 5-22 is a close-up of the original composite with a hard matte edge line. Figure 5-24 shows the resulting blended edge after the blur operation. Be sure to go light on the blur operation and keep the blur radius small—1 or 2 pixels—to avoid smearing the edge into a foggy outline around the entire foreground. If the blended edge is noticeably lacking in grain, the same edge mask can be used to regrain it.

Figure 5-25 is a flowgraph of the sequence of operations for the edge blending operation on a typical bluescreen composite. Edge detection is used on the compositing matte to create the edge matte. The edge matte is then used to mask a gentle blur operation *after* the composite.

Ex. 5-5

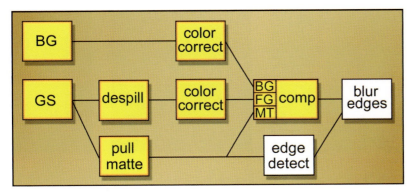

Figure 5-25 Flowgraph of edge blending operation.

5.4.2 Light Wrap

In the real world when a foreground object is photographed in its actual environment some of the light from that environment will have spilled onto the edges of the foreground object. This adds a wisp of environmentally colored light all around the edge of the foreground object that will be missing in a composite. The photo-realism of the composite (whether bluescreen or cgi) can be enhanced by synthetically spilling some light from the background around the edges of the foreground object. This can be done using the "light wrap" technique, where light from the background plate is "wrapped" around the edges of the foreground object.

The basic idea is to create a special type of edge mask from the foreground object's matte then use it to *screen* a little of the background plate over just the outer edges of the foreground object. The screen operation is a very useful image blending method described in fascinating detail in the next chapter. You will need to know how it works in order to control it so be sure to read up on the screen operation soon. In the meantime your compositing software may have a screen node that you can just plug in.

Let's consider the case shown in Figure 5-26 where a gray ball (carefully chosen for its lack of color) is to be composited over a colorful background (carefully chosen for its bright colors). The first step is to create an internal edge mask that is dense at the outer edge of the foreground's matte and fades to black a few pixels in toward the interior, as shown in the close-up in Figure 5-27. Creating such a mask is easy—simply blur the matte, invert it, then multiply it by the original matte.

This internal edge mask is then multiplied with the background plate, which results in a thin wisp of the background plate that will cover just the

Figure 5-26 Foreground and background.

Figure 5-27 Internal edge mask.

Figure 5-28 Background spill edge lighting wisp.

Figure 5-29 Close-up of edges before and after.

outer edge of the foreground object, as shown in Figure 5-28. This thin wisp of the background "light" is screened over the composited shot so that the foreground object will get a wisp of edge light added to its perimeter. This is a subtle effect that would be hard to see on a full-sized image, so Figure 5-29 shows a close-up of the before (right side) and after (left side) versions of the ball juxtaposed.

The previous section showed how to do edge blending and here we have the edge light wrap so in what order should they be done? Do the light wrap first, followed by the edge blend. Keep in mind that both of these operations are to be subtle so don't overdo it. We don't want to suddenly see a bunch of fuzzy composites with glowing edges out there.

Figure 5-30 is a flowgraph of the light wrap process added to a typical bluescreen matte extraction and compositing flowgraph. Again, this technique works equally well with cgi images and their alpha channels. First, the

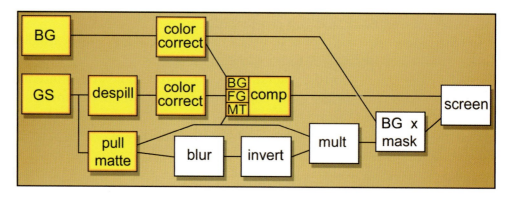

Figure 5-30 Flowgraph of light wrap operation.

Ex. 5-6

matte is blurred and inverted, then multiplied by the original matte to produce the internal edge mask. The background plate is then multiplied by this mask and the results are screened with the finish composite.

5.4.3 Soft Comp/Hard Comp

This is one of the most elegant solutions to the chronic problem of poor matte quality (from poorly shot bluescreens, of course). It seems that there are always two conflicting matte requirements. On the one hand you want lots of fine detail in the edges, but on the other hand you also want 100% density in the foreground area. In many cases these are mutually exclusive requirements. You can pull a matte that has lots of great detail around the edges, but the matte has insufficient density to be completely opaque. When you harden up the matte to get the density you need, the edge detail disappears and you get the "jaggies" around the edge. The soft comp/hard comp procedure provides an excellent solution for this problem, and best of all, it is one of the few procedures that does not introduce any new artifacts that you have to go pound down. It's very clean. This technique can also be used very effectively with keyers such as Ultimatte.

The basic idea is to pull two different mattes and do two composites. The first matte is the "soft" matte that has all of the edge detail, but lacks the density in the foreground region to make a solid composite. This soft matte is used first to composite the foreground over the background, even though the foreground element will be partially transparent. The matte is then "hardened" by scaling up the whites and pulling down on the blacks, which shrinks it a bit. This produces a hard-edged matte with a solid core that is slightly smaller than the soft matte and fits "inside" of it. This hard matte is then used to composite the same foreground layer a second time, but this time the previous soft composite is used as the background layer. The hard comp "fills in" the semitransparent core of the soft comp, with the soft comp providing fine edge detail to the overall composite. It is the best of both worlds. Figure 5-31 illustrates the entire soft comp/hard comp process.

Here are the steps for executing the soft comp/hard comp procedure.

Step 1. Create the "soft" matte. It has great edge detail, but does not have full density in the core.
Step 2. Do the soft comp. Composite the foreground over the background with the soft matte. A partially transparent composite is expected at this stage.

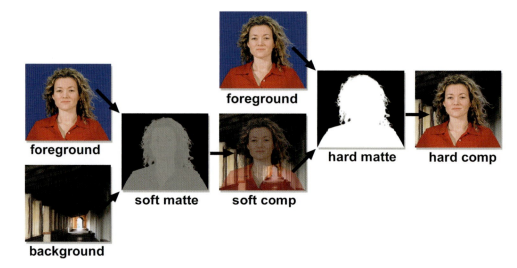

foreground

foreground

hard matte

hard comp

soft matte **soft comp**

background

Figure 5-31 Soft comp/hard comp sequence of operations.

Step 3. Create the "hard" matte. It can be made either by hardening and shrinking the soft matte or by pulling a new matte using more severe matte extraction settings to get a harder matte. Either way, the hard matte must be 100% solid and a bit smaller than the soft matte so that it does not cover the edges of the soft comp. You might even want to soften it a bit with a blur.

Step 4. Do the hard comp. Comp the same foreground again, but use the soft comp as the background. The hard matte fills in the solid core of the foreground, and the soft comp handles the edge detail.

In a particularly difficult situation you could consider a three-layer composite, with each layer getting progressively "harder." Any edge blending would be done only on the outermost layer, of **Ex. 5-7** course.

5.4.4 Layer Integration

The last two sections were concerned with refining the composite from an essentially technical point of view. Here we will look at refining a composite from an artistic point of view. Later chapters will explore the roll of matching color, lighting, and other aspects of the disparate layers to blend them together better by making them appear to be in the same light

space. But while we are still looking at the compositing operation, this is a propitious moment to point out that there is a compositing step that can be done to help "sell" the composite, which is to integrate, or "sandwich," the foreground layer *within* the background layer rather than just lay it on top.

Figure 5-32 illustrates simply pasting the foreground layer over the background. In this example the lighthouse is a foreground layer that has been created as a three-dimensional cgi element and then composited over the live action background. While the composite looks fine, the composite itself can be made even more convincing by integrating the lighthouse into the background layer by "sandwiching" it between elements of the background.

In this example, a bush from the background plate has been isolated and then laid back over the lighthouse at its base in Figure 5-33. In addition, a flight of pelicans was lifted from another live action plate and placed in the foreground to further the sense of depth and integration of the lighthouse into the scene. Of course, none of this is a substitute for properly color correcting the layers to match, but by layering the foreground element into the background it will appear more to the eye to be a single integrated composition. It's a perception thing.

Figure 5-32 Foreground over background without integration.

Figure 5-33 Foreground integrated into the background.

5.5 COMPOSITING CGI IMAGES

The explosion in the use of cgi in the movies and on television has brought with it an explosion in compositing cgi, and this trend will only increase in the future. On the surface, compositing cgi would seem a simple issue as it comes complete with its own perfect matte, the alpha channel. If all you had to do is slap the cgi over a background plate, life would indeed be easy.

However, you will invariably have to color correct the cgi, and bad things begin to happen because the cgi has been "premultiplied," meaning that by the time you got it, it has already been multiplied (scaled) by its alpha channel. This is the same operation that we use in regular compositing to scale the foreground by the matte. We have just referred to it as the "scaled foreground" rather than being "premultiplied." The fundamental problem here is that the color correction operations should be done *before* the foreground is premultiplied (scaled by the matte), not after. We therefore need to perform an "unpremultiply" operation to the cgi prior to color correction to restore it to a color correctable state. Then we will see how to solve the problems that the unpremultiply operation can introduce. Suddenly, working with cgi is not so simple.

5.5.1 The Premultiplied cgi Image

When we were exploring the compositing operation in Section 5.1.1.1 "Scaling the Foreground Layer", Figure 5-3 showed how the foreground layer is multiplied by the matte inside the compositing node to produce the scaled foreground layer. The hallmark of a multiplied (scaled) foreground image is that the foreground object is surrounded by black because the "not-foreground" pixels have all been scaled to zero. A cgi image is referred to as a "premultiplied" image because the RGB layer has *already* been multiplied by its matte (the alpha channel) and must not be multiplied by its matte again during the compositing operation. The problem is that this matte multiplying operation is done *inside* the compositing node.

If a premultiplied cgi element is scaled by its matte again during the composite, all RGB pixels that are over semitransparent alpha pixels (any alpha value not exactly zero or 1.0) will get scaled down and become darker. The semitransparent alpha pixels appear in three places: the anti-aliasing pixels around the edge of objects, semitransparent objects such as glass, and motion blurred edges. All of these pixels will turn darker than they should, which will put an ugly dark fringe around your cgi composite. Your

task is to determine if your compositing operation has an "on/off" switch for the foreground scaling operation so that you can disable it for cgi composites and enable it for normal bluescreen composites.

Here is a very simple test that you can do to confirm that you have the composite operation set up correctly for cgi images. Composite the cgi element over a zero black background plate and then toggle between the composited cgi version and the original cgi element. If things are set up properly they will be identical. If you are scaling the cgi layer again you will see the edges darken when you toggle to the composited version.

Ex. 5-8

Adobe Photoshop Users—You have a problem here when trying to composite a typical cgi image over a background. As shown earlier, a cgi image has been

Ex. 5-9 premultiplied by its alpha channel. If you try to make the surrounding black region transparent by loading the cgi alpha channel as a selection or by copying the alpha channel into a Layer Mask, Photoshop will multiply the cgi by the alpha channel *again*. This darkens edges and semitransparent regions, ruining the composite. Your composite will not look like the composite done with a regular compositing program. However, it is possible to outsmart Photoshop by doing the composite "manually." Exercise 5-9 will show you how.

5.5.2 The Unpremultiply Operation

The premultiplied form of cgi images can introduce special problems when it comes to color correcting. The interaction between the color correction and the semitransparent pixels can disturb the relationship between the RGB values of a pixel and its associated alpha pixel, which can result in color anomalies. If this problem arises the cgi image must be unpremultiplied before color correction. However, the unpremultiply operation itself can introduce problems. Before describing the unpremultiply operation, we will first look at the problems introduced by working with the original premultiplied cgi image. Because the digital artist will have to decide whether to work with either the premultiplied or the unpremultiplied version, you will know how to pick your poison by the end of this section.

5.5.2.1 The Zero Black Alpha Pixel Problem

When the alpha channel of a cgi element has a zero black pixel it normally means that this part of the final composited image is supposed to be the

background so the RGB pixels' values in this region are also supposed to be zero black. Some color correction operations can raise these black RGB pixels above zero, giving them some color where they should be zero black. Under normal circumstances this would be no problem because these "colorized" black pixels would be scaled back to zero black during the compositing operation.

However, as shown in Section 5.5.1 "The Premultiplied CGI Image" with premultiplied cgi images, the foreground multiply operation must be turned *off*. This means that any "colorized" black pixels in the cgi layer are no longer scaled back to black so they end up being summed with the background layer, discoloring it. Because we cannot turn the foreground multiply operation on to clear them out lest we double-multiply the cgi by the alpha channel (a very bad thing to do), something must be done to prevent them from appearing in the first place.

 There are two possible solutions here. One is to use only color correction operations that will not affect the zero black region of the cgi image, such as an RGB scaling operation. The other possibility is to use the alpha channel itself as a mask to protect the zero black pixels. Depending on the image content, this often works. However, that still leaves the second problem: the partially transparent alpha pixels.

5.5.2.2 The Partially Transparent Alpha Pixel Problem

When cgi is composited over live action (or other cgi, for that matter), the compositing artist will be obliged to apply some color correction. However, there is a little problem with the partially transparent alpha channel pixels that can cause the color correction to run amok and introduce artifacts. Here's the story.

In a cgi render the pixel values in the alpha channel will fall into one of three categories: 100% white (1.0), 100% black (zero), or partially transparent (semitransparent) with a value between zero and 1.0, such as 0.5. In this discussion we are only concerned with these partially transparent alpha pixels. They show up in two different places in a cgi render: in the anti-aliasing pixels around the edges of solid objects and in any semitransparent objects, such as glass or plastic.

Let's follow the action inside a cgi render starting with Figure 5-34, which represents the edge of some cgi object, referred to awkwardly at this stage as the *unpremultiplied* image. It has this ungainly name to indicate that it has not yet been multiplied by the alpha channel. Again, this is *inside* the

Figure 5-34 Unpremultiplied image.

Figure 5-35 Alpha channel.

Figure 5-36 Premultiplied image.

render process so this image has not been saved to disk yet. Notice that the edge pixels are the same color as the interior pixels and that the image has the "jaggies" (aliased). Figure 5-35 shows the associated alpha channel for the cgi object with partially transparent pixels all along the edge for anti-aliasing. What happens inside the cgi render process is that the unpremultiplied image is multiplied (scaled) by the alpha channel to produce the *premultiplied* image in Figure 5-36. This is the version that is delivered to you for compositing. We sensible two-dimensional types would call this the scaled foreground.

Next we take the premultiplied cgi image from Figure 5-36 and composite it over a gray background to produce the fine composite in Figure 5-37. So far so good. Now let's just add a little color correction operation to the cgi element just before the composite and suddenly we have introduced the ugly edge seen in Figure 5-38. All that was done here was to color correct the cgi image in HSV color space, lowering the V value by a mere −0.2 to darken it a bit. When the cgi image is unpremultiplied *before* the color correction operation, the color-corrected composite no longer has edge artifacts (Figure 5-39).

Figure 5-37 Premultiplied composited.

Figure 5-38 Color-corrected premultiplied.

Figure 5-39 Color-corrected unpremultiplied.

The artifacts were introduced in Figure 5-38 because the color correction operation disturbed the delicate relationship between the RGB values of the pixels in the image and the partial transparency values of the pixels in the alpha channel. Remember, those RGB pixels were altered during the premultiply operation (Figure 5-36) and are no longer the same color as their brothers in the solid parts of the object. The bottom line is that before you can color correct a cgi object, you must undo the premultiply operation and restore the image to its unpremultiplied state like Figure 5-34.

5.5.2.3 How to Unpremultiply

The solution to the zero black and semitransparent pixel problems described earlier is to unpremultiply the cgi image. It turns out this is easy to do. All you have to do is divide the premultiplied image by its alpha channel and it will restore the image to its unpremultiplied state. This actually makes sense because the premultiplied image was created by multiplying it by its alpha channel, so dividing it by the same alpha channel should put things back where they were—unpremultiplied. If the cgi is divided by its alpha, then you can color correct it. It is then multiplied (scaled) by the alpha again for the composite.

A flowgraph of this new work flow can be seen in Figure 5-40 with the unpremultiply operation shown in the node labeled "unpre-mult." The question now becomes where is the best place to multiply the RGB image by the alpha again? Because the cgi image is no longer premultiplied, it can be sent right into the composite node with the foreground scaling operation turned on, like any normal composite. Here is a summary of the cgi compositing rules.

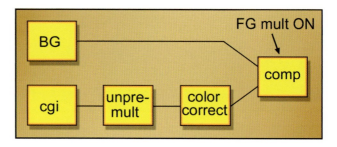

Figure 5-40 Flowgraph of an unpremultiplied composite of a cgi element.

- Unpremultiply cgi before doing color correction (if necessary)
- Unpremultiplied cgi—compositing foreground scale ON
- Premultiplied cgi—compositing foreground scale OFF

Truth be told, if the color correction operation is relatively minor, then the artifacts introduced will not be noticeable and the whole unpremultiply thing can be ignored.

All of this hoo-hah about premultiplied and unpremultiplied images can become messy, especially in a high-end cgi operation where there might be 6 to 10 layers (or more!) rendered for each object that the compositor must then combine. As a result, some cgi facilities will render all cgi images unpremultiplied for the compositing department. It is actually a very efficient way to work if you can get used to seeing the jaggies on all your cgi elements.

Ex. 5-10

Adobe Photoshop Users—Because Photoshop does not have a divide operation, you cannot do the unpremultiply operation just described. However, if you can get unpremultiplied cgi renders, they can be used directly in the normal way to composite in Photoshop and you won't need to unpremultiply.

5.5.3 Unpremultiply Highlight Clipping

Here is the hideous artifact I promised you. There are certain situations where the unpremultiply operation can clip the RGB values in specular highlights. This occurs when any of the three RGB values of a pixel are *greater* than its alpha pixel value. Diabolically, the clipping will not be visible until after the cgi element is composited. This condition occurs when a reflective highlight is rendered on a semitransparent surface, such as a specular kick on a glass object. The example in Figure 5-41 represents a semitransparent glass ball with a specular highlight reflecting off the top. The original rendered high-

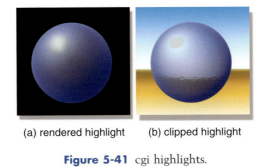

(a) rendered highlight (b) clipped highlight

Figure 5-41 cgi highlights.

light is shown in Figure 5-41a and the clipped highlight after the composite in Figure 5-41b. The clipping has introduced an ugly "flat" spot in the center of the highlight.

5.5.3.1 What Goes Wrong

Virtually all software packages clip any pixel values that exceed 1.0. Under certain conditions the unpremultiply operation done during compositing can result in pixel values greater than 1.0 so they get clipped. When these clipped pixels are composited, they produce the clipped "flat" spot in the highlights. Here is how it happens.

For a typical solid or even semitransparent surface the cgi render outputs a premultiplied RGB pixel value that is *less than or equal* to its associated alpha pixel value, but never greater. The reason is simple—the RGB pixel values range between zero and 1.0 and the alpha channel pixels also range between zero and 1.0. When these are multiplied together during the premultiply operation the resulting premultiplied RGB pixel value will always be less than or equal to the alpha channel pixel. For example, an RGB pixel value of 0.8 and an alpha pixel value of 0.2 will result in a premultiplied pixel value of 0.16 ($0.8 \times 0.2 = 0.16$). Note that the premultiplied pixel value of 0.16 is less than the alpha value of 0.2.

When the unpremultiply operation is performed on this pixel it will be divided by its alpha pixel value to restore it to its original value of 0.8 ($0.16 \div 0.2 = 0.8$). No problem here. However, if this same pixel is in a specular highlight the cgi rendering algorithm will increase the RGB value from the original 0.16 to, say, 0.3, but leave the alpha pixel at its original 0.2. Now the RGB pixel value of 0.3 is *greater* than the alpha value of 0.2. Now when the RGB value is divided by the alpha value we get a result that is greater than 1.0 ($0.3 \div 0.2 = 1.5$). There is a big problem here because the compositing software will clip the 1.5 pixel value down to 1.0. The specular highlight just got clipped to a flat spot. Keep in mind that this is a per-channel issue, so it is entirely possible for, say, just the red channel to get clipped, resulting in a shift to cyan in the highlight.

5.5.3.2 How to Fix It

 There are three general approaches to fixing the unpremultiply highlight clipping artifact. The first solution, which I strenuously recommend, is to render the highlights as a separate layer and composite them separately. It's simple, easy, and works every time. It also allows separate control of the highlight at composite time, and

operations other than compositing can be used to mix it in. However, you might be handed a finished render with the highlights rendered in and no opportunity to rerender, but you still have two options. The first is to switch the compositing math to floating point, which does not clip. Problem solved. Not everyone has a floating point option, so the second solution is to prescale the cgi. This is a bit more obtuse and entails the use of some math.

As explained earlier, the fundamental problem with highlight pixels is that their RGB values exceed their alpha values. This results in unpremultiplied values that exceed a value of one, which in turn get clipped. This problem can be solved by prescaling the RGB values of the cgi layer down until the greatest RGB value is at or below its alpha value *prior* to the unpremultiply operation. With all RGB values less than their alpha values, the unpremultiply operation will no longer produce any values that exceed one, so there is no clipping. The background plate must also be scaled by exactly the same amount and then the finished composite "unscaled" to restore its original brightness. Of course, the alpha channel itself is not scaled. The flowgraph for the prescaled unpremultiply operation is shown in Figure 5-42.

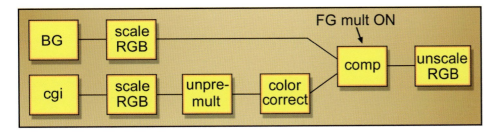

Figure 5-42 Flowgraph of prescaled unpremultiply operation.

Let's say that you had to scale the RGB channels down by 0.5 and then performed the unpremultiply operation followed by the color correction. The background plate must also be scaled down by 0.5 and then the two layers composited. Because the foreground is now unpremultiplied, the scale foreground operation is ON. The resulting composite is then scaled back up by the *inverse* of the original scale factor to restore all brightness levels. In this example it is $(1 \div 0.5 = 2.0)$. Of course, these scaling gyrations cannot be done on 8-bit images without introducing serious banding. The cgi renders and background plates must both be 16-bit images. The color correction operation (which is why you are bothering with the unpremultiply in the first place) is done after the unpremultiply and before the composite, as usual.

Ex. 5-11

Compositing is not the only way to blend two images together. While very appropriate for placing solid object A over solid background B, there are whole categories of other visual, atmospheric, and light phenomena that look much better with other methods of image blending. This chapter explores blending operations found in every compositing package plus some found only in Adobe Photoshop. Photoshop is used extensively in digital effects production so the equations for some of the most important blending modes unique to Photoshop are provided in a form that can be implemented in any compositing package.

Image blending operations use no mattes so the results are based simply on what type of blending operation is chosen plus any color correction done to the elements before or after the blend. We will see where to use the screen operation, a mighty useful alternative way of mixing "light" elements such as flashlight beams and lens flares with a background plate. We will also examine the multiply operation, which, when set up properly, can provide yet another intriguing visual option for the modern digital compositor. For those occasions where suitable elements are available, the maximum and minimum operations can also be used to surprising advantage.

 Adobe Photoshop Users—All of the blend operations in this chapter can be done in Photoshop. Indeed, some of them were invented by Photoshop and are revealed here so that they can be replicated in typical compositing programs.

6.1 COMPOSITING BLEND OPERATIONS

The following blending operations are available in virtually all compositing software packages with the sole exception perhaps of the screen operation. To cover that base the exact setup to create your own screen operation is provided.

6.1.1 The Screen Operation

The screen operation is a very elegant alternative method to combine images ("Screen" in Adobe Photoshop). It is not a composite. It does not use a matte and it gives very different results than a composite. Perhaps the best way to

describe its purpose is when you want to combine the *light* from one image with a background picture, like a double exposure. One example would be a lens flare. Other examples would be the beam for an energy weapon (ray gun) or adding a glow around a light bulb or fire or explosion. The key criterion that it is time to use the screen operation is when the element is a light-emitting element that does not itself block light from the background layer. Fog would not be a screen candidate because it obscures the background, blocking its light from reaching the camera. Please composite your fogs.

Figure 6-1 shows an example of a lens flare element for screening. One key point about the screen layer is that it is always over a zero black background. If any of the pixels are not zero black, they will end up contaminating the background plate in the finished picture. Figure 6-2 shows the background plate, and Figure 6-3 shows the results of screening the lens flare over the background plate. Note that the light rays are mixed with but do not actually block the background image. The dark pixels in the background plate behind the hot center of the lens flare may appear blocked, but they are just overexposed, like a double exposure of a bright element with a dark element. The bright element dominates.

 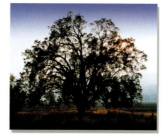

Figure 6-1 Lens flare.

Figure 6-2 Background plate.

Figure 6-3 Lens flare screened over background plate.

Figure 6-4 illustrates the "double-exposure" behavior of the screen operation. It depicts two identical gradients, images A and B, screened together. The key characteristic to note here is how the maximum brightness approaches but does not exceed 1.0. As the two images get brighter the screened results also get brighter, but at a progressively lesser rate. They become "saturated" as they approach 1.0, but cannot exceed it. When black is screened over any image the image is unchanged, which is why the screen object must be over a zero black background.

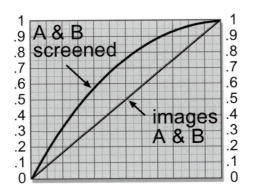

Figure 6-4 Results of two gradients screened together.

6.1.1.1 Adjusting the Appearance

You cannot "adjust" the screen operation to alter the appearance of the results. It is a hard-wired equation somewhat like multiplying two images together. If you want the screened element to appear brighter, dimmer, or a different color, then simply color grade it appropriately *before* the screen operation. Again, be careful that none of your color grading operations disturb the zero black pixels that surround the light element because any black pixel values raised above zero will end up in the output image.

Some compositing programs actually have a screen node, and Adobe Photoshop has a screen operation. For those of you not blessed with a screen node, we will see how to use either your channel math node or discrete nodes to create a perfect screen operation, but first, the math. Following is the screen equation:

$$1 - ((1 - \text{image A}) \times (1 - \text{image B})) \tag{6-1}$$

In plain English it says "multiply the complement of image A by the complement of image B and then take the complement of the results." In mathematics the complement of a number is simply one minus the number. The number, in this case, is the floating point value of each pixel in the image. Again, note that there is no matte channel in a screen operation. It just combines the two images based on the equation. This equation can be entered into a channel math node to create your own screen node.

In the event that you do not own a math node or don't want to use the one you do have, Figure 6-5 shows the flowgraph for "rolling your own" screen operation using simple discrete nodes in your compositing software. You will

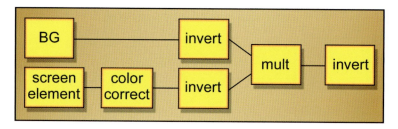

Figure 6-5 Flowgraph of discrete nodes for creating a screen operation.

undoubtedly find that the composite runs much faster using the discreet nodes than the math node anyway. The screen element is first color corrected if needed and then both images are "inverted" (some software may call this operation "negate," whereas in mathematics it is the "complement" operation used in Equation 6-1). They are then multiplied together and the results are inverted. That's all there is to it. You can build this into a macro and save it out as your own personal screen node. You could even share it with your colleagues. Or not.

6.1.2 The Weighted Screen Operation

A composite blocks the background layer, whereas the screen operation doesn't. There are times, however, when you would like to have the "glow" of the screen operation, but still suppress the background layer a bit. This is the time to use the weighted screen operation. The idea is to create a matte for the screen element (the light emitter) and use it to partially suppress the background layer prior to the screen operation. The matte can be generated any number of ways. Most commonly it is a luminance version of the screen object itself or perhaps the alpha channel in the case of a cgi element. However it is done, a matte is needed for the weighted screen.

We can compare the results of a regular screen operation vs the weighted screen operation starting with Figure 6-6, the screen element. Comparing the two background plates in Figure 6-7 and Figure 6-9, you can see the dark region where the screen element was used as its own matte to partially suppress the background layer by scaling it toward black. Comparing the final results in Figure 6-8 and Figure 6-10, the normally screened image looks thin and hot, whereas the weighted screen has greater density. While the weighted screen is more opaque, this is not a simple difference in transparency.

Figure 6-7 Original BG.

Figure 6-8 Normal screen.

Figure 6-6 Screen element.

Figure 6-9 Scaled BG.

Figure 6-10 Weighted screen.

A semitransparent composite would have resulted in a loss of contrast for both layers.

The *only* difference between the two results is that the background plate was partially scaled toward black using the screen element itself as a mask prior to the screen operation. The increased opacity results from darkening the background so less of its detail shows through, and the darker appearance of the final result stems from the screen element being laid over a darker picture. It's a different look. And of course, as explained in the previous section, the screen element itself can be increased or decreased in brightness to adjust its appearance even further.

The flowgraph for the weighted screen operation is shown in Figure 6-11. The screen element is used to create a mask to moderate the scale RGB operation to darken the BG layer. The screen mask could be generated any number of ways, such as making a simple luminance version of the screen element. The screen element is then color corrected if needed and then screened with the scaled background image.

Ex. 6-1

Adobe Photoshop Users—You can create a weighted screen by following the flowgraph in Figure 6-11. Create a scaled background as shown in Figure 6-9 as a separate layer and then use it as the background layer for the screen operation.

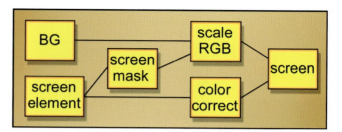

Figure 6-11 Flowgraph of weighted operation screen.

6.1.3 Multiply

The multiply operation simply multiplies two images together and is another "matte free" way of combining two images ("Multiply" in Adobe Photoshop). Like the screen operation it simply mixes two images together mathematically without regard to which is "on top." The multiply operation is analogous to "projecting" one image over the other, somewhat like putting a picture in a slide projector and projecting it over some object in the room. Of course, if you really did project a slide onto some object the resulting projected image would appear quite dark. The reason is that you are not projecting it on a nice white reflective screen, but on some darker, poorly reflective, and probably colored surface. The multiply operation behaves similarly.

Figure 6-12 and Figure 6-13 show an example of two images for multiplying. The ceramic tile painting in Figure 6-13 is surrounded by a 100% white border in order to leave the wooden gate unmodified in this region. With a multiply operation, any 100% white pixels in one layer will leave the

Figure 6-12 Layer 1.

Figure 6-13 Layer 2.

Figure 6-14 Multiplied layers.

other layer unmodified. This is because the white pixels are treated as 1.0, and 1 times any pixel value results in the original pixel value. Note that the multiplied results are darker than either original layer, as we would expect from "projecting" a slide on a less than 100% white surface. We will deal with this issue momentarily.

While results of the screen operation lighten the images universally, results of the multiply operation darken universally. The reason for this can be understood by taking an example. If you multiply 0.5×0.5 you get 0.25, a much smaller number. And so it is with all of the numbers between zero and 1.0.

Figure 6-15 illustrates two identical gradient images, A and B, multiplied together and the resulting darker image. It is actually a diagonally mirrored version of the screen operation graph in Figure 6-4. You could even think of the screen operation as an "inverted multiply," which results in a brighter output, where the regular multiply results in a darker output.

Figure 6-15 Results of two gradients multiplied together.

6.1.3.1 Adjusting the Appearance

Like the screen operation, you cannot "adjust" the multiply operation. The two images are multiplied together and that's it. However, like the screen operation, you can preadjust the images for better results. Normally you will want to brighten up the results so the two plates need to be brightened before the multiply. You want to raise the black levels and/or increase the gamma rather than adding constants to the plates. Adding constants will quickly clip the bright parts of each image.

Figure 6-16 illustrates the results of preadjusting the two plates before the multiply operation. By comparison the uncolor corrected version in Figure

Figure 6-16 Color graded layers multiplied.

Figure 6-17 Semitransparent composite.

6-14 is too dark and murky. Of course, you can also color correct the resulting image too, but when working in 8 bits it is better to get close to your visual objective with precorrections and then fine-tune the results. This avoids excessive scaling of the RGB values after the multiply operation, which can introduce banding problems with 8-bit images, whereas 16-bit images would not suffer from banding problems.

An interesting contrast to the multiply operation is the semitransparent composite of the exact same elements, shown in Figure 6-17. The composited results are a much more bland "averaging" of the two images rather than the punchy and interesting blend you get with the multiply. Each of the two images retains much more of its "identity" with the multiply operation.

6.1.4 Maximum

Another "matte-less" image combining technique is the maximum operation ("Lighten" in Adobe Photoshop). The maximum node is given two input images and it compares them on a pixel-by-pixel basis. Whichever pixel is the maximum between the two images becomes the output. While used commonly to combine mattes, here we will use it to combine two color images. Who among us has not tried to composite a live action fire or explosion element over a background only to be vexed by dark edges? The fire element is, in fact, a poor source of its own matte.

The virtues of the maximum operation are that it does not need a matte and it usually produces very nice edges. The problem with the maximum operation is that it requires very specific circumstances to be useful. Specifically, the item of interest must not only be a bright element on a dark background, but that dark background must be darker than the target image

Figure 6-18 Fireball on a dark background.

Figure 6-19 Dark target image.

Figure 6-20 Fireball max'd with target image.

that it is to be combined with. The basic setup can be seen starting with the fireball in Figure 6-18.

The fireball is on a dark background and the target image in Figure 6-19 is also a dark plate. When the two images are "max'd" together in Figure 6-20 the fireball comes "through" the target image wherever its pixels are brighter. Because there is no matte there are no matte lines, and even subtle details such as the glow around the bottom of the fireball are preserved.

One problem that you can have with the maximum operation is that there might be internal dark regions within the fireball that will become "holes" through which the target image can be seen peeking through. To fix this, a luminance matte can be generated from the fireball and then eroded to pull it well inside the edges. The original fireball can then be composited over the max'd image (Figure 6-20) to fill in the interior, somewhat similar to the soft comp/hard comp procedure shown in Chapter 5. What you end up with are the nice edges of the maximum operation and the solid core of the composite operation.

The appropriate use for this operation is when the "hot" element is live action where you have no control over its appearance. If it is cgi or a painted element then you do have control and can have the hot element placed over zero black for a screen operation or generate a matte for compositing. With a live action element you have to take what you are given and make it work. In addition to fire and explosion elements, the maximum operation can be used with photographed light sources, beams, or even lens flares—any bright live action element on a dark background.

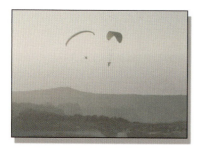

Figure 6-21 Paragliders source plate.

Figure 6-22 Garbage-matted source plate.

Figure 6-23 Paragliders min'd into a background.

6.1.5 Minimum

The minimum operation is, not surprisingly, the opposite of the maximum ("Darken" in Adobe Photoshop). When presented with two input images, it selects the darkest pixel between them as the output. While this may not sound very exciting, it can occasionally be very useful as another "matte-less compositing" technique. The setup for the maximum operation is that the item of interest is a dark element on a light background and the target image is also light, just the opposite of the setup for the maximum operation.

Take, for example, the paragliders in Figure 6-21. They are fairly dark, and the sky is fairly light, but there are dark regions near the bottom of the screen. To solve this little problem the plate has been garbage matted with a white surround in Figure 6-22. With the minimum operation the white surround becomes a "null" element that will not come through the target plate. The garbage-matted version is then "min'd" with a background plate to produce the very nice "composite" in Figure 6-23.

Of course, the minimum operation suffers from all the same limitations as the maximum operation in that you must have suitable elements, you

 may have to pull a matte to fill in the core, and you may have to garbage matte the item of interest to clear the surround. However, when it works it can be a very elegant solution to a tough

Ex. 6-2 problem.

6.2 ADOBE PHOTOSHOP BLENDING MODES

 In many digital effects studios there will be an art director type that will invariably use Adobe Photoshop to prepare test composites with a variety of "looks" for the clients' selection and approval. The Photoshop artist might even create elements that

the compositor will actually use in the shot, up to and including a matte painting that is the basis for the entire shot. When finally approved, the finished Photoshop test image will be handed to you as a reference for matching. Of course, the Photoshop artist will have used several clever and subtle Photoshop blending modes to add the smoke, snow, clouds, and lighting effects, all the while oblivious to the fact that you have no such matching operations in your compositing package. Tough pixels—you have to make your composite match anyway.

Wouldn't it be grand if your compositing program had matching operations to the Adobe Photoshop blending modes? Well, for the most part, it can. This section looks at how several of the most important Photoshop blending modes work and how you can replicate them in your compositing software. Photoshop 7 has 22 blending modes, but we will only concern ourselves with the 7 most useful ones (a *real* artist would not actually use the "Pin Light" blending mode). The good news is that 4 of the 7 are very simple and, of course, the bad news is that 3 of them aren't. They will require the entry of an equation into a math node that supports two input images. It isn't practical to construct these more complex blending modes from discreet nodes, such as multiply and screen, because it takes a hideous mess of nodes and would introduce data clipping. Better to byte the bullet and do the math.

6.2.1 Simple Blending Modes

Here are the first four easy ones. Note that these operations are "symmetrical," which means you can swap the two input images on the blending mode and it will not affect the results. All four of these operations were described earlier from the compositing software point of view but are listed again here to collect the list of Photoshop operations all in one place for handy reference.

Screen—this is the same screen operation that was discussed back in Section 6.1.1. Oddly, both we and they use the same name for this operation.

Multiply—their multiply is the same as our multiply, which was covered in Section 6.1.3.

Lighten—this is actually just our "maximum" operation by another name. It was discussed in Section 6.1.4.

Darken—another of our operations by another name, this is actually the "minimum" operation described in Section 6.1.5.

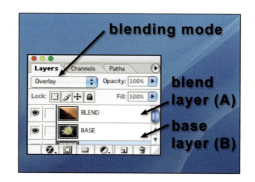

Figure 6-24 Adobe Photoshop layers palette with the blend and base layers.

6.2.2 Complex Blending Modes

Here are the three complex Adobe Photoshop blending modes. The two layers that are blended together are referred to as the BLEND layer and the BASE layer, with the blend layer listed above the base layer in the Photoshop layer palette shown in Figure 6-24. Note that these operations are *not* symmetrical, which means that if you swap the base layer with the blend layer in your composite, the results will be very wrong. If you should forget this critical fact you will be severely punished by a cruel and unyielding universe.

In keeping with our traditional compositing nomenclature where we refer to compositing image A over image B, let us refer to the blend layer as "A" and the base layer as "B" as illustrated in Figure 6-24. This makes it easy to remember because in the Photoshop palette the blend layer (A) is "over" the base layer (B). If we wanted to say, for example, "take the complement of the base layer (B) and then multiply that by the blend layer (A)," we would write such an equation thusly:

$$(1 - B) \times A$$

You, however, must convert these general image equations into specific channel equations for the channel math node of your software. Your math node will not be referring to image A and B, but rather to the color channels of input images 1 and 2. Assuming A is connected to the image 1 input and B is connected to the image 2 input of the math node, the image equation $(1 - B) \times A$ might be entered into a mythical math node as three channel equations that look something like this:

R channel out: $(1 - r2) \times r1$

G channel out: $(1 - g2) \times g1$

B channel out: $(1 - b2) \times b1$

where r2 is the red channel of image 2 (our B image) and r1 is the red channel of image 1 (our A image) and so on. One further issue is the syntax used by your particular math node. While virtually everybody uses "*" for multiply and "+" for addition, there are differences for more complex operations such as square root and "if/then" statements so don't try to copy the equations written here literally. They are all written in "pseudo-code" as a template that you must convert to the syntax of your particular math node.

The following blending mode examples use the blend layer and base layer shown in Figure 6-25 and Figure 6-26. Let us begin.

Figure 6-25 Blend layer.

Figure 6-26 Base layer.

Overlay—the overlay operation actually changes its behavior depending on the pixel values of the *base* layer color. If the base color pixel is less than 0.5, a multiply operation is done. If it is more than 0.5, it switches to a screen type of operation.

$$\text{If } (B < 0.5) \text{ then}$$
$$2 \times A \times B$$
$$\text{else}$$
$$1 - 2 \times (1 - A) \times (1 - B) \tag{6-2}$$

Hard Light—the hard light operation changes its behavior depending on the pixel values of the *blend* layer color. If the blend color pixel is less than 0.5, a multiply operation is done. If it is more than 0.5, it switches to a screen type of operation.

$$\text{If } (A < 0.5) \text{ then}$$
$$2 \times A \times B$$
$$\text{else}$$
$$1 - 2 \times (1 - A) \times (1 - B) \tag{6-3}$$

You may have noticed that the hard light equation looks very like the overlay equation. In fact, the only difference is which image the test for less than 0.5 is done on. This actually means that you can take an overlay equipped math node and just switch the input images to get the hard light. Don't tell anybody.

Soft Light—the soft light operation also changes its behavior depending on the *blend* layer color. Its visual results are similar to the overlay operation, but its Byzantine equation is much more complex.

If (A < 0.5) then

$$2 \times B \times A + (B^2 \times (1 - 2 \times A))$$

else

$$sqrt(B) \times (2 \times A - 1) \times 2 \times B \times (1 - A) \qquad (6\text{-}4)$$

Someone at Adobe stayed up very late cooking this one up. Actually, Adobe does not publish its internal math equations so they have been reverse engineered by various clever people. In fact, the soft light equation just given is actually slightly off in the very darks, but is very close. You can get the rundown on this and all the other Photoshop blending modes on a wonderful Web site by a little German software company at www.pegtop.net/delphi/blendmodes.

 To confirm that you have implemented the equations correctly, I recommend that you use the test images on the accompanying CD-ROM to compare your math node versions to the Photoshop versions that have been provided before using them in a

Ex. 6-3 production job.

6.3 SLOT GAGS

Slot gags are a terrific little animation effect that can be used to good effect in a variety of situations. They get their name from classical film opticals, which is where they were invented in about 100 B.C. (Before Computers). What is presented here is the digital analog of the optical process. The idea is to simply take two high contrast (hicon) elements, gently animate one (or both), and then mask one with the other. In our world, we achieve the masking operation simply by multiplying the two elements together. The setup is simple and is mapped out in Figure 6-27.

Figure 6-28 shows two simple masks multiplied together to produce the unexpected diamond pattern on the right. When hicon masks are multiplied,

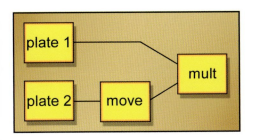

Figure 6-27 Flowgraph of slot gag setup.

Figure 6-28 Two masks multiplied together.

Figure 6-29 Rotational slot gag mask.

Figure 6-30 Resulting animation effect.

the result is just the areas where they overlap. Because the overlapping area of two complex masks is hard to visualize, the results are often surprising, which we can use to good effect.

There are virtually an unlimited number of things you can do with this basic concept—masking one moving mask against another. One common gag is to create a spiky starburst-looking graphic thingy like the one in Figure 6-29. If two similar masks are masked against each other while one (or both) is rotated the result is a really cool starburst animation effect like that in Figure 6-30. Another effect is to twinkle a star field (deliberately this time) by making an appropriate mottled mask and sliding it over the star field while multiplying them together.

However, the most common application of the slot gag is to roll a glint across some text. A simple example is shown starting with the text graphic in Figure 6-31. A glint mask is created (Figure 6-32), which is animated to move across the face of the text. It is in turn masked (multiplied) by the

Ex. 6-4

alpha channel of the text, producing the masked glint seen in Figure 6-34. This masked glint is then colorized and screened or composited over the text to create the glinted text shown in Figure 6-33. It's simple, easy, cheap, and looks great.

Figure 6-31 Text.

Figure 6-32 Glint mask.

Figure 6-33 Glinted text.

Figure 6-34 Masked glint.

At this juncture we hopefully have a technically excellent composite with a great matte and a fine despill, and now it is time to color correct it so the foreground layer visually integrates into the background layer. The two layers of the composite were photographed separately under very different lighting conditions, and when they are simply thrown together in a composite it becomes perfectly obvious that they were photographed separately under different lighting conditions. One of the most important steps in the digital compositing process is to get the two layers to appear as though they are together in the same light space, which is the subject of this chapter.

To color correct the layers of a composite to appear to be in the same light space, the capable compositor not only needs artistic training, but should also have a solid understanding of the nature of the color of light, as well as its behavior under different circumstances. These are the topics of the first two parts of this chapter.

Leonardo DaVinci was not only the greatest artist of his day, but also a great scientist. The artistic brilliance that he exhibited in his paintings and sculptures was backed up by a deep knowledge of technical issues such as human physiology and perspective. There is a science to our art. For those of you familiar with the inverse square law and diffuse surface absorption spectrums, this will be a quick review. For those not familiar with them, it will be a crash course. The attempt here is to make the science as clear and relevant to digital compositing with as little math as possible. There are a good number of charts and graphs, and I hope that you will be tolerant of them and look at them closely. They are packed full of information and are the clearest, most concise way to describe complex phenomena—and light is a complex phenomena.

Surely there is a better approach to color correcting a composite than just pushing image around color space until it looks right. It looks too dark, so brighten it up. Now it looks to red, so bring the red down. The third section of this chapter is devoted to technique, which is based on the principles and vocabulary developed in the sections on the color and behavior of light. This section develops an orderly method for color matching the elements of a composite that will hopefully help you achieve not only more correct but also more complete color matching in that more issues, such as interactive lighting, are addressed and set aright. If there are five or six lighting issues to get

right, how good can the composite look if only two or three of them are done?

7.1 THE COLOR OF NATURE

This section is about how color is created and altered by light sources, filters, and the surfaces of objects. It is not the usual additive and subtractive color theory lecture. Hopefully you got plenty of that in art school and are already clear on how to make yellow with red and green. It is about the practical aspects of color from real lights that shine through filters to strike actual surfaces to make the pictures you and I have to color correct for our composites. Understanding how color works in the real world will help us make better simulations of it in the digital world.

7.1.1 Visible Light

It is not an RGB universe. In the real world, the electromagnetic spectrum, the stuff of light, is a vast continuum of energy ranging in wavelengths from miles long in radio waves to tiny fractions of an atom for X-rays. The visible light spectrum that we can see makes up a tiny little sliver within this vast range. The actual wavelengths of our little sliver can be seen in Figure 7-1, ranging from the reds at 700 nm (nanometers, one billionth of a meter) to the blues at 400 nm. Wavelengths a little longer than 700 nm are known as infrared (below red), whereas those shorter than 400 nm are ultraviolet (above violet), both of which actually do get involved in the film business in that film is naturally responsive to both of these regions so precautions have to be taken to keep them out of the picture, so to speak.

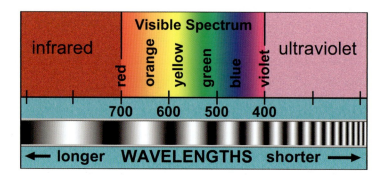

Figure 7-1 The visible light spectrum.

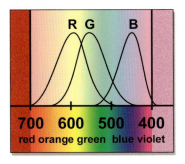

Figure 7-2 The spectral sensitivity of the eye.

It is called the visible spectrum because it is the little piece of the full spectrum that we, as humans, can actually see. The reason that we can see this particular range is because our sun puts out most of its energy in this range. Our eyesight actually evolved in response to the specific output of light from our particular sun. While the visible spectrum is continuous, our eyes do not perceive all of its frequencies equally. It just samples it at three convenient regions, the two ends and the middle, that we have named red, green, and blue. The eye, like film and CRTs, is an RGB device. The spectral sensitivity of the human eye is approximated in Figure 7-2, which explains why it can be fooled by other three-color systems like film and CRTs. Both film and CRTs emit light in frequency ranges very similar to those to which the human eye is sensitive. They have been carefully designed that way to make them compatible with our eyes.

7.1.2 The Color of Lights

The color of a light is described by its "emission spectrum"—the spectrum of light frequencies that it emits. The color of the light depends on how much energy the light source emits at each wavelength across its spectrum. Figure 7-3 illustrates the emission spectrum of a typical incandescent light source. Because it is emitting more light energy between 500 and 700 nm (red through green) and less energy around 400 nm (blue), we might expect this light to have a yellow cast to it. Note that its emission spectrum is continuous and extends well past the visible spectrum at both ends. This is typical of incandescent light sources such as light bulbs, fire, stage lights, and the sun, which achieve light emission by heating things up so much that they glow. An incandescent light source appears white because it is emitting such a broad range of frequencies of light that virtually all of the colors are

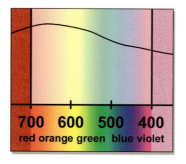

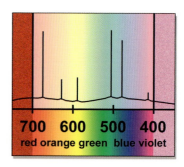

Figure 7-3 Emission spectrum of an incandescent light source.

Figure 7-4 Emission spectrum of a fluorescent light source.

represented equally, which, of course, is white. Incandescent light sources that appear yellow are simply a bit short at the blue end.

Compare the emission spectrum of the incandescent light source in Figure 7-3 to the emission spectrum of a fluorescent light source in Figure 7-4. The fluorescent light source is characterized by very low-level emissions across the spectrum with just a few "spikes" at very narrow wavelengths. This is typical of fluorescent lights and glowing gas light sources such as sodium and mercury vapor lights. The location and height of theses narrow energy spikes give the light source its color. With only a couple of small energy spikes in the red and orange (650 nm) but more energy in the green (500 nm) and blue (450 nm), we would expect this fluorescent light to shine with a flattering greenish-blue cast.

7.1.2.1 Color Temperature

As humans with eyes we never think about the color of ambient light. It always appears white to us because our eyes automatically compensate for any slightly off-white light sources. In cinematography and videography, however, the color of ambient light can impart an overall unpleasant color tint to the picture if things are not set up correctly to compensate for the color of the "off-white" light. For video, this is addressed by a process called "white balancing," where the video camera is adjusted to compensate for the color of the ambient light. For film, it is addressed by selecting a film stock that is prebalanced for the color of the ambient light. The various colors of "white light" are described properly by their *color temperature*, and to understand what this is we need a science moment.

The term "color temperature" does not refer to literally how hot the object is, but to the color of the light it is emitting. The color of this light is based on the concept of black body radiation. Suppose you had a very, very black object and heated it up. As we have all experienced around the campfire, when an object gets hot enough it starts to glow. It will first glow a dull red. Raise the temperature and it will glow a bright orange. Raise the temperature more and it will glow yellow, then white, then blue. Yes, blue-hot is hotter than white-hot. The temperature of this heated black body can be used to describe the color of light it radiates as a given temperature will always radiate the same color of light.

What is happening here is that every body (black or not) that has a temperature above absolute zero emits a full spectrum of electromagnetic radiation, from very low radio frequencies to very high frequencies, including visible light, albeit at very low levels. If an object is not a perfect black body, then its emission spectrum is not a perfect fit to the ideal model, but it still emits a very broad spectrum of energy above and below visible light. As a body heats up the visible portion of the spectrum gets bright enough to be seen, but most of the visible energy is in the lower visible frequencies, which appear as red to us.

As things heat up even more the emitted light gets brighter and spreads out to include more of the shorter wavelengths toward the blue end of the spectrum (see Figure 7-1). Things start to appear orange and then yellow. Heat things up even more and the emissions across the visible spectrum become fairly uniform to the eye. Now all of the colors are represented in roughly equal amounts so things look "white hot." Increase the temperature yet again and the blue end of the spectrum gives off even more light so things begin to look blue-white. So now you know that for display devices such as monitors, flat panel displays, video projectors, and film, red is the "coolest" temperature and blue is the "hottest." End of lecture.

7.1.2.2 Monitor Color Temperatures

Modern video monitors can have their temperature settings adjusted by the user. So what color temperature should you set your monitor for? That depends on what you are working on.

When working with film frames the appropriate monitor temperature setting is 5400° (5400 degrees), the same temperature as the film projector bulb. When working with video, set your monitor temperature to 6500°. Save the 9000° setting for spreadsheets and word processing.

The tragedy here is that science and art have defined these terms exactly the opposite of each other, as illustrated in Figure 7-5 through Figure 7-7. To

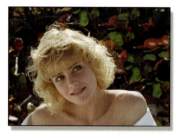

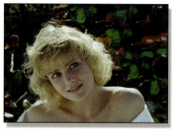

Figure 7-5 Color temperature @ 5400° artistically "warm."

Figure 7-6 Color temperature @ 6500° normal.

Figure 7-7 Color temperature @ 9000° artistically "cool."

the scientist, the cooler color temperature (5400°) will be reddish, but the artist will refer to it as "warm," probably because that's how it makes you feel when you look at it. The higher color temperature (9000°), which appears bluish, the scientist will refer to it as hot, whereas the artist will insist on calling it "cool." Can't we all just get along?

7.1.2.3 Film Color Temperatures

Indoor film stocks are set to the incandescent light sources of stage lights with a color temperature of about 3200°. Outdoor film stocks are set for direct sunlight with a color temperature of about 5400°. To indoor film set for 3200° white light, a 5400° light source is too blue. To outdoor film set for 5400° white light, a 3200° light source is too yellow. If an indoor film stock is used outdoors without a compensating filter to block the excess blue light, the exposed film will look too blue. In the same way, if an outdoor film stock is used indoors without a compensating filter there will be too much yellow light for it, resulting in yellow-looking shots. Fluorescent lights will add a green hue to the film. When you get film scans with these color anomalies you have permission to point at the cinematographer and snicker about his lack of proper filtering.

7.1.3 The Effects of Filters

Filters work by blocking (absorbing) some portions of the spectrum and passing others. The portion of the spectrum that a filter passes is called the "spectral transmittance" of the filter. Figure 7-8 illustrates a filter that blocks most of the red and orange frequencies, but passes some green and a lot of blue. This filter would appear cyan to the eye.

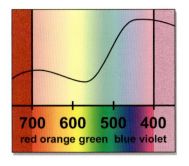

Figure 7-8 Color filter spectral transmittance.

There are two things to keep in mind about filters. The first is even though a filter appears red because it is passing the red light, it is not passing *all* of the red light. To some degree, the filter is reducing the presence of the very color that it is designed to pass. The second thing to keep in mind is that filters are in fact light blockers. When you look at a yellow filter, think of it as a blue blocker. This is especially meaningful when you are placing color filters over a wedge trying to figure out how much to adjust each color channel. If a yellow filter makes your wedge match a reference clip, don't add yellow to your shot—subtract blue.

When a filter is placed over a light source, the resulting appearance of the light is the spectral emissions of the light source multiplied by the spectral transmittance of the filter, as illustrated in Figure 7-9. In this example, the original light source appears yellow because it is strong in the red, orange, and green portion of the spectrum, but the filter blocks most of the red and orange portions of the spectrum. As a result, the appearance of the filtered light will be strong in the green and blues, or cyan.

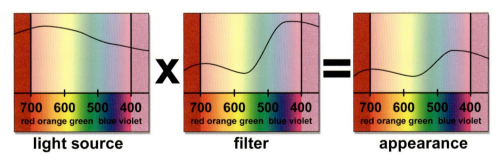

Figure 7-9 Interaction of the spectral emission of a light source with the spectral transmission of a filter that results in the appearance of the light.

Putting a cyan filter over any light source does not necessarily guarantee a cyan-colored light, however. The cyan filter blocks reds and oranges, so if a cyan filter were placed over a red light source almost all of the light would be blocked. The point is that you cannot just look at the color of the filter and predict the resulting color of the light. The spectrum of light that the light source produces is the other half of the equation.

7.1.4 The Color of Objects

The color of an object comes from the spectrum of frequencies that are not absorbed and therefore successfully reflect off of its surface. In other words, the color of a surface represents the colors of light that it does not absorb. Figure 7-10 illustrates the "spectral reflectance" (the spectrum of light that it reflects) of a red surface such as a tomato or an apple. The light frequencies between 600 and 400 nm, which appear to us as yellow, green, and blue, are almost all absorbed by the surface, and only the red frequencies are reflected back to be seen. However, for a surface to reflect a particular color frequency, it has to be present in the light source in the first place.

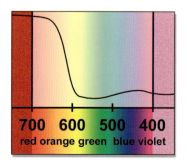

Figure 7-10 Spectral reflectance of a surface.

Figure 7-11 illustrates what happens when the emission spectrum of a light source encounters the spectral reflectance of a surface. The light source is a strong emitter in the reds and greens, whereas the surface in question is a strong reflector in the greens only. Multiplying the two graphs together produces the spectral graph of the resulting appearance of that surface under that light. The resulting appearance is strong in the greens only. As a result, a yellow light shining on a green surface results in a green appearance. The red part of the light source was absorbed by the green surface and never seen again. The chlorophyll in plants gets its energy from the sun from two particular colors of light, which it absorbs to drive its chemical reactions. By

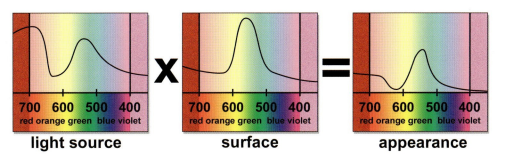

Figure 7-11 Interaction of a light source's emission spectrum with a reflective surface's spectral reflectance that results in the appearance of a surface.

simply observing that the color of plants is green, you can deduce which colors of light chlorophyll gets it energy from.

Figure 7-12 illustrates a very important concept in this whole spectral emission/spectral reflectance thing. Using the same light source as before, which is weak in the 600 nm range, but this time using a surface that reflects strongly in the same 600 nm region, we get a surface appearance that is, well, dark. Like two ships passing in the night, the light source emits frequencies that the surface doesn't reflect, and the surface reflects frequencies the light source doesn't emit. This sort of frequency-specific behavior occurs all over the scene lighting, film exposing, and print developing process. Then we get to fix it at compositing time.

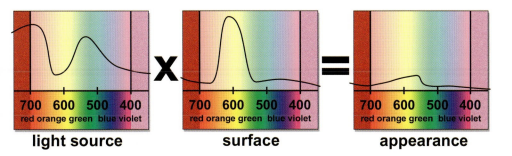

Figure 7-12 Mismatch between emission spectrum and spectral reflectance.

Gray surfaces represent an important special case in the spectral reflectance story. By definition, they reflect all wavelengths of light equally. That is what makes them gray. Black surfaces are just very dark grays so they also reflect all wavelengths equally, just not very much of them. White surfaces are just very bright grays so they too reflect all wavelengths equally. The reason that grays are so important is that they provide a color balance

reference in the middle of the color range that no other color can. Don't assume that you can just set the RGB values equal to each other to correct the gray. In some display systems equal code values do not make a neutral gray.

7.2 THE BEHAVIOR OF LIGHT

This section explores the actual behavior of light in different situations: how it falls off in brightness over distance, the different ways it reflects, how the light from many objects intermingles to create the overall ambient light, and how scattering light creates glows and beams. When two layers that were shot separately are composited together, not only are their light characteristics different, but they are also missing all of the light interactions that would occur between them naturally if they had been shot together. Our job as digital compositors is to correct the lighting differences and create those missing interactions, which will be more difficult to do if you don't know what they are. Increasing our understanding of how light behaves will improve the photo-realism of our composites because it will suggest what is needed to blend two disparate layers together into a single integrated light space.

7.2.1 The Inverse Square Law

The rule that describes how the brightness of light falls off with distance from the source is called the inverse square law. Simply put, if the amount of light landing on a surface was measured and then that surface was moved twice as far from the light source, the amount of light at the new distance would be a quarter as strong. Why this is so can be seen in Figure 7-13. The area marked "A" is one unit from the light source and has a certain amount of light within it. At area "B," also one unit from "A," the same amount of light has been spread out to four times the area, diluting it and making it dimmer. The distance from the light source was doubled from "A" to "B," but the brightness has become one-quarter as bright.

 This tells you nothing about the actual brightness of any surface. It simply describes how the brightness of a surface will change as the distance between it and its light source changes or how the brightness will differ between two objects at different distances from a light source. The math equation is

$$\text{brightness} = 1/\text{distance}^2 \qquad (7\text{-}1)$$

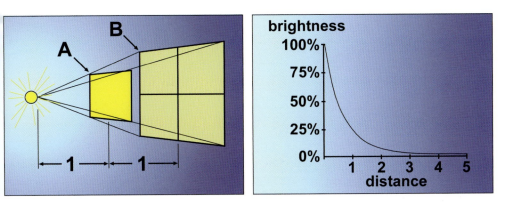

| **Figure 7-13** Inverse square law. | **Figure 7-14** Graph of inverse square law brightness falloff. |

What Equation 7-1 is saying is that the relationship between the distance and the brightness is an inverse relationship because as the distance gets larger, the brightness gets smaller, and that it is a "square" relationship because the light is spreading out in two dimensions (X and Y) to cover an area. What this means in the real world is that as objects move away from their light sources, their brightness falls off much faster than their distance increases. The actual rate of brightness falloff is graphed in Figure 7-14. For a distance three times further from the light source the brightness is 1/9 as much, and so on.

7.2.2 Diffuse Reflections

Diffuse reflections are given off by diffuse surfaces, which are flat, matte, dull surfaces like the green felt of a pool table. The vast majority of the pixels in a typical shot are from diffuse surfaces because they make up what we think of as "normal" surfaces, such as clothes, furniture, trees, and the ground. When light hits a diffuse surface it "splashes" in all directions, much like pouring a bucket of water on a concrete surface (Figure 7-15). As a result, only a small fraction of the infalling light actually makes it to the camera, so diffuse surfaces are much, much dimmer than the light sources that illuminate them. In fact, the exposure for photographing a scene is based on the brightness of the diffuse surfaces, and the "shiny spots" (specular reflections) are simply allowed to spike as high as they must so they usually get clipped because they exceed the dynamic range of the capture medium (film or video).

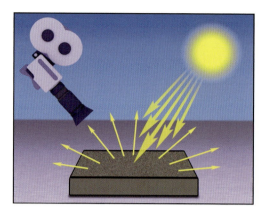

Figure 7-15 Diffuse reflections scatter incoming light.

As shown in Section 7.1.4 "The Color of Objects" the color of surfaces is due to which frequencies of the incoming light source are reflected and not absorbed. Keep in mind that the final color of a surface is the combination of the spectral emissions of the light source (the color of the light) and the spectral reflectance of the surface (the color of the surface). A yellow light (red plus green) on a green surface will result in a surface that appears green, whereas a red light on a blue surface will appear nearly black. This is because the blue surface is absorbing all of the red light, but the light source has no blue light to give so the resulting reflected light from the surface is almost none—black.

The details of how light is absorbed and reflected from surfaces are really complex and will not add a whit to making better digital effects. Just be aware that the incoming light interacts with the different atoms and molecules of the material in a wide variety of ways to produce the resulting appearance. While some light frequencies are simply absorbed and others reflected, others can burrow into the material and be reradiated as a different color and/or polarized; in many cases the angle of the incoming light changes the effect. At grazing angles, most any diffuse surface can suddenly become a specular reflector. Witness the "mirage" on the normally dull black pavement of an asphalt road. This is the sky reflecting off of what becomes a mirror-like surface at grazing angles, like laying a half mile of Mylar on the pavement.

For all practical purposes, a 2% black diffuse reflective surface is the darkest object we can make. To make a 1% reflective surface you have to actually build a black box, line it with velvet, and punch a hole in it and shoot into the hole! On the bright side, a 90% white diffuse reflective surface is the

brightest object we can make. This is about the brightness of a clean white T-shirt. A surface more than 90% reflective starts to make things shiny, which makes them become specular surfaces.

7.2.3 Specular Reflections

If diffuse reflections are like water splashing in all directions, then specular reflections are like bullets ricocheting off a smooth, solid surface, such as is shown in Figure 7-16. The surface is shiny and smooth, and the incoming light rays bounce off like a mirror so that you are actually seeing a reflection of the light source itself on the surface. What makes a reflection specular is that the light rays reflect off of the surface at the same angle that they fell onto the surface. Technically speaking, the angle of reflection equals the angle of incidence.

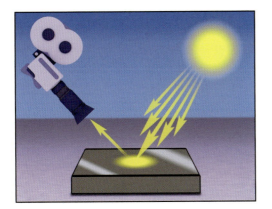

Figure 7-16 Specular reflections mirror light sources.

Specular reflections have several key features. Most importantly, they are much brighter than the regular diffuse surfaces in the picture due to the fact that they are a reflection of the actual light source, which is many times brighter than the diffuse surfaces they are illuminating. Specular reflections are usually so bright that they get clipped and become the maximum code value of the picture.

Another key characteristic of specular reflections is that their color is usually dominated more by the color of the light source than the color of the surface. This varies wildly with materials, of course. Copper will tint reflections a reddish color, whereas chrome and glass largely return the true color of the light source. The point here is that specular reflections cannot be used

as a reference for the color of a surface because there is so much of the color of the light source in them.

Another difference between specular and diffuse reflections is that the specular reflection will move with even slight changes in the position of the light source, angle of the surface, or point of view (location of the camera). Once again this is due to the mirror-like source of specular reflections. The same moves with diffuse reflections may only result in a slightly lighter or darker appearance, or even no change at all. Because specular reflections are often polarized by the surfaces they reflect from, their brightness can be reduced by the presence and orientation of polarizing filters.

7.2.4 Interactive Lighting

When light hits a diffuse surface some of it is absorbed and some is scattered, but where does the scattered light go? It goes to the next surface, where some more is absorbed and some scattered, which goes to the next surface, and the next, and so on until it is all absorbed. This multiple bouncing of light rays around a room is called interactive lighting and is a very important component of a truly convincing composite.

The net effect of all this bouncing light is that every object in the scene becomes a low-level, diffuse-colored light source for every other object in the scene. Because the bouncing light rays pick up the color of the surfaces that they reflect from (of course, we know that light does not actually "pick up" color from surfaces), it has a mixing and blending effect of all of the colors in the scene. This creates a very complex light space, and as a character walks through the scene he is being subtly relit from every direction each step of the way.

7.2.5 Scattering

The scattering of light is a very important light phenomenon that is frequently overlooked in composites. It is caused by light rays ricocheting off of particles suspended in the air. Figure 7-17 illustrates how the incoming light collides with particles in the atmosphere and scatters in all directions. Because the light scatters in *all* directions it is visible from any direction, even from the direction of the original light source. Some of the following illustrations are simplified to suggest that the light just scatters toward the camera, but we know that the light scattering is omni-directional, like Figure 7-17.

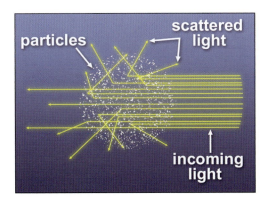

Figure 7-17 Light scattered by particles.

Light scattering accounts for the glowing halo around light sources, visible cones of light such as flashlight beams, and depth haze effects. If a light bulb were filmed in a perfectly clear vacuum the light rays would leave the surface of the light source and head straight into the camera, which is illustrated in Figure 7-18. Without any atmospheric scattering the light bulb would appear to have a stark, clean edge (again, ignoring any lens flares).

If there are particles in the intervening medium, however, some of the light is scattered and some of the scattered light gets to the camera. What happens is a light ray leaves the light source and travels some distance, ricochets off of a particle, and heads off in a new direction toward the camera (Figure 7-19). The point that it scattered from becomes the apparent source of that light ray so it appears to have emanated some distance from the actual light source. Multiply this by a few billion trillion and it will produce the "halo" around a light source in a smoky room. For a flashlight beam the point of view is from the side of the beam. The light rays travel from the flashlight

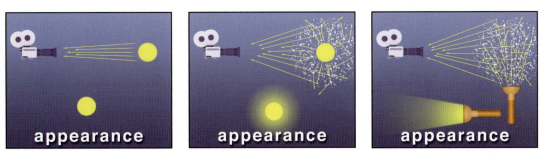

Figure 7-18 No scattering. **Figure 7-19** Light halo. **Figure 7-20** Light beam.

until some hit a particle and scatter in all directions. A small fraction of the scattered rays bounce in the direction of the camera shown in Figure 7-20. Without the particles to scatter the light toward the camera the flashlight beam would not be seen.

Because there are normally more light rays that travel the straight line to the camera compared to the ones that scatter, the surrounding glow is not as bright as the light source. But this is just a question of degree. If the particle count were increased enough (real dense smoke, for example), there could be more scattered rays than straight ones. In extreme cases the light source itself could actually disappear within the fog, resulting in just a vague glow.

Unless your light source and camera are literally out in the vacuum of space, there are *always* particles in the air that scatter the light between the light source and the camera. It is merely a question of degree. If the air is very clear and the light source is only a few feet from the camera there may be no perceptible scattering, but there is always some. Because the glow is "local" to the proximity of the light source, if the light source were behind a character the character would block the glow. This is the opposite of what happens with flare, which is covered in Chapter 7. In the case of flare, it would appear over the character no matter where he was positioned relative to the light source.

The most common scattering particles are the smog, water vapor, and dust particles found in the atmosphere, which produce the familiar atmospheric haze. Atmospheric haze is so important that it is addressed separately in Section 7.3.7. For interior shots the most common scattering particles are smoke. The scattering particles can impart their own color to the light source as well because they also selectively absorb some colors of light and reflect others, like a diffuse surface. In fact, the sky is blue due to the fact that the atmosphere scatters blue light more effectively than any other wavelength. As a result, there is less red and green light coming from the sky, hence the sky appears blue. If there were no atmospheric scattering, the light from the sun would shoot straight through the atmosphere and out into space, leaving us with a black, star-filled sky during the day.

7.3 MATCHING THE LIGHT SPACE

This section outlines production procedures and techniques designed to help you achieve the ultimate objective—making two pictures that were photographed separately appear to be in the same light space when composited together. The working theory here is that combining the technical

understanding of the behavior of light from the aforementioned sections with good procedures will augment your already considerable artistic ability to color match two layers. The idea is to inspect each shot and analyze the light space using the light theory presented in the previous sections. Once a mental model of the lighting environment is developed for a shot, it can be used to suggest the effects that will enhance the realism of the composite.

The method here is to approach the color-matching task in a logical way by first making a luminance version of the composite to correct the brightness and contrast. After the brightness and contrast are set, then the color aspects of the shot are addressed. Following that, the issues of light direction, the quality of light, and interactive lighting effects are explored as refinements to the basic color correction. Shadows are examined for edge characteristics, density, and color phenomena. There is also a section on the effects of atmospheric haze and techniques to best duplicate them. At the end of this section is a checklist of the key points of color matching that I hope you will find helpful to review after color matching a shot.

The presentation of the material here is in the context of color matching a foreground element to a background plate during a composite. The assumption here is that the background plate is already color graded and the foreground element needs to be made to match it. This is largely, although not totally, a technical task that can be helped by both theory and technique. Of course, in the case of a greenscreen layer the color grading must be done after the despill operation and before the compositing operation.

These same principles are applicable to color grading (color timing) a series of plates to match a hero plate. Color grading the initial hero plate is largely an artistic effort to achieve the "look" and "feel" that the director wants. But once the look has been established, the mission then becomes to color grade the rest of the plates in the sequence to match it, which is a somewhat of a less artistic and more technical endeavor.

7.3.1 Brightness and Contrast

A very good place to start in the color-matching process is to first match the brightness and contrast of the two layers. This matches the overall "density" of the two layers. Further, if the matching is done using a proper *luminance* version of the picture, the color issues can be kept out of the way until we are ready to deal with them. By dealing with one issue at a time the problem becomes more manageable. Sort of a divide and conquer approach.

There are three things to get right for the brightness and contrast to match: the blacks, the whites, and the midtones. The blacks and whites are one of the few things that can be set "by the numbers"—in other words, there are often measurable parameters within the picture itself that can be used as a reference to set the blacks and whites correctly. The midtones and color matching, however, usually require some artistic judgment, as they often lack usable references within the picture.

The working example for the following discussion is Figure 7-21, which shows a raw composite with a badly matching foreground layer. The luminance version in Figure 7-22 shows how it can help reveal the mismatch in brightness and contrast. The foreground layer is clearly "flatter" than the background and badly in need of some refinement. Again, starting off by getting the luminance version balanced properly will take you a long way toward a correct result. It is certainly true that if the luminance version does not look right the color version cannot look right.

Figure 7-21 Badly matching raw composite.

Figure 7-22 Luminance version of raw composite.

7.3.1.1 Matching Black and White Points

The black point of a picture is the pixel value that a 2% diffuse reflective black surface would have. That is to say, a surface so black that it only reflects 2% of the incoming light, which is *very* black, like black velvet cloth. It is bad form to have the black point of "natural" images (digitized live action, as opposed to cgi or digital matte paintings) actually at zero for a variety of

reasons. Because natural images have unpredictable variation, you run the risk of winding up with large flat "clipped" black regions in the picture. It is also important to have a little "foot room" for the grain to chatter up and down. For 8-bit linear images a good place to keep the black point is around code value 10 (0.04).

The white point is the pixel value that a 90% diffuse reflective white surface would have, and it should have a pixel value that is somewhat below 255. This is because you need some "headroom" in the color space for the "superwhite" elements that are brighter than the 90% white surface, such as specular highlights or actual light sources, such as the sun, lights, and fire. How much headroom is needed varies from case to case depending on how much visual separation these "superwhite" elements need from the white point.

Figure 7-23 is a grayscale version of the image with black and white points marked for both the foreground and the background. The basic idea is to adjust the blacks of the foreground layer until they match the blacks of the background layer. This is usually done easily by simply measuring the black values in the background and then adjusting the foreground levels to match. They can often be set "by the numbers" this way.

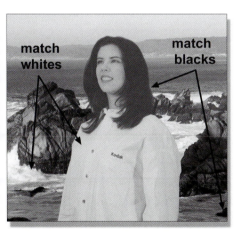

Figure 7-23 Luminance version of raw comp showing black and white points.

Figure 7-24 Resulting luminance version after correcting black and white points.

The whites of the two layers are similarly matched. Locate a white reference in the foreground plate and a matching white reference in the background plate (Figure 7-23) and then adjust the foreground white to the

background white value. A word of caution is needed when selecting the white references. Make sure that you don't pick a specular highlight as a white point. We are trying the match the brightness of the regular diffuse surfaces, and because specular highlights are much brighter, they are not a good reference.

Literally using brightness and contrast adjustments to match the blacks and whites can be problematic because the two adjustments interact and mess each other up. If you get the blacks set with a brightness adjustment and then try to match the whites with a contrast adjustment, you will disturb the black setting. You can eliminate these annoying interactions by using a color curve to set both the blacks and the whites in one operation. The procedure is to use a pixel sampling tool on the foreground and background layers to find the values of their blacks and whites and then use a color curve to fix them both at once. Let's assume that after the pixel samples you get numbers like those in Table 7-1.

Table 7-1

	Foreground	Background
blacks	0.15	0.08
whites	0.83	0.94

What is needed, then, is to map the foreground's black value of 0.15 to the background's black value of 0.08, and for the whites, the foreground value of 0.83 needs to map to the background's 0.94.

Figure 7-25 illustrates a color curve with both the blacks and the whites corrected based on the sampled numbers in Table 7-1. The foreground values

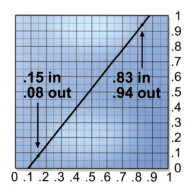

Figure 7-25 Black and white points adjusted with color curve.

are set on the "image in" axis, and the target values of the background are set in the "image out" axis. If some manual refinement is still needed, the blacks or whites can be refined individually without disturbing each other. Figure 7-24 shows the luminance version of the composite with the foreground layer corrected for the black and white points. It now visually integrates much better with the background layer. Once the color curve is established for correcting the luminance version, it can be applied to the color version.

7.3.1.1.1 Increasing Contrast with the "S" Curve

 Because we are *increasing* contrast in the example just given, let's pause for a moment to address an issue. The problem with increasing contrast with the simple color curve shown in Figure 7-25 or the typical contrast adjustment node is that they can clip the blacks and whites. A more elegant solution to increasing the contrast of any image is the "S" curve shown in Figure 7-26. The contrast of the picture is increased in the long center section, but instead of clipping the blacks and whites the curved sections at the ends gently squeeze them rather like the shoulder and toe of print film. When decreasing contrast, there is no danger of clipping so it can be done safely with the simple linear color curve or a contrast node.

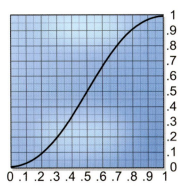

Figure 7-26 "S" color curve for increasing contrast.

A rather stark example of contrast clipping can be seen starting with the original image in Figure 7-27. Figure 7-28 has had the contrast increased using a typical contrast adjustment node, resulting in severe clipping. The hair and shoulders are clipped in the whites and the background foliage is clipped in the blacks. Compare that with Figure 7-29, which had the

Figure 7-27 Original image.[1] **Figure 7-28** Linear curve. **Figure 7-29** "S" curve.

contrast adjusted with the elegant "S" curve. The highlights in the hair are no longer clipped and there is much more detail in the darks of the bushes in the background.

7.3.1.1.2 When You Don't Have Good Black and White Points

What do you do if your background and foreground plates lack convenient black and white points? Look for something that is close to the black point in density that can be found in both layers and use it instead. Very often you can identify similar type black elements in both plates that *should* be the same density based on an analysis of the picture content.

For example, let's say that the background has an obvious black point (a black car, for example) but the foreground does not. Perhaps the darkest thing in the foreground layer is a deep shadow under a character's arm. Search the background plate for a similar type of deep shadow and use it as the black point for matching the foreground. Of course, there will not be a handy character in the background plate with a convenient deep shadow under his arm for an ideal match, but there may be a tree with what appears to be a very similar deep shadow to the deep shadow of the foreground. Because we are working with the luminance version of the picture, our black point is essentially unaffected by the fact that the two deep shadows are slightly different colors. A good understanding of the behavior of light allows you to make informed assumptions about the picture content that can help you with color matching.

The whites are a more difficult problem when there are no clear 90% white points to use as references. The reason is that it is much more difficult to estimate how bright a surface should be because its brightness is a com-

[1] "Marcie" test picture courtesy of Kodak Corporation.

bination of its surface color plus the light falling on it, neither of which you can know. The blacks, however, are simply the absence of light and are therefore much easier to lock down. Further, when you just have midtones to work with they will be affected by any gamma changes that will be made after the white point is set. There is an approach that might be used if the foreground layer has some specular highlights on the midtone surfaces. You can usually assume that the specular highlights are the 100% white point, so they can be scaled up to nearly the maximum code value.

7.3.1.2 Matching Midtones

Even though the black and white points have been matched between the foreground and the background layers there can still be a mismatch in the midtones due to dissimilar gammas in the two layers. This can be especially true if you are mixing mediums—a film element as the background with a video or cgi element as the foreground or a film element from a greenscreen as the foreground over a matte painting from Adobe Photoshop. Regardless of the cause, the midtones must also be made to match for the comp to fly.

The problem with the standard fix for midtones of gamma correction is that it will disturb the black and white points that have just been carefully set. The reason is that the gamma adjustment will alter all pixel values that are not either exactly zero black or 255 white, and hopefully your black and white points are not exactly zero or 255 white. Some gamma tools may permit you to set an upper and lower limit on the range that it will affect, in which case you can set the range equal to the black and white points and use the gamma node without disturbing them.

 However, few gamma nodes offer such elegant controls. The same color curve used to set the black and white points, however, can also be used to alter the midtones without disturbing the original black and white points. The reason is that you already have a control point set at the black and white points, and it is just a matter of "bending" the middle of the color curve to adjust the midtones like the example shown in Figure 7-30.

Bending the color curve like this is not a true gamma correction, of course, because a gamma correction creates a particular shaped curve, which this will not exactly match. This is not terribly important, however. Nothing says that any mismatch in the midtones is actually due to a true gamma difference requiring specifically a gamma curve to fix. It is simply that gamma corrections are what we traditionally use to adjust the midtones so we can use a

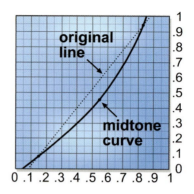

Figure 7-30 Using black and white point color curve to set midtones.

Figure 7-31 Black point, white point, and midtones corrected.

color curve just as well. At this point we have entered the zone of "what looks right, is right." Once the black, white, and midtone corrections have been developed for the luminance version, they are then applied to the color version, as shown in Figure 7-31. While nicely matched for overall density, the color balance is still seriously off with way too much red. Now it is time for the actual color matching. But first, before we leave the luminance version, a little tip.

7.3.1.2.1 Gamma Slamming

A word of caution for folks working with film (video people can listen in but don't get to ask questions). When you view your shots in the screening room you are obviously watching a print, not the original negative. Print film has a severe "S"-shaped response curve

that gently crushes the blacks and whites together. If the foreground and background layers have poorly matched blacks, you may not see it in the projected print because it has pulled them closer together, but you will see it when the negative is scanned in telecine for the video version. In telecine the blacks are "stretched" so that even a small mismatch between the two layers will suddenly become exaggerated. "Gamma slamming," shifting your monitor gamma to extremes both up and down, will "stretch" the composite in the blacks and whites to reveal any bad matches. When you think the blacks and whites are correct, do a little gamma slamming to see if it still holds together at the extremes.

7.3.1.3 Histogram Matching

A histogram is an image analysis tool that can be helpful for matching brightness and contrast between two images. What a histogram does is create a graph of the distribution of pixels in an image based on their brightness. It does not tell you the brightness of any particular area of the image. Instead, it is a *statistical* representation of how the pixel brightness is distributed over the entire image (or window, in case just a region is selected). The actual pixel values are on the horizontal axis and their percentages of the picture are plotted on the vertical axis.

Figure 7-32 shows three examples of histograms covering normal, dark, and light image content. Grayscale examples are shown here as most histograms plot the luminance of the image, but there are programs that will also display the histogram for each color channel. Starting with the normal

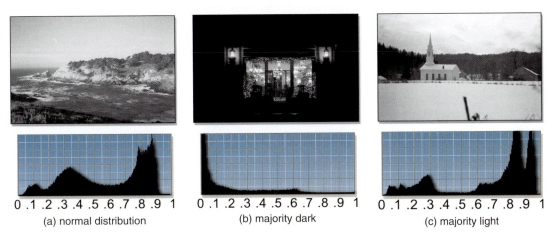

0 .1 .2 .3 .4 .5 .6 .7 .8 .9 1 0 .1 .2 .3 .4 .5 .6 .7 .8 .9 1 0 .1 .2 .3 .4 .5 .6 .7 .8 .9 1

(a) normal distribution (b) majority dark (c) majority light

Figure 7-32 Histogram examples.

distribution image in Figure 7-32a, there is a large peak in the graph around pixel value 0.8. This is the sky region of the picture, and the graph is saying that there are many pixels in the image with this brightness value, which is not surprising because the sky covers a lot of the picture. Note that the white surf will also fall into this brightness region and be included in the same peak. Conversely, there are not very many pixels with a brightness of 0.1, which are the dark rocks in the foreground.

The vertical scale is usually not labeled with the percentage because it is a self-scaling graph and the percentages change from sample to sample. In one image the strongest peak might represent 15% of the pixels, but in another it may only be 3%. Some histograms allow you to move a sample tool over the graph to read the actual percentages at different locations, but knowing the percentages is usually not very useful. What you do get is an overall sense of the brightness distribution, which is easy to see in the next two examples, which are deliberately extreme. Figure 7-32b is a night picture that has a majority of dark pixels. The snowy church in Figure 7-32c has a majority of light pixels, and you can see how its histogram is very different than the dark picture. You can even see how the trees are clustered in the region between zero and 0.3.

So what good is all this? One of the main uses is histogram equalization. That is, if an image does not fill the available color space completely, it can be detected with the histogram because it reveals the lightest and darkest pixels in the image. The image can then be adjusted to pull the maximum and minimum pixel values up and down to completely fill the available data range from zero to 1.0. As an example, the normal distribution example in Figure 7-32a has had its contrast lowered by raising the blacks in Figure 7-33 and then a new histogram has been taken.

You can immediately see two big differences in the histogram for Figure 7-33 compared to Figure 7-32a. First of all the graph has been "squeezed" to the right. This reflects the blacks in the image having been "squeezed" up toward the whites. This has left a large void in color space between zero and 0.3 so this image no longer fills the available color space. If the contrast were adjusted to pull the blacks back down to or near zero, it would "equalize" the histogram. You can use the histogram to monitor the image while you adjust the contrast until it fills the color space. You may even have a histogram equalization operation available that will adjust the image for you automatically. Images imported from foreign sources such as cgi renders or flatbed scanners will often be cramped in color space and will benefit from histogram equalization. Keep in mind, however, that not every image should have its histogram equalized. Some images are naturally light or dark and should stay that way.

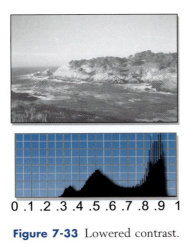

0 .1 .2 .3 .4 .5 .6 .7 .8 .9 1

Figure 7-33 Lowered contrast.

The second difference between the histogram in Figure 7-33 compared to Figure 7-32a is the addition of data "spikes." These are introduced whenever an image has been resampled. What has happened is that several nearby pixel values have become merged into one, which piles them up into the statistical "spikes." The spikes can become gaps if the image is resampled in the other direction, stretching pixel values apart. Either way, these data anomalies are a tip-off that an image has been manipulated digitally.

The second use of the histogram is histogram matching. You can take the histogram of a background plate and a foreground element and compare them. Sometimes this will give you helpful clues as to how to match the brightness and contrast. An occasion where the histogram is not helpful is when the background and foreground are not supposed to have the same dynamic range so their histograms are not supposed to match. For example, a normally lit foreground character may have a normal distribution histogram such as Figure 7-32a but the background may be a dark room with a dark distribution such as Figure 7-32b.

All of the histograms shown here have been taken from the luminance version of the image. We have already talked about making a luminance version of the image to set the basic brightness and contrast, which would apply here. Unfortunately, histograms are less helpful when it comes to actual color correction. First of all, a three-channel histogram only tells you about

the statistical distribution of each color channel individually, and color has more to do with how they are paired up. Second, small changes in the histogram make for big changes in color so it is

Ex. 7-1 usually too crude a measure to be helpful.

7.3.2 Color Matching

Using the luminance version of the image, the black point, white point, and gamma have been set. Now it is time to look at the issue of the color itself. Unfortunately, there are so many variables in the overall color of a plate that an empirical approach is usually not possible. As shown in Section 7.1.4 "The Color of Objects" even the same object illuminated with different colored lights will appear differently and different colored objects will respond to the same light differently. This means that if a person, for example, was filmed on location under natural light and then the same person with the same clothes was filmed later on a stage with stage lighting, all of the flesh tones and clothes colors will have shifted *relative to each other*. They are not all simply warmer or cooler overall. You might get the flesh tones to match, but the shirt will be off, for example. As a result, there are times when choices have to be made as to what is most important to make right and what to let go.

In contrast to varied lighting, when colored filters are used on a camera it introduces global color changes that affect everything in the scene equally. A yellow filter may reduce the blue level by 10%, but it will be 10% for everything in the scene. The colors did not shift relative to each other, and a single overall 10% increase in the blue channel will put things aright.

The film stock and its exposure is another source of color difference. Different film stocks have slightly different responses to the colors in the scene, so like different colored lights, the colors in the scene can shift relative to each other. This means that they cannot be corrected with global color corrections to the entire plate. Even though the color-matching phase has fewer clues to work with, there are some techniques that can help.

7.3.2.1 Grayscale Balancing

There is a situation where an empirical approach can be used, and that is if there are gray elements in the shot. If there are objects in the picture that are known (or can reasonably be assumed) to be true gray, you have a giant clue to the color correction. In this context, gray includes its extremes, black and white. Knowing that gray surfaces reflect equal amounts of red, green, and blue provides a "calibration reference" that no other color can.

Let's say that you were presented with two different plates, each with a red object in the picture. You would have no way of knowing whether the differences in the two reds were due to surface attributes, lighting differences, filters on the camera, or film stock. With gray objects we know going in that

all three channels should be equal, and if they are not, it is due to some color balance bias somewhere in the imaging pipeline. The source of this color bias is not important. By simply making all three channels equal, we can cancel it out. Fortunately, there are many objects out there that can be black (tires, ties, hats), gray (suits, cars, buildings), or white (paper, shirts, cars) so there is often something to work with.

Normally the reference grays in the background plate will not be true grays with equal values of red, green, and blue. There will be some color bias due to the artistic color grading (color timing) of the background plate. What needs to be done first is to measure and quantify the color bias of the grays in the background plate and then adjust the grays in the foreground plate to have the same color bias. Because the grays in the foreground plate will not be the same brightness as the grays in the background plate either, the color bias becomes a "universal correction factor" that can be used to correct any gray in the foreground, regardless of its relative brightness. This is the swell thing about grays.

Table 7-2 has a background gray that we can use to color correct a foreground gray to match. The procedure is to measure one or more grays in the background plate, calculate the color bias percentages, and use those percentages to calculate the corrected RGB values for the grays in the foreground. We are using a "green-based" approach where the green channel is used as the reference while the red and blue percentages are calculated relative to it. An example is shown in Table 7-2. A gray is sampled in the background plate and entered in the column labeled "RGB values." The percentage of difference for the red and blue channels relative to the green channel is then calculated in the next column. In this example, because the grays are warm, the reds are 5% greater and the blues are 10% less than the green channel. This relationship will hold for all of the grays in the picture.

For a foreground gray, its original RGB values are sampled and placed in the column marked "Original RGB values." Using the red and blue percent-

Table 7-2

	Background gray		Foreground gray	
	RGB values	Percentages	Original RGB values	Corrected RGB values
Red	0.575	+5%	0.650	0.735
Green	0.500	—	0.700	0.700
Blue	0.450	−10%	0.710	0.630

ages, new red and blue values are calculated in the column marked "Corrected RGB values." Note that the green value is left unchanged. The "Corrected RGB values" are the target values of the gray after the foreground plate is color corrected. The new gray will have the same color bias as the gray in the background and will appear to be in the same light space, taking all of the other colors in the foreground with it.

7.3.2.2 Matching Flesh Tones

Flesh tones can be another useful color reference. The background plate rarely has flesh tones in it, but if it does, they can often be used as a color reference for any foreground layer flesh tones.

Getting the flesh tones right is one of the key issues in color matching. The audience may not remember the exact color of the hero's shirt, but any mismatch in the flesh tones will be spotted immediately. Matching the flesh tones was the technique used for the final color-matching step shown in Figure 7-34.

Figure 7-34 Color corrected.

7.3.2.3 The "Constant Green" Method of Color Correction

Altering the RGB values of an image more than a little bit will alter the apparent brightness as well. This often means that you have to go back and revise the black and white points and perhaps the gamma adjustments. However, it is possible to minimize or

even eliminate any brightness changes by using the "constant green" method of color correction. It is based on the fact that the eye is most sensitive to green so any changes to the green value have a large impact on the brightness while red and blue have much less. In fact, in round numbers, about 60% of the apparent brightness of a color comes from the green, 30% from the red, and only 10% from the blue. This means that even a small green change will cause a noticeable brightness shift, whereas a large blue one will not.

The idea, then, of the constant green color correction method is to leave the green channel alone and make all color changes to the red and blue channels. This requires "converting" the desired color change into a "constant green" version as shown in Table 7-3. For example, if you want to increase the yellow in the picture, lower the blue channel instead. Of course, if you want to lower something instead of increase it, then simply invert the operation in the "adjust" column. For example, to *lower* the cyan, *raise* the red.

Table 7-3: "Constant green" color corrections

to increase	adjust
RED	R↑ G B
GREEN	R↓ G B↓
BLUE	R G B↑
CYAN	R↓ G B
MAGENTA	R↑ G B↑
YELLOW	R G B↓

7.3.2.4 Daylight

Objects lit outdoors by daylight have two different colored light sources to be aware of. The obvious one, the sun, is a yellow light source, but the sky

itself also produces light, and this "skylight" is blue in color. An object lit by the sun takes on a yellowish cast from its true surface color, and a surface in shadow (skylight only with no sunlight) takes on a bluish cast from its true surface color. Foreground greenscreen elements shot on a stage are very unlikely to be lit with lights of these colors so we might expect to have to give a little digital nudge to the colors to give them a more outdoor daylight coloration.

Depending on the picture content of the greenscreen layer, you may be able to pull a luminance matte for the surfaces that are supposed to be lit by direct sunlight. By inverting this matte and using it to raise the blue level in the "shady" parts of the foreground, the sunlit areas will appear more yellow by comparison without affecting brightness or contrast. This can help sell the layer as being lit by actual outdoor sunlight and skylight.

7.3.2.5 Specular Highlights

There will usually be specular highlights in the foreground element that need to match the specular highlights of the background plate. Of course, specular highlights in the foreground layer came from lights on the greenscreen stage instead of the lighting environment of the background plate. Very often little attention is paid to matching the lighting of the greenscreen element to the intended background plate, so serious mismatches are common.

The good news is that specular highlights are often easy to isolate and treat separately simply because they are so bright. In fact, they will normally be the brightest thing in the frame unless there is an actual light source such as a light bulb (rare for a greenscreen layer). You can often pull a luminance matte on the specular highlights in the foreground plate and use it to isolate and adjust them to match the specular highlights in the background plate.

There is one thing to watch out for when darkening specular highlights. While they are often the color of the light source rather than the surface, sometimes they do appear to be the same color as the surface. Regardless of their appearance, they are still considerably less saturated than the rest of the surface because the bright exposure has squeezed the RGB values together somewhat. When the RGB values of any color are brought closer together, it moves toward becoming a gray. Because of this, when specular highlights are darkened they tend to turn gray. Be prepared to increase the saturation or even add color into the specular highlights if they gray down.

7.3.3 Light Direction

If the foreground layer of a composite is supposed to be in the same light space as the background layer, then the direction that the light is coming from should obviously be the same for both layers. Interestingly, this is the one lighting mistake that the audience will often overlook, but the client may not. If the density, color balance, or light quality is wrong, the eye sees it immediately and the entire audience will notice the discrepancy. But the direction of the light source seems to require some analytical thinking to notice so it escapes the attention of the casual observer if it is not too obvious.

This is also one of the most difficult, if not impossible, lighting problems to fix. If the background clearly shows the light direction coming from the upper left, say, but the foreground object clearly shows the direction to be upper right, there is no way you can move the shadows and transfer the highlights to the other side of the foreground object.

There are only a few possibilities here, none of them particularly good. On rare occasions one of the layers can be "flopped" horizontally to throw the light direction to the other side, but this is a long shot. A second approach is to try to remove the largest clues to the wrong lighting direction in one or the other layers. Perhaps the background plate could be cropped a bit to remove a huge shadow on the ground that screams "the light is coming from the wrong direction!" Yet another approach is to select one of the layers to subdue the most glaring visual cues that the light source is wrong. Perhaps some very noticeable edge lighting on a building in the background could be isolated and knocked down a few stops in brightness, making the light direction in the background plate less obvious. Maybe the shadows can be isolated and reduced in density so that they are less noticeable. If you can't fix it, minimize it.

7.3.4 Quality of Light Sources

The quality of a light source refers to whether it is small and sharp or large and diffuse. The two layers of a composite may not only have been photographed separately under totally different lighting conditions, they may have even been created in completely different ways, for example, a live action foreground layer over a cgi background, a cgi character over a miniature set, or any of the aforementioned over a digital matte painting. When elements are created in completely different "imaging pipelines," they have an even greater chance of a major mismatch in the quality of light. To some degree, one of the layers is sure to appear harsher and more starkly lit than

the other layer. It may be objectionable enough to require one of the layers to be adjusted to look softer or harsher in order to match the light quality of the two layers.

7.3.4.1 Creating Softer Lighting

The general approach is to decrease the contrast, of course, but having a few small light sources can cause more "hot spots" on the subject and deeper shadows than broad, diffuse lighting. The highlights may still be too stark relative to the midtones, so it may also be necessary to isolate them with a luma-key and bring them down relative to the midtones and perhaps even isolate the deep shadows and bring them up, which was done in the example in Figure 7-35. Again, be on the alert for highlights turning gray as they are darkened.

Figure 7-35 Softer lighting. **Figure 7-36** Original image. **Figure 7-37** Harsher lighting.

7.3.4.2 Creating Harsher Lighting

If the element needs to be adjusted to appear to have harsher lighting, then the first thing to do is increase the contrast. If there is any danger of clipping in the blacks or the whites be sure to use the "S" curve in a color curve as described in Section 7.3.1.1 "Matching the Black and White Points." If the lighting needs to be made even harsher than the contrast adjustment alone can achieve, the highlights and shadows may need to be isolated and pulled away from the midtones like the example in Figure 7-37. The more that the highlights and shadows move away from the midtones, the harsher the lighting will appear.

Ex. 7-2

7.3.5 Interactive Lighting

In some situations interactive lighting effects can become very important in making two disparate layers appear to be in the same light space. It is one of several things that "cross over" between the two layers that helps give them the feeling that they share the same light space. As explained in Section 7.2.4 "Interactive Lighting" the effects usually require close proximity between the two surfaces to become very noticeable. If a character in a white shirt walks up to a dark wall, the "wall side" of the shirt will get noticeably darker. If the wall were a brightly lit red wall, the shirt will pick up a red tint. Of course, a white shirt is not required for the interactive lighting effects to be seen, it just makes them more noticeable. Any diffuse reflecting surface will show interactive lighting effects from the surrounding environment to one degree or another. Adding interactive lighting effects and, even better, animating them will go a long way toward selling the two layers as one.

7.3.6 Shadows

Shadows are actually fairly complex creatures. They are not simply a dark blob on the ground. We all learned about the umbra, penumbra, and core of a shadow in art school, but not how they get there. Shadows have edge characteristics, their own color, and a variable interior density. Clearly, the first approach is to observe any available shadow characteristics of the background plate and match them, if there are any available for inspection. Failing that, the following guidelines can be helpful for synthesizing a plausible looking shadow based on careful observations of the scene content and lighting environment.

7.3.6.1 Edge Characteristics

Edge characteristics stem from a combination of the sharpness of the light source, the distance between the object edge and the projected shadow, and the distance from the camera. A large light or a diffuse light source will produce a soft-edged shadow, whereas a small light will produce a sharp-edged shadow. At a distance from the shadow-casting object, even a sharp shadow gets soft edges. The shadow from a tall pole, illustrated in Figure 7-38, will have a sharper edge near the base of the pole, which will get softer the further from the pole you get. The distance from the shadow to the camera causes the shadow to appear sharper as the distance is increased. If there are no shadows in frame to use as

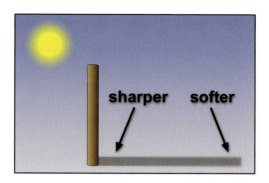

Figure 7-38 Softness of shadow with distance.

a reference, these general rules can be used to estimate the appropriate edge characteristics of your synthetic shadow.

7.3.6.2 Density

The density (darkness) of a shadow results from the amount of infalling *ambient* light, not the key light source (the light casting the shadow). If the key light is held constant and the ambient light is decreased, the shadow will get denser. If the ambient light is held constant and the key light is increased, the density of the shadow will not change. However, it will *appear* more dense relative to its surroundings simply because of the increased brightness of the surrounding surface, but its actual density is unaffected.

Due to interactive lighting effects the interior density of a shadow is not uniform. The controlling factors are how wide the shadow-casting object is and how close it is to the cast shadow surface. The wider and closer the object is, the more ambient light it will block from illuminating the shadow. Observe the shadow of a car. The portion that sticks out from under the car will have one density, but if you follow it under the car the density increases. Look where the tires contact the road and it will turn completely black. This is some serious interactive lighting effects in action. Amazingly, many of the synthesized car shadows for TV commercials are one single density, even at the tires!

Figure 7-39 illustrates a shadow-casting object that is far enough away from the cast shadow surface that the ambient light is free to fall over the entire length of the shadow, indicated by the ambient light arrows remaining the same length over the length of the shadow. Figure 7-40 shows the same object and light source, but the object is now laid over so that it gets closer to the cast shadow surface at its base. The shadow gets progressively

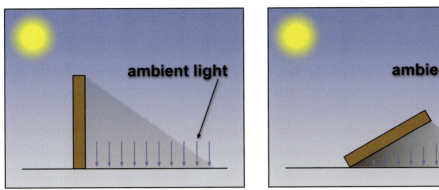

Figure 7-39 Constant density shadow.

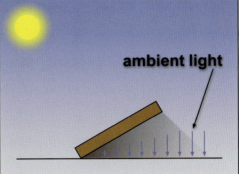

Figure 7-40 Variable density shadow.

darker toward the base because the object is blocking progressively more incoming ambient light, indicated by progressively smaller ambient light arrows.

In truth, Figure 7-39 technically oversimplifies the situation. Very near the base of the object the density of the shadow would actually increase because the object is blocking progressively more ambient light coming from the left. The effect is small and can often be ignored if the object is thin, like a pole. However, when the shadow casting object is close to the cast shadow surface, the effect is large. For example, if a person were standing 3 feet from a wall we would not expect to see a variable density shadow. If he were leaning against it, we would.

The most extreme example of increasing shadow density due to object proximity is the all-important contact shadow. At the line of contact where two surfaces meet, such as a vase sitting on a shelf, the ambient light gets progressively blocked, which results in a very dark shadow at the line of contact. This is a particularly important visual cue that one surface touches another. Omitting it in a composite can result in the foreground object appearing to be just "pasted" over the background.

7.3.6.3 Color

If you were standing on a flat surface in outer space far enough from the earth, moon, and any significant light sources other than the sun, your shadow would be absolutely black. But this is about the only place you will find a truly black shadow. On earth, shadows have both brightness and color. The brightness and color of a shadow are results of the spectral interaction of the

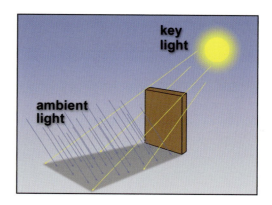

Figure 7-41 Brightness and color of a shadow from the ambient light.

color of the surface it is projected on plus the color of the *ambient* light sources. Figure 7-41 illustrates how a shadow is created by a key light, but inherits its density and color from the ambient light.

For an outdoor shadow, there are two light sources: a bright yellow sun and a dim blue sky. The skylight is showering blue ambient light down on the ground, so when something blocks the yellow light of the sun it is free to illuminate and tint the shadow blue. You can think of outdoor lighting as a 360° dome of diffuse blue light with a single yellow light bulb shining through a hole in it. Now, if you imagine blocking the direct sunlight, the skylight will still provide quite a bit of scene illumination, albeit with a very blue light. This we call shade.

Interior lighting is more complex because there is usually more than the two light sources of the outdoors, but the physics are the same. The shadow is blocking light from the key light, call it light source "A," but there is always a dimmer light source "B" (usually also light sources "C," "D," "E," etc.) that is throwing its own colored lighting onto the shadow. In other words, the color of the shadow does not come from the light source that is casting it, but from the ambient light plus any other light sources that are throwing their light onto the shadow.

7.3.6.4 Faux Shadows

 The oldest shadow gag in the known universe is to use the foreground object's own matte to create its shadow. With a little warping or displacement mapping it can even be made to appear to drape over objects in the background plate. There are limitations, however, and you don't want to push this gag too far. The thing to keep in mind is that this matte is a flat projection of the object from the point of

view of the camera that filmed it. The effect will break down if you violate that point of view too much.

For example, the shadow in Figure 7-42 looks pretty good, until you think about the shadow's right shoulder ruffles. From the angle of the shadow, the light is clearly coming from the upper left of the camera. If that were really true, then the head's shadow would be covering the right shoulder ruffle shadow. Of course, technical details like this are usually not noticed by the audience as long as the shadow "looks" right—meaning color, density, and edge characteristics—so as not to draw attention to itself and invite analysis.

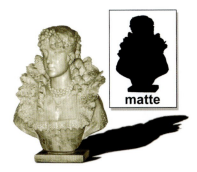

Figure 7-42 Using the matte to make a faux shadow.

The technically ideal location for the light source of the faux shadow is in exactly the same place that the camera is located, which puts the shadow directly behind the foreground object where it cannot be seen at all. This being a somewhat unconvincing effect, you will undoubtedly want to offset the shadow to some degree, implying a light source that is offset a bit from the camera position. Just keep in mind that the further from the technically correct location the faux light source is, the more the effect is being abused and the more likely it will be spotted.

Rather than trying to use color correction techniques to make a shadow, make a solid plate of dark blue and then use the shadow matte to composite it over the background. The hue and saturation of the shadow can be refined easily by adjusting the color of the plate, and the density can be adjusted separately by changing the degree of transparency. This arrangement also makes it easier to incorporate sophisticated interactive lighting effects.

 The solid color plate could be a gradient, its color and density could be animated, and the shadow matte could be given an increase in density where it joins the body. And don't forget the contact shadow.

Ex. 7-3

7.3.7 Atmospheric Haze

Atmospheric haze (depth haze, aerial perspective) is a fundamental attribute of most outdoor shots and all smoky indoor shots. It is one of the visual cues to the depth of an object in a scene along with relative size and occlusion (in front or behind other objects). While the effects of atmospheric haze stem from the scattering effects of the particles in the intervening atmosphere, there are actually two different light sources to consider.

The first light source is the intervening atmosphere between the camera and the mountain, shown in Figure 7-43. Just like the side scattering of the flashlight beam in Figure 7-20, some of the sunlight and skylight raining down is scattered in midair, and some of that scattered light enters the camera. This has the effect of laying a colored filter over the scene. The density of this "filter" is a function of the distance to each object, and its color is derived from the color of the scattered light.

The second light source is the distant object itself, like the mountain shown in Figure 7-44. Some fraction of the light reflecting from the mountain hits particles in the atmosphere and gets scattered before reaching the camera. This has a softening effect on the mountain itself that reduces detail, much like a blur operation. It is the sum of these two effects, the atmospheric light scattering and the object light scattering, that creates the overall appearance of the atmospheric haze.

Figure 7-43 Scattered atmospheric light. **Figure 7-44** Scattered mountain light.

An example of the sequence of atmospheric haze operations can be seen starting with the original plate in Figure 7-45. The mission is to add a new butte in the background and color correct it for atmospheric haze. The big butte on the left was lifted out, flopped, and resized to make an addition to the background butte on the right side of the frame. Figure 7-46 shows the raw comp of the new butte with no color correction. Without proper atmospheric haze it sticks out like a sore thumb. Figure 7-47 shows just a color correction operation added to simulate the scattered "atmospheric" light (per

Figure 7-45 Original plate. **Figure 7-46** Raw composite.

Figure 7-47 Color corrected. **Figure 7-48** Softened.

Figure 7-43). It now blends in better with the original butte, but it has too much fine detail compared to its other half. A gentle blur has been added in Figure 7-48 to allow for the loss of detail due to the scattering of the "mountain" light (per Figure 7-44).

It is certainly possible to adjust the color of the foreground element to match the background plate by adding a simple color correction operation, but there is another approach that can be more effective. The procedure is to make a separate "haze" plate that is the color of the atmospheric haze itself and do a semitransparent composite over the foreground element. The starting color of the haze plate should be the color of the sky right at the horizon and then it can be refined if needed.

There are several advantages to this approach. First of all, the color of the haze and the degree of transparency can be adjusted separately. Second, in certain cases the haze plate could be a gradient, giving a more natural match to any gradient in the real atmospheric haze. Third, if there is more than one element to comp in, by giving each object its own matte density the density

Ex. 7-4 of the haze can be customized for each element. If the shot shows terrain a few miles deep, the matte can be given a gradient that places very little depth haze in the foreground and progressively more into the distance.

7.3.8 Nonlinear Gradients for Color Correction

Gradients are often used as a mask to mediate (control) a color correction operation. Where the gradient is dark the effect of the color correction is reduced and where the gradient is bright the color correction is more pronounced. Common examples would be when applying depth haze to a shot or adding (or removing) a color gradient in a sky. When a gradient is created it is linear, so it goes from dark to light uniformly. A slice graph of such a gradient would naturally show a straight line. But a mediating gradient need not be linear, and using a nonlinear gradient will give you an extra degree of control over the results. Besides, Mother Nature is almost never linear, so a nonlinear gradient often looks more natural.

A nonlinear gradient is made by adding a color curve to a linear gradient so that its "roll-off" (how quickly it changes from one extreme to the other) can be adjusted, which in turn controls the falloff of the color correction operation. The color curve is added to the grad (gradient) *before* it is connected to a color correction node as a mask. Figure 7-49 shows a flowgraph of how the nodes would be set up. The gradient can now be refined with the color curve to alter its roll-off from light

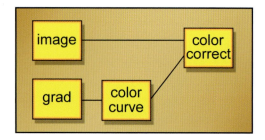

Figure 7-49 Flowgraph of nonlinear gradient for color correction operation.

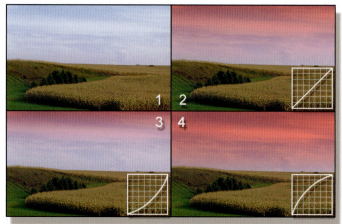

Figure 7-50 Color correction controlled by adjusting the roll-off of a gradient.

to dark either faster or slower, which in turn causes the color correction operation to fall off faster or slower.

Figure 7-50 shows a series of pictures that illustrate how a nonlinear grad can affect the falloff of a color gradient added to a sky. In all cases the color correction operation is left constant and only the roll-off of the gradient has been changed. Picture 1 is the original image and picture 2 shows the color correction applied using the original linear gradient. A little graph of the slope of the gradient is included in each example. Picture 3 has the gradient dark-

ened in the middle by the color curve so the color effect falls off more quickly. Picture 4 has the gradient brightened in the middle so the color effect falls off much more slowly, which now takes the color effect almost to the horizon.

Ex. 7-5

Adobe Photoshop Users—You can implement this technique using the gradient tool. It allows you to not only set the gradient colors, but to also change the midpoint of the gradient, which is analogous to adjusting it with the color curve. In addition to that you can also add a transparency gradient and adjust its midpoint as well to get a nonlinear roll-off in transparency.

7.3.9 Adding a Glow

Adding a glow to an element is wondrously simple with computer graphics. Just make a heavily blurred version of the element and then screen it together with the original like the example shown in Figure 7-51 through Figure 7-53. Done. Well, perhaps not quite. You may want to increase or decrease the brightness of the glow, which is done by scaling the glow element with a color curve. You may not want the glow to cover dark parts of the picture, so a color curve can also be used on the glow element to pull down on the blacks, which will remove them from

Figure 7-51 Original element.

Figure 7-52 Glow element created with blur.

Figure 7-53 Glow element screened with original element.

Figure 7-54 Original Marcie.

Figure 7-55 Marcie all glowed up.

the scene (no mattes required!). Some may wish to composite the glow in, but this would not be right. A composite is for things that block the light from the background, and a glow simply adds light to the background light without obscuring it. Screen in your glows, please.

In the before time, when all that mankind had for making movies was film cameras, if an aging actress needed a flattering close-up they would smear Vaseline on the lens to give her what I like to call the "Doris Day glow" effect. Today, we can apply our digital glow technology with good effect to erase the years from any aging dowager. An example of this magical treatment can be seen in Figure 7-54 and Figure 7-55. A bit over-done for book illustration purposes, the ageless Marcie girl is all glowed up. Doesn't she look lovely?

Ex. 7-6

7.3.10 A Checklist

Here is a checklist of points that you may find helpful to run through when you finish a shot to make sure you have hit all of the issues:

1. Brightness and Contrast
 - Do the black and white points match? (check with a luminance version)
 - Does the gamma match? (check with a luminance version)
 - Do the layers still match with the display gamma set way up? Way down?
2. Color Matching
 - Do flesh tones match?
 - Does the overall color of light match?
 - Do the specular highlights match?

3. Light Direction
 - Does the light all seem to come from the same direction?
 - If not, can the most obvious clues be eliminated or subdued?
4. Light Quality
 - Do all layers appear to be lit with the same quality (soft/harsh) of light?
5. Interactive Lighting
 - Does the shot need any interactive lighting effects?
 - Do the interactive lighting effects make sense within the apparent light space?
 - Should the interactive lighting effects be animated over time?
6. Shadows
 - Do the faux shadows match the real ones?
 - Do the edges look right?
 - Does the density and color look right?
 - Does the proximity of the shadow require variable density?
7. Atmospheric Haze
 - Does this shot require atmospheric haze or depth haze?
 - Is the color of the haze a convincing match to the natural haze?
 - Is the density of the haze appropriate for the depth of each hazed object?
 - Do any of the hazed objects need softening?

Whenever a scene is photographed, all of the objects in the scene have obviously been filmed with the same camera so they all share the same "look." When two layers are shot with different cameras on different film stocks and are then later composited, the film and camera lens differences can defeat the photo-realism of the composite. This chapter explores the issues of camera lens effects such as focus, depth of field, and lens flares, as well as film grain characteristics and how to get a better match between disparate layers. The ultimate objective here is to make the composited shot look like all of the objects in the scene were photographed together with the same camera lens and film stock.

One of the worse offenders in this area is, of course, cgi. Not only does the cgi have no grain, it also has no lens. While the cgi is rendered with a user-specified computer-simulated "lens," these are mathematically perfect simulations that have none of the flaws and optical aberrations that characterize real lenses. Further, cgi lenses are perfectly sharp, whereas real lenses are not. The "sharp" edges in a 2k film frame will be a few pixels wide, but the same sharp edge in a 2k cgi render will be exactly one pixel wide. Even if the cgi element is rendered with a depth of field effect, the in-focus parts of the element will be razor sharp. The cgi element will appear too stark and "crispy" when composited into a film background.

 Blurring the cgi render will work, but it is very inefficient. Because a great deal of computing time has been invested to render all that fine detail, it would be a shame to turn around and destroy it in the composite with a blur to make it look right. Better to render a somewhat lower resolution version, around 70% of the final size, and then scale it up. This will both soften the element and cut the rendering time nearly in half.

8.1 MATCHING THE FOCUS

While there are algorithms that will effectively simulate a defocus operation on an image, most software packages don't have them so the diligent digital compositor must resort to a blur operation. At first glance, under most circumstances, a simple blur seems to simulate a defocus fairly well. However, in fact it has serious limitations, and under many circumstances the blur fails quite miserably. This section explains why the blur alone often fails and offers more sophisticated approaches to achieve a better simulation of a defocused

image, as well as methods for animating the defocus for a focus pull. Sometimes the focus match problem requires an image to be sharpened instead so the pitfalls and procedures of this operation are also explored.

8.1.1 Using a Blur for Defocus

Photographing a picture out of focus will make it blurry, but blurring a picture does not make it out of focus. The differences are easy to see with side-by-side comparisons using the festive outdoor lighting element shown in Figure 8-1. The stark lights over a black background are an extreme example that helps reveal the defocus behavior clearly. In Figure 8-2 a blur was used to create an "out-of-focus" version, whereas Figure 8-3 is a real out-of-focus photograph of the same subject. The lights did not simply get fuzzy and dim like the blur, but seem to "swell up" or expand while retaining a surprising degree of sharpness.

Figure 8-1 Original image.

Figure 8-2 Blurred.

Figure 8-3 True defocus.

Figure 8-4 Faux defocus.

Increasing the brightness of the blurred version might seem like it would help, but the issues are far more complex than that, as usual. Obviously the simple blurred version is a poor approximate of a real defocused image.

With the blur operation each pixel is simply averaged with its neighbors, so while bright regions seem to get larger, they get dimmer as well. Figure 8-5 illustrates the larger and dimmer trade-offs that occur when a blur is run over a small bright spot. The original bright pixels at the center of the bright spot (the dotted line) have become averaged with the darker pixels around it, resulting in lower pixel values for the bright spot. The larger the blur radius, the larger and dimmer the bright spots will become. The smaller and brighter an element is, the less realistic it will appear when blurred.

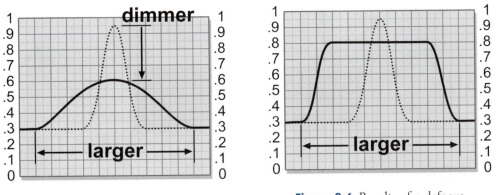

Figure 8-5 Results of a blur operation.　　　　**Figure 8-6** Results of a defocus.

When a picture is actually photographed out of focus, however, the brighter parts of the picture expand to engulf the darker regions. Compare the size of the bright lights between Figure 8-2 and Figure 8-3. The lights are much larger and brighter with the true defocus. Even midtones will expand if they are adjacent to a darker region. In other words, a defocus favors the brighter parts of the picture at the expense of the darker parts. The reason for this can be seen in Figure 8-6. The light rays that were originally focused onto a small bright spot spread out to cover a much larger area, exposing over any adjacent dark regions. If the focused bright spot is not clipped, then the defocused brightness will drop a bit as shown in Figure 8-6 because the light rays are being spread out over a larger area of the negative, exposing it a bit less. The edges will stay fairly sharp, however, unlike the blur. If the focused bright spot is so bright that it is clipped (which happens frequently), then the defocused bright spot will likely stay clipped too, depending on the actual brightness of the light source.

8.1.2 How to Simulate a Defocus

Very few software packages have a serious defocus operation, so you will most likely have to use a blur. The key to making a blurred image look more like a defocus is to also simulate the characteristic expansion of the brights. This can be done with an edge processing operation that expands the bright, or maximum, parts of the picture. This is not the "maximum" operation that simply selects the maximum brightness pixel between two input images. It is a type of convolution kernel that compares the values of adjacent pixels and expands the bright regions at the expense of the darker, similar to a real defocus. A flowgraph of the sequence of defocus operations is shown in Figure 8-7. After the edge processing operation is used to expand the brights, the image is then blurred to introduce the necessary loss of detail. The results of this "faux defocus" process are shown in Figure 8-4. While not a perfect simulation of the out-of-focus photograph, it is much better than a simple blur.

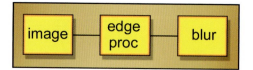

Figure 8-7 Defocus flowgraph.

If your software does not have a suitable edge processing operation, there is a workaround called the "pixel shift" method. A couple of pixel shifts "max'd" together with maximum nodes will give a rough approximation of expanding the brights with edge processing. When a layer is shifted by a few pixels and then max'd with the original unshifted layer, the brighter pixels of the two layers are retained at the expense of the darker. This is a crude simulation of spreading the incoming light around to a larger area with a defocus. Pixel shift operations are suggested for shifting the image because they are integer operations and are therefore computationally much faster than floating point 2D moves.

A flowgraph of the pixel shift sequence of operations is shown in Figure 8-8, and the associated sequence of images is shown in Figure 8-9 through Figure 8-12. Working through the flowgraph in Figure 8-8, it starts with the original star image shown in Figure 8-9. The star is shifted horizontally and then max'd with the original star at "max 2," with the results shown in Figure 8-10. Next it is shifted vertically and max'd with the "max 2" version at "max 4," with the results shown in Figure 8-11. The "max 4" version is then blurred, with the results of the final defocus image in Figure 8-12.

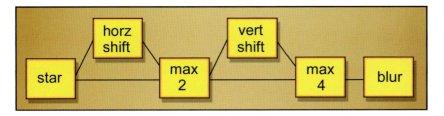

Figure 8-8 Flowgraph of four max'd images.

Figure 8-9 Star. **Figure 8-10** Max 2. **Figure 8-11** Max 4. **Figure 8-12** Blur.

For comparison, Figure 8-13 shows the same star with just a blur operation alone. It has actually "shrunk" visually compared to the original star in Figure 8-9 and is not nearly as "enlarged" as the final blurred star in Figure 8-12, which has had the benefit of the simulated brightness expansion. While the pixel-shifted version may not be as good as a true edge processing version, it certainly looks better than just a plain blur.

Figure 8-13 Blur only.

One problem with this pixel shift workaround is with small details, such as the very tips of the stars. You can see the "double printing" of the star tips in Figure 8-11. There are dark pixels between the double tips, but with a real edge processing operation there would not be any. As a result, when the pixel shift version is blurred, the tips are a bit darker and blunter than they should be. This will rarely be an issue, but you should always be aware of the artifacts of any process that you are using.

 One last thought here. The wise digital artist always tries the simplest solution to a problem first, and if that doesn't work, only then does he move on to more complex solutions. For many normally exposed shots with limited contrast range the simple blur will produce acceptable results and should always be tried first. High-contrast shots will fare the worst, so if the simple blur doesn't cut it, only then move up to the more complex solution.

8.1.3 Focus Pull

Sometimes a shot requires the focus to be animated during the shot to follow the action. This is called a "focus pull" or a "follow focus." To simulate a focus pull, both the blur *and* the expansion of the brights must be animated, and animated together. The animation must also be "floating point" animation, not integer. An integer-based operation is one that can only change one full unit (pixel) at a time, such as a blur radius of 3, 4, or 5, rather than floating point values of 3.1, 3.2, 3.3, etc. The integer-based operations result in one pixel "jumps" between frames as you try to animate them. Many software packages do not support floating point edge processing or a floating point blur radius. You may need a workaround for one or both of these limitations.

 The workaround for the lack of a floating point blur operation is to use a scaling operation instead of a blur. This is not a problem because scaling operations are always floating point. The idea is that instead of blurring an image with a radius of 2, you can scale it down by 50% and then scale it back up to its original size. The scaling operation will have filtered (averaged) the pixels together, similar to a blur operation. The smaller you scale it down, the greater the resulting "blur" when it is scaled back to original size. By the by, if your blur routines run silly slow when doing very large blurs, try scaling the image down to, say, 20% of its size, running a small blur radius, and then scaling it back to 100%. This sequence of operations may actually run much faster than the large blur radius on the full-sized image.

 The workaround for the integer-based pixel shift operation is to switch to a floating point translation (pan) operation to move the layers. The floating point translation operation can be animated smoothly while the pixel shift cannot, so the amount of "enlargement" horizontally and vertically becomes smooth and easy to control. The edge processing operation gives more realistic results,
Ex. 8-1 but when it can't be used this becomes another option.

8.1.4 Sharpening

Occasionally, an element you are working with is too soft to match the rest of the shot, so image sharpening is the answer. Virtually any compositing software package will have an image sharpening operation, but it is important to understand the limitations and artifacts of this process. There are many.

8.1.4.1 Sharpening Kernels

Sharpening operations do not really sharpen the picture in the sense that they actually reverse the effects of being out of focus. Reversing the effects of defocus is possible, but it requires Fourier transforms, complex algorithms not normally found in compositing packages. What sharpening operations do mathematically is simply increase the difference between adjacent pixels. That's all. Increasing the difference between adjacent pixels has the effect of making the picture *look* sharper to the eye, but it is just an image processing trick.

One consequence of this digital chicanery is that the sharpening will start to develop artifacts and look "edgy" if pushed too far. A particularly hideous example of an oversharpened image can be seen in Figure 8-16. The original image in Figure 8-14 has been nicely sharpened in Figure 8-15, so sharpening can work fine if not overdone.

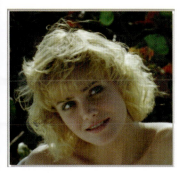 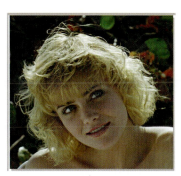

Figure 8-14 Original image. **Figure 8-15** Sharpened. **Figure 8-16** Oversharpened.

Why the sharpening operation produces that "edgy" look can be seen in Figure 8-17, which is one channel of a seriously oversharpened image. You can actually see the behavior of the algorithm as it increases the difference between adjacent pixels, but at the expense of introducing the "contrasty" edges. Note also that the smooth pixels of the skin have also been "sharpened" and start taking on a rough look.

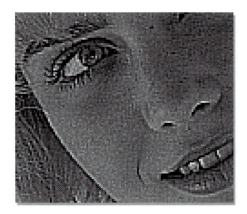

Figure 8-17 Sharpening artifacts.

Now you see what I meant when I said that it does not actually increase the sharpness of the picture, it just increases the difference between adjacent pixels, which tends to *look* sharper to the eye. It is a cheap trick. The other thing to keep in mind is that as the image is sharpened, so is the film grain or video noise. It is the artifacts that limit how far you can go with image sharpening.

8.1.4.2 Unsharp Masks

Now that we have bemoaned the shortcomings of the sharpening kernels, we consider their big brother, the "unsharp mask." It is a bitter irony of nomenclature that sharpening kernels sharpen and that unsharp masks sharpen. I guess like "flammable" means that it burns, and "inflammable" also means that it burns. Oh well. Let's get back to our story.

The unsharp mask is a different type of image sharpening algorithm, but many compositing software packages don't offer it. The unsharp mask is worth a try because it uses different principles and therefore has a different look. And sometimes different is better. The more tools in your tool belt the more effective you will be as an artist. The unsharp mask does, however, have several parameters that you get to play with to get the results you want. What those parameters are and their names are software dependent, so you will have to read and follow all label directions for your particular package. However, if you've got one, you should become friends with it because it is very effective at sharpening images.

8.1.4.3 Making Your Own Unsharp Mask

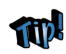 Many compositing packages do not offer the unsharp mask operation so you might find it useful to be able to make your own. It's surprisingly easy. The basic idea is to blur a copy of the image, scale it down in brightness, subtract it from the original image (which darkens it), and scale the results back up to restore the lost brightness. By the way, the blurred copy is the "unsharp mask" that gives this process its name.

The same scale factor that was used to scale down the unsharp mask is also used to scale up the results to restore the lost brightness. Some good starting numbers to play with would be a blur radius of 5 pixels for a 1k resolution image (increase or decrease if your image is larger or smaller) and a scale factor of 20%. This means that the unsharp mask will be scaled down to 20% (multiplied by 0.2) and the original image will be scaled up by 20% (multiplied by 1.2). These numbers will give you a modest image sharpening that you can then adjust to taste.

Figure 8-18 shows the edge characteristics of the unsharp mask and how the blur and scale operations affect it. The unsharpened edge obviously has more contrast than the original edge, which accounts for the sharper appearance. Again, it does not really sharpen a soft image, it only makes it look sharper. The scale operation affects the degree of sharpening by increasing the difference between the unsharp edge and the original edge. The blur operation also increases this difference, but it also affects the "width" of the sharpened region. As a result, increasing the scale *or* the blur will increase the sharpening. If a small blur is used with a big scale, edge artifacts such as the sharpening kernel can start to appear. If they do, then increase the blur radius to compensate.

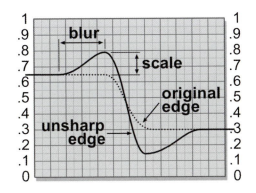

Figure 8-18 Unsharp mask edge characteristics.

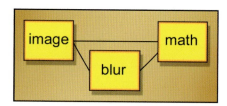

Figure 8-19 Unsharp mask using a math node.

There are a couple of different implementations of the unsharp mask depending on whether you want to use a math node or a few discrete nodes. Let's start with the math node implementation shown in Figure 8-19 as it is the simplest. The original image and the blurred version are the inputs to the math node, and inside the math node is the following equation:

$$((1 + Z) \times \text{image}) - (Z \times \text{blurred image}) \qquad (8\text{-}1)$$

where Z is the brightness scale factor expressed as a floating point number. Using the starting numbers suggested earlier, if the percentage factor is 20%, Z would be 0.2 and Equation 8-1 would become simply

$$(1.2 \times \text{image}) - (0.2 \times \text{blurred image})$$

While the math node approach uses fewer nodes, it is also harder to work with and computationally slower so many folks don't like using it. For those of you that prefer the "discrete" approach, Figure 8-20 shows the unsharp mask operation implemented with discrete nodes. A blurred version of the image is scaled down using either a scale RGB node or a color curve node. The scaled blurred version is then subtracted from the original image in the "sub" node, and the results are scaled up to restore lost brightness, again using either a scale RGB or color curve node.

You may have noticed a subtle difference between the discrete node version and the math node version. In the math node version the original

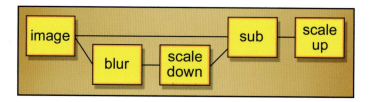

Figure 8-20 Unsharp mask using discrete nodes.

image was scaled up before subtracting the unsharp mask, whereas in the discrete version the scale up occurs after the unsharp mask subtraction. The reason for this difference is to avoid the clipping that would occur with the discrete node version if the image were scaled up first. The scale-up operation can create pixel values greater than 1.0, which would be clipped upon output by the discrete nodes (unless you are working in floating point). They

Ex. 8-2

will not be clipped internally by the math node, however, because it will subtract the unsharp mask, which restores all pixel values to normal before output. You will get the same great results with either implementation.

8.2 DEPTH OF FIELD

Cinematographers go to a great deal of trouble to make sure that the picture is in proper focus. Barring the occasional creative camera effect, the reason that anything would be out of focus in the foreground or the background is due to the depth of field of the lens. Depth of field is used creatively to put the object of interest in sharp focus and the background out of focus in order to "focus" the audience's attention on the subject.

Camera lenses have a depth of field, a "zone" within which the picture is in focus. Objects closer to the camera are out of focus, as are usually objects on the other side of the depth of field, as illustrated in Figure 8-21. There is one case where the far background will stay in focus and that is if the lens is focused at its "hyperfocal" point. Everything from the hyperfocal point out to infinity will be in focus.

From the point at which the lens is focused, the depth of field is defined to be the region considered to be in focus, which extends one-third in front and two-thirds behind the point of focus. The reason for the evasive phrase "considered to be in focus" is that the lens is actually only in perfect focus at

Figure 8-21 Depth of field of a lens.

a single point and gets progressively out of focus in front and behind that point, even within the depth of field. As long as the degree of defocus is below the threshold of detectability, however, it is considered to be in focus.

 The depth of field varies from lens to lens and whether it is focused on subjects near or far from the camera. The following are a few of rules of thumb about the behavior of the depth of field that you may find helpful:

- The closer the subject is, the shallower the depth of field.
- The longer the lens, the shallower the depth of field.

Assuming a "normal lens" (28 to 35 mm) focused on a subject at a "normal" distance, you would expect to see

- When a subject is framed from head to toe, the background will be in focus.
- When a subject is framed from waist to head, the background will be slightly out of focus.
- A close-up on the face will have the background severely out of focus.
- When focused real close on a face, the depth of field can shrink to just a few inches so that the face may be in focus but the ears out of focus!

8.3 LENS FLARE

When strong lights enter the camera lens the light rays refract off of the many surfaces in the lens assembly and strike the film to produce a lens flare. The complexity and character of the flare are due to the number and nature of the lens elements. Even a strong light source that is just out of frame can still generate a flare. The key point is that it is a lens phenomenon that showers light onto the film where the original picture is being exposed. Objects in the scene cannot block or obscure the lens flare itself because it exists only inside the camera. If an object in the scene were to slowly block the light source, the flare would gradually dim, but the object would not block any portion of the actual lens flare.

8.3.1 Creating and Applying Lens Flares

A lens flare is essentially a double exposure of the original scene content plus the flare, so a normal composite is not the way to combine it with the background plate. Composites are for light-blocking objects, not light-emitting ele-

ments. The screen operation is the method of choice, and its ways and wonders are explained in full detail in Chapter 6.

Figure 8-22 through Figure 8-24 illustrate a lens flare placed over a background plate. Where this is particularly effective is when a light source such as a flashlight has been composited into a scene and then a lens flare added. This visually integrates the composited light source into the scene and makes both layers appear to have been shot at the same time with the same camera. Many artists have discovered this fact so the lens flare has often been over-done. Do show restraint in your use of them.

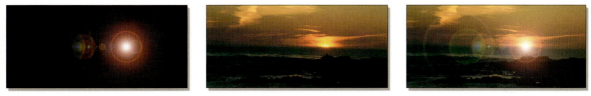

Figure 8-22 Lens flare. **Figure 8-23** Original image. **Figure 8-24** Flare applied to image.

 While it is certainly possible to create your own lens flare with a flock of radial gradients and the like, most high-end paint systems such as Adobe Photoshop can create very convincing lens flares on demand. Real lens flares are slightly irregular and have small defects due to the irregularities in the lenses so you might want to rough yours up a bit to add that extra touch of realism. Also avoid the temptation to make them too bright. Real lens flares can also be soft and subtle.

8.3.2 Animating Lens Flares

If the light source that is supposed to be creating the lens flare is moving in the frame, then the lens flare must be animated. The flare shifts its position as well as its "orientation" relative to the light source. With the light source in the center of the lens, the flare elements "stack up" on top of each other. As the light source moves away from the center the various elements fan out away from each other. This is shown in Figure 8-25 through Figure 8-27 where the light source moves from the center of the frame toward the corner. Many 3D software packages offer lens flares that can be animated over time to match a moving light source. Again, watch out for excessive perfection in your flares.

Figure 8-25 Centered light source. **Figure 8-26** Off center. **Figure 8-27** More off center.

8.3.3 Channel Swapping

If your lens flare generating software does not have good control over the colors, you could, of course, color correct it to get the color you want. However, you would be crushing and stretching the existing color channels, sometimes a great deal, and with 8-bit images it could get real ugly real quick. Wouldn't it be nice if the lens flare was already basically the color you wanted and you just had to refine it a bit?

You can do this with channel swapping, as illustrated in the sequence of images from Figure 8-28 through Figure 8-30. The original image is basically a reddish color, but blue and green versions were made simply by swapping the color channels around. Swap the red and blue channels, for example, to make the blue version in

Figure 8-29. Swap the red and green channels to make the green version in Figure 8-30. Of course, channel swapping is a generally useful technique that can be used to make a recolored version of any element, not just lens flares.

Ex. 8-3

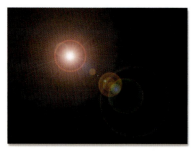

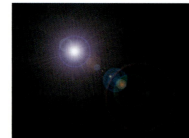

Figure 8-28 Original lens flare. **Figure 8-29** Channel swap red and blue. **Figure 8-30** Channel swap red and green.

8.4 VEILING GLARE

Remember all of those nifty little lens diagrams from school like Figure 8-31 that showed straight little parallel light beams entering the lens and converging neatly at the focal point? Did you ever wonder about the nonparallel light beams? Where did they go? They never showed them to you in school because it made the story too messy. Well, the real world is a messy place and you're a big kid now, so it is time you learned the ugly truth. The nonparallel light beams fog up the picture and introduce what is called veiling glare. There are also stray light beams glancing off of imperfections in the lens assembly, as well as some rays not absorbed by the light-absorbing black surfaces within the lens and camera body. Even within the film emulsion layers there are errant photons. These random rays all combine to add to the veiling glare.

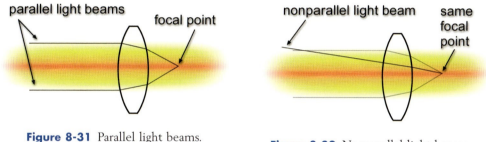

Figure 8-31 Parallel light beams.

Figure 8-32 Nonparallel light beams.

Figure 8-32 shows a nonparallel light beam from some other part of the scene entering the lens and landing on the same focal point as the parallel light beams. The rogue nonparallel light beam has just contaminated the focal point of the proper parallel light beams. This adds a slight overall "fogging" to the image that is sort of the average of all of the light in the picture. An extreme example is a greenscreen shot. The greenscreen in the background represents a large area of green light flooding into the lens. A small character standing in front of it would alter the light sum negligibly. This green light floods the camera lens, and some of it is nonparallel. As a result, a light green fog will be laid over the entire frame, including the small character. While a green fog over the greenscreen is hardly an issue, a green fog over the character is.

If you were to film the character again on the same greenscreen stage with the greenscreen replaced by a *gray* screen, the green level of the character would suddenly drop. The green "fog" has now become a gray fog, which no longer alters the hue of the character, but adds some light that milks up the

blacks. If the gray screen were struck and replaced by a totally black background, the fog from the gray screen would disappear and our character would suddenly increase in contrast as his blacks got denser. Fortunately, the color correction process will normally compensate for the differing veiling glare of the composited layers in most cases.

8.5 GRAIN

Technically, film grain is an artifact—a defect—but we have grown to love it. It adds a kind of charm and a "look" to film that video lacks. Video can have noise that looks somewhat like grain, but real grain is good. When a foreground layer is composited over a background layer, the grain structure must reasonably match for the two layers to appear to have been shot on the same film. If the foreground is a cgi element, it has no grain at all and really must get some to look right. While the discussion here focuses on film grain, virtually all of the concepts and principles apply to video work as well, as much video work is film transferred to video, grain and all.

If the entire shot is cgi or digital ink and paint cel animation, there is no grain structure and you (or the nice client) now have an interesting artistic decision to make, namely to add grain or not. You cannot count on the film recorder to add grain. Film recorders go to great lengths to avoid adding any grain because they are designed to refilm previously filmed film, if you know what I mean. If you are recording out to a laser film recorder, it will add essentially no grain whatsoever. If you are recording to a CRT film recorder, it will only add a little grain. The reasons for this are explained in Chapter 12.

In the final analysis, the decision to add grain or not to a "grainless" project is an artistic decision. If it is a "grained" project, the question becomes whether two or more layers are similar enough to go unnoticed. That, of course, is a judgment call. Should you decide to fix the grain, read on.

8.5.1 The Nature of Grain

While hard-core mathematicians would define grain characteristics in terms of standard deviations, spatial correlations, and other mathematically unhelpful concepts, for the rest of us there are two parameters that are more intuitive for defining the grain characteristics: size and amplitude. Size refers to how big the film grains are, and amplitude refers to how much brightness variation there is from grain to grain.

At video resolution, the grain size is usually no larger than a single pixel. At 2k film resolutions, however, the grain can be several pixels in size and irregularly shaped. Different film stocks have different grain characteristics,

but in general the faster the film, the grainier it is. This is because the way film is made faster is to give it a larger grain structure to make it more sensitive to light. It will take less light to expose the film, but the price is the larger grain.

The size and amplitude of the grain are not the same for all three color records of the film. The red and green records will be similar in size and amplitude, but the blue layer will be very much larger. These differences are shown in the color channel grain samples shown from Figure 8-33 through Figure 8-35. If one wanted to simulate the grain very accurately, the blue record would get more grain than the red and green in both size and amplitude. Having said that, it will often suffice to give all three layers the same amount of grain. It is also more realistic if each channel gets a unique grain pattern. Applying the same grain pattern to all three layers will cause the grain pattern of all three channels to lie on top of each other in a most unnatural way.

The behavior of grain also changes with the degree of exposure. Figure 8-36 uses a gradient to illustrate the behavior of the grain relative to image

Figure 8-33 Red grain.

Figure 8-34 Green grain.

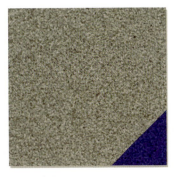

Figure 8-35 Blue grain.

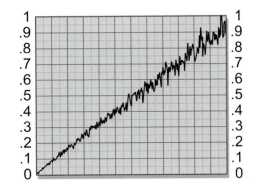

Figure 8-36 Grain amplitude from dark to light.

brightness. As the brightness goes from dark to light, the amplitude of the grain increases. It is as if the grain were there all the time in the unexposed film and then it scales up in amplitude as more and more light falls on it. A thoroughly accurate grain simulation would therefore attenuate the amplitude of the grain based on the brightness values of the original image. There would be higher grain in the brights and lower grain in the darks.

8.5.2 Making Grain

As mentioned earlier, the grain structure for video work is usually just one pixel. Just hitting the video frames with a noise generator will usually suffice. For feature film work, however, more sophisticated techniques are required to truly simulate the grain structure. Some software packages have "grain generators" that add film grain to the images directly. A few packages have tools that will statistically measure the grain in an image and then replicate it. Use'em if you've got'em, but many software packages just have noise generators that you will have to use to simulate grain and match by eye.

 Occasionally, just adding a little noise to the film frames will be good enough and should always be tried first just in case it suffices. If, however, you need to use a generic noise generator to whip up some serious grain for feature film work, the recommended method is to prebuild several "grain plates" and then use them to apply grain structure to the images. If you are going all out for maximum photorealism in your synthesized grain structure, then you will want to do the following.

1. Make a three-channel grain pattern. Real grain patterns are unique to each layer, so don't use the same single channel noise pattern on all three color channels.
2. Make the grain plate for the blue channel with both larger size and greater amplitude grain, as this is the way of the blue record.
3. Make the grain amplitude greater in the brights than in the darks.

8.5.2.1 Generating the Grain

Generating the grain plates can be compute intensive. To reduce compositing time, you can prebuild just a few (five or seven) grain plates and cycle through them continuously over the length of the shot. The first order of business is to set the size and amplitude of the grain in the grain plates to the desired level and lower their brightness levels down to very dark values, nearly black.

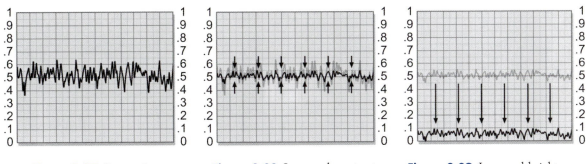

Figure 8-37 Raw noise. **Figure 8-38** Lowered contrast. **Figure 8-39** Lowered brightness.

If we assume a 50% gray plate has had noise added to it, a slice graph of it might look something like Figure 8-37. If this grain is for film, then run a blur over the noise plate to increase the size of the "grain" structure. Increasing the amount of blur will increase the grain size. For video the grain is typically one pixel in size anyway so skip the blur operation. The amplitude of the noise can be reduced simply by lowering the contrast with a contrast operation as illustrated in Figure 8-38. It is usually much faster to adjust the amplitude with a contrast operation than regenerating the noise at a lower level and then reblurring. Either way will work, of course.

Next, the brightness of the grain plate needs to be lowered to nearly black (Figure 8-39) so that the pixel values sit just above absolute zero (brightness, not Kelvin). Make sure to lower the brightness by subtracting from the pixel values, not scaling them. Scaling them would alter the amplitude again, and we are trying to keep the two adjustments independent. If the contrast is reduced later, the brightness can be lowered a bit. If it is increased, the brightness will have to be raised a bit to prevent clipping the darkest noise pixels to zero.

The sequence of operations is shown in the flowgraph in Figure 8-40. The gray plate gets noise added to it and then the noise plate is blurred (if it is a film job). After that the amplitude is set by lowering the contrast and then the brightness is lowered to bring the grain plate pixel values very close to zero. It may take several iterations to get the grain plates to match the exist-

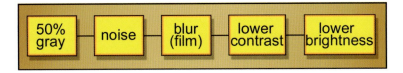

Figure 8-40 Flowgraph of grain plate generation.

ing grain. By prebuilding them in a separate flowgraph like this they can be revised and rerendered quickly.

8.5.2.2 Applying the Grain

Now that you have prebuilt your grain plates, how do you apply them to the images? The pixels in the original image need to have their brightness values displaced both up *and* down without altering the overall brightness of the original image. This can be done with a simple two-step procedure. First, simply sum the grain plate with the image and then subtract a small constant value that represents the average of the grain height. Adding the grain plate will increase the brightness of the image slightly, so subtracting the constant value simply restores the original brightness.

A flowgraph of the process is shown in Figure 8-41. The grain plate is summed with the original image in the "add" node and then a small constant is subtracted from the grained image to restore the original brightness. If the addition of the grain plates introduces clipping in the whites, then the subtract operation can be done first. If that introduces clipping in the blacks, then the image has pixels values both near zero black and 100% white. The RGB values may need to be scaled down a bit to introduce a little "headroom" for the grain.

Figure 8-41 Flowgraph of grain application.

The pixel behavior of the grain application process can be followed by starting with the slice graph of the raw grain plate in Figure 8-42, which has been prebuilt to nearly black using the procedures outlined earlier. Even so, it has an average brightness value of 0.05. If you're not sure of the average brightness of your grain, just blur the heck out of it to average all the pixels together and then measure the brightness anywhere on the image. A slice graph of the original grainless image is shown in Figure 8-43. Figure 8-44 has summed the grain plate with the original image, which has raised the average

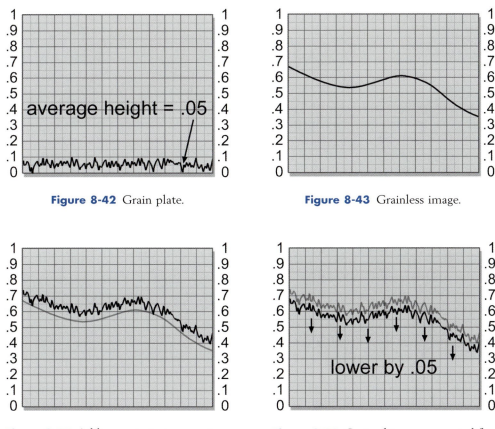

Figure 8-42 Grain plate.

Figure 8-43 Grainless image.

Figure 8-44 Adding grain to image raises brightness.

Figure 8-45 Grained image corrected for brightness increase.

brightness by 0.05. The original image is shown as a light gray line for reference. The original image brightness is restored in Figure 8-45 when the small constant (0.05) is subtracted from the grained image.

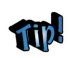 For those hearty folks that would like to simulate the increased grain in the lights, the following procedure is offered. The luminance of the image itself can be used to modulate the grain amplitude frame by frame just before it is applied. The flowgraph in Figure 8-46 shows the setup and assumes that a three-channel grain plate is being scaled by a three-channel image. The blue channel could be dark in the same place that the red channel is light so using all three channels of the image to attenuate the grain is the most authentic simulation. If you use a one-channel grain plate instead, then the image would be converted to a one-channel luminance image before being inverted. The rest of the flowgraph is unchanged.

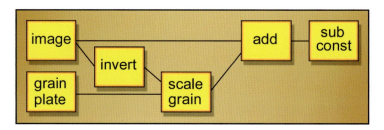

Figure 8-46 Using image luminance to scale grain.

The "scale grain" node is where the grain pattern is scaled down based on the luminance of the image to be grained. It is an RGB scaling operation that is modulated by a mask input (the inverted image in this case), which is available in some form in all compositing software. The image is sent through the invert operation so that the darks become light. With the darks now light in the mask, the grain will be scaled down more in the darks, which is what we are trying to simulate—less grain in the darks. The modulated grain structure is now summed with the image in the "add" node as before, followed by the subtraction of the small constant value to restore original brightness.

Scaling the grain based on the brightness of the image does introduce a slight artifact that the truth in compositing law requires me to reveal. The assumption with this setup is that the grain *average* is everywhere the same— 0.05 in the examples given earlier. Scaling the grain down in the darks not only lowers its amplitude, but also lowers its average. The grain in the darks may now average 0.02 instead of 0.05, for example. This means that when the small constant is subtracted to restore the original brightness, the darks will be overcorrected and end up ever so slightly darker than they should. This will impart a very slight increase in contrast to the grained image, but the difference will usually be too slight to notice. If, however, the increased contrast is objectionable, just add a slight reduction in contrast to the grained image. There are ways to reduce the grain amplitude and not disturb the grain average, but the increased complexity is simply not worth the trouble for this minor artifact.

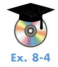

Ex. 8-4

8.5.3 Matching the Grain of Two Film Layers

With a classic greenscreen composite you have two layers of film, one for the greenscreen and one for the background plate, each shot at different times and places and invariably on different film stocks. The mission is usually to match the foreground layer to the

background because the background plate will normally already be matched to all of the other background plates and cannot be altered. A key point in matching the grain of two layers is to match them channel by channel. Don't try to judge the overall graininess of the two layers just by looking at the full color images. Make sure the red layer matches, then the green layer, and then the blue layer.

The final test of the grain match must be made at a frame rate that is at or near real time (24 fps for film, 30 fps for video) and at full resolution. Comparing static frames will not work because you need to see the grain "dance" and low-resolution proxies will not work because too much grain detail is lost. For video work, viewing full resolution real-time sequences is not a problem for the modern workstation. For feature film work, however, workstations cannot yet play 2k film frames in real time. The most practical acceptance test is to crop out one or two regions of interest at full resolution that are small enough to be played on the workstation at or near real time. You also don't need the whole shot here. Twenty or 30 frames will be enough to see how the grain plays.

If the foreground layer has less grain than the background, the problem is simple. Add a small amount of grain until it matches the background. If the foreground is *more* grainy than the background, then we have a more prickly problem. Removing grain from film is an extremely difficult prospect. The basic problem is that the grain edges are very similar to the object edges in the image and any process that eliminates one tends to also eliminate the other. There are some very sophisticated algorithms that can actually detect the object edges in the image and then not remove the grain from those pixels. However, this method is very compute intensive and is not available in most software packages. Of course, if your software has a sophisticated grain removal operation, be sure to try it. But what can you do if it doesn't?

The obvious workaround is some delicate blurring operations, but they will also destroy some picture detail in the image. Following the blur operation with image sharpening to restore the detail is just pushing the problem around (with the addition of artifacts) so don't go there. An unsharp mask after a gentle blur may be worth a try because it works on different principles than plain old image sharpening, as described in Section 8.1.4.2, "Unsharp Masks."

 One trick that might help is to blur just the blue channel. Most of the grain is in the blue channel, and most of the picture detail is in the red and green channels. This approach kills the most grain with the least loss of detail.

8.5.4 Adding Grain to Grainless Layers

Because cgi elements are rendered without any grain, it all must be added at compositing time. For video work, a gentle noise operation will usually suffice due to the one pixel nature of video grain. For film work, some of the more sophisticated procedures cited previously will be more effective. In the case of a matte painting there will probably be some regions with some "frozen" grain and other regions that are totally grainless. This is because matte paintings are often made from some original picture that had film grain and then other regions were added or heavily processed so the grain is missing. You might want to see if the matte painter can clear the grain out of any grainy regions, as these will respond differently to the introduced grain than the grainless regions.

 A held frame is another "frozen" grain situation. Because the plate already has the frozen grain, only a little additional grain is needed to give it "life," but this may not be a convincing match to the rest of the shot. If you have the tools and time, degraining the held frame and then introducing full moving grain is the best approach. If the scene content is right, sometimes a grain-free held frame can be made by averaging several frames together. If you had, say, five frames to work with, scale each of them by 20% in brightness and then sum them all together to get back to 100% brightness. This makes by far the best grainless plate.

Ex. 8-5

8.6 A CHECKLIST

 Here is a checklist of points that you may find helpful to run through when you finish a shot to make sure you have hit all of the issues:

1. Focus
 - Is the sharpness right for all elements in the shot?
 - If there is a simulated defocus, does it look photo-realistic?
 - If there is any image sharpening, are there any edge artifacts?
2. Depth of Field
 - Does the composited element have the correct depth of field?
 - Is there a focus pull requiring a matching defocus animation?
3. Lens Flare
 - Will a lens flare help the shot?
 - If a lens flare has been added, is it overdone?

4. Veiling Glare
 - Is there any noticeable veiling glare in the shot?
 - Do the layers match in their apparent veiling glare?
5. Grain
 - Does the grain match between the composited layers?
 - Are there any held frames or elements that need moving grain?

Many shots are complete when the light space and camera attributes of the compositing layers match, but some shots will require you to match the "action," or motion, as well. Motion tracking is one of the key tools for this and is used to track one element onto another to create a "match move." Yet another application of motion tracking is to stabilize a shot. Both of these processes and their variations are described along with some helpful tips, tricks, and techniques.

Geometric transformations, both 2D and 3D, are used to change the shape, size, and orientation of images as well as to animate them over time, as in the case of motion tracking. An understanding of the effects of pivot points and filter choices will protect you from degraded or unexpected results. The discussion of pivot points leads to some helpful techniques for the sometimes onerous task of lining one image up onto another. And as long as we are pushing images around, a discussion of image warps and morphs is in order.

9.1 GEOMETRIC TRANSFORMATIONS

Geometric transformations are the processes of altering the size, position, shape, or orientation of an image. This might be required to resize or reposition an element to make it suitable for a shot or to animate an element over time. Geometric transformations are also used after motion tracking to animate an element to stay locked onto a moving target as well as for shot stabilizing.

9.1.1 2D Transformations

2D transformations are called "2D" because they only alter the image in two dimensions (X and Y), whereas 3D transformations put the image into a three-dimensional world within which it can be manipulated. The 2D transformations—translation, rotation, scale, skew, and corner pinning—each bring with them hazards and artifacts. Understanding the source of these artifacts and how to minimize them is an important component of all good composites.

9.1.1.1 Translation

Translation is the technical term for moving an image in X (horizontally) or Y (vertically), but may also be referred to as a "pan" or "reposition" by some less

Figure 9-1 Image panning from left to right.

formal software packages. Figure 9-1 shows an example of a simple image pan from left to right, which simulates a camera panning from right to left.

Some software packages offer a "wraparound" option for their panning operations. The pixels that get pushed out of frame on one side will "wrap around" to be seen on the other side of the frame. One of the main uses of a wraparound feature is in a paint program. By blending away the seam in a wrapped-around image a "tile" can be made that can be used repeatedly to seamlessly tile a region.

 Figure 9-2 shows an original cloud image. In Figure 9-3 it has been panned in wraparound mode, which created a seam down the middle of the picture. The seam has been blended away in Figure 9-4, and the resulting image has been scaled down and tiled three times horizontally in Figure 9-5. If you took the blended image in Figure 9-4, wrapped it around vertically, and then painted out the horizontal seam, you would have an image that could be tiled infinitely both horizontally *and* vertically.

Figure 9-2 Original.

Figure 9-3 Wraparound.

Figure 9-4 Blended.

Figure 9-5 Tiled.

9.1.1.1.1 Floating Point vs Integer

You may find that your software offers two different pan operations: one that is an integer and one that is a floating point. The integer version may go by another name, such as "pixel shift." The difference is that the integer version can only position the image on exact pixel boundaries, such as moving it by exactly 100 pixels in X. The floating point version, however, can move the image by any fractional amount, such as 100.731 pixels in X.

 The integer version should never be used in animation because the picture will "hop" from pixel to pixel with a jerky motion. For animation, the floating point version is the only choice because it can move the picture smoothly at any speed to any position. The integer version, however, is the tool of choice if you need to simply reposition a plate to a new fixed location. The integer operation is not only much faster, but it will also not soften the image with filtering operations like the floating point version. The softening of images due to filtering is discussed later in the chapter.

9.1.1.1.2 Source and Destination Movement

With some software packages you just enter the amount to pan the image in X and Y and off it goes. We might call these "absolute" pan operations. Others have a *source* and *destination* type format, which is a "relative" pan operation. An example is shown in Figure 9-6. The relative pan operation is a bit more obtuse but can be more useful, as shown in the image stabilizing and difference tracking operations later. The source and destination values work by moving the point that is located at *source X,Y* to the position located at *destination X,Y*, dragging the whole image with it, of course. In the example shown in Figure 9-6, the point at source location 100, 200 will be moved to destination location 150, 300. This means that the image will move 50 pixels in X and 100 pixels in Y. It is also true that if the source were 1100, 1200 and the destination were 1150, 1300 it would still move 50 pixels in X and 100 pixels in Y. In other words, the image is moved the relative distance from the source to the destination. What good is all this source and destination relative positioning stuff?

source:	X	100
	Y	200
destination:	X	150
	Y	300

Figure 9-6 Source and destination type pan.

Suppose you wanted to move an image from point A to point B. With the absolute pan you have to do the arithmetic yourself to find how much to move the image. You will get out your calculator and subtract the X position of point A from the X position of point B to get the absolute movement in X and then subtract the Y position of point A from the Y position of point B to get the absolute movement in Y. You may now enter your numbers in the absolute pan node and move your picture. With the relative pan node, you simply enter the X and Y position of point A as the source and then the X and Y position of point B as the destination, and off you go. The computer does all the arithmetic, which, I believe, is why computers were invented in the first place.

9.1.1.2 Rotation

Rotation appears to be the only image processing operation in history to have been spared multiple names so it will undoubtedly appear as "rotation" in your software. Because most rotation operations are described in terms of degrees, no discussion is needed here unless you would like to be reminded that 360° make a full circle. However, you may encounter a software package that refers to rotation in *radians*, a more sophisticated and elitist unit of rotation for the true trigonometry enthusiast.

While very handy for calculating the length of an arc section on the perimeter of a circle, radians are not at all an intuitive form of angular measurement when the mission is to straighten up a tilted image. What you would probably really like to know is how big a radian is so that you can enter a plausible starting value and avoid whip-sawing the image around as you grope your way toward the desired angle. One radian is roughly 60°. For somewhat greater precision, here is the official conversion between degrees and radians:

$$360 \text{ degrees} = 2\pi \text{ radians} \tag{9-1}$$

Not very helpful, was it. Two pi radians might be equal to 360°, but you are still half a dozen calculator strokes away from any useful information. Here are a few precalculated reference points that you may actually find useful when confronted with a radian rotator.

Radians to degrees	Degrees to radians
1 radian ≅ 57.3°	10° ≅ 0.17 radians
0.1 radian ≅ 5.7°	90° ≅ 1.57 radians

At least now you know that if you want to tilt your picture by a couple of degrees it will be somewhere around 0.03 radians. Because 90° is about 1.57 radians, then 180° must be about 3.14 radians. You are now cleared to solo with radian rotators.

9.1.1.2.1 Pivot Points

Rotate operations have a "pivot point," the point that is the center of the rotation operation. The location of the pivot point affects the results of the transformation dramatically so it is important to know where it is, its effects on the rotation operation, and how to reposition it when necessary.

The rotated rectangle in Figure 9-7 has its pivot point in its center so the results of the rotation are completely intuitive. In Figure 9-8, however, the pivot point is down in the lower right-hand corner and the results of the rotation operation are quite different. The degree of rotation is identical between the two rectangles, but the final position has been shifted up and to the right by comparison. Rotating an object about an off-center pivot point also displaces it in space. If the pivot point were placed far enough away from the rectangle it could have actually rotated completely out of frame!

Figure 9-7 Centered pivot point.

Figure 9-8 Off-center pivot point.

9.1.1.3 Scaling and Zooming

Scaling, resizing, and zooming are tragically interchangeable terms in many software packages. Regardless of the terminology, there are two possible ways that these operations can behave. A "scale" or "resize" operation most often means that the size of the image changes while the framing of the picture is unchanged, like the examples shown in Figure 9-9.

1024 x 768 **768 x 576** **1280 x 1024**

Figure 9-9 Image scaling operation: image size changes but framing stays constant.

1024 x 768 **1024 x 768** **1024 x 768**

Figure 9-10 Image zoom operation: image size stays constant but framing changes.

A "zoom" most often means that the image size stays the same dimensions in X and Y, but the picture within it changes framing to become larger or smaller as though the camera were zoomed in or out, like the example shown in Figure 9-10.

9.1.1.3.1 Pivot Points

The resize operation does not have a pivot point because it simply changes the dimensions of the image in X and Y. The scale and zoom operations, however, are like the rotation in that they must have a center about which the operation occurs, often referred to as the pivot point, or perhaps the center of scale, or maybe the center of zoom.

The scaled rectangle shown in Figure 9-11 has its pivot point in the center of the outline so the results of the scale are unsurprising. In Figure 9-12, however, the pivot point is down in the lower right-hand corner and the results of the scale operation are quite different. The amount of scale is identical with Figure 9-11, but the final position of the rectangle has been shifted

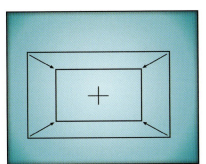

Figure 9-11 Centered pivot point.

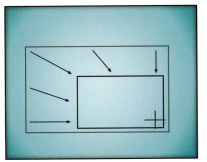

Figure 9-12 Off-center pivot point.

down and to the right in comparison. Scaling an object about an off-center pivot point also displaces it in space. Again, if the pivot point were placed far enough away from an object it could actually scale itself completely out of the frame.

9.1.1.4 Skew

The overall image shape of an image may also be deformed with a skew or "shear," like the examples shown in Figure 9-13. The skew shifts one edge of the image relative to its opposite edge; the top edge of the image relative to the bottom edge in a horizontal skew, or the left and right edges in a vertical skew. The skew normally does not have a pivot point because moving one edge relative to the other uses the opposite edge as the "center of action." The skew is occasionally useful for deforming a matte or alpha channel to be used as a shadow on the ground, but corner pinning will give you more control over the shape of the shadow and allow the introduction of perspective as well.

Figure 9-13 Horizontal and vertical skews.

Figure 9-14 Corner pinning examples.

9.1.1.5 Corner Pinning

Corner pinning, shown in Figure 9-14, is an important image deformation tool because it allows you to alter the overall shape of an image arbitrarily. This is especially useful when the element you want to add to a shot isn't exactly the right shape or needs a subtle perspective shift. The image can be deformed as if it were mounted on a sheet of rubber where any or all of the four corners can be moved in any direction. The arrows in Figure 9-14 show the direction each corner point was moved in each example. The corner locations can also be animated over time so that the perspective change can follow a moving target in a motion tracking application.

Always keep in mind that corner pinning does not actually change the perspective in the image itself. The only way that the perspective can really be changed is to view the original scene from a different camera position. All corner pinning can do is deform the *image plane* that the picture is on, which can appear as a fairly convincing perspective change, if it isn't pushed too far.

An example of a perspective change can be seen starting with Figure 9-15. The building was shot with a wide angle lens from a short distance away so the picture has a noticeable perspective that tapers the building inward at the top. Figure 9-16 shows the taper taken out of the building by stretching the two top corners apart with corner pinning. The perspective change makes the building appear as though it were shot from a greater distance with a longer lens. Unless you look closely, that is. There are still a few clues in the picture that reveal the close camera position if you know what to look for, but the casual observer won't notice them, especially if the picture is only on screen briefly.

Figure 9-15 Original image. **Figure 9-16** Perspective removed.

Another application of the perspective change is to lay an element on top of a flat surface, illustrated in Figure 9-17 to Figure 9-20. The sign graphic shown in Figure 9-17 is to be added to the side of the railroad car in Figure 9-18. The sign graphic has been deformed with four corner pinning in Figure 9-19 to match the perspective. In Figure 9-20 the sign has been comped over the railroad car and now looks like it belongs in the scene. Most motion tracking software will also track four corners so that the camera or target surface can move during the shot. The corner pinned element will track

on the target and change perspective over the length of the shot. This technique is used most famously to track a picture onto the screens of monitors and TV sets instead of trying to film them on the set.

Ex. 9-1

9.1.2 3D Transformations

3D transformations are so named because the image behaves as though it exists in three dimensions. You can think of it as though the picture was placed on a piece of cardboard where the cardboard can then be rotated and translated (moved) in any of the three dimensions and rendered with the new perspective. The traditional placement of the three-dimensional axis is shown in Figure 9-21. The X axis goes left to right, the Y axis goes up and down, and the Z axis is perpendicular to the screen, going into the picture.

Figure 9-17 Original graphic.

Figure 9-18 Original background.

Figure 9-19 Four corner pinning to create perspective version.

Figure 9-20 Perspective graphic on background.

Figure 9-21 Three-dimensional axis.

If an image is translated in X it will move left and right. If it is rotated in X (rotated about the X axis) it will rotate like the example shown in Figure 9-22. If the image is translated in Y it will move vertically. If it is rotated in Y it will rotate like the example shown in Figure 9-23. When translated in Z the image will get larger or smaller like a zoom as it moves toward or away

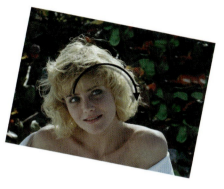

Figure 9-22 Rotate in X. **Figure 9-23** Rotate in Y. **Figure 9-24** Rotate in Z.

from the "camera." When rotated around Z it rotates like a conventional 2D rotation. The 3D transformation node will have rotate, scale, and translate operations in the same node so that they can all be choreographed together with one set of motion curves.

The time to use 3D transformations is when you want to "fly" something around the screen. Take a simple example like flying a logo in from the upper corner of the screen. The logo needs to translate from the corner of the screen to the center and, at the same time, zoom from small to large. Coordinating these two movements so that they look natural together using conventional 2D scales and transla-

tions is tough. This is because the problem is in reality a three-dimensional problem and you are trying to fake it with separate two-dimensional tools. It is better to use a 3D transformation node

Ex. 9-2 to perform a true 3D move on the logo.

9.1.3 Filtering

Whenever an image is transformed, its pixels are resampled, or "filtered," to create the pixels for the new version of the image. These filtering operations can affect the results of a transformation dramatically, so an understanding of how they work and which ones to use under what circumstances can be very important.

9.1.3.1 Effects of Filtering

In most cases the filtering operation will soften the image because the new version is created by blending together percentages of adjacent pixels to

create each new pixel. This is an irreversible degradation of the image. If you rotate an image a few degrees and then rotate it back, it will not return to its original sharpness.

An example can be seen starting with an extreme close-up of a small rectangular detail in the original image shown in Figure 9-25. It has a one-pixel border of anti-aliasing pixels at the outset. In Figure 9-26 the image has been rotated 5°, and the resampled pixels can be seen all around the perimeter. Figure 9-27 illustrates a simple floating point translation of the original image and shows how the edge pixels have become blurred by the filtering operation. Of course, scaling an image up softens it even more because in addition to the filtering operation you have fewer pixels to spread out over more picture space.

Figure 9-25 Original image. **Figure 9-26** Rotation. **Figure 9-27** Translation.

A low-resolution image such as a frame of video will have sharp edges that are one-pixel wide on most objects in the picture, while the "sharp" edges in a 2k resolution film frame naturally span several pixels. As a result, the effects of softening are much more noticeable on low-resolution images.

 If you have stacked up several transformations on an image and the softening becomes objectionable, see if you have a multifunction node that has all (or most) of the transformations in the one node. These nodes concatenate all of the different transformations (rotate, scale, translate) into a single operation so the amount of softening is reduced greatly because the image is only filtered once.

Simple pixel shift operations do not soften the image because they do no filtering. The pixels are just picked up and placed into their new location without any processing, which is also why it is such a fast operation. Of course, this makes it an integer operation, which should never be used for animation, but it is fine for the repositioning of a background plate.

The one case where filtering does not soften the image is when scaling an image down. Here the pixels are still being filtered, but they are also being

squeezed down into a smaller image space so it tends to sharpen the whole picture. In film work, the scaled image could become so sharp that it actually needs to be softened to match the rest of the shot. This usually does not happen with video because the edges are normally one-pixel wide already and you can't get any sharper than that.

9.1.3.2 Twinkling Star Fields

One situation where pixel filtering commonly causes problems is the "twinkling star field" phenomena. You've created a lovely star field and then you go to animate it—either rotating it or perhaps panning it around—only to discover that the stars are twinkling! Their brightness is fluctuating during the move for some mysterious reason, and when the move stops, the twinkling stops.

What's happening is that the stars are very small, only one or two pixels in size, and when they are animated they become filtered with the surrounding black pixels. If a given star were to land on an exact pixel location, it might retain its original brightness. If it landed on the "crack" between two pixels it might be averaged across them and drop to 50% brightness on each pixel. The brightness of the star then fluctuates depending on where it lands each frame—it twinkles as it moves.

This is not to be confused with interlace flicker in video, although they can look similar. The distinction is that interlace flicker only shows up when the image is displayed on an interlaced video monitor, not the progressive scan monitors of most workstations. Another distinction is that interlace flicker persists even with a static image.

 So what's the fix? Bigger stars, I'm afraid. The basic problem is that the stars are at or very near the size of a pixel so they are badly hammered by the filtering operation. Make a star field that is twice the size needed for the shot so that the stars are two or three pixels in diameter. Perform the rotation on the oversized star field and then size it down for the shot. With the stars several pixels in diameter they are much more resistant to the effects of being filtered with the surrounding black.

The problem is exacerbated by the fact that the stars are very small, very bright, and surrounded by black—truly a worst-case scenario. Of course, this phenomenon is happening to your regular images too, its just that the effect is minimized by the fact that the picture content does not contain the extremes of high contrast and tiny features like a star field.

9.1.3.3 Choosing a Filter

A variety of filters have been developed for pixel resampling, each with its own virtues and vices. Some of the more common ones are listed here, but you should read your user guide to know what your software provides. The better software packages will allow you to choose the most appropriate filter for your transformation operations. The internal mathematical workings of the filters are not described as that is a ponderous and ultimately unhelpful topic for the compositor. Instead, the effects of the filter and its most appropriate application are offered.

Bicubic—High-quality filter for scaling images up. It actually incorporates an edge-sharpening process so the scaled up image doesn't go soft so quickly. Under some conditions the edge-sharpening operation can introduce "ringing" artifacts, which degrade the results. Most appropriate use is scaling images up in size or zooming in.

Bilinear—Simple filter for scaling images up or down. It runs faster than bicubics because it uses simpler math and has no edge sharpening. As a result, images get soft sooner. Its best use is for scaling images down as it does not sharpen edges.

Gaussian—Another high-quality filter for scaling images up. It does not have an edge enhancement process. As a result, the output images are not as sharp, but they also do not have any ringing artifacts. Its most appropriate use is to substitute for the Mitchell filter when it introduces ringing artifacts.

Impulse—a.k.a. "nearest neighbor," a very fast, very low-quality filter. Not really a filter, it just "pixel plucks" from the source image, i.e., it simply selects the nearest appropriate pixel from the source image to be used in the output image. Its most appropriate use is for quickly making a lower resolution motion test of a shot. It is also used to scale images up to give them a "pixelized" look.

Mitchell—A type of bicubic filter where the filtering parameters have been refined for the best look on most images. It also does edge sharpening, but is less prone to edge artifacts as a plain bicubic filter. Its most appropriate use is to replace the bicubic filter when it introduces edge artifacts.

Sinc—A special high-quality filter for downsizing images. Other filters tend to lose small details or introduce aliasing when scaling down. This filter retains small details with good anti-aliasing. Its most appropriate use is for scaling images down or zooming out.

 Triangle—A simple filter for scaling images up or down. It runs faster than sharpening filters because it uses simpler math and has no edge sharpening. As a result, upsized images get soft sooner. Its

Ex. 9-3 best use is for scaling images down as it does not sharpen edges.

9.1.4 Lining up Images

There are many occasions where you need to precisely line up one image on top of another. Most compositing packages offer some kind of "A/B" image comparison capability that can be helpful for lineup. Two images are loaded into a display window and then you can wipe or toggle between them to check and correct their alignment. This approach can be totally adequate for many situations, but there are times when you really want to see both images simultaneously rather than wiping or toggling between them.

The problem becomes trying to see what you are doing, as one layer covers the other. A simple 50% dissolve between the two layers is hopelessly confusing to look at, and overlaying the layers while wiping between them with one hand while you nudge their positions with the other is slow and awkward. What is really needed is some way of displaying both images simultaneously that still keeps them visually distinguished while you nudge them into position. Two different lineup display methods are offered here that will help you to do just that.

9.1.4.1 Offset Mask Lineup Display

The offset mask method combines two images in such a way that if the images are not aligned perfectly an embossed outline shows up like the example in Figure 9-28. The embossing marks all pixels that are not identical between the two images. If they are lined up exactly on each other, the embossing disappears and it becomes a featureless gray picture.

To make a lineup mask simply invert one of the two images and then mix them together in equal amounts. This can be done with a dissolve node or a mix node set to 50%. To use discrete nodes, scale the RGB values of each

Figure 9-28 Embossed effect from offset images.

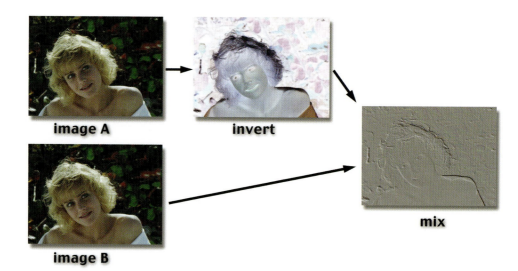

image A invert

mix

image B

Figure 9-29 Pictographic flowgraph of the offset mask lineup procedure.

image by 50% and then add them together. A pictographic flowgraph of the whole process is shown in Figure 9-29. A good way to familiarize yourself with this procedure is to use the same image for both input images until you are comfortable that you have it set up right and can "read" the signs of misalignment. Once set up correctly, substitute the real image to be lined up for one of the inputs.

Once set up, the procedure is to simply reposition one of the images until the offset mask becomes a smooth gray in the region you want lined up. While this is a very precise "offset detector" that will reveal the slightest difference between the two images, it suffers from the drawback that it does not tell you directly which way to move which image to line them up. It simply indicates that they are not aligned perfectly. Of course, you can experimentally slide the image in one direction, and if the embossing gets worse, go back the other way. With a little practice you should be able to stay clear on which image is which.

A second application of this lineup procedure is for creating a clean plate. Figure 9-30 shows such a setup for making a green-screen clean plate, but of course the procedure would work the same for any arbitrary background plate. Two different frames are mixed and lined up to show the regions that are identical (gray) and those that differ (color). A "paint through" operation or even a mask and a composite can be used to pull the clean background regions through and cover the regions that differ.

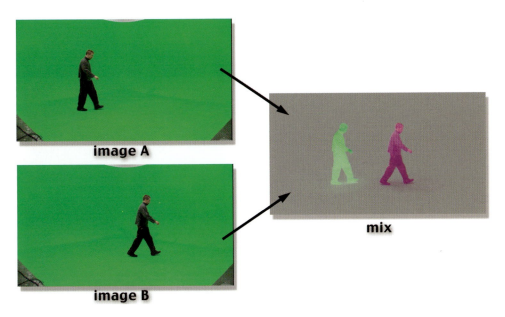

image A

mix

image B

Figure 9-30 Pictographic flowgraph of an offset mask for making a clean plate.

9.1.4.2 Edge Detection Lineup Display

Lineup method number two is the edge detection method. The beauty of this method is that it makes it perfectly clear which image to move in which direction to achieve the lineup. The basic idea is to use an edge detection operation on a monochrome version of the two images to make an "outline" version of each image. One image is placed in the red channel, the other in the green channel, and the blue channel is filled with black, as shown in the flowgraph in Figure 9-31. When the red and green outline images are lined up correctly on each other, the lines turn yellow. If they slide off from each other, you see red lines and green lines again which tell you exactly how far *and* in what direction to move in order to line them up.

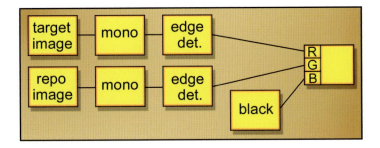

Figure 9-31 Flowgraph of lineup edges.

Figure 9-32 Grayscale image.

Figure 9-33 Edge detection.

Figure 9-34 Images offset.

Figure 9-35 Images aligned.

Examples of this lineup method can be seen in Figure 9-32 through Figure 9-35. They show the monochrome image and its edge detection version and then how the colors change when the edges are unaligned (Figure 9-34) vs aligned (Figure 9-35).

One of the difficulties of an image lineup procedure is trying to stay clear in your mind as to which image is being moved and in what direction. You have an image being repositioned (the repo image) and a target image that you are trying to line it up to. If you put the target image in the red channel and the repo image in the green channel, like the flowgraph shown in Figure 9-31, then you can just remember the little mnemonic "move the green to the red." Because the color green is associated with "go" and the color red with "stop" for traffic lights, it is easy to stay clear on what is being moved (green) vs what is the static target (red). While this method makes it easier to see what you are doing, it is sometimes less precise than the offset mask method described earlier.

9.1.4.3 The Pivot Point Lineup Procedure

Now that we have a couple of good ways to see what we are doing when we want to line up two images, this is a good time to discuss an efficient method of achieving the actual lineup itself. The effects of the pivot point location can be used to excellent advantage when trying to line up two elements that are dissimilar in size, position, and orientation. It can take quite a bit of trial and error in scaling, positioning, rotating, repositioning, rescaling, repositioning, and so on to get two elements lined up. By using a strategically placed pivot point and a specific procedure, however, a complex lineup can be done succinctly without all of the trial and error. Here's how.

The mission. Line up the smaller dark four point star with the larger gray star. The smaller star is out of position, rotated, and scaled differently in X and Y compared to the target star. Select a point that the two objects have in common to use as the pivot point. For this demo the lower left-hand corner will be the common point.

Step 1. Reposition the element so that its common point is on top of the common point of the target. Move the pivot point to this common point for all subsequent translations.

Step 2. Scale the element in X from the pivot point until its right edge aligns with the target.

Step 3. Rotate the element around the pivot point to orient it with the target.

Step 4. Scale the element in Y from the pivot point until its top edge aligns with the target. Done. Take a break.

Ex. 9-4

Adobe Photoshop Users—The transform operations support the reposition of the pivot point so you can use the aforementioned technique to good effect too.

9.2 MOTION TRACKING

Motion tracking is one of the most magical things that computers can do with pictures. With relentless accuracy and repeatability the computer can track one object on top of another with remarkable smoothness or stabilize a bouncy shot to rock-solid steadiness. The reason to stabilize a shot is self-explanatory, but the uses of motion tracking are infinitely varied. An element can be added to a shot that moves convincingly with another element and even follow a camera move or, conversely, an element in the scene can be removed by tracking a piece of the background over it.

Motion tracking starts by finding the "track" or the path of a target object in the picture. This track data is then used to either remove the motion from a shot in the case of stabilizing or to add motion to a static element so it will travel with the target object. It is the same tracking data, but it can be applied two different ways. There are even variations in the applications, such as smoothing the motion of a shot rather than totally stabilizing it and difference tracking where one moving object is tracked over another moving object.

When you have the bad luck of needing to rotoscope over wildly gyrating footage, motion tracking can make life much easier. First stabilize (or smooth) the shot and then roto over the stabilized version. When done, take the original data used to stabilize the shot, invert it, and it becomes tracking data that you can use to track the rotos over the original footage. Tracking is good.

Adobe Photoshop Users—You don't do motion so you might be tempted to skip this section. However, this is great background information if you were to ever work in a digital effects facility. You could very well be working on plates involved in motion tracking and you wouldn't want to paint out some critical tracking markers, now would you.

9.2.1 The Tracking Operation

Motion tracking is a two-step process. The first step is the actual tracking of the target object in the frame, which is a data collection operation only. Later, the tracking data will be converted into motion data. This motion data may

take the form of stabilizing the shot or tracking a new element onto a moving target in a background plate. Most compositing software will track the entire shot first and then export all of the motion data to some kind of motion node to be used in a subsequent render. Some systems, like Flame, track and export motion data one frame at a time so that you can watch it stabilize or track as it goes, but this is an implementation detail and not a fundamental difference in the process.

The first operation is to plant *tracking points* on key parts of the picture, which serve as the *tracking targets*, like those shown in Figure 9-36. The computer will then step through all of the frames in the shot, moving the tracking points each frame to keep them locked onto the tracking targets. This is the data collection phase, so collecting good tracking data is obviously a prerequisite to a good motion track.

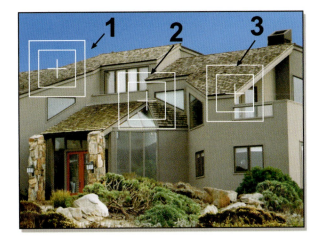

Figure 9-36 Tracking points on tracking targets.

You may have noticed that the tracking "points" shown in Figure 9-36 are surrounded by two boxes. The inner box is the *match box*. It is the pixels within this box that are analyzed for a match. The outer box is the *search box*, and it defines the area the computer will search looking for a match each frame. The larger these boxes, the more computing time will be required for each frame so they need to be as small as possible. If the motion from frame-to-frame is too great the target may land outside of the search box. To prevent this from happening the search box needs to be large if the motion is large. The larger the target, the larger the match box must be, so it is hoped that your shots will have small targets that move slowly. Motion tracking can become a time-consuming process.

While the actual algorithms vary, the approach is the same for all motion trackers. On the first frame of the tracking, the pixels inside the match box are set aside as the *match reference*. On the second frame, the match box is repositioned repeatedly within the bounds of the search box and the pixels within it are compared to the match reference. At each match box position a correlation routine calculates and saves a *correlation number* that represents how close those pixels match the reference.

After the match box has covered the entire search box, the accumulated correlation numbers are examined to find which match box position had the highest correlation number. If the highest correlation number is greater than the minimum required correlation (hopefully selectable by you), we have a match and the computer moves on to the next frame. If no match is found, most systems will halt and complain that they are lost and could you please help them find the target. After you help it find the target, the automatic tracking resumes until it gets lost again, the shot ends, or you shoot the computer (this can be frustrating work).

9.2.1.1 Selecting Good Tracking Targets

One of the most important issues at the tracking stage is the selection of appropriate tracking targets. Some things do not work well as tracking targets. Most tracking algorithms work by following the edge contrasts in the picture so nice high-contrast edges are preferred. The second thing is that the tracking target needs good edges in both X *and* Y. In Figure 9-36 tracking points #2 and #3 are over targets with good edges in both directions, whereas point #1 is not. The problem for the tracker becomes trying to tell if the match box has slipped left or right on the roof edge as there are no good vertical edges to lock onto. Circular objects (light bulbs, door knobs, hot dogs seen on end) make good tracking targets because they have nice edges both horizontally and vertically.

A second issue is to select tracking targets that are as close as possible to the *locking point*, the point in the picture that you wish the tracked item to lock to. Take the fountain shown in Figure 9-37 for example. Let's say that you want to track someone sitting on the fountain wall at the locking point indicated and the shot has a camera move. There are potential tracking points all over the frame, but the camera move will cause the other points in the picture to shift relative to the locking point, and for a variety of reasons.

If the position of the camera is moved with a truck, dolly, or boom, there will be noticeable parallax shifts in the shot that cause points in the foreground to move differently than those in the background. However, even if

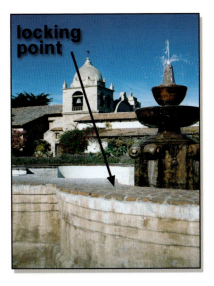

Figure 9-37

the camera is just panned or tilted there can still be subtle parallax shifts between points in the foreground and in the background.

Another variable is lens distortion. As the different tracking points move through the distortion field of the lens at different times, their relative positions shift in the picture. The problem with these problems is that they are often not perceptible to the eye. They are, of course, perfectly obvious to the computer. All of these subtle positional shifts introduce errors into the tracking data, which will result in the tracked object "squirming" around the locking point instead of being neatly stuck to it so make sure that you select tracking points that are as close as possible to the locking point.

9.2.1.2 Enable/Disable Tracking Points

The tracking targets are frequently not conveniently on screen for the full length of the shot. The tracking target may move out of frame or something may pass in front, blocking it from view for a few frames. To accommodate this, any motion tracker worth its weight in pixels will have an enable/disable feature for each tracking point. If the target for tracking point #3 goes away on frame 100, that point must be disabled on frame 100. Should the target be blocked for 10 frames, it is disabled for those 10 frames. Later, during the calculation phase, the computer will ignore the tracking point while it was disabled and only use the enabled points for its calculations.

9.2.1.3 Keep Shape and Follow Shape

Using the pixels from the first frame of the motion track as the match reference for all subsequent frames works fine if the tracking target maintains the same shape over the entire length of the shot, but what if it doesn't?

Figure 9-38 illustrates a fine tracking target, the corner of a square. It has strong vertical and horizontal edges, and the match reference that it creates on the first frame of tracking is shown in the inset. But this particular square rotates. Figure 9-39 shows the same square some frames later, and the inset shows what the match box sees then. Because this will correlate very poorly with the match reference made from the first frame, the system declares "no match" and halts.

Figure 9-38 Match reference. **Figure 9-39** Shape change.

The solution to this class of problem is to have the system follow the changing shape of the target in each frame by using the best match from the previous frame as a new match reference. Hopefully the target will not have changed very much between two adjacent frames. As a result, the best match of frame 51 becomes the match reference for frame 52, and so on. Creating a new match reference in each frame to follow a target that is changing shape constantly is called by some a *follow shape* mode. Keeping the same shape as the match reference over the entire shot is called by some a *keep shape* mode. Your software may have different names, of course.

You really want your software to allow you to select which mode to use, keep shape or follow shape, as well as switch between them when appropriate. The reason is that while the follow shape mode solves the problem of a tracking target that changes shape, it introduces a new problem of its own. It produces much poorer tracking data. This is because each frame's match

is based on the previous frame so small match errors accumulate over the entire length of the shot. With keep shape, each frame is comparing to the same match reference, so while each frame has its own small match error, the errors do not accumulate.

My favorite metaphor for describing the errors between keep shape and follow shape modes is to offer you two methods of measuring a long, 90-foot hallway. With the "keep shape" method you get to use a 100-foot measuring tape. While you may introduce a small measuring error because you did not hold the tape just right, you only have the one error. With the "follow shape" method you have to use a 6-inch ruler. To measure the 90-foot hallway you must crawl along the floor repositioning it 180 times. Each time you place the ruler down you introduce a small error. By the time you get to the end of the hall you have accumulated 180 errors in measurement and your results are much less accurate than with the single 100-foot tape measure. So the rule is, use keep shape whenever possible and switch to follow shape on just those frames where keep shape fails.

9.2.2 Applying Tracking Data

Once the tracking data is collected, the second step in motion tracking is to apply it to generating some kind of motion (except for Flame, which applies as it goes). Once collected, tracking data can be interpreted in a variety of ways, depending on the application. From raw tracking data the computer can derive the motion of a pan, rotate, or scale (zoom), as well as four point corner pinning (hopefully). Tracking data can also be applied in two different ways. Applied as tracking data, it tracks a static object on top of a moving target, matching movement, rotation, and size changes. Applied as stabilization data, it removes the movement, rotation, and zoom changes from each frame of a shot to hold it steady.

Multiple tracking points have been laid down, some enabled and disabled at various times, and all of this data needs to be combined and *interpreted* to determine the final track. Why interpreted? Because there are "irregularities" in raw tracking data, some sort of filtering and averaging must always be done. To take even a simple case such as tracking a camera pan, in theory all of the tracking points will have moved as a fixed constellation of points across the screen.

Determining the pan from such data should be trivial. Just average together all of their locations on a frame-by-frame basis and consolidate that to a single positional offset for each frame. In practice the tracking points do not move as a fixed constellation but have jitter due to grain plus squirm due to lens distortions and parallax. The calculation phase, then, has rules that

differ from software to software on how to deal with these issues to derive a single averaged motion, rotation, and scale for each frame.

The results of the tracking calculations are relative movements, not actual screen locations. Tracking data actually say "from wherever the starting location is, on the second frame it moved this much relative to that location, on the third frame it moved this much, on the fourth frame, and so on." Because the tracking data is relative movement from the starting position there is no tracking data for the first frame. Tracking data actually start on the second frame.

To take a concrete example, let's say that you have tracked a shot for a simple pan. You then place the object to be tracked in its starting location on the screen for frame one, and on frame two the tracking data will move it 1.3 pixels in X and 0.9 pixels in Y *relative to its starting location*. This is why it is important that the tracking points you place be as close as possible to the actual locking point. Tracking data collected from the top half of the screen but applied to an object that is locked to something on the bottom half of the screen will invariably squirm.

Ex. 9-5

9.2.3 Stabilizing

Stabilizing is the other grand application of motion tracking and it simply interprets the same motion tracking data in a different way to remove the camera motion from the shot. If the tracking data is smoothed in some way, either by hand or by filters, the bouncy camera move can be replaced by a smooth one that still retains the basic camera move. One thing to keep in mind about stabilizing a shot, however, is camera motion blur. As the camera bounced during the filming it imparted motion blur to some frames of the film. When the shot is stabilized, the motion blur will remain, and in extreme cases it can be quite objectionable.

Once the tracking data is collected, it is interpreted and then exported to an appropriate motion node to back out all of the picture movement relative to the first frame. All subsequent frames align with the first frame to hold the entire shot steady. This section addresses some of the problems this process introduces and describes ways to trick your software into doing motion smoothing rather than total stabilizing, which is often a more appropriate solution to the problem for a couple of reasons.

9.2.3.1 The Repo Problem

When a shot is stabilized each frame is repositioned in order to hold the picture steady. This introduces a serious problem. As the frames are reposi-

tioned the edges of the picture move into frame, leaving a black margin where the picture used to be. Let's say that we want to stabilize the sequence of bouncy camera frames shown in Figure 9-40 by locking onto the tower and holding it steady relative to frame one. The stabilized version of the same sequence is shown in Figure 9-41 with the resulting severe black reposition margins.

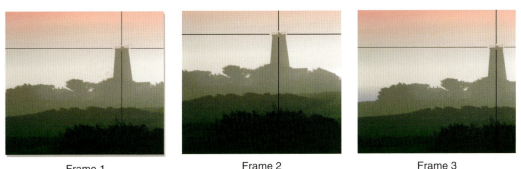

| Frame 1 | Frame 2 | Frame 3 |

Figure 9-40 Original frames with a tracking target.

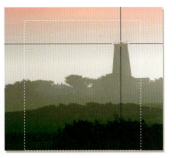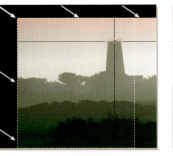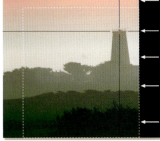

| Frame 1 | Frame 2 | Frame 3 |

Figure 9-41 Stabilized frames.

Frame 1 in Figure 9-41, being the first frame in the stabilized sequence, was not repositioned, as it is the reference frame to which all of the others are locked. Frames 2 and 3 in Figure 9-41 have been repositioned to line up with frame 1, resulting in severe black margins. The fix for this is to zoom into each frame by scaling it up *after* it has been repositioned such that all of the black margins are pushed out of frame. This means that the scale factor must be large enough to clear the black margin out of the worst-case frame.

The stabilized frames shown in Figure 9-41 have a dotted outline that represents the "lowest common denominator" of usable area that will remain after the scale operation. However, zooming into pictures both softens and

crops them. Therefore, as an unavoidable consequence of the stabilizing process, to some degree the resulting stabilized shot will be both zoomed in and softened compared to the original. Very often the client is unaware of this, so a little client briefing before any work is done might save you some grief later.

9.2.3.2 Motion Smoothing

Motion smoothing helps minimize the two problems introduced from stabilizing a shot, namely the push-in and the residual motion blur. While the push-in and softening from stabilizing are inherently unavoidable, they can be minimized by reducing the "excursions." The excursion is the distance that each frame has to be moved to stabilize it and the amount of scaling that is required is dictated by the maximum excursions in X and Y. Reducing the maximum excursion will reduce the amount of scaling, and the maximum excursion can be reduced by reducing the *degree* of stabilization. In other words, instead of totally stabilizing the shot, motion smoothing may suffice. Because some of the original camera motion is retained with motion smoothing, any motion blur due to camera movement will look a bit more natural compared to a totally stabilized shot.

To apply this to a practical example, if a bouncy shot has to be locked down to rock steady, the excursions will be at their maximum. If the bouncy camera motion can be replaced with an acceptably gentle moving camera instead, the maximum excursion can be reduced greatly so the amount of push-in and softening will also be reduced greatly. The following procedure is based on the use of a pan, or translate node, that has *source* and *destination* motion curves as described in Section 9.1.1.1, "Translation."

While presented here as a possible solution to excessive scaling in a stabilized shot, this motion smoothing procedure can also be applied to any wobbly camera move to take out the wobble but retain the overall camera move.

To simplify our story, we will assume a shot has been tracked that only has vertical jitter so we are only concerned with the Y track data shown in Figure 9-42. The raw track data represents how much the tracking target was displaced on each frame and is drawn as the light gray curve labeled "src" (source). It is called the source because to stabilize a frame it must be moved from its source position to its destination position. The destination position is marked with the flat line labeled "dst," which is a flat line, because to totally stabilize the shot the tracking target must be moved vertically to the exact

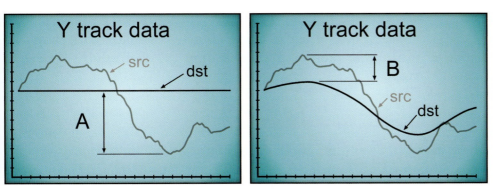

Figure 9-42 Totally stabilized. **Figure 9-43** Motion smoothing.

same position each frame. The maximum excursion is labeled "A" and represents the greatest distance that the picture will have to be repositioned to stabilize it.

Figure 9-43 represents a motion-smoothed version of the same Y track data. Instead of totally locking the shot off, this approach allows the camera to sway up and down gently, reducing the jittery camera to an acceptably smooth camera move. The maximum excursion, labeled "B," is reduced dramatically compared to the totally stabilized shot shown in Figure 9-42. It will now require less than half as much scaling to clear the black margins out of the frame, which will reduce the push-in and softening dramatically compared to the totally stabilized version.

Now the question becomes how this might be done with your particular software. With some software the motion tracker is a closed "black box" that does not permit you to get creative. If there is a motion smoothing option, you are in luck. If not, there is nothing you can do until you upgrade. Other software will allow you to export motion tracking data to other nodes that do the actual pan, rotate, and scale operations. These we can get creative with.

The basic idea is to export the tracking data to a pan (translate) node so that it ends up in a *source* motion channel and then create a smoothed curve in the *destination* motion channel like in Figure 9-43. There are two ways that the smoothed curve might be created. If your software has curve-smoothing functions, the choppy source channel can be copied into the destination channel and then smoothed. The second approach is to simply draw a new, smooth curve by hand in the destination channel. The pan node will then move each frame just the small distance from the source position to the destination position to smooth the motion. Be sure to export the data as *track* data, as though you wanted to track an object to the picture. This way the

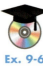

Ex. 9-6
actual motion of the target point is placed in the source motion channel. If the track data is exported as stabilize data, it will be inverted to remove all motion from the shot, which we do not want.

9.2.4 3D Motion Tracking

There is yet an even more sophisticated form of motion tracking, which is 3D motion tracking, sometimes referred to as a "match move." The purpose of this type of motion tracking is to derive the actual three-dimensional camera move in a shot and then transfer that camera data to a 3D animation package so that a matching camera move can be added to a cgi element that is to be composited into the scene. Because this is in actuality a cgi application, it is outside the scope of this book. However, a brief overview of the process might be interesting and informative and lend a few insights to 2D tracking situations as well.

There are three main requirements for 3D motion tracking: camera lens information, measurements from the set, and good tracking markers. Lens information is required by the analysis software that is trying to discover the camera position because the lens distorts the true position of the tracking markers and its effects have to be backed out of the calculations. A survey of the set to collect some reliable measurements is essential for the tracking software to have at least some solid references to work with. The analysis process entails a "best-fit" approach, so having at least a few reliable numbers to use as starting assumptions is essential.

Figure 9-44 shows an interior set with many convenient tracking points circled. The nature of the set provides several handy corners and small objects that make good tracking targets. This shot could be tracked as is using just measurements surveyed from the set. However, because many scenes do not have good tracking targets naturally, tracking markers are often added and then painted out later.

Because greenscreen shots by definition have large, featureless regions that provide no useful tracking points, they often have to be added. Figure 9-45 shows typical tracking markers (the crosses on the greenscreen) added to a greenscreen shot. There is much debate over what is the best color for these tracking markers. One school of thought, shown here, is to make them the same color as the backing so they can be keyed out like the main backing color. Another school of thought is to make them the "other" backing color (green markers on a bluescreen, blue markers on a greenscreen) so they too can be keyed out. Yet another school of thought is to make them any convenient color and just paint them out.

Figure 9-44 3D tracking points.

Figure 9-45 Greenscreen tracking markers.

Figure 9-46 Exterior tracking markers.

The main argument against this approach is the extra labor for the painting plus edge anomalies where the foreground crosses a marker and the contact edge was painted by hand.

Large, exterior shots provide a different set of challenges to the match move department. They often have very large, sweeping camera moves using booms, trucks, helicopters, cable-cams, and even hand-held steady-cams or, my personal favorite, hand-held unsteady cams. Broad, open spaces such as fields may also be fairly featureless, and any usable natural tracking points might be difficult to measure and located inconveniently 100 feet up a cliff face. Here, too, tracking markers might have to be added and measured as shown in Figure 9-46. These tracking markers will typically be spherical so that they provide a constant shape to the tracker from any camera angle.

While 2D tracking might be done with just 3 or 4 points, 3D tracking requires many more. In fact, the more points that can be tracked, the more accurate the resulting camera move data will be. It is not uncommon to track 50 to 100 or more points in these cases. The tracking software is also more sophisticated and difficult to operate, requiring much intervention from the operator to give it "hints" and "clues" as to where the camera must be (no, it is not below the ground looking up at the scene!) and when to discard confusing tracking points. There is also great variability between 3D tracking software packages in the speed and accuracy of their results. However, there is simply is no other way to create a cgi element with a matching camera move to the live action scene, a requirement being demanded by more and more directors who disdain locked off camera shots.

9.2.5 Tips, Tricks and Techniques

When theory meets practice, reality steps in to muddle the results. In this section some of the problems that are often encountered with motion track-

ing are described along with some tips and techniques on how to deal with them.

9.2.5.1 Tracking Preview

Before you start motion tracking a shot, make a low-resolution preview of the shot that you can play in real time. Look for good tracking targets and note when they go out of frame or are occluded. Watch for any parallax in the scene that will disqualify otherwise attractive tracking targets. Having a well-thought out plan of attack before you begin placing any tracking points will save you time and trouble when you go to do the actual motion tracking.

9.2.5.2 Low-Resolution/High-Resolution Tracking

Some motion trackers will allow you to track a shot at low resolution with proxies and then switch to the high-resolution images later. If your software permits this, then there is a very big time-saver here when you are working with high-resolution film frames (the savings are minimal with video resolution frames). The basic idea is to set up the motion track on the low-resolution (low-res) proxies and then retrack on the high-res frames after you get a clean track at low-res.

Tracking the shot with low-res proxies first provides two big advantages. The first is that the tracking goes much faster so problems can be found and fixed that much more quickly. The second advantage is that any tracking target that the tracker can lock onto at low-res it can lock onto even better at high res because of the increased detail. This means that when you switch to high-res and retrack the shot it should track the entire shot the first time through without a hitch. All of the tracking problems have been found and fixed at low-res, which is much faster than slugging through the high-res tracking several times trying to get a clean track.

A related suggestion, again for high-resolution film frames, is that it will often suffice to track the shot at half-resolution and then apply half-res tracking data to the high-res frames. In other words, motion-tracked data from half-res proxies are often sufficiently accurate for full-res frames so it is often not necessary to do the actual tracking at high-res. This assumes that your motion tracker is "resolution independent" and understands how to scale all of the motion data appropriately when you switch from half-res to full-res.

9.2.5.3 Preprocessing the Shot

Problems can arise in the tracking phase from a number of directions. The tracking targets may be hard to lock on to, you may get a jittery track due to film grain, and you might have "squirm" in your tracked motion due to lens effects. There are a number of things that you can do to preprocess the shot that will help the hapless motion tracker do a better job.

9.2.5.3.1 Increase the Contrast

One of the most annoying problems is the motion tracker losing the tracking target, even when it is right in plain view. Assuming that the problem is not simply that the target is outside of its search box so that it just can't find it, there may not be enough contrast in the picture for it to get a good lock. Make a high-contrast version of the shot and use it for tracking. Many motion trackers just look at the luminance of the image anyway and don't actually look at the color of the pixels. Perhaps a high-contrast grayscale version would be easier for the tracker to lock onto or perhaps just the green channel would make a better target. Beware of going too far in slamming the contrast, however. This will harden the target's edge pixels, making them chatter. The resulting track would then "jitter" as it attempted to follow a chattering edge. Not good.

9.2.5.3.2 Degrain

Speaking of jittery tracks, film grain can also give you jittery tracks. High-speed films and dark shots can have very big grain, which creates a "dancing target" for the tracker, resulting in a jittery motion track. Increasing the contrast will increase the problem. There are a couple of approaches. You can degrain the picture or, if you don't have a degrain operation, a gentle blur might do. Another approach is to get rid of the blue channel, which has the most grain. Copy the red or green channel into the blue channel to create a less grainy version of the image to track with or make a monochrome version by averaging the red and green channels together.

9.2.5.3.3 Lens Distortion

Lens distortion is another cause of motion-tracking woes. Lens distortions will result in the tracked item "squirming" around its locking point. The reason this happens can be seen in Figure 9-47, which shows the distortion map of a representative lens. As the

Figure 9-47 Effects of lens distortion on tracking points.

camera pans to the right, you would expect points 1 and 2 to both move to the left in a perfectly straight horizontal path and at the same speed. However, point 2 moves in an arc and also changes speed relative to point 1. The two points drift both left and right, as well as up and down relative to each other.

With a theoretically perfect lens the two points would stay locked together at the same distance apart as they moved. When the time comes to calculate the actual camera pan from these two points, the averaging of their positions will cause the calculated locking point to drift around, which introduces the squirm into the tracking data.

The preprocessing fix for this lens distortion is to "undistort" the entire shot to make the picture flat again. Tracking *and* compositing are then done on the "flat" version and then the finished results are warped back to the original shape if desired. While difficult to do, it can be done with any image warping package. Clearly this is only worth the effort if lens distortions are wreaking havoc with your motion track. If there is a zoom in the shot then the lens distortions may change over the length of the shot, rendering the problem that much more difficult.

You would think that someone could write a program where you could just enter "50-mm lens" and it would back out the lens distortions. Alas, this is not even in the cards. Not only do you often not even know what the lens is, but each manufacturer's 50-mm lens will have a different distortion, and there are even variations from lens to lens of the same manufacturer! The most effective method is to film a grid chart with the actual lens used in the shot and use that to make a distortion map.

9.2.5.4 Point Stacking

In general, the more points you track on a shot the better the resulting tracking data will be. This is because the various tracking points will be averaged together later to derive the "true" track of the target, and the more samples that are averaged together the more accurate the results. However, what if there are not five or six convenient tracking targets in frame for the whole shot? What if there are only one or two potential tracking targets in the shot? The answer is . . . point stacking, of course. You can paste several tracking points on top of each other over the same target like the example shown in Figure 9-48. The computer does not know that they overlap or that they are on the same target. You get valid tracking data from each point, just as though they were spread all over the screen.

Figure 9-48 Point stacking.

One key point, however, is that the tracking points must not be stacked exactly on top of each other. If they are, they will all collect the exact same tracking data, which is no better than one tracking point. But by having them slightly offset from each other, like the three tracking points shown in Figure 9-48, each match box generates a slightly different sample of the image for the correlation routine. All three tracking points will eventually be averaged together to create a single, more accurate track.

This can also be a fine solution for jittery tracks caused by grain. Each tracking point jitters due to grain, but when they are averaged together it tends to average out the grain jitter.

9.2.5.5 Difference Tracking

Normally, motion tracking is used to track a stationary object onto a moving target. However, there are times when you have a moving object to track onto a moving target. This is where difference tracking comes in. You want to track the difference between the moving object and the moving target. This technique requires the source and destination type motion nodes described in Section 9.1.1.1.2, "Source and Destination Movement." For purposes of a simplified example, we will assume that the only motion to be tracked are translations in X and Y so that a pan node will suffice.

The basic idea is to perform tracking operations on both the moving object and the moving target and then combine their motion data in a single *difference pan node* that will keep the moving object tracked on the moving target. The motion curves in Figure 9-49, Figure 9-50, and Figure 9-51 represent generic motion channels within the pan nodes. Following are the specific steps.

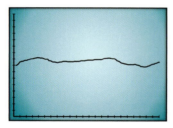
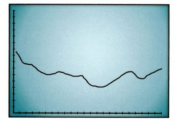
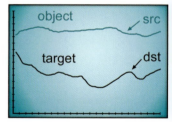

Figure 9-49 Pan node #1, object motion track.

Figure 9-50 Pan node #2, target motion track.

Figure 9-51 Pan node #3, difference track.

Step 1. Track the moving *object* and then export its track data to pan node #1 (Figure 9-49).

Step 2. Track the moving *target* and then export its track data to pan node #2 (Figure 9-50).

Step 3. Copy the moving object's motion data from pan node #1 to the source channels of pan node #3 (Figure 9-51).

Step 4. Copy the moving target's motion data from pan node #2 to the destination channels of pan node #3 (Figure 9-51).

Step 5. Connect pan node #3 to the moving object image for the composite over the target image (Figure 9-52).

Step 6. Reposition the moving object to its desired starting position by shifting the source channel motion curves in pan node #3.

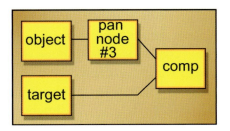

Figure 9-52 Flowgraph of difference track.

Pan node #3 (the difference tracking node in Figure 9-51) now has the motion track of the moving object in its source channels and the motion track of the moving target in its destination channels. Recalling that the "source and destination" position channels mean "move the image from the source position to the destination position," pan node #3 will move the moving object position to the moving target position in each frame.

This assumes that the moving object starts in the correct position, which was the purpose of step 6. Selecting the entire *source X* motion channel and shifting it up and down in the curve editor will shift the starting position of the moving object left and right. Similarly, shifting the *source Y* motion channel up and down will shift the starting position vertically.

If your software does not support some of the operations required for this procedure, there is a fallback procedure. You could first stabilize the moving object and then track the stabilized version onto the moving target. This is less elegant and performs two transformations that increase the rendering time and degrade the image by filtering it twice rather than once, but you may have no choice in the matter.

9.3 WARPS AND MORPHS

The image warp is another one of those magical effects that only computers can do. Only a few compositing packages contain image warping tools so this operation is often done using a dedicated external software package and then importing the warped images or the morph into the main compositing package. While the image warp is occasionally used to reshape an element so that it will physically fit into a scene, the most common application of warps is to produce a morph.

9.3.1 Warps

Warps are used to perform "nonlinear" deformations on images. That is to say, instead of a simple linear (equal amount everywhere) operation, such as

scaling an image in X, this process allows local deformations of small regions within the image. The corner pinning operation described in Section 9.1.1.5 is a global operation: the corner is repositioned and the entire image is deformed accordingly. With warps, just the region of interest is deformed.

One of the earliest and simplest warp methodologies is the mesh warp, illustrated in Figure 9-53. The mesh is a two-dimensional grid superimposed over the image. The intersections are points that can be moved around to describe the desired deformation, and the connections between the points are a spline. If a straight line were used between the mesh points, the resulting warped image would also have straight section deformations. The splines guarantee gracefully curved deformations that blend naturally from point to point. You basically move the mesh points around to tell the machine how you want to deform the image and then the computer uses your mesh to render the warped version of the image.

Figure 9-53 Mesh warper.

Figure 9-54 The warped image.

While a mesh warper is easy to design and use, it is difficult to control. You don't have control points exactly where you want them, and it is hard to correlate the warped image to its intended target shape. Its most appropriate use is "procedural" warping effects, such as lens distortions, pond ripples, and waving flags.

The spline warper is the "second generation" of warpers and works on entirely different principles. It offers much more control over the warp and excellent correlation to the target image and is accordingly more complicated to learn and use. Think of a warp as the movement of different regions of the picture from one location to another. There must not only be a way to describe those regions to the computer, but also their final destinations. This is done with the "source" and "destination" splines along with their correlation points.

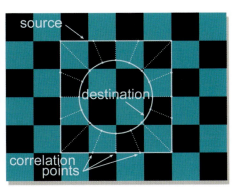

Figure 9-55 A spline warper.

Figure 9-56 The warped image.

The operator (that's you) draws an arbitrary shape on the image that represents the source, or start position of the warp, represented by the square in Figure 9-55. This line means "grab the pixels here." The operator then draws a second arbitrary shape, the "destination," represented by the circle, which means "move those pixels to here." In this particular example we are warping a square region into a circular one. After the source and destination splines are set the operator must then establish the "correlation" between them which describes their connectivity. This tells the computer which regions of the source spline go to which regions of the destination spline. These connections are indicated by the "correlation points," the dotted lines in Figure 9-55. This arrangement provides unambiguous instructions to the computer as to which regions of the image you want moved to what destinations in order to create the warp you want.

One of the very big advantages of spline warpers is that you can place as many splines as you want in any location you want. This allows you to get lots of control points exactly where you want them for fine detail work. The mesh warper has control points at predetermined locations, and if that isn't where you want them, tough pixels. You also do not waste any control points in regions of the image that are not going to be warped. The other cool thing about the spline warper is that the "finish" spline can be drawn directly on another image—the target image. The warper will then displace the pixels under the start spline directly to the finish spline so there is excellent target correlation. This is particularly useful when using warps to do morphs, which provide an elegant segue to our next topic.

9.3.2 Morphs

It takes two warps and a dissolve to make a morph. The first step is to prepare the two warps, with a simple five frame example shown in Figure 9-57. The

Frame 1 Frame 2 Frame 3 Frame 4 Frame 5

Figure 9-57 The A and B sides of the warp.

"A" side of the warp is the starting picture of the morph and the "B" side is the ending picture. The "A" side image starts out perfectly normal and then over the length of the morph it warps to conform to the "B" side. The "B" side starts off warped to conform to the "A" side and then over the length of the morph relaxes gradually to return to normal. So the "A" side starts out normal and ends up warped, the "B" side starts out warped and ends up normal, and they both transition over the same number of frames. The warping objects must be isolated from their backgrounds so they can move without pulling the background with them. As a result, the A and B sides of the morph are often shot on greenscreen, morphed together, and then the finished morph composited over a background plate.

After the A and B warps are prepared, the last step is to simply cross-dissolve between them. A representative timing for the cross-dissolve example is shown in Figure 9-58 where roughly the first third of the morph shows the A side, the middle third is used for the cross-dissolve, and the last third is on the B side. Of course, your timing will vary based on your judg-

Figure 9-58 Typical morph cross-dissolve timing.

Frame 1 Frame 2 Frame 3 Frame 4 Frame 5

Figure 9-59 Dissolve between A and B sides of the warps to make the morph.

ment of the best appearance, but this usually is a good starting point. The final results of the A and B warps with their cross-dissolve can be seen in the sequence of pictures shown in Figure 9-59.

9.3.3 Tips, Tricks, and Techniques

The single most important step in creating an excellent morph is to select appropriate images to morph between. What you are looking for in "appropriate images" is feature correlation—features in the two images that correlate with each other. The most mundane example is morphing between two faces—eyes to eyes, nose to nose, mouth to mouth, etc. The closer the two faces are in size, orientation of the head, and hairstyle, the better the morph will look. In other words, the more identical the A and B sides of the morph are, the easier it is to make a good morph.

If a face were to be morphed to a nonface target, say the front of a car, then the issue becomes trying to creatively match the features of the face to the "features" of the car—eyes to headlights, mouth to grill, for example. If the task is to morph a face to a seriously nonface target, say a baseball, the utter lack of features to correlate to will result in a morph that simply looks like a mangled dissolve. This is because without a similar matching feature on the B side of the morph to dissolve to, the black pupil of the eye, for example, just dissolves into a white leather region of the baseball. It is high-contrast features dissolving like this that spoil the magic of the morph.

Meanwhile, back in the real world, you will rarely have control over the selection of the A and B side of the morph and must make do with what you are given. It is entirely possible for poorly correlated elements to result in a nice morph, but it will take a great deal more work, production time, and creative imagination than if the elements were well suited to begin with. The following suggestions may be helpful when executing morphs with poorly correlating elements.

1. Having to warp an element severely can result in unpleasant moments of grotesque mutilation during the morph. Scale, rotate, and position one or both of the elements in order to start with the best possible alignment of features before applying the warps in order to minimize the amount of deformation required to morph between the two elements.

2. Occasionally it may be possible to add or subtract features from one or the other of the elements to eliminate a seriously bad feature miscorrelation. For example, in the face-to-car example mentioned earlier, a hood ornament might be added to the car to provide a "nose feature" for the car side of the morph. It probably wouldn't work to remove the nose from the face, however. Use your judgment.

3. When uncorrelated high-contrast features look "dissolvey," such as the pupil cited earlier dissolving into the white part of the baseball, try warping the offensive element to a tiny point. It will usually look better shrinking or growing rather than dissolving.

4. Don't start and stop all of the warp action simultaneously. Because morphs invariably have several separate regions warping around, start some later than others to phase the action. A large deformation might start soonest so it will not have to change shape so quickly, calling attention to itself in the process.

5. Don't do the dissolve between the entire A and B sides all at once. Separate the dissolve into different regions that dissolve at different rates and at different times. The action will be more interesting if it doesn't all happen at once. Perhaps a region on the B side looks too mangled, so hold the A side a bit longer in this region until the B side has had a chance to straighten itself out.

6. Warps and dissolves need not be simply linear in their action. Try an ease in and an ease out on the warps and the dissolves. Sometimes warps or dissolves look better or more interesting if the speed is varied over the length of the shot.

Ex. 9-7

Gamma is important to understand because it permeates the entire production pipeline from image capture through manipulation to display. It is also a difficult topic because it is basically a mathematical concept (yikes!) and therefore unattractive to the "true artist." The situation is complicated further by widespread misunderstanding of this topic in part due to confusing naming conventions and the fact that explanations of it are usually very technical and full of gnarly math. This results in more glazed eyes than enlightened minds. However, in digital compositing we have to be more than just true artists. We need to be competent technicians as well. This chapter presents this highly technical topic in a lightly technical way with just a tiny sprinkling of innocuous math and relates it all to the real world of sitting in front of a monitor with a picture on it. Besides, you gotta do gamma before you can do video, and video is the next chapter.

It turns out that monitors are nonlinear display devices and we are glad that this is the case. Studies of human perception reveal that we like a little gamma in our image displays, and how much depends on the local lighting conditions. We will also learn that there are really three gammas to know about when discussing the gamma of your monitor. We will also discover which gamma is best for video versus film. There are even some cool test patterns for determining the actual gamma of your monitor. All of the gamma examples herein are for the typical PC monitor, as it is by far the most prevalent display device used in production today. Flat panel displays, SGI, and Mac monitors are each described in their own little sections.

10.1 WHAT IS GAMMA?

In the mathematical abstract, gamma is a power function. That is to say, some value raised to the power of some other value. As a simple math equation applied to pixel data it would look like this:

$$\text{new pixel} = (\text{pixel})^{\text{gamma}} \qquad (10\text{-}1)$$

In other words, the new pixel value is the original pixel value raised to the power of the gamma value. Because pixel values are always normalized for gamma calculations, a pixel value of 128 is represented as 0.5, and for a gamma of 2.2, for example, it would be $0.5^{2.2}$ (0.5 to the power of 2.2). A gamma greater than 1.0 will lower the pixel values, darkening the image, and

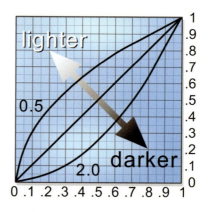

Figure 10-1 Gamma curves.

gamma values less than 1.0 will raise the pixel values, brightening the image. A gamma of exactly 1.0 returns the same pixel value so there is no change to the image. Figure 10-1 illustrates the basic behavior of gamma values less than, equal to, and greater than 1.0 using as examples a gamma of 0.5 and 2.0.

By convention, when we speak of a gamma *correction*, this implies using the *inverse* of the gamma value. For example, if a gamma correction of 2.0 were applied to an image, the pixel values would actually be raised to the power of 1/2.0, which is 0.5. Because 0.5 is less than 1 it will increase the brightness of the image.

Most software packages have a gamma operation to adjust the brightness of images, and when you apply values greater than 1.0 to an image it usually gets brighter. This means, of course, that the software is really applying the inverse of the number you typed in. Check your software. If you enter a gamma value greater than 1.0 and the picture brightens, it is inverting your gamma value. If it gets darker, it is not.

Gamma is not an inherent attribute of an image any more than saturation is. You can raise or lower the saturation of an image, but you would never ask someone "what is the saturation of that picture?" You can apply a gamma correction to an image to make it brighter or darker, but an image itself does not have a "gamma" value. In fact, if you are not viewing an image within the context of its intended display environment, you have no way of judging whether it is too bright or too dark. More on this disturbing thought later.

10.2 EFFECTS OF GAMMA CHANGES ON IMAGES

We like to use gamma changes rather than scaling operations to alter the brightness of images for two reasons. First, because gamma changes affect an

image in a way that is similar to the nonlinear response of the eye, the brightness changes seem more natural. Second, they do not clip the image. When we alter the brightness of an image with a gamma operation its brightness changes in a way that is wholly different from the usual scaling operation. There are also secondary effects on the image that the deft compositor might want to be aware of.

Figure 10-2 and Figure 10-3 illustrate the different behavior of the pixels when the brightness is increased with an RGB scaling operation compared to a gamma correction. The pair of points at A and B are at the same starting locations on the midline in both diagrams.

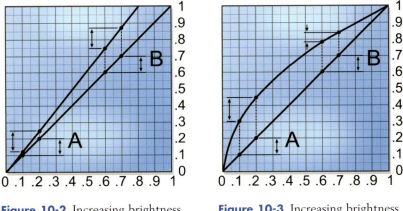

Figure 10-2 Increasing brightness by scaling RGB values.

Figure 10-3 Increasing brightness with gamma correction.

In Figure 10-2 the brightening operation has scaled up both the A and the B point pairs by the same amount. When they were scaled up they also moved apart vertically, which can be seen by the left set of arrows being longer than the right set. The pixels at point A, in the darks, moved up only a little, making them a little brighter, whereas the points at B, in the lights, moved a lot, making them a lot brighter. The scaling operation has also increased the contrast of the whole image uniformly. Note also that the top of the line was scaled off the chart so if there were any bright pixels in this range the image would now be clipped.

Figure 10-3 reveals an entirely different behavior of the same pixel pairs with gamma correction. At point A, in the darks, the two pixels have become much brighter compared to the scaling operation in addition to moving apart vertically. The arrow on the left of point A shows the greater separation between them than the arrow on the right. At point B, in the lights, the situation is reversed. They have moved up, getting brighter, but they have also moved closer together vertically. This means that in the darks the contrast and saturation have increased, but in the lights the contrast and saturation

have actually decreased. Overall, the image will appear to lose contrast, getting "flatter" as it gets brighter, whereas the contrast is increased with the scaling operation. Another important feature of the gamma operation is that, unlike increasing brightness or contrast, it does not introduce clipping in either the blacks or the whites, it just "bends" the midtones.

 The zero black and 100% white pixels are totally unaffected by gamma operations. The fact that the gamma operation does not disturb the black and white pixels is an important attribute of the gamma operation and should always be kept in mind.

To convert all this abstract discussion into observations on real pictures, we have three examples using Kodak's Marcie girl (the color corrections were overdone here in order to exaggerate the key points). Figure 10-4 was made brighter by scaling the RGB values of the original image as in Figure 10-2. You can see all the key effects of the scaling operation: the increase in contrast, much brighter highlights, and, most importantly, clipping in the hair and shoulders. Compare this result with Figure 10-6 where the brightness was increased using a gamma correction like Figure 10-3. Note that it has no clipping, the darks came up much more, and the image now looks "flatter," or lower in contrast. Of course, gamma corrections can also be used to make pictures look darker and more "contrasty" as

Ex. 10-1 well.

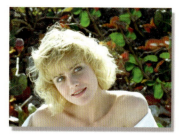
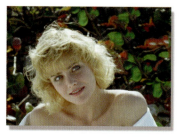
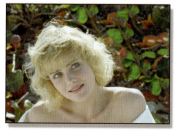

Figure 10-4 Scaling. **Figure 10-5** Original. **Figure 10-6** Gamma.

10.3 THE THREE GAMMAS OF A DISPLAY SYSTEM

Monitors, and most other display systems, are not linear devices. The monitor darkens a displayed image based on the gamma characteristics of the monitor. To compensate, a gamma correction is introduced. For aesthetic reasons, the gamma correction does not totally eliminate the monitor gamma so there is a residual gamma effect called the end-to-end gamma. These are the three gammas of a display system: the monitor gamma, the gamma correction, and the end-to-end gamma. This section describes how they work and interact

with each other, as well as what gammas to use under what circumstances. The following principles apply to all monitors, whether they are SGI, PC, or Mac, because they apply to all cathode ray tube (CRT) devices. Flat panel devices have different issues and are discussed in their own section.

10.3.1 Monitor Gamma

You would think that if you loaded a perfectly linear gradient image to display on your monitor that you would see a perfectly linear gradient on your monitor. A linear gradient on the monitor would mean that increasing pixel values would result in an equal amount of increasing monitor brightness. Of course, such is not the case because the brightness output of the monitor is nonlinear. The nonlinear response of the monitor means, for example, that a pixel value of 50% only results in a monitor brightness of around 20% instead of 50%. The results would look more like Figure 10-7. The gradient on the monitor would stay dark across much of its width and then quickly get bright near the right end. That's because the monitor is darkening the midtones of the gradient. The black and white extremes are unaffected, but it is as if the entire grayscale between them "sags" darker, like a rope hung between two poles of unequal height.

Figure 10-7 Nonlinear appearance of a linear gradient on a monitor.

Figure 10-8 illustrates the nonlinear output of a typical monitor that explains the darkening of the midtones in Figure 10-7. At the midpoint of the gradient, an input pixel brightness of 0.5 results in a screen brightness of only about 0.18. When we look for a mathematical model that describes this behavior, it turns out to be a power function—a gamma function (surprise!). Further, when measurements of screen brightness are compared to input data, the gamma value turns out to be about 2.5. In other words, if the input pixel value of 0.5 were raised to the power of 2.5, we would get an output bright-

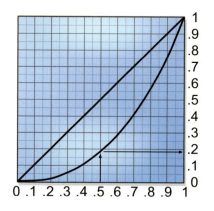

Figure 10-8 Typical monitor gamma curve of 2.5.

ness value of about 0.18, which closely matches the characteristics of real monitors.

The cause of this nonlinearity is not due to the response of the phosphors on the screen, but is due instead to the electron gun itself in the CRT of the monitor. Increasing the voltage to the electron gun increases the stream of electrons to the phosphors on the screen, which in turn glow brighter, but the stream of electrons does not increase equally (linearly) with the increase in voltage at the electron gun. It is the electron stream increasing with a power function (gamma) of 2.5 relative to the input voltage that results in the nonlinear screen brightness.

This 2.5 gamma response is characteristic of the construction of all CRTs, whether they are in your workstation monitor, the TV set in your living room, or an oscilloscope in the engineering department. In practice, the gamma of CRTs can range from about 2.35 to 2.5, but we will use 2.5 as a representative value for this discussion. The monitor's gamma behaves like the definition of gamma we saw in Figure 10-1 where a gamma greater than 1.0 resulted in a smaller (darker) number. In other words, the gamma of the monitor darkens the picture, and a gamma of 2.5 darkens it at lot.

10.3.2 Monitor Gamma Correction

So the monitor intrinsically darkens images based on a gamma function of 2.5, and now we must compensate to correct for it lest all of our pictures look too dark and "contrasty." The way this is done is to apply a gamma *correction* to the image on its way to being displayed on the screen. Most systems misleadingly label this monitor gamma correction as "display gamma" or "monitor gamma." You can be forgiven for thinking that when you set the "display gamma" to 2.2 that you were actually setting the display gamma to 2.2. You were not. You were actually setting a gamma *correction* of 2.2 to whatever the gamma of the monitor was.

The way the gamma correction is applied physically is through a Look Up Table (LUT) between the image and the monitor. This way the gamma correction resides in the display device (the workstation) so that the image data itself does not have to be altered to appear right.

The sequence of operations can be seen starting with Figure 10-9, the original image, which is a simple linear gradient in this example. The original image is first loaded into the *frame buffer* of the workstation, an area of special RAM that holds images for display on a monitor. As it is read out of the frame buffer each pixel value goes to a LUT to get a new output value. The LUT is so written that it does a gamma *correction* of 1/gamma, as shown in Figure 10-10. The image is now way too bright. This overbright image is now sent to the CRT, which darkens it back down due to its internal monitor gamma, shown in Figure 10-11. The resulting display is back to a linear gradient, as shown in Figure 10-12, resulting in a faithful replication of the original image.

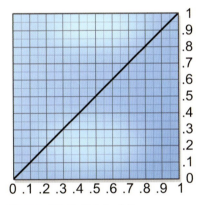

Figure 10-9 Original linear gradient.

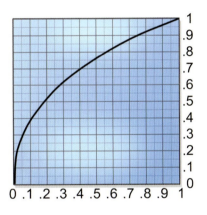

Figure 10-10 Gamma correction in LUT.

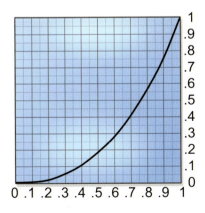

Figure 10-11 Gamma of monitor CRT.

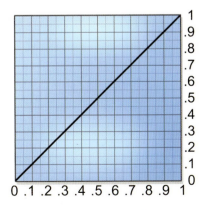

Figure 10-12 Resulting linear display.

This is exactly what goes on whenever you display an image on your workstation monitor. Well, almost exactly. The truth is that we don't really want a perfectly linear display in the monitor so the monitor gamma is typically *under*corrected by setting the gamma correction to 2.2 instead of 2.5. Why we want to do this will have to wait until we cover the dim surround topic in a bit. In the meantime, let's assume for a moment that we actually want a linear response from the monitor.

10.3.3 The Monitor LUT

Figure 10-13 illustrates how a pixel in image data gets "remapped" to a new value in the monitor LUT. The image data is loaded into the frame buffer with each pixel containing its brightness value, which is 57 for our example pixel shown in Figure 10-13. The value of that pixel is then used as an *index* into the LUT that "looks up" a new output value for that pixel, which is 85 for our pixel. In this manner the LUT "remaps" every pixel value in image data to a new output value for the monitor. The key point to this arrangement is that while output image data to the monitor is altered, original image data is not. Also, simply by creating different LUTs, different versions can be displayed on the monitor. The LUT for a color monitor actually contains three lookup table lists, one for each color channel.

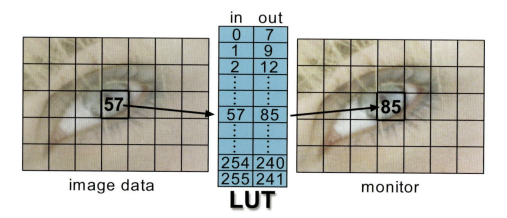

Figure 10-13 Remapping pixel values through the monitor LUT.

Recall that when we say "gamma correction" we mean to invert the stated gamma number so that we will get a gamma value of less than 1.0, which will brighten the image to counter the natural darkening of the monitor's gamma. That would mean that a gamma correction of 2.5 is inverted to

become 1/2.5, which is 0.4. So here is the confusing bit. A gamma correction of 2.5 might be referred to as a gamma correction of 2.5 *or* a gamma correction of 0.4. You have to figure out from the context what is actually meant. Knowing as you do (now) that a gamma change of less than 1.0 brightens and greater than 1.0 darkens will help you sort out the intended meaning.

So how is this gamma correction LUT created? When you tell your computer to set the gamma correction to (say) 2.5, it simply runs a little equation like this:

$$\text{data out} = (\text{data in})^{1/2.5}$$

which is evaluated for a data range of 0 to 255 for the typical 8-bit frame buffer. A table with 256 entries is created that has this gamma correction built into it. Tracing the path of a pixel with a midpoint value of 128 (0.5), it goes to the 128th entry in the LUT to get a new output pixel value of 209 (0.82), which reflects the brightening shown in Figure 10-10. This new, brighter pixel value gets converted to a voltage that is 0.82 of the maximum for the electron gun in the CRT instead of the 0.5 from the original data. The electron gun then imposes its gamma function of 2.5 as shown in Figure 10-11, which darkens the pixel from 0.82 back down to 0.5 as shown in Figure 10-12. An image pixel value of 0.5 became a monitor pixel brightness of 0.5, producing a perfectly linear response from a nonlinear display device. Again, in the real world, we do not actually want linear display devices so we will not be using a gamma correction of 2.5.

10.3.4 End-to-End Gamma

All these years you probably thought that when you set your monitor gamma to 2.2 you were actually setting the monitor gamma to 2.2. The truth, as usual, has turned out to be a lot messier. What is really going on is that you are setting a gamma *correction* of 2.2 to a monitor gamma of 2.5. The resulting gamma of the entire viewing system is now actually about 1.1. We can refer to the "resulting gamma of the entire viewing system" as simply the *end-to-end* gamma. The gamma correction of 2.2 is prebrightening the image because the monitor gamma of 2.5 is going to darken it back down. Because the gamma correction to prebrighten the image is less than the monitor gamma that darkens it down, the net result is to darken the image.

End-to-end gamma, then, is the resulting gamma change to an image as a result of the interaction between the gamma correction and the monitor gamma in the display system. The formula for end-to-end gamma is

$$\text{end-to-end gamma} = \text{monitor gamma/gamma correction} \qquad (10\text{-}2)$$

For example, if a CRT has a monitor gamma of 2.5 and you set a gamma correction of 2.2, then the end-to-end gamma of the entire viewing system becomes 2.5/2.2 = 1.1. So there are the three gammas in your monitor: the monitor gamma, the gamma correction, and the end-to-end gamma. In point of fact, it is only the end-to-end gamma that really matters because that is what determines the appearance of the displayed image.

10.4 MEASURING YOUR END-TO-END GAMMA

Always keep in mind that of the three gammas in your display system, the only one that really matters is the end-to-end gamma. That is what you are actually looking at. You can know the gamma correction because you can look that up and even change it. However, the monitor gamma is simply assumed because it cannot be measured. Applying the same gamma correction to two different monitors can give you two different results. What you really want to know is what the actual end-to-end gamma is.

Fortunately, it is not difficult to directly measure the end-to-end gamma of your monitor using a kicky little test pattern (included on the DVD). The principle is illustrated by the gamma patch shown in Figure 10-14. The gray patch on top is a 50% gray (8-bit code value 128) and the striped patch below is simply alternating stripes of zero black (0) and 100% white (255). From a sufficient distance the striped patch would appear to blend together and form a 50% gray patch. As shown earlier, a gamma of 1.0 is perfectly linear, so if your monitor (or this book) had an end-to-end gamma of 1.0, then the

Figure 10-14 Gamma patch.

50% gray patch on top would match the striped patch below. But the monitor does not have a gamma of 1.0 so the gray patch doesn't match the stripes.

The key thing about the striped patch is that it will appear as a 50% gray regardless of the end-to-end gamma of the display system (and that includes this book). No matter what gamma change the display system imparts to an image, the zero black and 100% white points are unaffected so the striped patch is immune to the effects of gamma. But the 50% gray patch on top is not immune. If the monitor gamma is altered, the gray patch will change with it. This gives us an easy way to measure the end-to-end gamma of any display system—a CRT monitor, a flat panel display, or even a book.

Now that we understand how the gamma patch works, we can step up to the larger concept of measuring the end-to-end gamma of a monitor using a whole set of gamma patches assembled together into the gamma chip chart shown in Figure 10-15. It is an end-to-end gamma test chart that can be displayed on any monitor (yes, even a MacIntosh!) to see directly what the end-to-end gamma is. The chart was made by starting with a 50% gray chip (code value 128) for gamma 1.0 and then a gamma change was made to this gray chip to create each of the other gray chips. The numbers on each chip are the gamma changes for that chip.

Figure 10-15 Gamma chip chart.

To measure the end-to-end gamma of any monitor, just view the chart from about 6 feet away and find which gamma chip best matches the striped section. The number on the matching chip will be the end-to-end gamma of your display system. For a typical video-type gamma you would expect a match around 1.1 or 1.2. For a typical print media setup the match should be around 1.4. When you go to set the monitor gamma on a typical PC you see things like "Monitor Gamma 2.2" or "Monitor Gamma 1.8." We now know that this is the gamma correction being applied to the monitor hardware. If your monitor gamma is what the software manufacturer expects, then the gamma correction will result in the desired end-to-end gamma. The trouble is, the software cannot actually read the monitor gamma so it is working blind.

The only way to know the end-to-end gamma is to measure it, which the gamma chip chart does. Maybe you need a gamma correction of 2.1 to get an end-to-end gamma of 1.1.

Note that the monitor brightness and contrast must be set correctly first or you will get bogus readings. The Production Exercise for this section will walk you through a complete monitor setup along with the gamma chip chart. Also, this chart must not be scaled in size or zoomed in any way because that will average the black and white stripes together, destroying the validity of the thing. We will see shortly how to use this gamma chip chart to set two or more monitors to match each other.

Ex. 10-2

10.5 THE DIM SURROUND EFFECT

This section answers the question of why we don't want linear display devices. When you look at a monitor it only fills a small portion of your field of view. The rest of your field of view is filled with the wall behind the monitor, which surrounds the monitor. If the room lights were adjusted up and down you would notice an interesting perceptual phenomenon. As the scene surrounding the monitor got darker, the picture on the monitor would appear to go flat and lose contrast. As the room lights were brought back up the picture on the monitor would appear to gain contrast. This is formally known as lateral darkness adaptation, and informally as the dim surround effect. The effect is demonstrated in Figure 10-16 and Figure 10-17 where two identical gray patches are surrounded by black and white fields. The dark

Figure 10-16 The gray patches have less apparent contrast.

Figure 10-17 The gray patches have more apparent contrast.

surround of Figure 10-16 makes the two gray patches appear to lose contrast (appear closer in brightness), whereas the light surround of Figure 10-17 makes them appear to have more contrast (greater separation).

If we wanted the picture on the monitor to appear constant as the surrounding room light got darker, we would increase the *end-to-end* gamma of the display steadily as the lights went down. As the end-to-end gamma increased, the picture would increase in apparent contrast, which compensates for the loss of contrast due to the darker surround. Equation 10-2 shows that to increase the end-to-end gamma we must decrease the monitor gamma correction. Because the monitor gamma has a natural darkening effect on the image, reducing the gamma correction causes the picture to get darker. Experiments have been done and standards have been set for the required end-to-end gamma for different surround conditions. It is the dim surround conditions of the viewing environment that determine what the end-to-end gamma should be in a display system.

10.5.1 Dim Surround for TV

The viewing environment for TV in the typical home is considered a dim surround environment. The established best end-to-end gamma for a dim surround is around 1.1 to 1.2. The reason for the vagaries in the range is because homes vary in how dim their dim surround is. It is also hoped that your studio has a similar dim surround for viewing the monitor on your workstation if you are doing television work.

10.5.2 Dark Surround for Film

The viewing environment for film is dark, not dim, and is much more controlled and standardized than home viewing of TV. Recalling the earlier discussion, the darker the surround, the greater the end-to-end gamma required, so you may not be surprised to find out that the end-to-end gamma for movies in a dark surround is 1.5.

10.6 THE GAMMA OF VIDEO

Instead of having gamma correction in every TV set in the world, all video images are precorrected at the video camera to achieve an end-to-end gamma of 1.1 to 1.2. Assuming the CRT in the TV set has a gamma of 2.5, what is the gamma correction that must be applied to the video signal to achieve an end-to-end gamma of (say) 1.125 on the monitor? Solving Equation 10-2 for gamma correction, we get

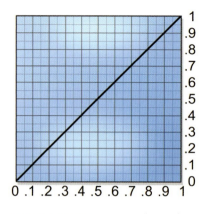

Figure 10-18 Linear gradient shot with video camera.

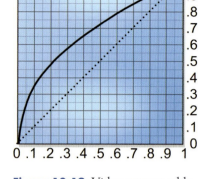

Figure 10-19 Video camera adds 2.2 gamma correction.

$$\text{gamma correction} = \text{monitor gamma/end-to-end gamma} \qquad (10\text{-}3)$$

We can calculate the necessary gamma correction by dividing the monitor gamma by the end-to-end gamma. Using 2.5 as the monitor gamma and 1.125 as the desired end-to-end gamma for the dim surround, the calculated gamma correction required is

$$\text{gamma correction} = 2.5/1.125 = 2.22$$

A gamma correction of 2.22 means that the pixel values are raised to the power of 1/2.22, which is 0.45. A gamma value of 0.45 is less than one, so the image is brightened (see Figure 10-1 if you want to review how this works) at the video camera when the scene is shot. This is very different from other image sources. Those other images are gamma corrected by the work-station with a LUT between the image data and the monitor so as to not alter the original image data. With video, the original image data is altered at the camera with a built-in gamma correction and there is no LUT between the image and the monitor (the TV set). This is the point—video images have a built-in gamma correction of 2.2 (or 0.45 if you are a video engineer) as they come out of the video camera.

Figure 10-18 through Figure 10-21 illustrate the video "gamma gauntlet" from original scene brightness to the display on the TV screen. The scene brightness in Figure 10-18 represents the original scene linear luminance as seen by the video camera. Figure 10-19 shows the in-camera gamma correction of 2.2, dramatically raising the brightness of the midtones of the video images as they come out of the camera. Figure 10-20 shows the TV set monitor gamma of 2.5 that darkens the picture back down. Because the

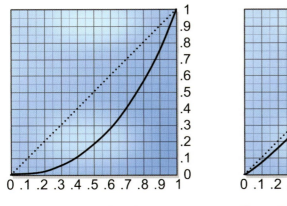

Figure 10-20 TV CRT has monitor gamma of 2.5.

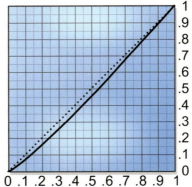

Figure 10-21 Resulting end-to-end gamma of 1.1.

monitor gamma of 2.5 is greater than the camera gamma correction of 2.2, the picture is somewhat undercorrected and therefore more "contrasty" than the original scene because of a resulting end-to-end gamma of about 1.1 as shown in Figure 10-21.

A gamma correction of 2.2 is rather severe and can produce some unpleasant surprises. Note how steep the very low end of the gamma curve is in Figure 10-19. Data in the range of 0 to 0.10 on the horizontal input axis becomes stretched to 0 to 0.35 on the vertical output axis. This great stretching in the darks can introduce banding in the darks of 8-bit images. For films transferred to video it suddenly reveals details in the darks of the negative that were previously hidden. Ever seen an old optically composited space movie such as the "Star Wars—Episode IV" on TV? The spaceships are often surrounded by a moving ghostly rectangular shape. This is the garbage matte from the original optical composite that had just a bit of density difference from the background plate. Projected in the theatre, it was not seen because the print film stock crushed the blacks. Transferred to video the blacks became stretched so much that you can now see their handiwork. The gamma slamming tip offered in Chapter 7 will spare you such future embarrassments.

10.7 THE GAMMA OF FILM

Camera negative film has a gamma of 0.6, whereas the projection print has a gamma of around 2.5. The resulting end-to-end gamma of making a print from a negative is 0.6 * 2.5 = 1.5, which is exactly the desired gamma for the dark surround of film. In fact, the gamma of the film chain is carefully set to the requirements of the dark surround. While the response curve of the negative has a great straight line section where the gamma is a constant

0.6, print film is more complex. As described in Chapter 12, print film has an "S"-shaped response curve. In its short straight line section it can have a gamma of up to 3.0, but overall the gamma of print film is considered to be about 2.5.

 What gamma correction should you use on your workstation monitor for film work? In principle you want an end-to-end gamma of 1.5, just like film, which you will get with a gamma correction of 1.7 (from Equation 10-2, 2.5/1.7 = 1.5). However, there is no guarantee that your film data is not being gamma corrected somewhere in the data pipeline at the film scanner, during conversion, or out to the film recorder. You will have to consult your in-house gamma guru for the house rules on this one.

10.8 SETTING YOUR MONITOR GAMMA

While setting up a monitor is not technically part of compositing, it warrants some coverage here because the monitor setup can have a profound impact on the results of your digital effects shots, especially when it is set up wrong. This section provides some general information about PC, Mac, and SGI monitors, plus a little information on flat panel displays.

10.8.1 PC Monitors

 The default setup of a PC monitor is for video. The operating system lies in a default monitor LUT with a gamma correction of 2.2, which is, as we have seen, the gamma correction for video. The gamma correction of 2.2 combines with the inherent display gamma of the monitor of around 2.5, resulting in an end-to-end gamma of about 1.1 to 1.2.

Many application packages such as Adobe Photoshop allow the user to adjust the monitor gamma. A critical difference between the PC monitor and the TV set is brightness. A typical TV set is much brighter than the typical monitor. If you are going to do work on your PC for video you will want to hook up an NTSC monitor to one of the video outputs that are now on virtually every video card made today.

10.8.2 Mac Monitors

The default setup for a Mac monitor used to be for print, but is now video, like the PC. The older operating system laid in a default monitor LUT with a gamma correction of 1.8, which is more suitable for representing "dot gain," which is sort of the "gamma" of

the print process. This resulted in an end-to-end gamma of about 1.4 for the Mac, making it a darker display than the PC. As a result, an image created on a PC then displayed on an older Mac will appear a bit darker. More recent Macs are set up with a gamma correction of 2.2, which is intended for video like the PC.

The same comment about the PC monitor not being as bright as a TV set applies to the Mac as well. For serious video work you will want to hook up an NTSC monitor to check the appearance of all graphics on TV.

10.8.3 SGI Monitors

The default setup of an SGI monitor is for film. The operating system lays in a default monitor LUT with a gamma correction of 1.7, which combines with the inherent display gamma of the monitor of around 2.5, resulting in an end-to-end gamma of about 1.5, just right for film. The SGI monitor is more "agnostic" about its setup than the PC or Mac and allows the operator easy access to its settings. There is a unix (and linux) utility to alter the monitor gamma from the command line and most application programs also contain their own gamma setting tools.

If you are doing work in film, you probably want the gamma correction set to 1.7, but that is a facility question that depends on the house settings for the film scans. If you are working in video you probably want the gamma correction set to about 2.2 and in print to about 1.8. In either case, send a test image to the target display system (film recorder, video monitor, printing press, etc.) before churning out thousands of images. Also, the TV brightness warning in the PC paragraph given earlier applies to the SGI monitor like any other.

10.8.4 Flat Panel Displays

The various flat panel technologies (plasma, LCD, etc.) are based on very different physics and optics than CRTs and therefore have very different display characteristics. The good news is that they all strive to match the appearance of a CRT display so these differences are essentially transparent to you, the trusting user. Be warned, however, that some flat panel manufacturers are less successful than others in matching the CRT display characteristics so you might want to look into what's called the colorimetry of a display before buying it. You will not be able to simply color correct your images to compensate for any problems because the color distortions will be too complex.

10.9 MAKING TWO MONITORS MATCH

 You may well have two or more monitors that you want to display images on and have them actually appear the same regardless of which monitor they are on. If you don't have a color scientist and a computer service guy, you can still get things pretty close with a few simple steps in this order:

1. Set the color temperature of the monitor appropriately to your work (6500° for video) on each monitor.
2. Set the brightness first, then contrast second on each monitor, and then do not touch.
3. Pick one monitor to be the "reference" for setting the gamma of all the others. Measure its end-to-end gamma with the gamma chip chart shown in Figure 10-15 and write it down. Put the gamma chip chart up on the second monitor and increase or decrease the monitor gamma correction until you get the same end-to-end gamma reading as the reference monitor.

 If you do not want to alter the gamma correction of a workstation monitor for some reason you could instead develop a gamma correction that is applied to all images displayed on that station. First, select the reference monitor you want to match to and determine its end-to-end gamma. Let's say it's 1.4. Next, display the gamma chart on a second workstation and apply a gamma correction to the gamma chart image using the compositing software until it shows a match for the 1.4 chip. Let's say a gamma correction of 0.8 makes the 1.4 chip match. If you now apply a gamma correction of 0.8 on any image displayed on the second workstation it should now match the reference station.

Film is a wonderfully simple medium in concept. A shutter flicks open for a fraction of a second and a frame of film is exposed, capturing a moment of time in full color. If something happens to be moving, it naturally leaves an agreeable streak on the film to signal its motion. Video is not nearly so simple. Video suffers from a desperate need to pack the maximum picture into the minimum signal so it can be broadcast over the airwaves. All of the moving pictures must be squeezed into a single rapidly gyrating radio wave. This one fantastically high-pitched wave must carry a black and white picture, an overlay of all of its color, and a little sound track tucked in on the side.

While one frame of video is packed into a tiny fraction of the space of a frame of film, it still looks surprisingly good. This is because the scientists and engineers that designed our modern video system very carefully placed the maximum picture information into the same parts of the visual spectrum as the most sensitive parts of human vision. There is a flurry of picture information wherever the eye can see fine detail. Where the eye is nearly blind, there is almost none. While brilliant in concept and execution, all of these compression techniques come at a price. They introduce artifacts.

Compared to an equivalent frame of film, each frame of video is degraded in a variety of subtle ways, both spatially and temporally, as carefully calculated sacrifices to data compression. These artifacts and defects are all neatly tucked away into the visual "corners" of the human perception system, but emerge to haunt you when the video is digitized and you try to manipulate it. Understanding the cause of each of these artifacts and how to compensate for them is the subject of this chapter.

11.1 GETTING VIDEO TO AND FROM A WORKSTATION

You might get video from the client already digitized as a QuickTime movie (.mov file), YUV files, or as sequential tiffs loaded on a firewire drive or a data tape of some kind. In this case you are good to go as soon as they are loaded onto your hard drive. However, the client might just hand you a video tape, in which case it will have to be converted to files on a disk drive before you can work with it.

The video tape that the client gives you could be analog or digital. Either way, it must become a digital image file on your workstation before you can do anything with it. There are two general approaches to getting the frames from tape to workstations. The first method is to use a digital disk decorder

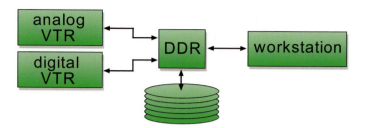

Figure 11-1 Video route with DDR setup.

(DDR). The DDR is little more than a high-speed disk drive with some video circuitry. The video route using a DDR is shown in Figure 11-1. A video tape recorder (VTR) is connected to the DDR to play the video tape. The tape is played at normal speed, and the video images are laid down on the disk drive of the DDR in real time. A 10-second shot takes 10 seconds to lay off. The DDR will have two inputs, one for digital VTRs, such as D1, and the other for analogue VTRs, such as BetaSP. The analogue input will digitize the incoming video, whereas at the digital input it is already digital and just needs to be routed to the disk.

Once the video frames are on the disk of the DDR, they can be transferred to the workstation as ordinary files over a network, such as Ethernet. When the shot is completed the frames are transferred back to the DDR over the network like any file. The transfer command includes information as to where on the DDR you would like the frames to be located. After the finished frames have all collected themselves on the DDR, the shot can be played back and viewed on a monitor in real time for review and then simply dubbed off to video tape on the same VTR that was used to load them on.

The video capture card video route is illustrated in Figure 11-2, which is a lower cost setup than a DDR. A special video card is installed in the workstation that is capable of digitizing incoming analog video in real time. If the input is digital video, it is simply routed to the workstation disk drive. Once the video frames are on the disk drive, they are available for compositing. When the finished shot is ready to go back to video tape the video

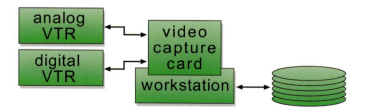

Figure 11-2 Video route with video capture card.

capture card can send the frames back to the tape recorder. Again, if it is an analog recorder, it will convert the digital files to analog for the VTR.

11.2 HOW VIDEO WORKS

Video is such a hideously complex medium to work with that simply memorizing a few rules or guidelines will not work. To be truly competent, you must actually understand it. This section describes how the video frame is put together in space and time and the artifacts that this introduces when trying to work with video. This background information is essential for understanding the rest of the chapter, which addresses the practical issues of how to deal with or work around those artifacts. After the operational principles of video are laid out, the differences between NTSC and PAL are described, as they both use the same principles with just minor variations in frame size and frame rate.

The effort here is to avoid the usual video technobabble and just describe the aspects of its operation that actually affect the digital manipulation of video images. It is video as seen from the digital compositor's point of view. As a result, it is mercifully incomplete. Knowing that it was invented by Philo T. Farnsworth and is encoded on a 3.58-megahertz subcarrier will not help you to pull a matte or resize a frame. Knowing how field interlacing works or how to compensate for the nonsquare pixels will. Everything you need to know, and nothing you don't. Let us begin.

11.2.1 Frame Construction

This section describes how a frame of video is constructed from interlaced fields and the troublesome effect this has on the motion blur of moving objects. This is essential information for understanding why and how to deal with interlaced images. How the pixel data is formed is also described because it is not a simple red, green, and blue data value for each pixel, even though when viewing a frame of video on your monitor it appears that you have typical RGB data. This has important implications for the amount of detail when pulling a matte.

11.2.1.1 The Scanning Raster

In this first approximation of the video frame we introduce the concept of an idealized scanning raster. While film opens a single shutter to expose the entire frame at once, video is forced to peel the picture out serially one pixel at a time because it is being broadcast over a single carrier wave to the home

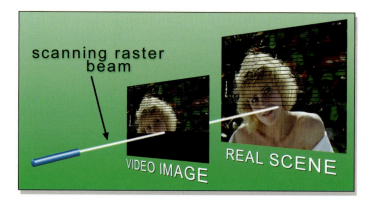

Figure 11-3 Digitizing a scene to video with a scanning raster beam.

TV receiver. It's like building up the scene a pixel at a time by viewing it through a tiny moving peephole as in Figure 11-3.

Real TV cameras, of course, do not physically scan scenes with raster beams. The image is focused on the back of the video capture tube and there it is scanned digitally with a moving "raster." The following description, then, is a helpful metaphor that will illuminate the problems and anomalies with interlacing and motion blur that follow.

The raster starts at the upper left-hand corner of the screen and scans to the right. When it gets to the right edge of the screen it turns off and snaps back to the left edge, drops down to the next scan line, and starts again. When it gets to the bottom of the frame the raster shuts off and snaps back to the upper left-hand corner to start all over again.

This simple first approximation is not practical in the real world because it generates too much data to be transmitted over the limited bandwidth of the video carrier wave. A way had to be found to reduce the amount of trans-mitted data that would not degrade the picture too much. Simply cutting the frame rate in half from 30 to 15 fps would not work because the frame rate would be so slow it would introduce flicker. To solve this little problem, the clever video engineers at NTSC introduced the concept of "interlaced" video where only half the picture is scanned on each pass, reducing the demands on the electronics and the signal bandwidth for broadcast. But this "half the picture" is not half as in the top or bottom half, but half as in every other scan line.

11.2.1.2 Interlaced Fields

Interlacing means that it takes two separate scans of the scene, called "fields," which are merged together to make one "frame" of video. Field 1 scans the entire scene from top to bottom, but only the odd scan lines. Starting with

the first scan line of active video (ignoring vertical blanking and other scan line activities that have nothing whatsoever to do with the picture as seen on your monitor), it then scans lines 3, 5, 7, 9, and so on to the bottom of the frame. The raster snaps back to the top for field 2 and rescans the entire scene from top to bottom again, but only the even scan lines, starting with line 2 and then 4, 6, 8, and so on. These two fields are then merged, or interlaced together on the TV screen to form a complete video frame.

Figure 11-4 illustrates how field 1 and field 2 are interlaced (merged) to make a full video frame. The number of scan lines has been reduced to just 28 for clarity. If the field 1 and field 2 pictures in Figure 11-4 were slid together, they would fill in each other's blank lines to make a full picture. The reason this does not flicker is due to the persistence of vision. Each field stays glowing on the screen for a few milliseconds after it has been drawn by the raster, fading slowly (electronically speaking). So while field 1 is fading away, field 2 is being drawn between its scan lines. While field 2 is slowly decaying the next field 1 writes between its scan lines, and so on. These interlaced fields rapidly replace each other and blend together to form continuous motion to the eye.

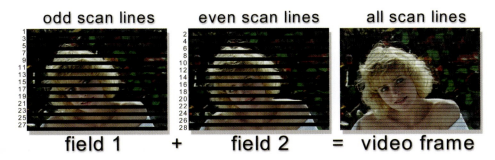

Figure 11-4 Even and odd scan lines of field 1 and field 2 combine to make one video frame.

11.2.1.3 Effects on Motion Blur

Interlacing even and odd fields was a wonderful ploy to cut down on the required bandwidth to broadcast the TV picture, but it brought with it some hideous artifacts. One example is the motion blur on moving objects. Think about it. With film, the shutter opens, the object moves, and it "smears" across the film frame for the duration of the shutter time. Simple, easy to understand, and looks nice. With video, there is a continuously scanning raster spot that crosses the moving object many times *per field*, and with each crossing the object has moved to a slightly different location. Then it starts over again

to scan the same frame for the next field but the object is in yet another whole place and time. The key point here is that each field of a video frame represents a slightly different "snapshot" in time. Suffice it to say, this results in some rather bizarre motion blur effects on the picture. This all works fine when displayed on an interlaced video system, but creates havoc when trying to manipulate the fields digitally while integrated as static frames.

Let's take a look at how horizontal motion blur works with interlaced video fields. Figure 11-5 illustrates a simple ball moving horizontally, which we will "photograph" in motion with both film and video to compare. With film, the motion of the ball with the shutter open "smears" its image horizontally, as shown in Figure 11-6. A simple and intuitive result. With interlaced video, the ball is captured at two different moments during the video frame, appearing in two places. Worse, the two images are split between odd and even lines so the odd set of lines (field 1) shows the ball at an earlier moment and the even lines (field 2) show the ball at a later moment as shown in Figure 11-7. It's like looking at the scene twice through a venetian blind that somebody is shuttering open and closed.

Figure 11-5 Object moving horizontally.

Figure 11-6 Film motion blur.

Figure 11-7 Interlaced video fields motion blur.

Taking the next case, let's look at vertical motion blur as seen by film and video. The original ball moving vertically is depicted in Figure 11-8. Its film version can be seen in Figure 11-9 with a nice vertical motion blur, similar to the film motion blur of the horizontal ball. But once again, the interlaced video fields present some bizarre anomalies shown in Figure 11-10, and for the same reason as the horizontal example given earlier. The ball was "snapshot" twice each frame in a slightly different position, and the two snapshots were interlaced by even and odd lines. When it comes time to operate on these images, these interlace artifacts must be addressed properly or the results will be truly hideous.

Figure 11-8 Object moving vertically.

Figure 11-9 Film motion blur.

Figure 11-10 Interlaced video fields motion blur.

11.2.1.4 Field Dominance

While this may sound like an unnecessary techno-video detail, believe me, if you ever get it wrong on a project you will be so glad that you know about it. You will be able to turn calamity into heroism with practically just a flick of a switch. We saw in the previous section how field 1 is interlaced with field 2 to make a full frame of video. But a video camera is a continuously running device. In point of fact, it is not putting out full "frames" but continuous alternating fields. The only thing that distinguishes field 1 from field 2 is whether they start on even or odd scan lines. To the eye, it is a continuous series of fields and which is even or odd makes no never mind. This means that you could just as easily make a video frame from a field 2 followed by the next field 1. Nothing in the normal video pipeline would be harmed by this, until you digitized the video to a workstation, that is.

When the video is digitized to a workstation it is no longer a continuous stream of fields. The video fields are now "frozen" and paired together to make video frames. Normally, each video frame would consist of a field 1 followed by the next field 2, as shown in Figure 11-11. This is called field 1 dominance. If, however, you delayed the digitizing until the start of field 2, each video frame would now consist of a field 2 followed by the next field 1. This would be field 2 dominance. These field 2 dominant frames would look fine on your workstation because you are not viewing them with an interlaced video monitor. Your workstation monitor is a progressive scan, meaning that it scans

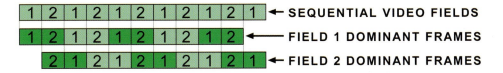

Figure 11-11 Field dominance.

every scan line from top to bottom once. Even a local "movie" played on your workstation will look fine, until you send it back to the video monitor.

When images are sent to a DDR the scan lines are laid down just like they are on your system. The top scan line, being odd, goes to field 1, and the second scan line, being even, goes to field 2, and so on. The problem here is that the system assumes that the field 1 of each frame is the field 1 that comes *before* the field 2 of that frame, not after. If your digitized video was field 2 dominant, each field 1 actually belongs to the following frame of video, which is a moment *later* in time rather than a moment *earlier*. The transfer utility that sends the frames from your workstation to the DDR knows nothing of this and assumes the field 1 comes before the field 2, not after. As a result, the two fields get swapped in time on the DDR. When you play the video, any motion in the picture has a wildly jerky appearance because the action is literally taking two steps forward followed by one step backwards, which is a calamity of the first order.

 To confirm that you have field dominance problems, put the DDR in single field mode and single step through the video to follow the action. The motion will literally take one step forward and then one step backward. This is your conclusive test. Now you get to be the hero. Announce to your stunned clients and colleagues that there is simply a field dominance problem and you will have it fixed shortly. The fastest and simplest fix is to switch the field dominance in the utility that transfers the frames from your workstation to the DDR. If that is technically or politically impossible, then the original video will have to be transferred to your workstation again with the dominance switched.

11.2.1.5 Color Resolution

You might reasonably think that when you are looking at a 720×486 frame of NTSC video in RGB mode on your workstation that you have 720×486 pixels of red, green, and blue. Of course, that would be wrong. Again, the contortions here are another data compression scheme to again reduce the bandwidth required to broadcast the picture. It is based on the observation that the eye is much more sensitive to detail in luminance (brightness) than it is to color. Why pack more color information into the image than the eye can see?

To take advantage of the reduced sensitivity of the eye to color, the RGB image in the video camera is converted into another form upon output called YUV.

Nomenclature disclaimer

The truth is that for NTSC the correct signal name is YIQ and for PAL it is YUV. However, in computer land the label YUV has been misapplied to NTSC so much that it has stuck. Rather than confusing everybody by insisting on using the correct term, we will go with the flow and refer to it as YUV, but you and I know wherein lies the truth.

It is still a three-channel image, but instead of one channel for each color the YUV channels are mathematical mixes of the RGB channels. The "Y" channel is luminance only, what you would get if you took an RGB image and converted it to a grayscale image. All of the color information is mixed together in a complex way and is placed in the "U" and "V" channels, which are then referred to as "chrominance." The hue is *not* stored in one channel and the saturation in the other. One channel carries the hue and saturation for orange–cyan colors, while the hue and saturation for yellow–green–purple are in the other.

Now that the video signal is converted to one channel of luminance and two channels of chrominance the data compression can begin. Since the eye is most sensitive to luminance, it is digitized at full resolution. Since the eye is less sensitive to the chrominance part of the picture, the two chrominance channels are digitized at *half-resolution*. The digitizing of these three channels is referred to as 4:2:2, which are four samples of luminance for every two samples of one chrominance channel and two samples of the other chrominance channel. This means that a YUV frame consists of a luminance channel that is full resolution, plus two chrominance channels at half-resolution in the horizontal direction. This results in a full frame of picture with the equivalent of just two channels of data, instead of three channels, like true RGB image formats. This lightens the data load by one-third, equivalent to a data compression of 1.5 to 1.

Figure 11-12 illustrates the difference between a true RGB image and a YUV image. A short "scan line" of four pixels is illustrated for each. For the RGB image, all four pixels have unique data values in each channel. The YUV image does not. The Y (luminance) channel has four unique pixel values, but the U and V channels only have two data values each to span the four Y pixels.

This is obviously a bad omen for any chrominance (color)-based operation, such as pulling a bluescreen matte, for example. The matte will have a

Figure 11-12 Color resolution of RGB vs YUV.

serious case of the jaggies. The situation is not quite as bad as it seems from Figure 11-12, however. Because the Y channel is full res, when a YUV image is converted to RGB each pixel does inherit some detail from it across all three channels. But this detail is a mathematical interpolation rather than the result of a direct digitizing of the original scene so there is lost information and therefore a loss of detail. A picture photographed with a film camera and then digitized to 24 bits RGB and resized to video resolution will contain more fine detail than a $4:2:2$ YUV version converted to RGB, even though they are both the same resolution and file size. You can't fool Mother Nature.

As we have seen, the $4:2:2$ sampling described previously has four samples of luminance for every two samples of the chrominance components of the video signal. Of course, there are other sampling schemes out there. To reduce the amount of video data further, some video systems use $4:1:1$ sampling. There is also a $4:2:0$ and even a $4:1:0$ (gasp!). It would be pointless and tiresome to go into the differences between these sampling schemes, as it would not improve your digital effects shots one iota. Suffice it to say that they get progressively uglier as they go down in their sampling rates and that you would like to get as high a sampling rate as possible as your video source. Of course, if the video was captured with $4:1:1$ sampling it would do absolutely no good to dub it over to a $4:2:2$ video format. But you probably knew that.

11.2.1.6 Time Code

Professional video standards have a continuously running time code embedded with the video images on a separate track in the format

hours:minutes:seconds:frames. One problem you may have is that while your version of the video is digitized frames on disk that are numbered from one to whatever, the client will constantly be referring to the time code.

 It is possible to make a list of the time code that was digitized as frame one of a shot and then do some messy math to figure out what frame they are talking about, but a better approach is to ask to also be given a "window burn" of the shot. The window burn is a video tape dub that has the video time code printed (burned) into the picture of each frame and it looks something like this:

03:17:04:00* typical video time code

This reads as "hour 3, minute 17, second 04, frame 00" (yes, they number their frames from 0 to 29). There will also be a little "tik mark" (shown here as an asterisk) that varies from manufacturer to manufacturer to mark field 1 and field 2.

11.2.1.7 Drop Frame Time Code

While your head is still reeling from the concept of video time code, this would be a good time to hit you with the fact that there are actually *two* kinds of time code—drop frame and nondrop frame—and you need to be clear on which one you and the client are using.

The problem is that video does not run at exactly 30 frames per second (fps). It actually runs at 29.97 fps due to yet another obscure technical issue with video. It seems that years ago when they went to add color to the original black and white TV signal at exactly 30 fps there were some harmonics of the new color signal that beat against the audio subcarrier causing scratchy noises in the audio. To fix this little problem they shifted the frequency of the entire video signal ever so slightly so the harmonics would no longer clobber the audio. The amount they shifted the video signal was small enough that it was still in spec for the old black and white TV's, but the video now ran at 29.97 fps rather than 30 fps. TV viewers did not seem to notice that the video was running slow by one part in a thousand.

However, this clever little fix introduced another problem that required yet another clever little fix (this video stuff just gets better and better). The new problem was that the video time code continuously drifted out of sync. Remembering that each frame of video has its own time code so it is actually counting frames, not real time, consider what would happen after just 5 minutes. At 30 fps, 5 minutes would be exactly 9000 frames, but at 29.97 fps there would only be 8991 frames. We are 9 frames short in only

5 minutes. Think of the lost advertising revenue in a 1-hour show! To fix this little problem they skip (or "drop") a total of 9 time code numbers (not video frames) spread out over the 5 minutes so the time code will keep up with clock time. There is a complex rule that is used to figure which time codes are dropped that comes out to about one every 30 seconds or so, but the actual rule is not important here.

So how does this affect you? Two ways. First, when the client delivers a video tape you need to ask if it is drop frame or nondrop frame because it slightly changes the total number of frames you have to work with. Two tapes of the same run time, one drop frame and the other nondrop frame, will be off by two frames after 1 minute. This variable timing issue will also wreak havoc if you mix drop and nondrop video elements and then try to line them up based on their time codes. The second issue is that whenever you are going to deliver a video tape to the client you should always ask if he wants drop frame or nondrop frame time code.

Proper digital effects protocols require that a nondrop frame time code is used throughout. The reason is that drop frame is only needed for broadcast, and working with illogical drop frame is very confusing for us logical digital types.

11.2.2 NTSC and PAL Differences

NTSC is American and PAL is European. They both operate under the principles described earlier, but there are important differences in the number of scan lines in a frame, their frame rate, and their pixel aspect ratios. Yes, video pixels are not square so video frames become distorted when displayed on the square pixel monitor of your workstation.

11.2.2.1 Frame Rate

11.2.2.1.1 NTSC

NTSC video runs at 30 frames per second, consisting of 60 interlaced fields per second. Well, sort of. Like all things video, there is more to it than that. As shown earlier, it really runs at 29.97 frames per second. What effect does this have on you? Practically none. You just have be clear on whether the client's video is drop frame or nondrop frame time code.

11.2.2.1.2 PAL

PAL video runs at exactly 25 frames per second, consisting of 50 interlaced fields per second. There is no drop/nondrop frame time code issues with PAL because it runs at exactly the advertised frame rate.

11.2.2.2 Image Size

11.2.2.2.1 NTSC

A digitized NTSC frame is 720 × 486. That is to say, each scan line is digitized to 720 pixels, and there are 486 active scan lines of video. In truth, of the 720 pixels, only 711 are picture and the remaining 9 are black. For the sake of simplifying all calculations, we will assume all 720 pixels are picture. This introduces an error of only around 1%, which is far below the threshold of visibility in video. The aspect ratio of the NTSC image as displayed on a TV screen is 4:3 (1.33).

11.2.2.2.2 PAL

A digitized NTSC frame is 720 × 576. That is to say, each scan line is digitized to 720 pixels, and there are 576 active scan lines of video. In truth, of the 720 pixels only 702 are picture and the remaining 18 are black. For the sake of simplifying all calculations, we will assume all 720 pixels are picture. This introduces an error of only around 1%, which is far below the threshold of visibility in video. The aspect ratio of the PAL image as displayed on a TV screen is 4:3 (1.33).

11.2.2.3 Pixel Aspect Ratio

If you calculate the image aspect ratio based on the image size data given earlier for video frames, you will get a rude surprise. While both PAL and NTSC video images are supposed to have an aspect ratio of 1.33, when you do the math for NTSC you get an aspect ratio of (720 ÷ 486 =) 1.48, and for PAL you get an aspect ratio of (720 ÷ 576 =) 1.25. This is because neither PAL nor NTSC have square pixels! However, your workstation does have square pixels, which introduces a number of messy problems. This section describes how the nonsquare pixels work; how to deal with them will be covered later in Section 11.5.4, "Nonsquare Pixels."

11.2.2.3.1 NTSC

The aspect ratio of a pixel in NTSC is 0.9. That is to say, the pixels are 10% narrower than they are tall. Here's the story. The video frame has a very specific number of scan lines—exactly 525, of which exactly 486 contain picture, which is what we work with and therefore all we care about. One cannot arbitrarily increase or decrease the digitizing resolution vertically—there must be exactly one scan line of data to one scan line of video. There are no such

hard barriers horizontally, however. The original analog video signal could be digitized horizontally at any desired resolution, limited only by the speed of the hardware. It was decided to digitize each scan line to 720 pixels as the best compromise between limiting data bandwidth and visual sufficiency.

This means, however, that the video is digitized more finely horizontally than vertically. If the horizontal digitizing resolution matched the vertical resolution to make square pixels, then each scan line would be digitized to about 648 pixels instead of 720. None of this causes a problem until you display a video image on your workstation monitor. When you do, the image suddenly stretches 10% horizontally.

Figure 11-13 illustrates what happens when a video image with nonsquare pixels is displayed on a workstation monitor that has square pixels (all effects have been exaggerated for the sake of illustration). Note how the circle on the video monitor on the left was perfectly round, but becomes stretched when displayed with the square pixels of the workstation. This stretching of the image has a couple of implications, which are also addressed in Section 11.5.4, "Nonsquare Pixels."

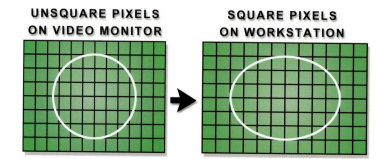

**UNSQUARE PIXELS
ON VIDEO MONITOR**

**SQUARE PIXELS
ON WORKSTATION**

Figure 11-13 NTSC image stretches 10% horizontally when viewed on a workstation monitor.

11.2.2.3.2 PAL

The aspect ratio of a pixel in PAL is 1.1. That is to say, the pixels are 10% wider than they are tall. PAL is digitized to the same 720 pixels that NTSC is, but it has 576 scan lines of picture compared to the 486 of NTSC. When placed on a video monitor, the PAL image is "squeezed" vertically, making its pixels wide. NTSC is squeezed horizontally, making its pixels tall. When a PAL image is displayed on the square pixel display of a workstation monitor it stretches vertically, which would make the circle in Figure 11-13 tall and skinny.

11.2.2.4 Country Standards

There are basically three world television standards distributed roughly by the political affiliations of the inventing countries. NTSC, invented in America, is prevalent in countries that are our neighbors and allies. PAL was invented in Europe and so is most prevalent there. The French, of course, had to develop their own television standard (SECAM) to preserve and protect their cultural uniqueness. The old USSR, unable to develop their own, opted to adopt the French SECAM format because of its singular virtue of being neither American nor European. You see, France is not really European. It's France.

Following is a partial list for ready reference of the most prevalent countries that you might be doing business with. If you find yourself doing effects for Zimbabwe, you will have to look them up in a world television standards reference.

NTSC—America, Japan, Taiwan, Canada, Mexico, most of Central and South America.
PAL—United Kingdom, Australia, China, Germany, Italy, and most of Europe.
SECAM—France, Russia, and most of the old communist world.

11.2.3 Types of Video

In addition to the exciting challenges offered by interlaced fields and non-square pixels, video also comes in a variety of types. Component video is better because it contains more information for digital manipulation. Composite video is necessary for broadcast. Some video formats are digital, whereas others are analog. Here we define each of these types with just enough depth to enable you to understand the various video *formats*, which is the topic of the following section. I told you video was hideously complex. Did I lie?

11.2.3.1 Component Video

A video camera shoots a scene as an RGB image internally but converts the video to YUV upon output for video taping as described in Section 11.2.1.5, "Color Resolution." When the video is in this format it is referred to as *component* video because the video is separated into its luminance and chrominance *components*. In fact, this is the form of video we have been discussing all along. It is the highest resolution of video data and is the best for digital compositing.

11.2.3.2 Composite Video

Component video is unsuitable for broadcast because it is a three-channel format. It needs to be encoded into a single-channel format so it can be used to modulate a single carrier wave for broadcasting. When component video is encoded into a single channel like this it is referred to as *composite* video because it is a composite of the three components. This encoding process is yet another data compression scheme, and it both introduces artifacts and degrades the quality of the picture yet again compared to the original component version.

For composite video to be digitized for a workstation it must first be decoded through a transcoder to convert it back to component (YUV) and then converted to RGB. The resulting RGB image does not have the sharpness and color detail of the original component version.

11.2.3.3 Digital and Analog

Not only does video come in component and composite formats, but there are analog and digital versions of each. The video signal in an analog format is laid down on tape as a continuously oscillating analog signal from the video camera somewhat like an audio tape cassette. In order to become digitized to a workstation, the analog tape deck is connected to the analog inputs of a DDR, which digitizes the video to its disk as it is played. This digitized form can then be converted to RGB and sent to the workstation. Successive copies (dubs) of an analog tape degrade with each generation, and digitizing the tape several times will produce slightly differing results each time due to variations in reading the analog signal with each playing.

For a digital video format the video signal is laid down on tape as digital data, somewhat like a computer data tape. The magnetic medium of the tape only records a series of ones and zeros instead of the continuously oscillating signal of the analog formats. When a digital tape is laid off to a DDR it is connected to the digital inputs and the data is simply copied from the tape to the DDR. Successive copies (clones) of a digital tape do not degrade with each generation, and laying the video down to a DDR several times will produce identical results because it is simply copying the same digital data with each playing.

In reality, of course, digital tape formats are not totally flawless and unlimited clones cannot be made. The truth is that errors on the magnetic tape do occur so digital formats include robust error detection and correction/concealment operations. When an error is detected the error correction logic attempts to reconstruct the bad pixel from error correction data on the tape.

If that fails, the error concealment logic takes over and creates a replacement by averaging adjacent pixels. This, of course, is not an exact replacement of the bad pixel, but is designed to go unnoticed.

11.2.4 Video Formats

Here is where we pull it all together to get specific about the most prominent video formats that you are likely to encounter. They are described in terms of being component, composite, analog, or digital, plus a few words on their intended applications and how good the picture quality is for compositing. Standard definition (Std-Def) is what we have been referring to as NTSC and PAL, whereas high definition (Hi-Def) is the new high-resolution digital video format that will be defined shortly.

11.2.4.1 All-Digital Formats

This is a listing of the major all-digital professional video tape formats. There are several manufacturers that make various models of these video tape machines.

D1—A component digital format using a 19-mm-wide tape. This is the current standard for studio and postproduction work where extra data precision is needed to retain quality while being manipulated digitally.
D2—A composite digital format using a 19-mm-wide tape. This is the current standard for television production and broadcast that accepts analog and digital inputs. The analog input is digitized internally. Output is both analog and digital.
D3—A composite digital format using half-inch-wide tape that accepts analog and digital inputs. The analog input is digitized internally. Output is both analog and digital.
D4—No such format. Legend has it that Sony, being a Japanese company, decided to skip this model number since the number 4 is unlucky in Japanese culture, rather like the number 13 in Western cultures.
D5—A component digital format using half-inch-wide tape that supports NTSC and PAL standards. It also has an HDTV mode with about a 5:1 compression. In the HDTV mode the frame size is 1920 × 1080 with square pixels.
D6—An uncompressed HDTV interlaced and progressive scan format using a 19-mm-wide tape. Its use is primarily for electronic theater projection. The frame size is 1920 × 1080 with square pixels.

11.2.4.2 Sony

Sony struck off on its own and developed its own video tape standards referred to as the "beta" format. They are all component formats for professional applications.

Beta—An analog component format using half-inch-wide tape. It has fair quality and is used mostly for electronic news gathering.

BetaSP—An analog component format using half-inch-wide tape. It is a higher-quality version of the beta format. It is a very good quality source of video for an analog format.

DigiBeta (digital beta cam)—A digital component format using half-inch-wide tape. It is a high-quality source of video, even though it has about a 2 : 1 data compression.

11.2.4.3 DV Formats

A new generation of video cameras and recorders have appeared that have in common that they output digital video, which is then data compressed as MPEG-2 before it goes down to video tape. This allows for larger frame sizes, smaller tape stocks, and compression artifacts.

DVC-PRO—A Std-Def digital component format using a compression ratio of 5 : 1 with a 4 : 1 : 1 sampling rate. DVC-PROP is a Std-Def progressive scan using 4 : 2 : 0 sampling, and DVC-PROHD is the Hi-Def version.

DV-CAM—A Std-Def digital component format using a compression ratio of 5 : 1 and 4 : 1 : 1 sampling.

HD-CAM—A Hi-Def digital component using a 7 : 1 compression ratio and 4 : 2 : 2 sampling. Has a Std-Def recording mode without compression.

11.2.4.4 Consumer/Commercial

These formats are for the home consumer or the industrial commercial market. None of these formats is suitable for broadcast work. Nevertheless, a client may provide them anyway because it is all they have.

VHS—The standard analog composite format for the consumer using a half-inch-wide tape. Low quality.

SHVS—An analog component format for high-end consumer or commercial applications using half-inch-wide tape. Being a component format, it is higher quality than plain VHS.

U-Matic—An ancient analog composite format for commercial applications using a three-fourths-inch-wide tape. Low quality, but better than VHS.

DV—A digital component format for high-end consumer and low-end commercial applications using 8-mm-wide tape. It uses a very effective DCT (discrete cosine transform) compression scheme. It has the best quality of the nonprofessional standards.

11.3 HI-DEF VIDEO

So far the video discussion has been about what is referred to as standard definition (Std-Def) video. However, high-definition (Hi-Def) video is rapidly advancing in the television industry and even making inroads into feature film production. This means that whether you work in film or video, today's able artist must also be prepared to do digital effects shots in Hi-Def. While Std-Def has its NTSC and PAL versions, at least each version is locked down as to frame size, scan mode, and pixel aspect ratio. Hi-Def, however, is a *family* of standards with three different scan modes, two image sizes, and three frame rates that can be mixed and matched to make a bewildering array of combinations.

The good news, however, is twofold. First, all Hi-Def formats have square pixels (joy!). Second, you are likely to encounter only a few of the many possible combinations of Hi-Def. Even if you encounter an obscure format one day, your newfound understanding of the principles behind Hi-Def video formats gleaned herein will allow you to cope easily.

11.3.1 Picture Aspect Ratio

Along with square pixels, the picture aspect ratio (ratio of width to height) is one of the few constants in the Hi-Def standard. All Hi-Def pictures, regardless of their dimensions, have an aspect ratio of 16 × 9 (16 by 9) whereas Std-Def has an aspect ratio of 4 × 3. The reason for the change in aspect ratio is to make the new Hi-Def video more compatible with feature films, which are wide screen (see Figure 11-14). Film folks may refer to the 16 × 9 picture aspect ratio by its floating point name, 1.77 or perhaps 1.78, depending on how mathematically faithful they want to be rounding off the decimal places (16 ÷ 9 = 1.7777777 . . .). This is in keeping with the film practice of referring to their picture aspect ratios as 1.66, 1.85, 2.35, etc.

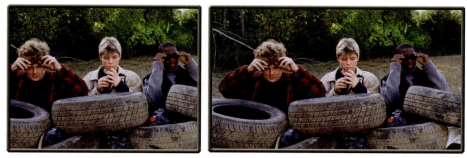

Std-Def 4x3 aspect ratio **Hi-Def 16x9 aspect ratio**

Figure 11-14 Comparison of Std-Def and Hi-Def aspect ratios.

11.3.2 Image Size

The ATSC (Advanced Television Standards Committee) has defined the various image sizes for digital television, which includes both Std-Def and Hi-Def. The two image sizes for Hi-Def are 1920×1080 and 1280×720. If you do the math you will find that both of these have an aspect ratio of 1.78 (16×9). In Hi-Def speak when you want to refer to the 1920×1080 image size you can just refer to it as "1080." Similarly the 1280×720 size is referred to as "720." Because the aspect ratio is locked to 16×9, stating just the number of scan lines unambiguously defines the image width.

11.3.3 Scan Modes

Tragically, the Hi-Def standards still support an *interlaced* scan mode that has two offset fields just like the interlaced scanning described in Section 11.2.1.2. Fortunately, it also supports a *progressive* scan mode as well, which is becoming wonderfully popular for reasons we shall see shortly. Progressive scanning works just like you might imagine it—the raster starts at the top left corner of the screen and scans a horizontal line from left to right, drops down to the next line and scans it left to right, and so on until it reaches the bottom of the frame. It conceptually models what a camera shutter does when exposing film in that each frame represents one moment in time with the appropriate motion blur for moving objects.

Technically there is a third scan mode called the progressive scan segmented frame, or PsF. It was designed to allow progressive scan video to be compatible with existing interlaced video gear and monitors. The good news is that the interlacing is all internal and what you get is a nice clean progressively scanned video frame so you can ignore it.

11.3.4 Frame Rates

Hi-Def video supports three frame rates: 60, 30, and 24 fps. In the real world, however, you are only likely to encounter the 30- and 24-fps frame rates.

11.3.5 Naming Conventions

Now, when someone wants to describe to you what kind of Hi-Def video you are going to be given for an effects shot, it takes three parameters to define it completely. You need the image size (in scan lines), the scan mode, and the frame rate. The naming convention is

[number of scan lines] [scan mode] [frame rate]

For example, video that was 1920 × 1080 with an interlace scan at 30 frames per second would be written as 1080i30. Another example of 1920 × 1080 with a progressive scan at 24 frames per second would be written as 1080p24. However, as often happens, a shorthand has evolved. Today the 1080i30 is most likely to be referred to as just "30i," while the 1080p24 will be shortened to "24p." While this does leave the number of scan lines unspecified, the assumption is that it must be 1080 scan lines because, I guess, nobody in their right mind would ever actually use the 720 scan line format.

11.3.6 The Mighty 24p Master

Of all the possible Hi-Def formats, the industry is converging on 24p (1080p24) as the "mastering" format. When a feature film is transferred to video, it is done using the 24p format. When Hi-Def video television shows are video taped and edited this too will usually be done at 24p. The reason is that from a 24p master all other versions and sizes can be generated quickly and easily with no loss of quality. Because it isn't interlaced, it has none of the messy problems associated with deinterlacing. It is the largest format so any other version would be the same size or smaller. It runs at 24 fps so it is immediately compatible with 24 and 25 fps systems and is converted easily to 30 fps.

To make the normal 30 fps interlaced version for Std-Def broadcast one need only "downconvert" the image to the smaller size and add a 3:2 pull-down (described in the next section), just like transferring film to video. To make the DVD version the 24p is simply downconverted to Std-Def size and left at 24p. If a 3:2 pulldown were added the DVD compressionist would

just have to pull it out. To make a PAL version the 24 fps version is simply transferred to PAL video at the PAL frame rate of 25 fps. This speeds up the show by 4%, but this is exactly what is done with film and nobody notices the tiny speed change. Of course, the sound track has to be adjusted by the same 4%, but that's easy.

11.3.7 Anamorphic Video

The makers of DVDs wanted to market to all those new wide screen TV owners so they cooked up an anamorphic (squeezed horizontally) video format that looks better on Hi-Def TV sets than the usual letterbox format. These DVDs might be labeled as "enhanced for wide-screen TV" or "enhanced for 16 × 9" or some such similar description. The standard letterbox format has these great black bars at the top and bottom of the screen, wasting screen space, whereas the anamorphic format fills the entire video frame with picture information. As a result, the Hi-Def TV gets a noticeably better picture from the DVD than with letterbox. You just might be handed some video formatted this way, so here is a heads up.

Figure 11-15 shows the anamorphic video process. The original video is 16 × 9 Hi-Def. The anamorphic version is created by squeezing the Hi-Def 33% horizontally and resizing it down to Std-Def resolution. This squeezed Std-Def is what is burned onto the DVD and what you might be given to work with. The DVD player in the home is set for whatever type of TV is connected to it. If it is a Std-Def TV, then the DVD player squeezes the video vertically and adds the black bars top and bottom, sending a letterboxed picture to the TV. If the TV is Hi-Def, then the DVD player sends the entire

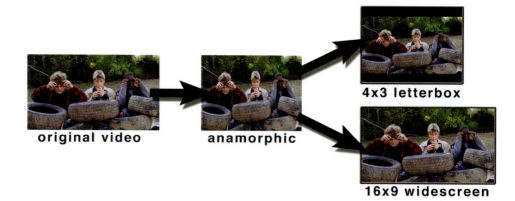

Figure 11-15 The anamorphic video process.

anamorphic frame and the Hi-Def monitor resizes it to fill the screen. Even though it is a Std-Def video image squeezed onto a DVD the relatively high bandwidth of DVD video presents a surprisingly good-looking image to a large-screen TV.

 As with any anamorphic image you may want to "flatten" it to square the pixels in order to perform some operations and then squeeze it back to anamorphic.

11.4 TELECINE

Even if you only work in video, most of your video was probably shot on film and then transferred to video on a machine called a telecine (tell-a-sinny). These video frames are profoundly different than the video frames shot with a video camera. You need to understand how and why so you can cope. Also, the client may turn to you for recommendations on the appropriate telecine setups for the best video transfer for your upcoming project together so you need to be acquainted with a few telecine terms and procedures.

11.4.1 The 3:2 Pulldown

There is no getting around the fact that film runs at 24 frames per second and Std-Def video runs at 30 frames per second. One second of film must become 1 second of video, which means that somehow 24 frames of film have to be "mapped" into 30 frames of video. Some folks call it the "cine-expand." The technique used to do this has historically been called the 3:2 pulldown. It is a clever pattern that distributes the film frames across a variable number of video fields until everything comes out even.

Seeking the lowest common denominator, we can divide both the 24 fps of film and the 30 fps of video by 6, which simplifies the problem down to every 4 frames of film have to be mapped into 5 frames of video. The way this is done is to take advantage of the video fields. In the 5 frames of video there are actually 10 fields, so what we really need to think about is how to distribute the 4 frames of film across 10 video fields.

The trick to putting 4 frames of film into 10 video fields is done with the film shutter "pulldown." When the film is transferred to video, the electronic "shutter" of the film is pulled down for each video *field* (there is no actual shutter, it is just a helpful metaphor for us nontelecine operators). To put one frame of film into one frame of video the shutter would be pulled down twice: once for field 1 and once for field 2. But what if we pulled the shutter down three times on the same frame of film, laying it down to three successive

video fields? That frame of film would actually appear in 1½ frames of video. We could put one frame of film into 2 fields, the next frame of film into 3 fields, the third frame into 2 fields, and the fourth into 3 fields. Four frames of film are now laid into 10 fields, making 5 frames of video. For some odd reason the eye does not notice the stutter step in the duplicate video fields and the action blends smoothly.

Figure 11-16 illustrates the 3:2 pulldown pattern for one full cycle (technical improvements have made it actually a 2:3 pulldown nowadays, but we honor tradition and still call it a 3:2 pulldown). The film frames are labeled A, B, C, and D, and each has a unique video field pattern. Frame A, for example, is the only one that exactly maps to one video frame by laying only on field 1 and field 2 of the same video frame. Note that the film frames have no compunction about starting or ending in the middle of a video frame. Film frame B, for example, ends in the middle of video frame 3, whereas film frame C is a two field frame that starts in the middle of video frame 3. To summarize, the film frames are laid down to video fields in an alternating pattern of 2:3:2:3:2:3 etc.

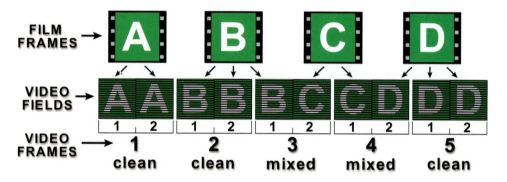

Figure 11-16 The 3:2 pulldown pattern for transferring film to video.

Viewing the situation from the video side, if you single step through these frames on your workstation you will see a repeating pattern of "clean" and "mixed" video frames. Because the mixed video frames have a different film frame in each field, the action is "fragged" along scan lines like the interlace motion blur shown in Figure 11-7. The clean frames have the same film frame in both fields. From the pattern of clean and mixed video frames shown in Figure 11-16 you can see that once you find the two adjacent mixed frames you know you are on video frame 3 and 4. From there you can back up two frames and know that you are on video frame 1, the A frame of film. Of course, to see the clean and mixed frames there needs to be motion in the picture content.

11.4.2 Pin Registered

While all telecines move the film using sprocket holes, at the gate where the film frame is digitized there may or may not be any registration pins to hold the film frame steady and register it accurately while it is being scanned. As a result, the video frames may wobble (gate weave) or chatter a bit, depending on how well adjusted the film transport mechanism of the telecine is. In fact, if you watch the corners of your TV while a movie is playing you can sometimes actually see this gate weave. For normal TV viewing of the movie of the week, this is not a problem. For compositing, however, it is.

 You cannot composite a nice steady title or graphic over a wobbling background layer or, worse, two wobbling layers over each other. If you do not want to have to stabilize your elements before compositing (which takes time and softens the images), then you want video that was transferred on a pin-registered telecine.

11.4.3 Recommendations to the Client

 It is hoped that you will have a chance to talk to the client about the job before the film has been transferred to video. This way you can give the client some tips on how to best transfer the film to video for a happy compositing experience. The two big issues you want are a pin-registered telecine and no 3:2 pulldown.

A pin-registered transfer costs the client a bit more than a nonpin-registered transfer. Just point out that if you have to stabilize the video the filtering used to reposition the frame softens the image. If the client is unmoved by the reduced quality argument, then hit him with the big guns—you will charge him three times as much as a pin-registered telecine to stabilize the video. Voila! A pin-registered transfer.

The other issue is the 3:2 pulldown; you don't want one because you will just have to spend time and trouble to remove it. If you are working on a Flame system it has such elegant tools for removing the 3:2 pulldown that this is not a real issue. If you are working with a generic compositing software package on a workstation, however, it is a big deal. The real problem here is actually communicating with the client. While all digital compositors are universally highly qualified experts in their field, in film and video production there are, uhm, "variations" in skill levels. When talking to someone that does not even know what a 3:2 pulldown is, you may have to express the request a couple of different ways until the client gets it. Try each of these until the light bulb goes on:

1. A 30 frame per second transfer. This is the professionally correct form of the request to the telecine operator. It means that 30 frames of film are laid down to 1 second of video rather than the usual 24 frames per second, hence no 3:2 pulldown is needed. This is not such a bizarre request as it might seem, as many TV commercials are actually filmed at 30 fps and then transferred to video at 30 fps.
2. A one-to-one transfer. This would be one frame of film to one frame of video, hence no 3:2 pulldown.
3. No cine expand. Do not expand (stretch) the cine (film) to make the 24 film frames cover 30 video frames.
4. No 3:2 pulldown. Could it be more clear than this?

 One other telecine issue to be mindful of is overexuberant image sharpening. When a telecine gets old, the operators might crank up the image sharpening to compensate. This can introduce ringing edge artifacts plus punch up the grain, which will be much more noticeable on a still frame on your workstation than on the moving footage on a video monitor. Advise the client to make sure this is not overdone because there is no image processing algorithm that can back out this edge artifact.

There is also noise reduction. This is another adjustable setting on the telecine process. While it is reducing noise (grain) in the transferred video, it also softens the image so it must not be overdone either. If the video needs softening, it is better to do it on the workstation so it can be tweaked as necessary. If laid into the video at telecine, you are stuck with it. Another artifact that excessive noise reduction can introduce is a "ghost" printing of one frame over the next.

The idea is to advise the client to make sure that the telecine transfer is as optimized as it can be for the following digital compositing operations. This way you won't inherit a set of utterly avoidable problems at the workstation that increase your production time (increasing costs) and lower overall quality.

11.5 WORKING WITH VIDEO

Now we will take all of the fascinating things that we have learned about how video works and see how to work around all of the problems that video introduces to compositing and digital manipulation. Now that you know all about interlacing, we will see how to get rid of it. Now that you understand the 3:2 pulldown, we will see how to pull it up. And now that you are

comfortable with nonsquare pixels, we will develop techniques to square them up.

All of the following procedures and techniques are intended for compositors working with video frames on a conventional workstation with some brand of compositing software. If you are using Flame or an on-line video effects system such as a Harry you are lucky because they have internal automatic processes to hide the complexity of video from the operators.

11.5.1 Pulling Mattes from 4:2:2 Video

The low color resolution of 4:2:2 video (not to mention the 4:1:1 of DV-CAM!) can cause serious problems when trying to pull a matte. This section describes a spiffy little workaround to help you pull better mattes from Std-Def and DV-CAM video.

As shown in Section 11.2.1.5, "Color Resolution," the YUV format of video is full-resolution for luminance but half-resolution for chrominance. When the YUV frame is converted to RGB for compositing the RGB version inherits this color detail deficiency. Figure 11-17 shows a close-up of an RGB greenscreen edge produced by such a YUV file. Figure 11-18 shows the Y channel that contains the full-resolution luminance information, whereas Figure 11-19 shows the half-resolution U and V channels containing the chrominance information. Notice the chunky data steps.

Figure 11-17 RGB greenscreen.

Figure 11-18 Y channel of YUV file.

Figure 11-19 U and V channel of YUV file.

Using the greenscreen in Figure 11-17 for a composite we get the hideous results shown in Figure 11-20. In fact, the composite looks much worse than the original greenscreen. The fix is to apply a blur to just the U and V channels before pulling the matte. The blurred U and V channels are shown in Figure 11-21 and the stunning improvement is shown in Figure 11-22.

Figure 11-20 Comp with original RGB greenscreen.

Figure 11-21 Blurred U and V channels.

Figure 11-22 Comp with blurred YUV image.

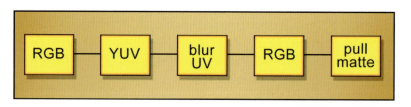

Figure 11-23 Flowgraph of UV blurring operation.

The sequence of operation is shown in the flowgraph in Figure 11-23. The RGB greenscreen is first converted to a YUV image and then *only* the U and V channels are blurred. Blur the U and V horizontally a little bit and vertically not at all (the actual numbers depend on your blur routine). The loss of UV resolution is in the horizontal direction only and we do not want to blur them any more than is absolutely necessary. Remember, blur kills. The blurred YUV file is then converted back to RGB to pull the matte and do the comp.

Of course, this slick trick comes at a price. While the blur operation is gracefully smoothing out the edges of our comp, it is simultaneously destroying edge detail. It must be done by the smallest amount necessary to improve the overall composite. It's all about the tradeoffs.

11.5.2 Deinterlacing

If the video was mastered (shot) on video then the video frames are all interlaced and will probably need to be deinterlaced before proceeding. If you are simply going to pull mattes, color correct, and composite, then deinterlacing may not be necessary. Deinterlacing is necessary if there is any *filtering* of the pixels. Filtering (resampling) operations are used in translations, scales, rotations, blurs, and sharpening. Integer pixel shift operations, such as moving the

image up one scan line or over 2 pixels, do not require filtering. To convince yourself of the need for deinterlacing, just take an action frame of interlaced video with visible motion blur and rotate it 5° and observe the carnage.

There are three deinterlacing strategies that can be used. They vary in complexity and quality, and of course, the most complex gives the best quality. The nature of the source frames, the requirements of the job, and the capabilities of your software will determine the best approach. The reason for having all of these different approaches is in order to have as many "arrows in our quiver" as possible. There are many ways to skin a cat, and the more methods that you have at your disposal the better you can skin different kinds of cats, or something like that. Gosh, I hope you are not a cat lover.

 Adobe Photoshop Users—You cannot deinterlace a frame of video. While it is rare to be given a frame of video to paint on, if it should happen make sure to insist that the video be deinterlaced for you. Be sure not confuse this with a 3:2 pulldown, which is covered shortly. That you can fix.

11.5.2.1 Scan Line Interpolation

This is the simplest and yet can have surprisingly good quality. The idea is to discard one field from each frame of video (field 2, for example) and then interpolate the scan lines of the remaining field to fill in the missing scan lines.

Figure 11-24 illustrates the sequence of operations for scan line interpolation. A single field is selected from each video frame and then the missing scan lines are interpolated. The key to success here is which scan line interpolation method is selected. Most compositing programs will offer a choice of interpolation schemes, such as line duplication (awful) to line averaging (poor) to the impressive Mitchell-Netravali interpolation filter (good).

The example in Figure 11-24 looks particularly awful because simple scan line duplication was used instead of a nice interpolation algorithm to illus-

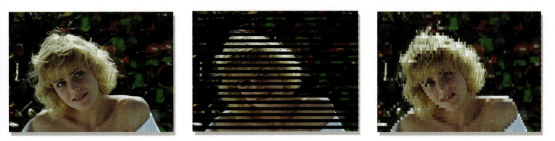

(a) original frame (b) single field (c) interpolated scan lines

Figure 11-24 Deinterlacing with scan line interpolation.

trate the degraded image that results (plus the painfully low resolution used for illustration purposes). Good compositing software offers a choice of scan line interpolation algorithms so a few tests are in order to determine which looks best with the actual footage. This approach suffers from the simple fact 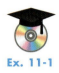 that half of the picture information is thrown away and no amount of clever interpolation can put it back. A well-chosen interpolation can look pretty good, even satisfactory, but it is certainly down **Ex. 11-1** from the original video frame.

11.5.2.2 Field Averaging

This next method retains more of the original picture quality for slowly moving images, but is a bit more complex. Figure 11-25 illustrates the sequence of operations for field averaging. Starting at the left, the frame is separated into its two fields. Each field gets the scan line interpolation treatment shown earlier, making two full interpolated frames of video. These two frames are then averaged together to make the final frame.

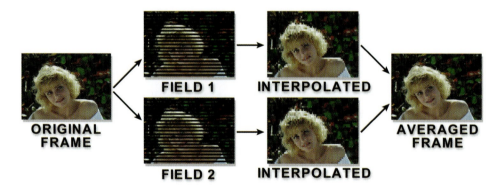

Figure 11-25 Deinterlacing with field averaging.

While this looks better than the simple scan line interpolation method shown earlier, it is still not as good as the original frame. Technically, all of the original picture information has been retained, but it has been interpolated and then averaged back together, slightly muddling the original image. Static details will look sharper with this technique and it works well if the action is fairly slow, but fast action can have a "double exposure" look, which might be objectionable. A test should be done and sent to the DDR for real-time playback on an interlaced video monitor to determine the best results for the actual picture content of the shot.

11.5.2.3 Field Separation

The previous methods degrade the quality of the video image somewhat because the video fields are interpolated in various ways, losing picture information. The method described here retains all of the picture information so it is the best quality. It is also much more complicated. Illustrated in Figure 11-26, the idea is to separate the fields of each frame, performing no interpolations, and then use the separated fields as new frames. In essence, the video has been converted into a 60 "frame" per second movie. While there is no degradation from frame interpolation, a number of messy complications have been introduced.

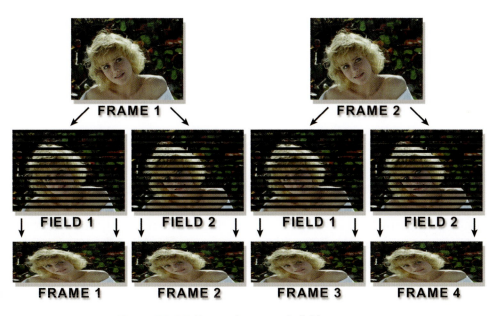

Figure 11-26 Deinterlacing with field separation.

Each new "frame" is half height due to half its scan lines being missing, and the number of frames has been doubled. Both of these issues add complications to the job, but again, all of the picture data is retained. After the compositing is done with the "short frames," they are reinterlaced before being sent to the DDR in exactly the same field order as they were deinterlaced. Watch your field dominance.

Okay, now for the bad news. Because the "short frames" are half height, all geometric operations must be done half as much in Y as in X. For example, to scale the image by 20% overall, you have to scale by 20% in X but only 10% in Y. The reason is that these "short frames" will become "stretched" in

Y by a factor of two when reinterlaced so all operations in Y will become doubled. The same holds for blurs and translations—half as much in Y as in X. Rotations are a special case. If you must rotate, the frame must first be scaled by two in Y to "square up" the image, rotated, and then scaled back to half height. This is a bit of a hassle, to be sure, but if maximum detail retention is the major concern, this is the way. Again, dedicated video systems like Flame and digital video effects switchers have built-in features that take care of these issues automatically.

11.5.3 The 3:2 Pullup

If the video was mastered on film and then transferred to video at 24 fps, then a 3:2 pulldown was used, which usually has to be removed before doing any effects. The 3:2 pulldown is removed by performing a 3:2 pullup, which simply removes the extra fields that the pulldown introduced. There is no loss of data or degradation of the image.

The reason that the pulldown "usually" has to be removed is because it introduced some interlaced frames and these interlaced frames create problems with most image processing operations. If you are simply going to pull mattes, color correct, and composite, then the 3:2 pullup may not be necessary. The pullup is necessary if there is any *filtering* of the pixels. Filtering (resampling) operations are used in translations, scales, rotations, blurs, and sharpening.

The problem that the 3:2 pullup introduces is that the number of frames in the shot is reduced by 20%, which throws off any video time code information you may have been given. A little arithmetic can correct the timing information, however, just by multiplying all times by 0.8 for the pullup version of the shot. A further timing issue is that time code for video is based on 30 frames per second, and when the shot is pulled up it once again becomes 24 frames per second. As a result, some video time codes will land in the "cracks" between the film frames, making the exact timing ambiguous.

 It is hoped that your software will have a 3:2 pullup feature and that your troubles will be limited to discovering which of the five possible pullup patterns (called the "cadence") you are working with and the timing information now requiring a correction factor. Watch out for the cadence changing when the video cuts to another scene. If the film was edited together first and then transferred to video continuously (like a movie), then the cadence will be constant. If the film was transferred to video and then the video edited (like a commercial), then each scene will have its own cadence.

If your software does not have a 3:2 pullup feature, then you will have to "roll your own." By studying Figure 11-16 carefully a painful but suitable procedure can be worked out. The hard part will be to determine the cadence of your shot—where the pattern starts—the "A" frame. Looking closely at the video fields in Figure 11-16 you will see a pattern of "clean" frames with no interlacing and "mixed" frames

Ex. 11-2

with interlacing. Reading video frames 1 through 5, the pattern is clean, clean, mixed, mixed, clean. Step through the video frames until you find the two mix frames and then back up two. That's the "A" frame. Good luck.

Adobe Photoshop Users—If you are working on film that has been transferred to video and given a video frame to work on that displays interlaced fields, give it back. By studying Figure 11-16 closely and getting the frames surrounding the one you need to work on you could do a 3:2 pullup yourself very slowly and painfully. It's better to get one with the 3:2 pullup already done if possible.

11.5.4 Nonsquare Pixels

The nonsquare pixels of NTSC video shown in Figure 11-13 introduce a variety of issues when they get to your workstation. Blurs and rotations don't work quite right. Adding new elements that were created with square pixels (such as an Adobe Photoshop painting) becomes problematic. Picture content created in video with nonsquare pixels suddenly stretches 10% in X when it lands on your workstation. To avoid having to continually compensate for the nonsquare pixels, the image can first be "squared" by stretching it in Y before manipulation and then restoring it when done.

When creating new images on a square pixel monitor (your workstation) you will undoubtedly want to create it as a "square" 1.33 image so that you don't have to continually compensate for nonsquare pixels during manipulation. When the image is completed it is deformed to 1.48 by squeezing it in Y before sending it to the DDR.

11.5.4.1 Manipulating an Existing Video Image

If you blurred a stretched frame on your workstation by 20 pixels in both X and Y, when seen back on the video monitor the X axis would in fact appear to have only been blurred by 18 pixels. This is because when the image is sent back to the video monitor it is squeezed in X by 10%, which reduces your blur in X by 10%. In the real world, however, this is not such a great difference and can be ignored in most situations. The important thing is that

you know what is going on and know how to fix it if it ever does become an issue.

Rotations of more than a few degrees, however, are a more serious problem. A little thought experiment will reveal why. Remember the stretched circle in Figure 11-13? If that were rotated 90° it would be tall and thin. When viewed back on a video monitor it would become even thinner, and no longer a circle. Again, in the real world, if the rotation is just a few degrees the deformation may not be objectionable. If it is objectionable, then the image must be "squared" before the rotation.

 Figure 11-27 shows the sequence of operations for "squaring" the video image. As usual, the squeezed and stretched elements have been exaggerated for clarity.

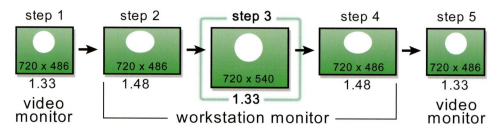

Figure 11-27 "Squaring" a video image on a workstation.

Step 1. The original video image displayed on a video monitor with nonsquare pixels. The aspect ratio of the image is 1.33 and the circle appears circular.

Step 2. The video frame transferred to the workstation monitor with square pixels. The image is the same size (720 × 486), but now has an aspect ratio of 1.48 due to the square pixels and the circle is stretched horizontally by 10%, as is the entire image.

Step 3. The "squared" video frame on the workstation. The image size has been increased to 720 × 540 by stretching it in Y, the circle is once again circular, and the aspect ratio of the image is again 1.33. All transformations and blurs are done on this squared version.

Step 4. After all filtering operations are done the squared image is once again restored to its stretched form by resizing it back to 720 × 486. It is now ready to send to the DDR.

Step 5. Sent to the DDR and displayed on a video monitor, the nonsquare pixels of the video monitor squeeze the image 10% in X, restoring the circle to its proper shape and the image to a 1.33 aspect ratio.

While this sequence of operations will restore the image to its correct aspect for filtering operations, it is not without losses. Simply resizing an image from 720 × 486 to 720 × 540 and back will reduce its sharpness in Y just a bit. This can't be helped. Also, remember you cannot do these resizing operations on interlaced video frames.

11.5.4.2 Creating a New Image for Video

When you create an original image on your workstation with square pixels and then transfer it to video with squeezed pixels, the picture content will be squeezed 10% in X. Here is how to compensate. Start with the "squared" image size of 720 × 540 as shown in step 3 of Figure 11-27. That is a 1.33 aspect ratio image with a width of 720. Create or place your image into this 720 × 540 image size. At this juncture, a circle will be a circle. After the image is completed, resize it to 720 × 486 as shown in step 4. This will squeeze it in Y by 10%, introducing the 10% horizontal "stretch." A circle will now look like it does in step 4 when displayed on your workstation. Send this "stretched" version to the video monitor and the stretched circle will become squeezed to perfectly round again as seen in step 5.

Don't create a 640 × 486 image and then stretch it in X to 720. While mathematically correct, this stretches the picture data in X, which softens the image, degrading it. Creating it as a 720 × 540 and then squeezing in Y shrinks the image data, preserving sharpness.

11.5.4.3 PAL Pixels

PAL video suffers from the same nonsquare pixel issues, but the numbers are a bit different because the PAL pixel aspect ratio is 1.1 compared to the 0.9 of NTSC. This essentially reverses all of the stretch and size issues described earlier. When the image moves from video to the square pixels of the work-

station it causes the image to appear stretched in Y instead of X, but the same blur and rotation issues still apply. To make a "square" version of a PAL frame, the original 720 × 576 frame is resized to

Ex. 11-3 768 × 576.

11.5.5 Interlace Flicker

If you were to create a video frame on your workstation that consisted of a white square on a black background it would look fine on your workstation monitor. But when displayed on a video monitor you would suddenly notice

that the top and bottom edges of the white square flickered. The reason for the flicker is that both the top and the bottom edges of the white square consist of a white scan line that is adjacent to a black scan line. As the interlaced video fields alternate, the adjacent black and white scan lines take turns displaying so the top and bottom edge flickers.

In the middle of the square each white line is adjacent to another white line so they do not flicker as they "take turns." The white square did not flicker on your workstation because its monitor uses a progressive scan instead of an interlaced scan. As shown in Section 11.2.1.2, "Interlaced Fields," interlaced scanning was developed specifically for broadcast television in order to lower the bandwidth of the transmitted picture. This is hardly ever an issue with live action scenes shot with cameras because it is very difficult to get a perfectly straight high-contrast edge to line up exactly on the video field lines. If it does, then even a live action scene will exhibit interlace flicker.

When you create graphics of any kind on a workstation they will invariably line up exactly on the scan lines. As a result, you stand a very good chance of introducing interlace flicker with any synthetic image so it might be good to know how to prevent it. The fundamental cause is the two adjacent high-contrast scan lines, like the white square story above. Knowing the cause suggests a solution. Actually, two solutions.

 The first is to lower the contrast. Don't have a zero black scan line adjacent to a 100% white scan line. Perhaps a light gray and a dark gray would do, or two different colors, rather than black and white.

 The second solution is to soften the edges so that the hard white edge blends across a scan line or two to the black lines. If you don't want to run a light blur over the image, you could try repositioning the offending graphic half a scan line vertically. The natural pixel interpolation that occurs with a floating point translation might be just enough to quell your throbbing graphics.

And of course, if your graphics package has a button labeled "anti-aliasing," be sure to turn it on. Anti-aliasing is an operation that eliminates the "jaggies" in graphics. It calculates what percentage of each pixel is covered by the graphic element so that the pixel can be given an appropriate percentage of the color of the element. For example, an 80% gray element that covers 50% of a pixel might end up making it a 40% gray. Even with anti-aliasing, however, if your graphic element has a horizontal edge exactly lined up on a scan line then it could end up

Ex. 11-4 with a hard edge anyway and flicker like a banshee.

11.6 WORKING WITH VIDEO IN A FILM JOB

Perhaps you have a monitor insert in a feature film shot or maybe you have to shoot the video out to film by itself. Either way, the idiosyncrasies of video will have to be dealt with if there is to be any hope of getting good results. Video that originated on video will have to be handled differently than video that originated on film, and how to compose to the film aperture with a 1.33 video frame that has nonsquare pixels is just one of the topics of this section.

11.6.1 Best Video Formats

Very often the client will ask you what is the best video format to deliver to you for film work. The key issue is what format the video footage was originally captured on. Starting with video mastered on VHS and then dubbing it to D1 will not improve the quality of the video. It's amazing how many clients don't realize this until it is explained.

Having said that, the highest quality Std-Def video is D1. It is digital, component video, and uncompressed (except for that little half-res chrominance thing described in Section 11.2.1.5, "Color Resolution"). The next best is DigiBeta. It is digital, component video, but has a compression of about 2.5 to 1 (in addition to the chrominance thing). The compression causes some loss of picture detail, Sony's denials notwithstanding. This could be important when working with blue- or greenscreens, as the loss of chrominance detail inherent in video is already hurting you. However, it also has 10 bits per pixel instead of the usual 8 so that's a good thing. After that the next best is Beta SP. It is an analog format (bad), but it is component (good), but also has the 2.5 to 1 compression (bad). Nevertheless it is a high-quality video source.

If the client has Beta SP or any analogue source ask him to make a digital dub (DigiBeta or D1) for you to import for the job. The main reason for doing this is that Beta SP is an analogue tape so settings on the front of the tape deck can alter the video levels affecting color and brightness. If the client makes a digital dub for you he will have made the color choices, not you, and the video is read off the digital tape the same every time.

If the client's tape is D2, a digital composite format, it will not be as high a quality as a D1 or DigiBeta, or perhaps even old analog BetaSP. Being a composite video format, the picture information has been compressed and encoded into the NTSC format, with a resulting loss of detail. It must go through a transcoder to convert it to component video and then the component video is converted to RGB for your workstation.

11.6.2 Video Mastered in Video

For Std-Def video that was mastered (shot) on video, the frame rate is 30 fps (29.97 fps to be technically correct) and the frames will all be interlaced. For video to be incorporated into film, either as a monitor insert in a film effects shot or to simply transfer the video to film, it has to be both deinterlaced and the frame rate reduced to 24 frames per second. How to deinterlace the video was covered in agonizing detail in Section 11.5.2, "Deinterlacing." The speed change, however, has a couple of options.

After the video has been deinterlaced using your method of choice, frame averaging in your compositing software can be used to reduce the frame rate from 30 to 24 fps. This can look good if there is not too much motion in the picture (people dancing the jitterbug) or if the motion is not very high contrast (a white cat running through a coal bin). The frame averaging technique introduces cross-dissolved frames, which looks like double exposures because they are. This can become objectionable. Some very modern compositing programs have "speed changers" that use (pick your term) motion vectors, motion compensation, and optical flow technology. These will do a fine job right on your workstation, but they are computationally expensive. But again, you are working with the deinterlaced frames, which have lost half their picture information.

 By far the best approach for a speed change from 30 fps interlaced video to the 24 fps of film is with one of the new standard conversion boxes found in any well-equipped video posthouse that uses "motion compensation" algorithms. These systems actually do a motion analysis on each pixel to determine its motion from frame to frame and then create intermediate frames from this data. It is not frame averaging. They are literally shifting pixels to the position they would have had if the shutter had been open at the desired moment in time. They are using both fields of the interlaced video so they are not throwing away any picture information. Along the way, they can also convert the image to progressive scan and even up-res the video to Hi-Def (1920 × 1080) if you want. Ask the client to have it done before giving you the video because there can be creative trade-offs to make during the conversion process and you want the client to make those choices, and pay for the conversion.

11.6.3 Video Mastered on Film

If the video was mastered (shot) on film and then transferred to video at 24 fps, then there will be 3:2 pulldown frames that have to be removed. This procedure was also discussed in arduous detail in Section 11.5.3, "The

3:2 Pullup." Once the 3:2 pulldown is removed, the video returns to the 24 fps speed of the original film and you are good to go.

If the film was shot at 30 fps and transferred at 30 fps, there will be no 3:2 pulldown frames because one frame of film is on one frame of video, except for the speed change, of course. Again, the two options here are frame averaging or standards conversion outlined earlier.

11.6.4 Frame Size and Aspect Ratio

Let's say you have a 720 × 486 video image to somehow position into a film frame, plus correct for the nonsquare video pixels. If the client wants the video to completely fill an academy aperture, common in a video-to-film transfer, simply resize the video frame to the academy aperture in one operation and you are done. Don't do it in two steps by first "squaring" the video to establish a 1.33 video frame and then resizing the 1.33 version up to film size. Each of these two operations introduces a filtering operation, softening the image each time. The image will already be suffering from excessive softness as it is. A little image sharpening might be helpful on the film resolution frames, but this also increases noise and adds an "edginess" to the image if overdone.

The academy aperture has an aspect ratio of 1.37, which is close enough to the video aspect ratio of 1.33 to ignore. When the 720 × 486 video frame (which has an aspect ratio of 1.48 as seen on your workstation) is resized to academy, it becomes a 1.33 image again just like on TV, correcting for the nonsquare pixels. The full frame of video fits nicely into the frame of film. But what if the video frame doesn't fit into the film frame so nicely?

If the mission is to fit the video footage into a film aperture of 1.85, for example, there are basically two choices, as shown in Figure 11-28. The entire video frame can be fit from top to bottom in a 1.33 "window" within the 1.85 format, but there will be the black "pillars" on either side (the pillarbox

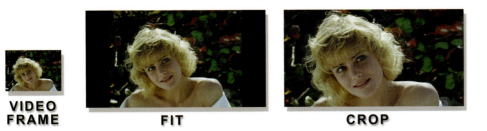

VIDEO FRAME FIT CROP

Figure 11-28 Alternate 1.85 film compositions for video frames.

format). The advantages are that the image is sharper and you get to keep the entire picture, but the black pillars may be objectionable. The other alternative is to crop the video frame to 1.85 and fill the entire film frame. The problems with this format are that the increased size results in a much softer image than the fit format, plus the original picture content is now seriously cropped. The 1.33 video frames are typically "composed" (framed) more tightly than 1.85 film frames, and cropping video like this can sometimes result in just seeing a pair of eyes and a nose. Be sure to discuss these two composition options with the client. It is amazing how many of them will be totally surprised to discover they must choose between these two options (or perhaps an in-between compromise).

An easy way to produce the cropped version is to resize the video frame to fill the entire academy aperture (or full aperture, depending on your film format) and then mask to the 1.85 aperture, if necessary. Be sure to check with the client. Sometimes they do not want the video "hard matted" to the projection aperture.

Ex. 11-6

11.7 WORKING WITH FILM IN A VIDEO JOB

If you have frames of scanned film to incorporate into video, several operations must be performed on the film scans. The film frame aspect ratio will have to match the video, nonsquare pixels will have to be introduced, the frame size will have to be reduced, and the film speed will have to be changed. The following steps are used for preparing film frames for a video format.

The film can be resized to video in one operation, which will even account for the nonsquare pixels. Simply crop the film frames to 1.33 and then resize them to 720 × 486. This will introduce the nonsquare pixels and create a perfect frame for display on a video monitor. For PAL, resize the 1.33 crop to 720 × 576. If the film frame is already cropped to some wider format such as 1.85, then simply pad the frame out top and bottom to 1.33 and resize to video.

If the film was shot at 30 fps, you are done. But most likely it was shot at 24 fps and will now need a 3:2 pulldown. Some compositing software can do this, but it might be faster and easier to send the 24 fps frames to the DDR and then set it to add the 3:2 pulldown when it records it to video tape. Of course, the film could be sent out and transferred to video on a telecine, but this would cost *money*. If there is only a small amount of film it is more cost effective to take care of it within the compositing program.

Ex. 11-7

11.8 WORKING WITH CGI IN A VIDEO JOB

Ideally, your cgi rendering software will offer you the options for an interlaced 30 fps 720 × 486 image with a pixel aspect ratio of 0.9, or perhaps not. Any cgi package worth its weight in polygons will at least offer the correct frame rate and frame size. If anything is missing it is probably the interlacing and the pixel aspect ratio options.

Rendering on fields and interlacing may be helpful if there is extremely rapid motion in the action. Usually good motion blur and a 30 fps render are just fine. There are some folks who actually prefer the look of a 24 fps render that is cine expanded. They feel it makes the cgi look more "filmic."

 If your rendering software does not offer a nonsquare pixel aspect ratio option, then you will have to render a 1.33 image and then resize. For NTSC, render a 720 × 540 and then resize to 720 × 486. For PAL, render a 768 × 576 and then resize to 720 × 576. Squeezing the rendered frames like this distorts the anti-aliasing a bit compared to correctly rendering the frames with the correct aspect ratio pixels. If this becomes a visible problem, try increasing the anti-alias sampling.

With today's digital effects pipeline it is entirely possible for the modern digital compositor to spend his/her entire production career without getting an opportunity to interact with physical film. The first time the shot will be encountered is probably when seeing it on a monitor. The last time will probably be when seeing it projected in the screening room. Unless you shoot some wedges, you may never actually touch a real frame of film. This can create vocabulary problems when talking to clients. The client, however, works with film all day long. While he may not know what a pixel is, he expects you to know his terms and vocabulary.

This chapter is about film as seen by the digital compositor, not an editor or cinematographer. It therefore leaves many things mercifully unsaid—things that, while perhaps technically true, are of no value or importance to you, the digital compositor. One of the most critical topics is the different film formats. It is essential for the compositor to know, for example, where the academy center is in a full aperture frame. You must routinely incorporate odd-sized elements from one format (or no format) into some other format. And very importantly, you must know what parts of the frame you must care about and what areas you can ignore. There is even a short description of how film scanners and film recorders work, plus a nice description of the digital intermediate process, an ever more important development in film finishing.

12.1 THE FILM PROCESS

The film in a feature film goes through several generations before it is projected in the theatre. As a digital compositor you will probably never get a chance to see how the film progresses through the postproduction process to create the final print projected in the theatre. However, the clients you work with live with these film processes every day, so a basic understanding of their world will go a long way toward helping you communicate with them. The following is a brief overview of the film processing steps from original camera negative to the final release print of a typical feature film as diagrammed in Figure 12-1. This information is also essential for the section on digital intermediate, which you don't want to miss.

Camera negative—this is the negative that was exposed by the cameras during the filming of the movie. After a camera roll is exposed, it is "canned out"

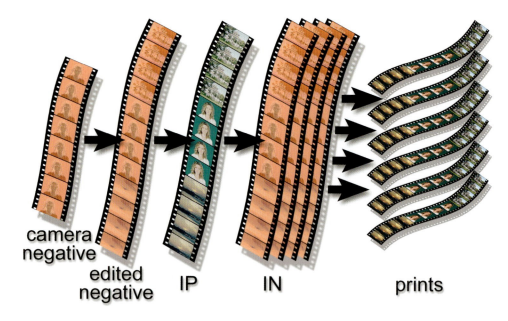

camera
negative
edited
negative IP IN prints

Figure 12-1 Film processing from camera negative to release prints.

(taken out of the camera and placed in a light-proof film can) and then delivered to a lab for developing overnight. A quick print of the developed "camera neg," called a "daily," is made by the next morning so the director and cinematographer can see the results of the filming done the day before. The trend is to see the dailies on Hi-Def video rather than film.

Edited negative—after the movie is "locked" (all of the editing decisions have been finalized), the selected scenes from the various camera negatives are cut and spliced together to create the "edited neg." There may be 1500 to 2000 cuts taken from 400 to 500 camera negs.

IP—abbreviation for InterPositive, it is made by printing the edited neg with adjustable printing lights so that the resulting IP is color timed (color corrected) on a shot-by-shot basis. The movie is now edited and color timed.

IN—abbreviation for InterNegative, several of these (typically 4 to 10) are printed from the one IP, which are then used to create all of the theatrical prints. The IN serves two purposes. First, the printing process is done with high-speed machines that would be too risky to put the IP through. Second, a negative is required to strike the prints in the first place.

Prints—from the several INs that were made, hundreds or even thousands of prints are "struck" and distributed to the theatres for projecting. One IN can strike 400 to 500 prints and each print costs a couple thousand dollars.

12.2 TERMS AND DEFINITIONS

Before diving into the academy aperture, there are some film terms and definitions used throughout the discussion that would be helpful to clarify. All of this will contribute to your "film vocabulary" and assist you in speaking with clients, not to mention reading the following sections. You want the client to realize that you know something about film lest they think you a total byte-head.

12.2.1 Conversions

You, the dauntless digital artist, will relate to film in terms of frames and pixels. The client, however, comes from a different world, an analogue world, with a different way of looking at things and different units of measure. For example, the client may refer to the length of a shot in terms of feet and frames, such as "4 feet 6 frames." Following, then, are a few key conversion numbers that you will find helpful to commit to memory.

- 24 frames per second
- 1440 frames in 1 minute
- 16 frames per foot of film
- 90 feet in 1 minute

12.2.2 Apertures

In film cameras there is a metal plate called a "gate" with a rectangular opening that sits just in front of the film that blocks some of the incoming light to define the area of the negative that is to be exposed. The rectangular opening in the gate and the exposed region of the film are both referred to as the *camera* aperture. When the film is projected the film projector has a similar gate with another rectangular opening called the *projection* aperture. The projection aperture is slightly smaller than the camera aperture in order to provide a narrow "safety margin" around the edge of the exposed frame in case the projection aperture is not aligned perfectly. Figure 12-2 illustrates both a camera aperture and a "generic" projection aperture to illustrate the basic idea.

The projection aperture, then, is a window within the camera aperture where the action is to stay confined. There are some projection apertures that are a great deal smaller than the camera aperture so it can be ambiguous as to what area of the film you really care about and how to position elements within it. Not surprisingly, it is the camera aperture that is often digitized by

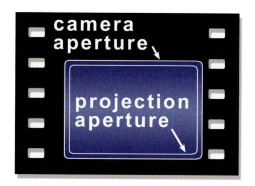

Figure 12-2 Film apertures.

film scanners and sent to a film recorder to film out, while the work may only need to be done in the projection aperture. Because there are a great many projection apertures, the ones you are likely to encounter are detailed in Section 12.3, "Film Formats."

12.2.3 Composition

Before a movie is filmed, a decision is made as to what format the cine-matography will be using. All shots are then "composed" for that format, meaning that the action and items of interest will stay framed within the prescribed aperture, or "window," of that format. If a shot is composed for academy 1.85, for example, then the action will be framed within that aperture.

 It is important to know what you are composing to because it affects both creative and work decisions you have to make. You may be given a full aperture plate to work with, but if the shot was composed for academy 1.85, there is no way to tell by just looking at it. Be sure to find out what the film projection format is at the very outset of a project.

To illustrate the impact of composition on a shot, Figure 12-3 shows an example of a 1.33 aspect ratio picture composed for 1.33. The subject is well framed and nowhere clipped within the 1.33 aspect ratio aperture. However, Figure 12-4 shows what happens when it is projected with a 1.85 aspect ratio projection gate. The top and bottom of the subject have become cropped. Beyond just esthetic impact, critical parts of the picture could be cropped out that even affect the storytelling.

Figure 12-5 shows the same subject in another 1.33 aspect ratio picture, but this one is composed for 1.85. Note that the subject is framed somewhat

Figure 12-3 Composed for 1.33.

Figure 12-4 Projected at 1.85.

Figure 12-5 Composed for 1.85.

Figure 12-6 Projected at 1.85.

wider than in Figure 12-3. When projected with a 1.85 projection gate in Figure 12-6, the subject is well framed and no longer cropped. Even though the subject was filmed in a 1.33 format in both examples, the composition would be different depending on the intended projection format of the film.

A related issue is the "safe to" aperture. The client may say the shot is composed for 1.85, but he wants it to be "safe to 1.66." This means that even though the action is composed for 1.85, you need to make sure the finished shot is good out to the 1.66 aperture. Outside of that it doesn't matter if it is less than a perfect picture. This can occasionally save you a great deal of unnecessary work if there is frame-by-frame work such as rotoscoping or painting or just bad matte edges outside of the safe area that you can safely ignore.

12.2.4 Aspect Ratio

The aspect ratio of a frame is a number that describes its shape—whether it is nearly square or more rectangular. The aspect ratio is calculated by dividing the width by the height like this:

$$\text{aspect ratio} = \text{frame width} \div \text{frame height} \qquad (12\text{-}1)$$

It does not matter what units of measure are used in the calculation. For example, the aspect ratio of an academy aperture in Cineon pixels is 1828 ÷ 1332 = 1.37. If you measured the film itself in inches, it would be 0.864 ÷ 0.630 = 1.37. An aspect ratio can also be expressed as an actual ratio, such as 4 : 3. This means that the item of interest is 4 "units" wide by 3 "units" tall. A 4 : 3 aspect ratio can also be expressed as a floating point number by performing the arithmetic of dividing the 4 by the 3 (4 ÷ 3 = 1.33). I prefer the floating point representation for two reasons. First, for many real world aspect ratios the ratio representation is hard to visualize. Would you rather see an aspect ratio expressed as 61 : 33 or 1.85? Second, you frequently need to use the aspect ratio in calculations of image width or height and would have to convert the ratio form into a floating point number anyway.

Figure 12-7 shows a series of aspect ratios to illustrate a pattern. An aspect ratio of 1.0 is a perfect square, and as the aspect ratio gets larger and larger the shape gets progressively more "wide screen." For aspect ratios greater than 1.0, trimming the perimeter of an image by a uniform amount, say, 100 pixels all around, will *increase* the aspect ratio.

Figure 12-7 Aspect ratios.

The aspect ratio is also essential in calculating image window heights and widths, e.g., cropping a 1.85 window out of a full aperture frame. We know the full aperture is 2048 pixels wide and we need to calculate the height of a 1.85 window. Slinging a little algebra, we can solve Equation 12-1 for height and width like so:

$$height = width \div aspect\ ratio \qquad (12\text{-}2)$$

$$width = height \times aspect\ ratio \qquad (12\text{-}3)$$

We want to figure the height, so using Equation 12-2 we would calculate

$$height = 2048 \div 1.85 = 1107\ pixels\ high$$

A 1.85 aspect ratio window within a full aperture frame is 2048 × 1107. We would actually round it up to 2048 × 1108 so that the image was nicely divisible by 2. This way if proxies or other subsamples are made the math comes out evenly.

12.2.5 Image Resolutions

The image resolution is given for each type of film format in terms of Cineon scans because their standards are followed by most other film scanners and recorders. Both Cineon scanners and film recorders allocate 4k (4096) pixels of resolution to the full width of 35-mm film (the full aperture). The vertical height varies depending on the format. While folks working with the 70-mm formats will want 4k scans, for the vast majority of 35-mm work the 2k (2048) scans are excellent and reduce the required database size and render times dramatically compared to 4k scans. Cineon refers to 4k scans as "full resolution" and 2k scans as "half-resolution." Table 12-1 summarizes the image resolutions and aspect ratios that are detailed in the following text. The image resolutions you are not likely to be working with are included for completeness, but are ghosted out.

In the detail sections that follow describing each film format, all 35-mm frame resolutions are given in terms of 2k scans, as that is most likely what you would actually be working with. Refer to Table 12-1 if you need to look up the 4k numbers. For 70-mm formats, the numbers are in terms of 4k scans,

Table 12-1 Cineon film scan resolutions

Format	2k scans	4k scans	Aspect ratio
Academy	1828 × 1332	3656 × 2664	1.37
Full aperture	2048 × 1556	4096 × 3112	1.33
Cinemascope	1828 × 1556	3656 × 3112	2.35
Vistavision	3072 × 2048	6144 × 4096	1.5
70 mm	2048 × 920	4096 × 1840	2.2
Imax (70 mm)	2808 × 2048	5616 × 4096	1.37

as that is most likely what you would be working with. Refer to Table 12-1 if you need to look up the 2k numbers.

12.3 FILM FORMATS

There are a number of film formats for 35-mm film, and it can get a bit confusing at times. This section examines the full aperture with its variations, the academy aperture and its variations, plus Cinemascope and VistaVision. The standard 65-mm format and its Imax variant are also discussed. Again, all image sizes are given in terms of Cineon pixel dimensions in the resolution you are most likely to be working in for that format. Tips and techniques are offered for reformatting, such as taking a vista frame to academy, and special attention is paid to the difficulties of working with Cinemascope.

12.3.1 Full Aperture

Full aperture is a 1.33 aspect ratio image that covers the film perf to perf left and right. Vertically it spans four perfs (perforations—the little holes in the side of the frame) and is so tall that it only leaves a thin frame line between frames (see Figure 12-8). Because the entire negative area is exposed, there is no room for a sound track so this format cannot be projected in theatres. Cineon full ap scans are 2048 × 1556.

Figure 12-8 Full aperture frame.

If the full ap frame cannot be projected in a theatre, what is it doing on your monitor getting an effects shot? There are two possibilities. One is that the shot was composed for full ap and will be printed down later to academy

format for theatrical release. The second possibility is that even though the full aperture was scanned, the shot was composed for academy aperture, which is described in the next section. The academy aperture only uses a portion of the full aperture so you can seriously mess up a shot if you are not aware of this little detail.

12.3.1.1 Super 35

Full ap is often referred to as "Super 35" and it is a very popular format because of the flexibility of being able to go in almost any direction from there. Again, it is very important to find out from the client what the composition and safe apertures are. You might hear it referred to as "full ap 185" or "super 185." What is meant is that the plate was shot full ap, was composed for a 1.85 aperture within the full ap frame, and the plan is to "print down" to an academy 1.85 format later. The only real impact this has on the compositor is to make sure to keep the action 1.85 safe in the full ap frame. Unless, of course, you are given the job of resizing the full ap frame down to academy digitally.

 The thing to keep in mind is that the full ap plate is a 1.33 aspect ratio and the academy plate is 1.37. To avoid stretching the nice client's picture slightly in X, you would crop a 1.37 window out of the full ap plate and then resize it down to the academy size.

The Super 35 2.35 format is a very important one. The full aperture is still exposed, but the action is composed for a 2.35 window within the full ap. The 2.35 window then is the full width of the full aperture (2048) and has a height of (2048 ÷ 2.35 =) 872. This is not Cinemascope. Cinemascope is 2.35 *and* anamorphic (squeezed in X), described later. The artistic intent is to eventually finish in Cscope (Cinemascope) for theatrical release. Later, the Super 35 will be reformatted into Cscope either optically or digitally. Perhaps it will be your job to do the digital refit for the effects shots.

12.3.1.2 Common Top and Common Center

The fact that there are several theatrical projection formats as well as multiple TV formats makes it difficult for the cinematographer to select a single format to shoot in. One attempt to find "one format that fits all" is to shoot Super 35 "common top" or "common center," shown in Figure 12-9. The full ap frame is shown with 1.66, 1.85, and 2.35 projection guides inside.

The idea of common top is that the top line of the frame is common to all formats, as if they all "hang" from the tops of their frames. Later, when the

Figure 12-9 Super 35 formats.

film is released in different formats, it is only the "foot room" that changes from format to format.

The common center format keeps the action centered vertically in the full ap frame and is more popular. Later, the release formats are taken from the center of the aperture, increasing top and bottom equally with the taller formats.

Ex. 12-1

In addition to asking the client what format you are working toward, with Super 35 you must also check whether it is common top or common center.

12.3.2 Academy Aperture

The academy aperture is a 1.37 aspect ratio image (often referred to as "1.33") that is smaller and shifted to the right relative to the full aperture to make room for a sound track. Of course, none of your film scans will have a sound track because it goes on the print for theatrical projection, not the original camera negative. Figure 12-10 has a dotted outline of the full aperture to illustrate how the academy aperture fits within it. It also shows how the academy center (black cross) is shifted to the right of the full ap center (light gray cross). Any reference to the academy center, then, refers to this "off-center" center. The Cineon scan of the academy aperture is 1828 × 1332.

To reformat some other film format to academy you would crop a 1.37 aspect ratio piece out of the source film and resize it to 1828 × 1332. If you

Figure 12-10 Academy aperture with sound track and full aperture outline.

have an academy shot but the film recorder can only shoot full aperture, then the academy frames must be pasted within a black full ap plate. The academy frame would be centered vertically and shifted to the right until the right edges line up.

An academy aperture scan is 1828×1332 and represents the *camera* aperture, not the projection aperture. This is the image size that you would both get from the Cineon scanner and send out to a Cineon film recorder. Just inside of the camera aperture is the *projection* aperture, shown in the academy camera guide in Figure 12-11. This is the portion of the film frame that would be seen if the full academy aperture were to be projected. It leaves a little "safety margin" all around the frame for the theatre projector, shown as the dark edge around Figure 12-11. The 1.85 aperture is not a 1.85 window into the 1828×1332 image, as that is the camera aperture. It is instead a 1.85 window in the academy *projection* aperture, which is slightly smaller.

Keep in mind that even though a shot was (say) an academy 1.85 shot, you could be given either an academy scan or a full ap scan to work with. The thing to watch out for with full ap plates is when the shot is actually composed for academy. Sometimes the shots are exposed, scanned, composited, and recorded out as full ap, but they are composed for academy. The center of action will be at the academy center, which is to the right of the full ap center as shown in Figure 12-10. The lens will be centered there, too, along with its distortions. If you were, for example,

to rotate the plate about the center of the full ap plate, the center of rotation would be quite noticeably wrong for the academy portion of the frame when projected, which is most embarrassing.

Ex. 12-2

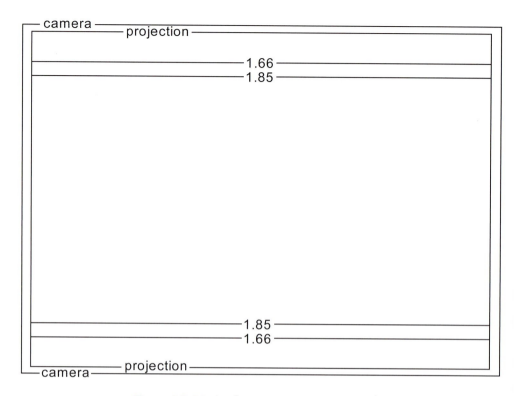

Figure 12-11 Academy aperture camera guide.

12.3.3 Cinemascope

Cinemascope is a 2.35 aspect ratio "wide screen" format with the image on the film squeezed in X by a factor of 2. At projection time a special "anamorphic" (one axis) lens stretches the image horizontally by a factor of 2 to restore the proper perspective to the picture. When an anamorphic image is unsqueezed it is referred to as "flat." This 2:1 relationship between the squeezed film frame and the flat projection frame is illustrated in Figure 12-12.

To get the squeezed image on the film in the first place it was initially photographed with an anamorphic lens that squeezed the scene by 2 in X. These lenses are less popular to work with than normal "spherical" lenses, which is one reason many movies are filmed in the Super 35 formats with regular spherical lenses for later reformatting to Cscope.

The real advantage of Cscope is that much more film area is used for the picture. This can be seen in the Cinemascope film aperture illustration in Figure 12-13. The Cscope frame has an academy width but a full aperture height (1828 × 1556). This gives an aspect ratio of (1828 ÷ 1556 =) 1.175,

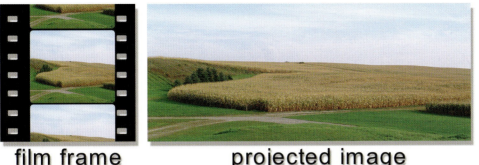

film frame projected image

Figure 12-12 Anamorphic projection of squeezed film frame.

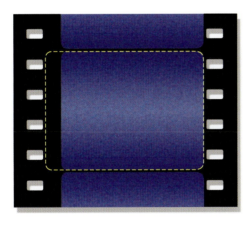

Figure 12-13 Cinemascope frame with full aperture reference outline.

which, when scaled by 2 in X at projection time, results in a (1.175 × 2 =) 2.35 aspect ratio image on the screen. Because it has an academy width it also has an academy center.

While the Super 35 2.35 format film area is a bit wider because it is full ap, it is not nearly as tall. As a result, there is much less film area compared to a Cscope frame. A Cscope frame has over 60% more projected film area than Super 35 2.35.

 You may encounter a Cscope job filmed at full aperture with picture covering the sound track area. The active picture area will still be just the academy width, and the action will be composed for it. More importantly, the lens will still have an academy center. In other words, don't let the fact that there is exposed film in the sound track area mislead you. Keep the action centered within the academy width, as well as the center of rotation or scale.

12.3.3.1 Working with Cscope

Speaking of rotation and scale, Cscope is a prickly format to work with. If your compositing software does not have an anamorphic image viewer, you have to either stare at squeezed images all day or add a resize node to double the width every time you want to look at a frame. Worse, an anamorphically squeezed image cannot be rotated or scaled without introducing serious distortions. If you scale an anamorphic image by, say, 10%, when it is later flattened during projection it will appear scaled 10% in Y and 20% in X.

If you attempt to rotate an anamorphic image it will end up both skewed and rotated. The rotational distortions are harder to visualize, so Figure 12-14 is offered as a case in point. The original image was squeezed 50% in X like Cscope, rotated 10°, and then flattened back to original size. As you can see, the target took a serious hit during the anamorphic rotation.

original image squeezed rotated unsqueezed

Figure 12-14 Distortions from rotating an anamorphically squeezed image.

Tragically, the production workaround is to flatten the Cscope images by scaling them by 2 in X. If there are only one or two "anamorphically illegal" operations, the image could be flattened just before the operation and then resqueezed afterward. If there are several, then it may have to be flattened at the first operation and left that way until after the last operation. The problem is that this obviously doubles the number of pixels in the image, which will seriously impact the rendering time. It also causes the image to be filtered (resampled) several times, which softens the picture. Perhaps someday someone will make an anamorphic rotate. If your scaling operation can scale differently in X than in Y, then you can make your own anamorphic scale simply by scaling twice as much in Y as in X and avoid the whole flattening thing.

Motion tracking can be done safely on a squeezed anamorphic image if the tracking is for panning only (translate X and Y). If you are trying to track rotation or scale (zoom), then data collected by the motion tracker from the squeezed frame will be dis-

torted and unusable. Perhaps someday someone will make an anamorphic motion tracker.

12.3.3.2 Reformatting Other Formats to Cscope

You will occasionally have other film formats to incorporate into a Cscope job, so you will have to reformat them. The key issue is to keep the number of filtering operations to a minimum—in this case, just one. Whether you are starting with a big bad Vista plate or (God help you) an academy frame, the procedure is the same:

Step 1. Crop a 2.35 window out of the source plate.
Step 2. Resize the cropped window to 1828×1556 in one resize operation.

Virtually all resize operations have an option to resize differently in X than in Y so the resize can be done in one step. This keeps the filtering down to one time only. If the Cscope layer is going to be flat (3656×1556) when it is joined to the imported element, then the imported element could be cropped to 2.35, left flat when it is resized to match at 3656×1556, composited with the Cscope, and then the

joined layers squeezed later in the composite. This would save squeezing the imported layer, flattening it later for composite, and then squeezing the results again. Again, try to keep the number of filtering operations to a minimum.

Ex. 12-3

12.3.4 3 Perf Film

All of the film formats described so far are referred to as "4 perf" in that they have four perforations (perfs) per frame. However, there is also an obscure format called "3 perf" that has only 3 perfs per frame (Figure 12-15). I bring it up because it is becoming not so obscure anymore due to the advent of the digital intermediate (DI) process (described later).

The advantage of 3 perf film is that it is cheaper to use because it saves film stock and lab expenses. Because the film is advanced only three perfs per frame rather than four it uses 25% less film for the same length of shot. Less exposed film also means less lab fees. It does, however, require a special 3 perf camera for filming.

A 3 perf scan is 2048×1168 and has an aspect ratio of 1.75. This aspect ratio is very close to the aspect ratio of Hi-Def video (1.78), so it maps very nicely to Hi-Def. In addition to that, the 1.75 aspect ratio can be mapped into the standard USA theatrical widescreen format of 1.85 by just trimming

Figure 12-15 3 perf film.

a little off the top and bottom of the frame. You could very well be receiving 3 perf film scans in the near future for digital effects shots.

12.3.5 VistaVision

Vista is a very high-resolution 35-mm format with a 1.5 aspect ratio that is used frequently for photographing background plates for effects shots. By starting with an ultrahigh-resolution element there is far less visible degradation by the end of the effects process, plus the grain is very small in what will likely be a held frame. Vista, sometimes referred to as "8 perf," uses far more negative than any other 35-mm format by turning the film *sideways* so that the image spans 8 perfs instead of the usual 4 (Figure 12-16). This means that the vista negative area is twice as big as the usual 4 perf full aperture. Transporting the film sideways obviously requires special cameras and projectors, but it uses the same film stock and lab processing as the rest of the 35-mm world.

Vista scans are a whopping 3096 × 2048, with a file size to match. You are unlikely to ever actually do an effects shot in Vista, but you are likely to be given a vista element to include in a more normally formatted shot. One common application is to load up a regular 35-mm photographer's camera with movie film stock and shoot stills to be used as background plates. Regular 35-mm stills are also an 8 perf 1.5 aspect ratio format, which fits nicely on your neighborhood Cineon film scanner. You wind up with beautiful vista plates without a film crew or anything more than a photographer and a still camera. The extra size of the vista plate also comes in handy when you need an oversized background plate in order to give it an overriding move or to push in (scale up).

Figure 12-16 Vista frame.

Figure 12-17 65-mm film with 5 perfs and a 2.2 aspect ratio.

12.3.6 65 mm/70 mm

A 65-mm camera negative is a 5 perf format with an aspect ratio of 2.2 and is often referred to by the term "5 perf 70." It is actually the release prints that are 70 mm, with the extra 5 mm on the outside of the sprocket holes for some additional sound track channels, illustrated by the dotted lines shown in Figure 12-17. Cineon full-res scans of 5 perf 65 mm are 4096 × 1840, and it is unlikely that you would use half-res scans for 65-mm work, as it would kind of thwart the whole purpose of the large 65-mm format.

12.3.7 Imax

Imax, the mother of all formats, is a 15 perf 70-mm format with a 1.37 aspect ratio, often referred to as "15/70." The negative, of course, is standard 65-mm

film. The film is laid on its side, like the vista format. This is a special venue format for Imax theatres. A full-res Cineon scan of an Imax frame is 5616 × 4096, and again, it is very unlikely that you would work with a half-res scan. While Cineon can scan a 65-mm negative, there is currently no Cineon 65-mm film recorder. When sending Imax frames out to a regular film recorder they will probably need to be sized down to something like 4096 × 3002.

Imax has a truly huge frame with over 10 times the negative area of a regular 35-mm academy frame. In addition to its enormous projected size, Imax theatres are designed so that the audience seats are much closer to the screen relative to its size. It is somewhat like having the entire audience sit in the first five rows of a regular theatre. The screen covers so much of the field of view that the action must be especially composed, as shown in Figure 12-18.

Figure 12-18 Imax frame with below center action "sweet spot."

The concept behind the Imax format is visual "immersion"; therefore much of the screen is intended to be literally peripheral. The action and any titles should stay in the action "sweet spot," below the center of the frame. Composing an Imax film like ordinary 35-mm films with the action in the center will cause the entire audience to crane their necks upwards for 40 minutes. Keeping the action low and using the rest of the huge screen to fill the peripheral vision of the viewer results in the "immersion" experience.

It is particularly difficult to work with the Imax format not just because of the huge frame sizes, but also because of the hugely different audience-to-screen relationship. Imax frames on video or your monitor look odd with the action and titles all huddled down into the little "sweet spot" area. The instinct is to raise things up and make them bigger—until you screen the shot in an Imax theatre. Then suddenly everything is way too big and overhead. To get some idea of what the image on your monitor will look like when pro-

jected, move your nose down low and to within about 3 inches of your monitor. Seriously.

12.4 FILM SCANNERS

The film scanner digitizes the film negative (or interpositive) and outputs data files for digital manipulation. The film frames you are working with at your workstation came off of a film scanner, so it might be helpful to know a bit about them. Information about hardware resolution and aperture correction can be helpful in selecting a scanning service bureau with which to work.

Figure 12-19 illustrates the typical film scanner configuration. It has a linear CCD array that digitizes one entire scan line of film at a time, plus a precision transport mechanism that single steps the film past the CCD array one scan line at a time. Because it is very difficult to build film transport and lens systems that are high precision and repeatable, as well as adjustable, most film scanners are "hard wired" to scan the full aperture horizontally at a fixed resolution, but can vary the vertical height of the scan simply by altering how many scan lines are stepped through per frame. For an academy aperture scan, for example, the full aperture would be scanned horizontally and the resulting scan cropped to academy size. Cscope just needs an academy crop horizontally with a full ap transport vertically. For a vista scan (the sideways format) the film transport just keeps moving for 8 perfs instead of the usual 4.

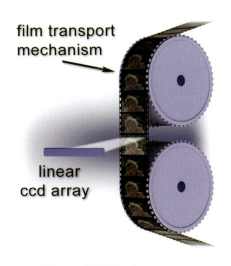

Figure 12-19 Film scanner.

One extremely important characterization of a film scanner is its hardware scanning resolution. For horizontal resolution the hardware scanning resolution depends on how many elements ("pixels") are in the linear CCD array. For vertical resolution it is the "finesse" of the film transport mechanism—that is to say, how small a "step" the transport mechanism can make when moving the film vertically.

 All film scanners have square pixels. Most scanners are either 2k (2048) or 4k (4096) scanners, meaning the resolution of their CCD arrays. The process of digitizing an image softens it for reasons clearly explained in the arcane science of signal theory (which we will mercifully skip). To compensate, some scanners apply "aperture correction," which is scanner speak for an image-sharpening algorithm. There is a very important point here. While most of the world actually uses only 2k scans, a 4k scan filtered down to 2k is a *much* better scan than a 2k scan. Always ask what the hardware scanning resolution is regardless of the resolution of the delivered images.

In the early days of film scanner design it was determined that a "lossless" scan of film would require a 4k resolution. Practical experience has shown, however, that a good 2k scan looks good enough for almost all applications and requires one-fourth the disk space, data transfer time, and rendering time of a 4k scan. Most scanners digitize the film at 12 to 14 bits of resolution and then filter it down to 8 or 10 bits. The 8 bits are for a linear version of the scan, and 10 bits for a log version. The differences between linear and log film images are covered in detail in Chapter 13. Most scanners can digitize either a negative or an interpositive. The interpositive has the same density range as the negative so the scanner optics do not have to be altered. The interpositive scan data just has to be inverted to convert it to negative scan data.

12.5 FILM RECORDERS

Film recorders take the digital image data and expose it back to film. There are two basic kinds of film scanners: CRT based and laser based. All film scanners try to add as little grain as possible, as they are designed to "rephotograph" previously digitized film that already has its own considerable grain content. The way to do this is to use a very fine-grained film. A very fine-grained film is also a very "slow" film, meaning that it takes a lot of light to expose it or, if you don't have a lot of light, then it will take a much longer exposure time. Because a CRT cannot produce the intensity of light that a laser can, it will be no surprise to find out that laser film recorders are faster than CRT recorders.

12.5.1 How Film Recorders Work

The CRT film recorder uses a film camera to shoot a picture off of a CRT, illustrated in Figure 12-20. The CRT is a special high-resolution black and white model. Color is achieved by filming each frame through the color wheel one channel at a time, which means that three passes are required for each frame. For example, the red channel is first displayed on the CRT, the red filter is rotated over the CRT, and the camera clicks the shutter, but does not advance the film. Next, the green channel is displayed on the CRT, the green filter is moved into position, and the camera clicks the shutter a second time, but again does not advance the film. This process is repeated for the blue channel and then the film is advanced to the next frame.

The laser film recorder literally "paints" each frame one scan line at a time directly onto the film negative as it is slowly moved vertically. The laser first passes through a beam modulator that alters its brightness for each pixel as it scans a line and then through a deflector that sweeps the beam horizontally to scan across the film. While Figure 12-21 shows just one laser for

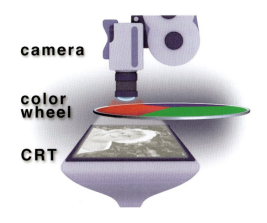

Figure 12-20 CRT film recorder.

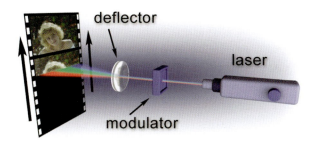

Figure 12-21 Laser film recorder.

clarity, there are actually three lasers, one for each color channel. Each beam has its own modulator and deflector so that all three beams can operate simultaneously to record the frame in one pass.

12.5.2 Comparison of Laser vs CRT Film Recorders

While the CRT film recorder does a good job in most cases and is much less expensive than laser film recorders, the laser wins all of the performance contests, hands down. The laser film recorder is

Faster—the light source of the laser recorder is much brighter than a CRT so it has much shorter exposure times for each frame. The CRT recorder also needs to make three passes per frame, whereas the laser recorder records all three channels simultaneously in one pass.

Finer grained—a second advantage of the intense light produced by the laser is that an even slower, finer grained film stock can be used.

Sharper—the spot size on a CRT is small, but cannot be kept constant because it tends to balloon with brightness. The laser can be focused to the same incredibly small spot regardless of intensity.

More saturated—because the laser beams are extremely narrow in their color frequencies, the red laser, for example, only exposes the red layer of the film with very little contamination of the other two layers. This gives the laser recorder excellent color separation, which results in superb color saturation. Because the color wheels on CRTs are not nearly as selective, the red color filter will let a little green and blue pass through, reducing color separation and therefore saturation.

12.5.3 Calibrating the Workstation to the Film Recorder

The single biggest question on the digital compositor's mind relative to film recorders is "why doesn't the film look like the picture on my monitor?" What it takes to actually make them look the same is, literally, a whole other book. What we can do here is try to appreciate some of the reasons it is very difficult to do what seems so obvious—make the monitor look like the film. It is not the digital compositor's job to achieve this. There are film recorder lookup tables as well as workstation monitor calibrations that need to be done, and these are the responsibility of the engineering department. Unfortunately, even when done properly, the monitor can only come close. Here are some of the issues involved.

12.5.3.1 Dark Surround

The human perception system adapts to the viewing environment. In a movie theatre (or screening room) the viewing environment is a "dark surround"— the room is totally dark except for the movie screen. The viewing environment in a typical compositing studio, however, is a "dim surround"—the room is dimly lit, and sometimes brightly lit. This issue is covered in greater detail in Chapter 10. The bottom line is even if you could somehow bring the movie screen into your compositing studio, it would suddenly appear very different because of the dim surround. The only way to replicate the dark surround in the compositing studio, of course, is to cover the windows and turn off all of the lights, which is just not going to happen.

12.5.3.2 Contrast Ratio

The contrast ratio of an image display system is simply the ratio of the brightest image you can display compared to the darkest image you can display. The darkest your monitor gets is the color of the screen with the power turned off and the lights down low. The darkest film gets is the maximum density of the print with a projector bulb attempting to shine through it. The brightest your monitor gets is displaying pixel value 255 with the monitor contrast and brightness adjusted properly. The brightest film gets is the minimum density (virtually clear) with the projector bulb shining directly on the screen. To quantify this issue, the contrast ratio of projected film is in excess of 150:1, whereas a good quality studio monitor is less than 100:1, even under ideal conditions. The modern monitor just does not have the "reach" to match the contrast ratio of film.

12.5.3.3 Primary Colors

The dyes in film act like color filters that pass the primary colors red, green, and blue, which blend together in the human perceptual system to make the sensation of color. These dyes pass primary colors with a particular range of frequencies. The rare earth phosphors in the CRT of your monitor also create red, green, and blue primary colors, but they have somewhat different ranges of frequencies than the film dyes. As a result, the red of your monitor is not an exact match to the red of the film, and so on. To some degree, this discrepancy can be reduced, but not eliminated, by careful calibration of both the monitor and the film recorder.

12.5.3.4 Film Layer Effects

Modern motion picture film is a complex layering of light-sensitive chemicals, plus a mind-boggling array of couplers, inhibitors, enhancers, blockers, and so forth. When red light hits the film, it does not simply result in neatly exposing just the red layer. Some of it exposes the blue layer, a bit of it is absorbed by this inhibitor, some is reflected by that interaction, then this other molecule over here shifts its frequency and reradiates it as ultraviolet, and on and on. The bottom line is that the optical chemistry of the physical film medium is very complex and there are interactions between the many layers of film. In contrast, when you add 10% to the red channel of the picture on your monitor the red increases by 10%. Period. There is no "model" of the physical film's behavior in the display of film images so the display is inherently incomplete and incorrect. This issue is only partially correctable with film recorder calibration.

12.5.3.5 Monitor Calibration

As we have seen, differences between film and monitors are far too great to be fixed with a little lookup table. However, proper monitor calibration combined with proper film recorder calibration can achieve a fairly close match. All film recorders come with calibration and lookup table preparation tools so this end of the pipeline is well cared for. Not so the monitors. To calibrate the workstation monitor properly, an expensive piece of calibration equipment with a light-sensing device must be attached to the screen that reads the actual color of light coming off the screen for a given RGB value in the frame buffer. It then builds a color lookup table that alters the color of the light from the screen to match a particular specification. This takes equipment, trained staff, data tables, technical procedures, and film recorder calibration data. Plus, these monitor calibrations must be performed every few weeks because of the inherent instability in CRT monitors. The resulting lookup tables will have three slightly different "S"-shaped film response curves for each color channel and will be unique for each workstation. It is no surprise, then, that simply adjusting the gamma won't make your monitor suddenly match the film.

12.6 DIGITAL INTERMEDIATE

Now that you know all about the film process, film formats, film scanners, and film recorders, let's pull it all together and take a look a the digital intermediate (DI) process. As shown in Section 12.1, "The Film Process," the

movie has to be color timed in a lab in order to color correct each shot. This color-timing process is being taken over by computers and soon all feature films will be color timed digitally. Not surprisingly, this has a certain impact on your digital effects shots. It might be wise to know something about the DI process of film finishing.

12.6.1 The DI Process

The first step is to digitize the movie—the entire movie. All 400 or 500 of the original camera rolls are delivered to the DI facility along with a list of all the cuts from each camera roll and where they go in the finished movie. The selected shots are scanned to disk over a period of a few weeks at 2k resolution. This forms an enormous database for a 100-minute movie of 144,000 frames separated into 1500 to 2000 cuts requiring around 1.5 terabytes (that's 1500 gigabytes!) of disk storage. Each frame scan must then be inspected and "dust-busted" (paint out the dirt).

The frame scans then go through a high-performance digital color corrector at 2k resolution for "color timing" by a highly paid colorist. The 2k color correctors have far more capability to color correct the film than the lab process ever did. They have "power windows" (crude mattes), can pull luma-keys and chroma-keys, and can use these in combination to isolate regions of the screen and effect, say, just the sky (just like a real compositor!). In addition to this spectacular color control, there are other image processing operations available, such as image sharpening and degrain—all in real time.

After the first reel is color timed it is sent to a film recorder for filmout. There will typically be five or six reels of 2000 feet each and they are not necessarily done in order. The titles will be in reel one and the last reel, of course, and a "textless" version of the color-timed live action is produced without the titles for the international market. A textless version is needed so that titles can be added in each country in their local language.

After the entire movie plus the textless footage is completed, the next step is the video master. Typically this will be a Hi-Def 24p master like we saw in Chapter 11. After the 24p master is produced, the "pan and scan" 4×3 version for the DVD will be made. In a lower budget situation this will be a simple crop of the 24p master. If there is budget available, the colorist will actually recompose (reframe) the entire movie on the original film scans to produce a nicer-looking 4×3 version.

Common practice in the DI process is to shoot the entire movie as full aperture and then reformat it in the DI process to academy for filmout. Most USA feature films finish as either 1.85 or 2.35. For a 1.85 finish the full aperture frame is simply scaled down to the academy aperture. For the 2.35 finish

a 2.35 window is cropped out of the full aperture frame (2048 × 872) and then resized to Cscope (1828 × 1556), which introduces the anamorphic squeeze. Tests have shown that performing the "scope extraction" digitally results in a sharper image than doing it optically. Of course, the resulting Cscope film is not as sharp as if it had been filmed originally in Cscope, but it avoids all the hassles of Cscope cinematography.

12.6.2 Advantages of DI

The main advantage of film finishing with the DI process to filmmakers is the creative control over the color-timing process. The capability to affect just selected parts of the picture, exotic color control such as saturation (not available in the lab process), and the ability to perform image processing operations such as image sharpening and degrain give the director and cinematographer unprecedented creative control. As a result, the finished movie simply looks artistically much better than if it were given the limited color timing available in the lab. Along with a prettier movie is the opportunity to fix problems and defects in the film that could not be done in the lab. A side benefit is that the precious and irreplaceable camera neg never has to be cut up for editing. No director or cinematographer who has done a DI wants to go back to doing it in the lab.

A second major advantage to doing a DI is the freedom to mix media together in one film, an ever-increasing demand. With a DI you can mix 35-mm 4 perf and 3 perf, 16-mm, Hi-Def video, digital effects shots, and even DV-CAM (gasp!). With an all laboratory film finish all of these different media would have to first be "bumped" to one format (e.g., the 16 mm transferred to 35-mm 4 perf) before the work could even begin. In addition to the cost, there is a generation loss. With DI you can mix media so that the original version of each format can go into the color corrector to be resized and color timed to match the rest of the movie.

A third advantage of the DI process is the digital version itself. The 24p master is made from the original film scans, not a telecine of the finished film, so it is a higher quality. The 4 × 3 version can be recomposed and does not have to be a simple crop of the letterbox version. The digital version is also just what is needed for digital cinema when that comes on line. Some far-sighted filmmakers ask for the digital tapes of their finished movie to preserve them for as yet unseen future repurposing.

12.6.3 DI and Digital Effects

So what has all of this got to do with you and your digital effects shots? A great deal. In the past the final deliverable to the client was your digital effects

shot on film, which would then be cut into the edited negative. In the future the deliverable will be your final render data file. What is happening in the DI process is that all the digital effects shots are delivered digitally, typically on a firewire drive sent back and forth between the DI facility and the digital effects facility. The digital effects shots join the digital film scans on the digital color corrector's timeline and get color corrected digitally before going to the digital film recorder.

This opens up several new cans of worms, the simplest being file formats. Do you deliver tiffs with linear image data or Cineon or DPX files with log image data (covered in the next chapter)? The next issue is color calibration. A digital effects facility with a film recorder will have a very carefully calibrated color pipeline between the monitor and the film recorder so that the film output matches the workstation monitors. When you send your data to a stranger in a strange facility you have no idea what his color pipeline is like and your pictures can suddenly take on an unexpected look for the worse.

Another issue is the color timing process itself. Your digital effects shots are color timed by the colorist right along with all the regular scanned film. The problem is that while your composite looked fine on your monitor, in the color timing suite the contrast is very often increased, which can cause you composite to "pull apart." Very small differences between the composited elements become exaggerated after color timing. The answer is to do the composite with color-timed plates. The problem is that the "look" of the movie will not be set until weeks after you have finished your shots so nobody is in a position to color time the plates for you.

 It is strongly recommended that even though the look of the film has not been established the background plates be given a basic color timing before compositing. It is hoped that this will minimize the change that occurs in the color timing suite and your shots won't pull apart.

Just a few years ago scanning film was an exotic and expensive thing to do so it was not done very much. Because it was slow and expensive only the biggest budgets could afford it. Today, thanks to the increase in the speed of film scanners plus the explosive rise in the digital intermediate process, scanning film has become fast, inexpensive, and common. As a result, the number of folks working with scanned film frames has skyrocketed. If you are working with scanned film frames, this raises the age-old question: log or linear?

One of the most byzantine topics in the digital film domain is the issue of log vs linear film data. It is a difficult subject because it crosses several disciplines, such as the human perceptual system, film response curves, and math. Lots of math. A scientifically rigorous explanation of all of this would make truly gruesome reading, and I fear most would not bother. Instead, I have taken liberties with precise scientific terms such as "brightness," simplified the math, tossed out troublesome details, and tried to present an understandable tale that you might actually read, and therefore benefit from. The attempt here is to present the behavior of film and its digital representation as seen from the compositor's point of view, not the engineer's. In the end, you will wind up with the same basic understanding of the principles that the scientifically rigorous approach would have given you, but with far less pain. If you want pain, just contact Kodak and request the technical papers on log film digitizing. They will give you all of the pain you want.

There are three reasons why you should care about log film data, besides deepening and enriching your understanding of your chosen profession. When film is digitized and then converted to 8- or 16-bit linear data for compositing in a typical digital studio, the image has been degraded. You should understand how and why. Second, if your 8- or 16-bit linear composite is converted to log for filmout on a film recorder, you now have a limited image that does not take full advantage of the dynamic range of film. You should also understand how and why this happens. Finally, if you are going to actually work in 10-bit log you need to understand how working with log data differs from working with linear data to avoid introducing artifacts and unrecoverable errors into your composites. So fasten your seatbelts and put your trays in the upright position as we take off into the wild blue yonder that is log film data.

13.1 DYNAMIC RANGE IN THE REAL WORLD

One of the first unintuitive issues to clear up is how much brighter the real world is than it appears. The real world has a deceptively enormous dynamic range—the darkest thing compared to the brightest thing. For the sake of putting practical limits on the discussion, let's stipulate that the darkest thing is a 1% black card that reflects only 1% of the light that falls on it. It is a "diffuse" surface (flat, matte, felt-like), which scatters the light that falls on it like most objects, in contrast to shiny surfaces. At the other end of the brightness spectrum we will use the sun is the brightest thing in the universe (of film, anyway). The thing that is hard to believe is that the sun is not 10 times brighter than the 1% black card or even 1,000 times brighter, but is something like 20,000 times brighter!

Between the sun and the black card there is an important reference point that we need to mark with a 90% white card. As you might guess, it diffusely reflects 90% of the light that falls on it. An example might be a really clean T-shirt. The reason that this is an important landmark is that this seems to be the upper end of diffuse reflective surfaces. In the real world it is very difficult to make a diffuse surface reflect more than 90%. Beyond this, things seem to become mirror-like and cause what are called specular (shiny) reflections. As a result, diffuse reflections are like felt or a white T-shirt, and specular reflections are mirror-like reflections off of shiny surfaces such as chrome and, well, mirrors.

We now have three points in our brightness range: the 1% black card, the 90% white card, and the sun. This divides the brightness range into two zones: between the 1% black and the 90% white cards, which we will call "normal brightness," and above the 90% white card, which we will call "superwhites" (above white). Things in the "normal brightness" range are the usual diffuse reflective surfaces we all know and love—clothes, skin, buildings, frogs, etc. Things in the superwhite range are either light emitters—candles, lamps, the sun, etc.—or their *reflections* off of shiny surfaces (specular highlights). It is the superwhites that throw the enormous dynamic range into the mix because they can be hundreds or thousands of times brighter than the "normal brightness" of diffuse reflective surfaces. The dynamic range of the diffuse surfaces, by comparison, is paltry. Relative to the 1% black card, the 90% white card is a mere 90 times brighter, whereas the sun is perhaps 20,000 times brighter.

The brightness ranges column in Figure 13-1 attempts to illustrate the situation. The 1% black card is at the bottom with a brightness of 1, and the sun is at the top with a brightness of 20,000. To squeeze it all in, the distance between the numbers has been fudged. If drawn to scale, the "normal

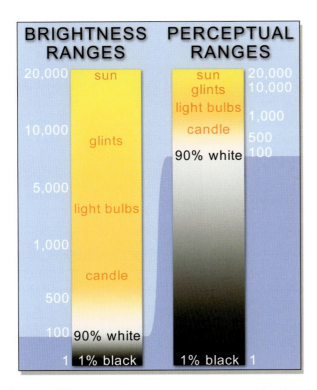

Figure 13-1 Real world brightness vs perceived brightness.

brightness" range between 1 and 100 would be squeezed to a tiny sliver at the bottom of the chart too small to see, much less print in a book. Distorted as it is, Figure 13-1 provides the basic insight to the awesome dynamic range of the real world on film. Superwhite objects are hundreds, even thousands, of times brighter than they appear to the eye.

So how does the eye deal with this? The human eye also has an enormous dynamic range, about four times that of film, but nowhere near enough to cope with 20,000:1. To cope with this oversize brightness range, the eye has a nonlinear response, i.e., it gets less sensitive as the brightness goes up. A linear response would mean that if object "A" was 100 times brighter than object "B," it would appear 100 times brighter. A nonlinear response means that object "B" appears, say, only 10 times brighter. If we attempt to describe the behavior of the eye mathematically, a good approximation would be a logarithmic response. More on this later.

The perceptual ranges column in Figure 13-1 illustrates how the eye perceives this same brightness. It "stretches" the darks to see more detail there and "squeezes" the brights for less detail. Interestingly, this is also how film behaves. Film even has a logarithmic response similar to the eye, which is

why film is such a great medium to capture images. The key point here is that the real world is very different than it appears to the eye. The diffuse reflective objects are very dim compared to superwhite objects and are squeezed down to the bottom of the range of brightness. However, the eye is very sensitive in this region and "stretches" it with increased sensitivity to see lots of detail. As a result, the superwhite region, which takes up the vast majority of the data range, is compressed up into a small region of the perceptual range. Film behaves this way too.

13.2 THE BEHAVIOR OF FILM

When film is exposed to light it turns dark. Silver halide crystals in the film turn opaque in response to how much light has fallen on them. The more light, the more opaque the film becomes up to its maximum opacity, which is measured in units called "density." Exposure is the grand total of all the light that has fallen on the film. It is not how bright the incoming light is, but the total number of photons that has fallen on the film over the period of the exposure time. A lot of light for a brief moment or a little light for a long time can give equivalent exposures, resulting in identical film densities. The relationship between the exposure and the resulting film density is one of the critical technical descriptions of the behavior of the film. This technical description is plotted on a graph called the response curve of the film. Different film types have different response curves and knowing the exact response of the film plus the amount of exposure being used is essential to avoiding over- or underexposing the film.

Having said all that, the compositor need not know the response curve of the particular film being used. The film has already been exposed, the densities are locked in, and the ASA of the film is now irrelevant. What is important for the complete compositor to know is how film response curves work in principle, for two reasons. First, from an artistic point of view, understanding where the image lies on the film response curve can be very important for color grading and converting film data from linear to log. Second, from a technical point of view, it is an essential background for understanding the problems with linear data and the large dynamic range that film captures.

13.2.1 Film Response Curves

Film response curves are a diagram of how the film will change its density as it is exposed to light. They are normally presented in log units for reasons that will become clear shortly. To introduce the film response curve in a more

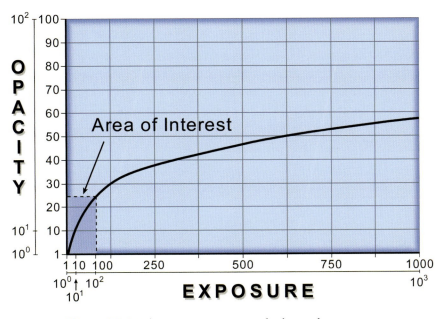

Figure 13-2 Film response curve with clumsy linear units.

intuitive way, we can start with Figure 13-2, which represents a typical film response curve in a most unusual way. It is graphed using familiar linear units instead of the usual, but obscure, log units. While it will make the graph much easier to understand to us linear thinkers, problems with using linear units will soon become very apparent. In Figure 13-2 the density is temporarily labeled "opacity" because we technically can't call it density yet until it is converted to log units. We will only have to bear this cross for a few pages.

13.2.2 Exposure

The horizontal axis, labeled "exposure," marks the exposure of the film ranging from 1 to 1000 units. But units of what, you may be wondering. In fact, the actual units are not important. It could be lux-seconds, photons per fortnight, or Mythical Exposure Units (a unit of exposure that I just made up). The reason that it is not important is that it doesn't matter whether the units range from 1 to 1000, or 0.001 to 1, or 3.97 to 3973. The relevant issue here is that the maximum amount of exposure is 1000 times greater than the minimum amount. An exposure *range* of 1000 to 1 is the key point, not what units it is measured in. Besides, what does a lux-second[1] mean to a true

[1] One lux-second is 1 lux of light for 1 second duration. That would be one standard candle at a distance of 1 meter for a period of 1 second.

artist anyway? I simply chose appropriately scaled units that make the story easier to follow.

Looking at the shape of the curve in Figure 13-2, it starts with a steep slope on the left with low exposures and gradually levels out as the exposure increases. What this means is that the opacity (density) increases rapidly at first with lower exposures and then as the exposure goes up the film gets less responsive. One "pound" of light added to the darks might raise the opacity of the film by 10%, but that same pound of light added to the brights might raise it only 1%. The reason for this "rolloff" in the response of film to increasing light is because the film grains are "saturating" as they get increasing exposure.

13.2.3 The Balloon Story

The rolloff of the film response curve might make more sense with a little down to earth story. Imagine a wall covered with 100 balloons. If you take a fistful of darts and fling them at the wall all at once "shotgun" style, you might pop, say, 10 balloons, i.e., that's 10% of them. If you fling a second fistful of darts at the balloons you might only pop 9 balloons, which is 9%, because some were already popped. Each successive fistful of darts will pop a progressively smaller and smaller number of balloons because more and more darts are wasted by landing on previously popped balloons. A graph of this progressive "saturation" would look like the solid line shown in Figure 13-3. The dotted line shows what a linear response would look like where every fistful of darts popped an equal number of balloons. The actual response is clearly nonlinear.

The balloons represent the film grains, the popped balloons represent the exposed film grains, and the darts represent photons of light. A similar thing

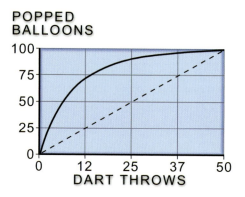

Figure 13-3 Rolloff of popped balloons.

happens with light photons striking progressively exposed film grains. The rolloff in popped balloons with every dart throw in Figure 13-3 resembles the rolloff in opacity with increased exposure in Figure 13-2. They are not an exact match because the film exposure process is a bit more complicated than popping balloons, but it illustrates the basic mathematical concept.

13.2.4 Meanwhile, Back at the Film . . .

Note in Figure 13-2 that the "exposure" axis has two rows of numbers. The top row is the normal exposure numbers and below them are the same values printed in exponent form.

A math moment:

Exponents are just math shorthand for writing very large or very small numbers. Instead of writing all the zeros in 10,000,000 (ten million), we can use exponents and just write 10^7, which means "10 to the power of 7," or 1 with 7 zeros.

Note also that the spacing of the exponents is not uniform. The distance between 10^0 and 10^1 is tiny, but there is a huge gap between 10^2 and 10^3. In fact, things get so crowded at the left end that there is no room to print all of the exponents so 10^1 was crammed in with a little makeshift arrow.

What if we want to see some detailed information about what is happening between 1 and 100? The problem is that our white card and black card fall exactly into this range, along with all the other objects in a normally exposed frame of film. In other words, all of the interesting things we want to see in our response curve are crushed down into the tiny little white square in the lower left of the graph labeled "Area of Interest" because the graph evenly spaces the huge range of possible exposures that film can respond to. The curve's lack of detail at the low end is a key failure of the linear representation.

13.2.5 Opacity

The vertical axis of Figure 13-2 is labeled "opacity" because the numbers there represent how opaque the negative will get based on the exposure to light (we will rename it "density" in a moment when the graph is recast into log units). Starting at the bottom with an opacity of 1 the film is essentially trans-

parent[2] and gets more opaque as the numbers go up to 100. This time the numbers are not mythical units. They are ratios based on comparison to the minimum opacity of an unexposed part of the film. The "100" means that the film negative is so opaque that it passes only 1/100 of the light compared to the film at unit 1. At 50 units it passes 1/50 of the light, at 10 it passes 1/10 of the light, etc. Note also the column to the left of the opacity numbers, which are the same values, is only in exponent form. Because this axis only has a range of 100 to 1, it was possible to squeeze all of the exponents in without resorting to a makeshift arrow.

However, we again have the crowding at the low end, and for the same reason as before. When dealing with numbers that range from very small to very large, to see any detail at the small end you must either scale the entire graph up enormously or crop out a tiny area of interest and blow it up. Neither solution is every elegant. What if we could spread the exponents out, however, to space them evenly?

13.3 REPRESENTING FILM DATA IN LOG FORMAT

Representing linear data in log format really means two things. First, there is a "name change." Instead of referring to the quantity 100 as 10^2 (10 to the power of 2), just the exponent "2" is used. So the log of 100 is 2, the log of 10 (10^1) is 1, and the log of one (10^0) is 0. The second thing it means is a "location change." The location on a number line for the quantities 1 (log 0), 10 (log 1), and 100 (log 2) are shifted so that their log numbers are spaced evenly. This means, of course, that the quantities they represent are no longer spaced evenly. The quantities get progressively squeezed together as they get larger.

Figure 13-4 illustrates what happens when we change the format of data from linear to log. Both number lines represent that exact same range of data. On the LINEAR number line at the top the linear numbers (1 through 100) are spaced evenly but the exponents just below (10^0, 10^1, and 10^2) are not, just like in Figure 13-2. On the LOG number line the two changes can be seen: first, the "name change" where just the log versions of the numbers are printed (0, 1, and 2); second, the "location change" as the log numbers are shifted to become spaced evenly. Below the LOG number line the old linear numbers have been reprinted in gray so you can see how they have been

[2] Actually, the unexposed part of the film is not quite totally transparent. This small amount of opacity is labeled "1" because that is the point of comparison for how opaque the negative gets as it is exposed to light.

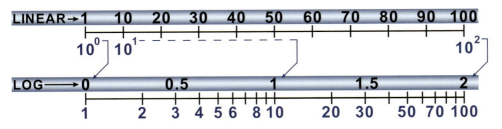

Figure 13-4 Linear data converted to log format.

redistributed accordion-like, getting progressively tighter as you move to the right.

On the original LINEAR line there was no room to print all of the numbers between 1 and 10, but on the LOG line there is much more room. However, the numbers between about 30 and 100 became all scrunched up on the LOG line so that not all of the numbers can be printed in the diminishing space available. Referring to the old linear numbers below the LOG line now, one unit of data between the values of 99 and 100 is the size of a flyspeck, but one unit between 1 and 2 is well over half an inch. In summary (and this is the punch line), we picked up a lot of additional "detail" at the low end of the numbers, but lost "detail" at the high end by converting the data from linear to log.

Returning to the film response curve in Figure 13-2, if we performed this same linear-to-log conversion on both the vertical and horizontal axis it would have the same spreading effect on the distribution of the data. This would give us plenty of room for detail down in the dark numbers, but we would lose detail in the bright numbers. As it turns out, we don't mind losing detail in the bright numbers because the eye also loses detail there. We would also like to get more detail at the low end so we can see better what is happening in the all important "Area of Interest."

Figure 13-5 shows what happens when we take the linear graph in Figure 13-2 and slide the numbers around to evenly space the exponents like Figure 13-4, thus converting the film response curve to a log representation. So that you may follow what has been moved where, the logs in Figure 13-5 have been printed in black on their own lines to make them stand out while the old linear units are ghosted out but still visible for reference.

First of all, the shape of the graph itself has changed to make the overall graph a nice straight line, which is very handy. There is also the sudden appearance of the flattened regions at each end of the curve. The one on the left was there all the time, but in the linear graph in Figure 13-2 it was squeezed down into the small detail in the corner where it couldn't be seen

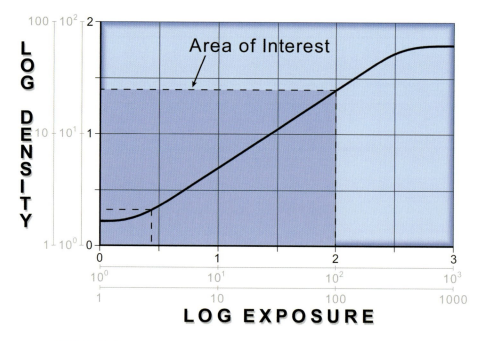

Figure 13-5 Film characteristic curve with log density vs log exposure.

at all. The log graph behaves as though there were a continuously increasing "zoom" factor going from right to left, with the left-hand corner being the closest zoom. It has effectively "zoomed in" to reveal a great deal of new detail down in the small numbers where it was needed most. The tiny white "Area of Interest" in the linear graph now makes up the majority of the log graph, which is another very helpful change.

By convention, because we are presenting the opacity in log form, it can now officially be called density. Only the name has been changed. A density of log 2 is the same as an opacity of 10^2, which is simply another name for an opacity of 100, which means it only transmits 1/100 of the light compared to the most transparent part of the film. Succinctly put, a density of log 2 will transmit 1/100 of the incoming light compared to the density at log 0.

Ok, let's take the training wheels off of the characteristic curve in Figure 13-5 and check out the standard log/log film characteristic curve in Figure 13-6. The film response curve has three zones where the behavior of the film is different. The zones are labeled the toe, straight line, and shoulder. There are also three important reference points: the 2% black, 18% gray, and 90% white references.

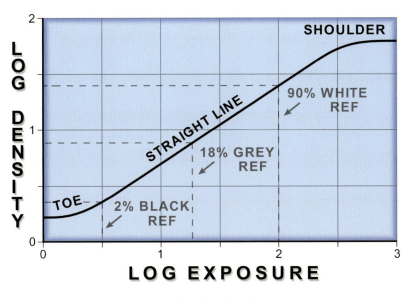

Figure 13-6 Standard log/log film characteristic curve.

13.3.1 The Three Film Zones

In the toe region the very low exposures cause little or no change in the density of the film. This means that small brightness variations in very dark regions, such as deep shadows, will all be flattened to the same film density, resulting in a permanent loss of detail. If any of the dark shadow detail lands in this region, it will appear "flat" with little or no variation in brightness. The reason for this is that below a certain level of exposure the film grains simply cease to respond to incoming light. If the exposure level is inched up, the film grains slowly begin to respond as the exposure increases. By the time the 2% black reference point is reached the film response is on the straight line segment. Just below it would be the 1% black card, but the film response is flattening out so little detail is actually preserved.

The next region of interest is the straight line segment. This is where the majority of the picture information wants to be for a properly exposed shot. Increases in exposure due to increased light levels, brighter objects, or opening up the camera aperture will result in a corresponding increase in the density of the film. Variations in the brightness of objects in the scene will result in a matching variation in the density of the film in this straight line segment. This is the "normal exposure" part of the film response curve where all of the diffuse reflective objects are supposed to land.

The shoulder of the curve, however, shows how the film starts to fail to respond to increasing exposures. The film has become "saturated" and cannot increase its density and any object here is soft clipped to the maximum density of the film. Remember the balloon story? When the balloons were almost gone, throwing more darts did not pop any more balloons. When the film grains are all exposed, adding more light will not expose any more grains. Because the response curve is essentially flat at an exposure of 1000 (oops! I mean a log exposure of 3), the sun, with its brightness of 20,000, would be gently soft clipped to this value.

13.3.2 The Three Reference Points

The black reference point represents the density value of the exposed film where a 2% reflective black card would appear in a properly exposed shot. It is not yet down into the toe of the film so there will still be visible detail in these blacks. Earlier we talked about a 1% black card, and now we are talking about at 2% black card. The 1% black card was not a reference point. It simply represented the practical "total black" in the scene and falls in the bend of the toe of the film. Because it is almost in the toe, it has very little visible detail and appears as practically a solid black color. The 2% black card, however, is an active and important part of the picture that does contain detail, so it must be above the toe. While it may not sound like it, they are actually very far apart in brightness, as the 2% card is actually twice as bright as the 1% card.

The 18% gray card only reflects 18% of the ambient light, but because of the log response of the eye it appears to be the 50% midpoint point between the black and the white references. It is also the control point that is measured at the lab to determine proper exposure and development of the film. The film is properly exposed when the 18% gray card results in a specific density as measured by a densitometer. This "locks" the midpoint of the normal exposure region to a specific location on the film response curve so that lighter and darker diffuse objects in the scene will fall predictably on the straight line section and not get crushed under the toe or squeezed into the shoulder.

The 90% white card represents the brightest diffuse reflecting surface in the shot and is well below the shoulder of the curve. This leaves a safety margin called "headroom" for overexposing the film without the normal exposure region sliding up into the shoulder. In properly exposed film, everything above the white reference is "superwhite" and it is routinely clipped out for video as well as for film scans in linear space.

13.3.3 Over- and Underexposure

If a scene is overexposed, it has the effect of sliding all of the film density up the response curve toward the shoulder. Not only does everything get brighter, but objects that should be on the upper end of the straight line section slide up over the shoulder and start to get crushed in the whites. This is an irretrievable loss of data, and no amount of color correction will replace it. The film simply does not contain the information about the object because it has all been squeezed into the "saturation" region of the film. Variations in object brightness are no longer matched by variations in the density of the film.

When a scene is underexposed it slides the picture information down the response curve toward the toe. Not only does everything get darker, but objects that should be on the lower end of the straight line section slide down into the toe and start to get soft clipped in the blacks. This is also an irretrievable loss of data, which cannot be color corrected back. Here, too, the film simply does not contain the information about the object because it has all been squeezed into the minimum density region of the film. Variations in the scene are no longer matched by variations in the film's density.

The key points of this discussion are the two amazing properties of film. First, it has such an enormous dynamic range that it can capture both dark objects and superwhite objects that are literally thousands of times brighter. The second amazing property is that it retains very fine detail down in the darks, but for very bright objects less and less detail is retained. This is well matched to human vision because our eyes also see great detail in the darks and get progressively less sensitive with very bright objects.

13.4 DIGITIZING FILM

In order to get the film into the computer it has to be digitized, converting it to numbers that the computer can manipulate. In the process the negative is inverted mathematically so that dark becomes light, like when making a print. The process of digitizing, or "quantizing," an image essentially "chops" the image into discrete numerical "chunks," whereas the original was a continuous analogue element. How the image is quantized (digitized) has a profound effect on the resulting image data file. The simple and obvious way of digitizing film linearly—simply assigning an increasing digital code value to each increasing brightness value—turns out to have a few unpleasant side effects. This section explores the causes of these side effects and drags us, kicking and screaming, to the conclusion that digitizing the film logarithmically is best.

13.4.1 Linear Data Problems

When setting the criteria of a good scheme for digitizing film, three things come to mind. First, we do not want any banding in the images. Second, for feature film work, we don't want any clipping so that we can keep the full 1000:1 dynamic range of the film. Third, the database needs to be as small as possible. Let's run through the math of digitizing film with linear data and see how it fares with these three criteria.

13.4.1.1 Banding

One of the main criteria to digitizing film is that the digitizing steps must be small enough to avoid the introduction of banding (contouring, false contouring, mach banding, etc.). What sets the limit on this is the human perception system. Tests have shown that the eye cannot distinguish between two adjacent gray patches if the relative difference in their brightness is less than 1%. The *relative* difference is the key adjective here. It simply means that given two adjacent gray patches, their difference in brightness *relative to each other* must be less than 1% or else the eye will see two patches and the line that divides them—banding. This "1% rule" applies all the way from the darks to the lights. The relative difference also means that if the patches were dark, the 1% relative difference would be a small change in brightness between them, and if they were light then it would be a large change.

Small brightness steps in the darks, large ones in the lights. Sounds simple enough. It turns out that keeping the relative brightness change from data step to data step less than 1% is a subtle point with profound consequences, which warrants a closer look.

Figure 13-7 illustrates the surprising consequences of digitizing an image linearly. It represents a typical case of a brightness range of 100:1 digitized as an 8-bit image. The left column is the 8-bit code value from 0 to 255, and next to it is the actual brightness value being digitized, from 1 to 100. Next to that is the brightness difference between two adjacent code values at several sample points ranging from darks to lights. The right-most column is the *relative* brightness change between two adjacent code values at those sample points. Keep in mind that it is this relative brightness change between two adjacent code values that must stay below 1% to avoid banding. What is really important here is not so much the actual percentage of change in the relative brightness column, but its overall behavior—the way the percentage *changes* from lights to darks. The relative brightness change is small in the lights, but gets bigger going toward the darks. This turns out to be a serious problem.

Figure 13-7 Relative brightness changes with linear digitizing.

At the top of Figure 13-7 we can see that the brightness difference between code value 254 and code 255 is $100 - 99.6 = 0.4$. In fact, the brightness difference between all of the adjacent code values is everywhere the same, namely 0.4. This is exactly what we expect from linear image data—equal steps of brightness between each code value. In fact, this is the definition of linear data. However, look at what happened to the all-important (to the eye, anyway) relative brightness change at each sample point.

At the top of the chart the brightness difference is 0.4 relative to a brightness of 100, which is a *relative* brightness change of 0.40%, well below the threshold of banding. However, in the dark region between digital code values 63 and 64 the brightness difference is also 0.4, but a 0.4 difference relative to a brightness of 25 is a relative brightness change of 1.60%—a far bigger jump in relative brightness than at code value 255 and well over the threshold of banding. And of course, the relative brightness gets progressively worse below code value 64. This progressive increase in the relative brightness with linear image data explains why banding is always worse in the darks.

In the real world the film grain actually hides some banding in digitized film, but only up to a point. You may have already realized this from your own experience because to eliminate banding in computer-generated images you added grain (or noise).

13.4.1.2 Data Inflation

The second bad thing that happens with linear digitizing is "data inflation" caused by wasted code values. Because the percentage change between code

values 254 and 255 is only 0.4%, we don't even need code value 254. We could go from code value 253 to 255 and see no banding because the relative brightness change is still less than 1%. If this were 16-bit digitizing with 65,535 code values there would be literally thousands of wasted code values from the midtones up to the brights. True enough, the 16-bit code values would be so close together in the darks that there would be no banding. The price, however, is a doubling of the file size compared to 8 bits.

For the example shown in Figure 13-7, a luminance range of 100:1 was digitized into an 8-bit image. Rest assured that if the luminance range were changed, say to 50:1 or the digitizing to 16 bits, it would only push the problem around—it would not change the fundamental nature of it at all. The relative brightness change in darks will always be greater than in the lights with linear digitizing. However, if the brightness range is reduced enough and/or the bit depth increased enough a point can be reached where the banding is too small to be seen by the eye, but the brights will be wasting code values at a tremendous rate, which increases the size of the database unnecessarily.

13.4.1.3 Limited Dynamic Range

When working in video, the film data must be clipped at the white reference due to the limited dynamic range of video. For quality feature film work, however, we need to keep the full dynamic range of the original negative. It turns out that this is a serious problem with linear data. Figure 13-8 illustrates the full 1000:1 dynamic range of film digitized to 8 bits. This is a nonstarter for two reasons. First, over 90% of the range of data is used up with the superwhite part of the picture. This only leaves perhaps 25 code values for all of the normally exposed picture between the black and the white reference, which is obviously nowhere near enough. If the film were digitized to 16 bits, there would be about 6400 code values for the normally exposed portion, which would be workable. However, there is a second, even bigger problem that even 16 bits won't help.

Because the full dynamic range is 90% superwhites, the normally exposed part of the picture is crushed down to the bottom 10%. In normalized brightness values the superwhites range from 0.1 to 1.0 and the normally exposed part of the pictures only ranges from 0 to 0.1. This means that the normally exposed part of the picture appears nearly black. If you displayed an image like this on your monitor all you would see is basically a black picture with a few bright spots here and there where some highlights made it up into the superwhite region. Sixteen-bit digitizing would not help this problem one iota. While the 16 bits add many more digitizing steps internally, the

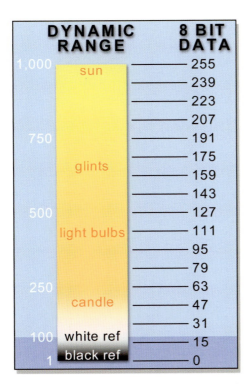

Figure 13-8 Digitizing the full range of film with 8 bits.

minimum and maximum brightness is identical with 8 bit, and this is a minimum and maximum brightness problem. So what can be done? Throwing out the superwhites is the most common approach.

Figure 13-9 illustrates the "throwing out the superwhites" solution. The 1000:1 dynamic range image is clipped at the white reference point to a much more limited dynamic range of only about 100:1. At least this keeps the normally exposed range of the picture, which is the most important part, and it will now look fine on your monitor. This white-clipped version is what you typically get with 8- or 16-bit digitized film. Video is similarly clipped. Of course, the obvious problem with this solution is that the superwhites are clipped, which degrades the appearance of the picture, sometimes seriously so.

Trying to digitize the full dynamic range of the film has resulted in two serious problems. First, the most important part of the picture is pushed down to nearly black and is virtually unviewable. Second, it requires the film to be digitized in at least 16 bits to avoid massive banding problems. This doubles the size of the database compared to 8-bit digitizing. Then there are all those wasted code values. These problems are solved (sort of) if the image is white clipped and digitized without the superwhites, but, of course, this introduces

Figure 13-9 Digitizing only the normally exposed range.

clipped regions into the image. There is another way, and it solves all of these problems. That "other way" is to digitize the film logarithmically.

13.4.2 Log Data Virtues

Having seen the perils and problems with digitized film in linear space, we now have the foundation for understanding the advantages and virtues of log space. Let's now examine log data digitizing and see how it fares with the three issues of banding, dynamic range, and database size.

13.4.2.1 Banding

Figure 13-10 illustrates the behavior of the relative brightness changes with log data. Using the same brightness range of 100 : 1 and 8-bit digitizing as the linear digitizing example in Figure 13-7, the different behavior of the relative brightness changes is apparent. With linear digitizing the brightness difference was constant everywhere and the relative brightness changed from sample point to sample point, getting larger toward the darks. With log dig-

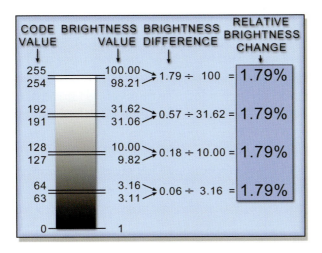

Figure 13-10 Relative brightness changes with log digitizing.

itizing the brightness difference changes and the relative brightness stays constant. From dark to light, one code value change represents a uniform change of brightness to the eye. While linear is uniform in brightness, log is uniform in perception. This is a huge step in the right direction in our quest for the perfect digitizing scheme.

With log digitizing the relative brightness is now constant from darks to lights. The problem now with the 8-bit precision is that it is also constantly too large—it is 1.79% everywhere, well over the 1% banding threshold. It turns out that this is fixed easily. Because the relative brightness is now uniform, it will drop uniformly by simply increasing the bit depth. Increasing from 8 to 9 bits would drop the relative brightness in half everywhere from 1.79% to around 0.9%, which is below the threshold for banding. Of course, 9 bits is too awkward to work with in the real world, but it illustrates the point that in log space simply increasing the bit depth globally lowers the relative brightness change.

13.4.2.2 Full Dynamic Range

The next issue is how to digitize the full dynamic range of the film to avoid any clipping. If we increase the brightness range to greater than 100:1, the relative brightness change will go up again, but it will still be uniform. If we want to digitize the full 1000:1 dynamic range of film, increasing the bit depth to 10 bits results in a constant relative brightness change of 0.67%, which is now well below the banding threshold. With log digitizing, then, the full dynamic range of 1000:1 can be digitized to 10 bits without any banding.

The full dynamic range of film is considered to be about 10 stops, where a "stop" is a doubling of the exposure. This means that from the lowest exposure that will cause a measurable change in the density of the film, the exposure can be *doubled* 10 times. That is an enormous dynamic range. The Cineon 10 bit standard actually provides a little over 11 stops, which leaves both some "head room" and "foot room" for adjusting the brightness up or down without clipping. With Cineon images, one stop is 90 code values.

Figure 13-11 illustrates digitizing the full 1000:1 dynamic range of film in log space to 10 bits of resolution. This gives a data range of 0–1023, the Kodak Cineon standard. When linear brightness data is converted to log, it is redistributed in such a way that the log brightness is spaced evenly and then the log values are digitized. This has the effect of redistributing the normal exposure range between the black and the white references to fill two-thirds of the data range compared to the tiny 10% for linear (see Figure 13-8). It has also compressed the superwhites up to the top third of the data range instead of taking up 90%. Log digitizing has retained the full dynamic range of the film and placed the normal exposure part of the image near the middle of the data range where it belongs.

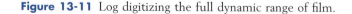

Figure 13-11 Log digitizing the full dynamic range of film.

13.4.2.3 Data Efficiency

Data compression of film scans is not an option for feature film work. The reason is that any compression scheme must be "lossless" to avoid degrading the image, and lossless compression schemes work by taking advantage of an adjacent pixel with identical values. Computer-generated images (3D animation, digital matte paintings, etc.) are loaded with adjacent pixels with identical values, but not scanned film. Any digitized "natural image" (a photographed live action scene as opposed to a computer-generated scene) is, by nature, "noisy" due to the film grain. This noise eliminates any identical adjacent pixels and along with it the opportunity for lossless data compression.

Without data compression the most that can be hoped for is a "brute force" bit map of the film scan that captures all of the required information without wasting any bits, bytes, or bandwidth. We saw how linear data wasted code values from the midtones to the lights by having progressively smaller relative brightness changes that became so small that many code values became useless. With log data we saw that the relative brightness changes were constant everywhere so not one single code value was wasted. At 10 bits per channel, all three channels of one pixel can be packed into a single 32-bit word (with 2 bits to spare!). With 16-bit digitizing it will take three 16-bit words per pixel, or 48 bits for each pixel—a 50% increase in file size—plus the 16-bit linear image will be clipped in the whites.

13.4.2.4 Conclusion

While linear data is the simple and obvious approach, it suffers from banding, data inflation, and limited dynamic range. All of this stems from the fact that the data is linear but the eye is log so there is a poor fit between the image data and our perception of it. Log data, however, is an excellent fit between the data and the eye so it is by far the most efficient carrier of picture information. With log data the entire dynamic range of the film can be efficiently carried in 10 bits without banding. Ten-bit log digitizing, then, has the following three big advantages:

1. No banding
2. Full dynamic range of $1000:1$
3. Smaller database

So, if log is so good, why isn't everybody doing it? The answer is because it is much more difficult to work with. We will see why in the next chapter.

13.5 BIT DEPTH

Bit depth is one of those arcane technical issues that will occasionally arise to ruin digital effects shots. Even though low bit depth can introduce banding, we still work in the lowest bit depth possible for a very practical reason: increasing the bit depth of images increases their file size, disk space, memory requirements, network transfer times, and computing time. The good news is that with today's rapidly advancing network and computer speeds and the dropping costs of disk drives and memory chips, we can look forward to a glorious day when we can all work in the higher bit depths. In the meantime, this next section will help you cope.

13.5.1 What Bit Depth Means

Bit depth refers to how many computer bits are allocated to represent the brightness values of each channel of an image's pixel—the more bits, the greater the bit depth. The number of bits defines how many "code values" (numbers) can be generated. Four bits can only generate 16 code values, which range from 0 to 15. Note that the maximum code value (15) is one less than the total number of possible code values (16) because one of the code values is 0. Each code value (0 to 15) is then assigned a brightness value from black to white that it represents so there can only be 16 possible brightness values from the 16 possible code values of a 4-bit image. It is important to recognize this distinction between the code value and the image brightness it represents because the same code value will represent different brightness values in different situations. More on this unsettling thought shortly.

Taking the most common example of an 8-bit image, there are 256 possible different brightness values, or gray steps, ranging from black to white. For a three-channel (RGB) image the number of possible colors works out to 256^3 (256 to the third power), which results in an astonishing 16.7 million colors (actually 16,777,216, but who's counting?). While 16 million colors sounds like a lot, it is very important to keep in mind that these millions of colors are made up of only 256 possible "shades of gray" in each color channel.

Figure 13-12 shows a graph of the gray steps, or shades of gray from black to white, for a few representative bit depths. The 4-bit image has 16 very large steps, the 6-bit image has many more but smaller steps, and the 8-bit image has 256 steps but appears as a continuous smooth line because its steps are too small for the eye to see. This is the point—to have such small brightness steps in the image that they appear smooth to the eye. When the brightness steps between adjacent code values become visible, we call this banding.

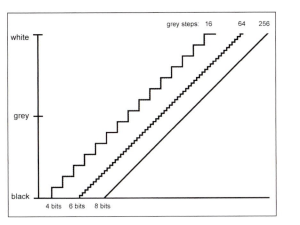

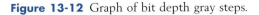

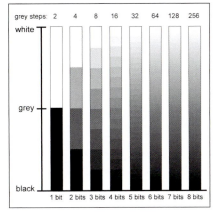

Figure 13-12 Graph of bit depth gray steps.

Figure 13-13 Gradients showing the visual effect of bit depth.

Figure 13-13 shows the same information but in a perceptual way that shows the visual effect of having progressively more brightness steps due to progressively greater bit depth. The 4-bit image with 16 brightness steps exhibits banding because it shows obvious jumps in brightness from one code value to another, whereas the 8-bit image with 256 brightness steps appears smooth to the eye. Keep in mind that it too has discrete steps just like the lower bit depth examples, and under adverse conditions even these fine steps can suddenly become visible and produce banding.

Before we leave Figure 13-13 there are a couple more things of note in this illustration. First of all, regardless of the bit depth, the "0" (zero) code value represents black, and it is the same black for all of them, regardless of bit depth. The second thing to note is that this same rule applies to white— the maximum code value of each bit depth (15 for 4 bits, 255 for 8 bits, etc.) represents the exact same white. This is a disturbing thought. In an 8-bit image code value 15 would be nearly black, but in a 4-bit image code value 15 is white. Further, when working with 16-bit images the maximum code value of 65,535 represents exactly the same white that 255 represents in an 8-bit image. Here is the punch line: switching to 16 bits does not get you brighter whites, just more numbers with smaller steps between each brightness value.

There are two exceptions to the brighter whites comment just given. One is 10-bit log images like Cineon and DPX and the other is Pixar's EXR file format. These image file formats have the white point defined to be well below their maximum code values to permit them to contain high dynamic range information well above white, such as specular highlights. This introduces considerable complexity when working with these types of images,

Table 13-1 Common naming conventions for various bit depths

Description	Usually means
8 bit	3 channel image (RGB) with 8 bits per channel *or* 4 channel image (RGBA) with 8 bits per channel *or* single channel image of 8 bits (matte, monochrome, etc.)
10 bit	3 channel image (RGB) with 10 bits per channel
16 bit	3 channel image (RGB) with 16 bits per channel *or* 4 channel image (RGBA) with 16 bits per channel *or* single channel image of 16 bits (matte, monochrome, etc.)
24 bit	3 channel image (RGB) with 8 bits per channel
32 bit	4 channel image (RGBA) with 8 bits per channel

hence the popularity of the simple 8- and 16-bit linear images, which work fine under most circumstances. Usually.

So what bit depths are you likely to encounter in the real world? In practice you will probably only encounter 8-, 10-, and 16-bit images. However, they can be referred to in a variety of confusable ways. Table 13-1 lists the most common meanings for the most common bit depth descriptions.

Did you notice that the 10-bit image didn't have four-channel or single-channel versions like all the others? While the 10-bit Cineon and DPX file formats technically do support one- and four-channel versions, you will almost never see one. The reason is that they normally hold three-channel

RGB-scanned photographic images (film or video), which will have no matte. The Cineon will have digitized film and the DPX will have either film or video. While cgi can be rendered as a DPX file, it is rarely done.

Ex. 13-1

13.5.2 The 10-Bit DPX Ambiguity

When presented with an 8-, 16-, 24-, or 32-bit image there is one assumption you can safely make, and that is that the image data is almost certainly linear, not log. When working with 10-bit Cineon files they are, by definition, always log. No ambiguity there. However, when confronted with a 10-bit DPX file, the data might be linear or it might be log. If the DPX file was made from a video source, then it will be linear. If it was made by digitizing film on a film scanner, then it is most likely log.

How can you tell? Assuming there is nobody to ask, a properly formatted DPX file will have information in its header that will tell you. If you have no tools that can read the file header, then display the image on a normal workstation monitor (one that is

not film calibrated, which is almost all of them). If the image appears low contrast, all bleached and blown out, then it is a log image. If it appears normal, then it is a linear image. If you are still not sure, try converting the mystery image from log to linear. If it is a linear image it will tank into the blacks and become hopelessly dark. If it actually looks nicer than the original then it is a log image.

13.5.3 Changing Bit Depth

There are a few situations where it makes sense to change the bit depth from 8 to 16 bits even though it will increase rendering time. The first situation is when creating a gradient graphic element (linear or radial) using cgi, a digital paint system, or the compositing system itself for a task such as creating a sky. If you are working in 8 bits there is a chance that banding will show up in the gradient. If it does, recreate the gradient in 16 bits, give it a light dusting of grain or noise, and then convert it to 8 bits (if necessary) before using it. If the 16-bit gradient is converted to 8 bits without the light dusting of grain it will exhibit the same banding as if it had been created in 8 bits.

The second situation where changing bit depth is needed is when combining two images (composite, screen, dissolve, multiply, etc.) of different bit depth, say a 16-bit cgi image with 8-bit video. The compositing software will want the two images to be the same bit depth. It is obviously better to promote the 8-bit image to 16 bits rather than crunching the 16-bit image down to 8 bits. Some compositing packages will even do this for you "automagically." If render time is a concern, the image can be demoted back to 8 bits after the combining operation.

The third situation is when working with an otherwise fine 8-bit image but some image processing operations have suddenly introduced banding. One example would be applying a big blur to a sky element. The blur eliminates the natural pixel variations and smooths them into flat shallow gradients. Another way to create your own banding problem is to string a series of color correction operations one after another. Promoting the 8-bit image to 16 bits *before* the sequence of operations will eliminate the banding. It is much easier to avert banding in the first place than to get rid of it after it has been introduced.

13.5.4 Floating Point

So far the discussion has been about the bit depth for what computer folks refer to as "integer" data, using only whole numbers, no fractions or decimals

allowed. With 8- or 16-bit integer data you will see pixel values such as 170 or 32576 or 1023, but not 170.00145 or −32567.801. In floating point the pixel values are represented as a decimal number between 0 and 1, with 0 representing black and 1 representing white. You would see pixel values such as 0.35787 or 0.98337819. The number of decimal places that are supported is referred to as the "precision" of the floating point. In an 8-bit system a 50% gray would get an integer code value of 128, whereas in floating point it would be represented as 0.5 or 0.50 or as many trailing zeros as the gui was designed to show.

Floating point (or "float" in salty computer speak) represents the highest possible image quality for computer graphics. There are no rounding errors or banding problems because the pixel values are not grouped into a few hundred discrete brightness steps like 8-bit images but are free of discrete steps. Float also has "overflow" and "underflow" capability. With 8-bit integer math you cannot have a value greater than 255 (overflow) or less than 0 (underflow). If a math operation generates values outside of 0 to 255, the numbers get clipped, which introduces rounding errors. Float can have underflow and overflow values outside of 0 and 1 such as −0.7576 or 1.908 without clipping.

Cgi is always computed in floating point for all rendering calculations and is then converted to 8- or 16-bit integer data upon outputting the image to disk. The texture maps, reflection maps, bump maps, and other image elements that make up the cgi may go in as 8-bit integer files but are converted to floating point internally for computation. Similarly in compositing, the input and output images can be an 8- or 16-bit integer but it is also possible to perform all internal calculations in floating point. Most compositing packages support floating point data these days.

If float is so hot, why isn't everybody using it? Because it is so very computationally expensive. The impact will vary between systems, but it can easily be 400% slower than 16-bit integer calculations, and sometimes worse. Float is rarely used in compositing simply because a 16-bit integer has such high data resolution that a problem is rarely encountered, and a 16-bit integer is way faster than floating point calculations.

A special version of floating point image data has been developed by Pixar called the EXR file format. While it is a floating point representation of pixel data, it is a "short" float of only 16 bits (normal floating point being 32 bits or more). This combines the vast range and precision of floating point data with the same data size as 16-bit integer images. It is, however, more computationally expensive than a regular 16-bit integer and requires special tools and training to work with. However, it represents a marvelous synthesis of

very high image quality with reduced data size and computational overhead compared to regular float.

13.6 BANDING

Banding is a particularly insidious artifact because it can be notoriously difficult to eradicate after it is introduced. Herein we will explore the perceptual nature of banding, strategies to prevent or eliminate it, and the disturbing phenomenon of display banding.

13.6.1 Preventing Banding in an Image

How to prevent banding depends on the type of image you are working with. There is a profound difference between photographic images and computer-generated images that directly impacts bit depth and banding. An original photographic image (slide, film negative, or photograph) has an enormous amount of continuous fine variation in its brightness values from point to point. When digitized to 8 bits, however, this continuous variation gets "clumped" (quantized) into only 256 possible brightness values per color channel. However, the fact that the initial image had all this fine variation means that the resulting digitized version also has variation in its pixel values, even for regions that are supposedly the same color. Upon close inspection the scan looks "noisy." A more polite term is "stochastic," meaning random. A slice graph of a photographic sky gradient will have a definite slope, but it will be made up of stochastic pixel values from these fine variations in the original photograph such as the example labeled "A" in Figure 13-14. In the case of video the original scene has all the fine variation and the resulting digital video is quantized into 256 values with stochastic pixel values.

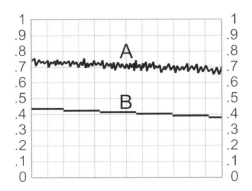

Figure 13-14 Slice graph of photographic gradient (A) vs computer graphic gradient (B).

Now compare the same slope for an 8-bit sky gradient synthesized with computer graphics (cgi, digital paint program, or compositing software) labeled "B" in Figure 13-14. It is characterized by uniform steps made up of smooth flat regions with sharp edges—very different from the scanned photograph. Even though there may only be a difference of one code value between each step, it may become visible as banding because the eye is very sensitive to adjacent uniform regions of slightly different brightnesses. This is the type of banding seen in the lower bit depth gradients shown back at Figure 13-13.

There are two consequences of this difference between photographic and synthetic images. First, the photographic image can be displayed with a lower bit depth without banding. This is good, for it saves data, and is often done. Second, if we want to avoid banding in a synthetic image we will either have to increase the bit depth or introduce stochastic data to its pixel values. In fact, good cgi has variation similar to natural photographs built into its models by adding texture maps, bump maps, and "grunge" maps for this very purpose (besides, it looks good). Further, good compositing adds grain (or video noise) to the cgi element to further the natural photographic look.

 If banding appears in a gradient synthesized in a digital paint system or compositing program the same solution applies: rebuild the gradient in 16 bits and then apply a light dusting of grain. If needed, it can then be converted to 8 bits without banding.

If the bit depth is reduced too much, even photographic images will show banding, which can happen with images that have been put through heavy data compression. Some of the new digital videotape formats are able to achieve full motion video on remarkably tiny videotapes by compressing it heavily. A grotesque example can be seen in Figure 13-15, which is a 4-bit version of the 8-bit original shown in Figure 13-16. The lower bit depth

Figure 13-15 Banding in sky gradient with a 4-bit image.

Figure 13-16 Clean sky gradient with the original 8-bit image.

reduced the number of possible brightness values for each channel from 256 down to 16 so there are large areas of the sky with the same code value, which introduced the banding. Figure 13-17 is a slice graph representing the sky region, which shows the large regions of depleted code values compared to the fine variations found in a normal photographic sky gradient shown in Figure 13-14.

Note also that there is disturbingly little degradation in the other parts of the 4-bit picture in Figure 13-15. There is enough texture (variation) in the nonsky parts of the picture that the low bit depth doesn't offend. It is the smooth gradient parts of an image where banding will show up first. Of course, you should never have to work with 4-bit images, but banding due to this type of depleted (missing) code values can be introduced by certain image processing operations. The code values get grouped into just a few values, such as the slice graph shown in Figure 13-17, and even though there are stochastic pixel values the eye still sees banding.

Banding due to limited bit depth is most common with 8-bit cgi images like the example shown in Figure 13-18. While 8-bit cgi renders are usually fine for video work, it is insufficient for film work because of the greater

dynamic range of film. The reason cgi is most vulnerable to banding is that it often contains the smooth gradients that are so attractive to the banding bug if it does not have the texture maps and added grain described earlier.

Ex. 13-2

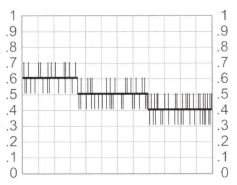

Figure 13-17 Banding from depleted code values of a photographic scan.

Figure 13-18 Banding in a cgi image.

13.6.2 Fixing Banding in an Image

Getting rid of banding can be a messy prospect, so again, the best strategy is to prevent banding in the first place. However, there are times when it is not possible to rebuild the offending element so you may have to eliminate the

banding in the image yourself. The standard solution is to apply some grain (or noise). There are times, however, when the amount of grain required to make the banding go away is so great that the image becomes hideous and useless so a more thoughtful approach is required.

The next step is to identify which of the two types of banding you have—is it the smooth gradient type like Figure 13-14 or the depleted code value type like Figure 13-17? If an otherwise fine image suddenly exhibits banding somewhere in the compositing flowgraph, then you have the depleted code value type of banding. The culprit might be a series of color correction operations strung one after another that was mentioned earlier. In an 8-bit image they can accumulate rounding errors, which produce the depleted code values until banding appears. If it is possible to replace the sequence of color correction operations with a single operation that combines them all, it may cure the banding. Otherwise, convert the image to 16 bits *before* the string of color corrections, then back to 8 bits afterward (if needed). The rounding errors will still occur in the 16-bit version, but will now be imperceptibly small. Some operations such as embossing may even require the image to be converted to float to get good results.

If the banding problem is of the smooth gradient type, then there is an extreme approach that will work. Unfortunately, it has limitations on where it can be used, but the procedure is offered here anyway on the chance that you might find it useful one day. The limitations will be pointed out after the procedure is described.

1. Convert the 8-bit image to 16 bits.
2. Apply a very big blur.
3. Add light grain.
4. Convert back to 8 bits (if needed).

Converting the grad to 16 bits in step 1 did not fix the banding, but it did open up 256 possible new code values between each and every code value in the original 8-bit image. The problem is that the 16-bit version still has all of its code values clustered into only 256 values that it inherited from the 8-bit image. Applying a very large blur in step 2 causes new code values to be interpolated between the original 256, which blends the few large steps of data into many much smaller steps. The data is no longer clustered in its original 256 values but distributed evenly in 16 bits. A light dusting of grain in step 3 will complete the process to make this gradient more stochastic like a photographic scan. Iterate on the radius of the blur to find the minimum blur that will do the job. Some compositing programs run slowly when apply-

ing large blurs so it might be faster to resize the image down to a very small size, apply a small blur, and then resize it back.

Now for the bad news. While this procedure does make a nice smooth gradient out of even a badly banding one, you cannot use it to fix a portion of an image, such as the sky within a shot. The heavy blur operation smears bordering objects (clouds, trees, etc.) into the blurred region, which discolors it. However, there are some situations where it can be used to good effect, so keep it in the back of your mind.

13.6.3 Display Banding

If you are working with high bit depth images and still see banding you might actually be looking at "display banding." It is possible to have a perfectly fine 10- or 16-bit image but still see banding on the workstation monitor. The truth is that the image does not have a banding problem at all—the workstation display does. This is because the workstation is converting the higher bit image down to 8 bits for display. If the image has high bit depth but banding is seen anyway, then consider the possibility of display banding. It would be a shame to waste time trying to fix a problem that wasn't really there.

To test for display banding, first scale the RGB values of the suspect image down to 0.2 and then scale them back up by 5 to restore original brightness.

If the banding is in the image, the restored version will have even more banding. If you have been looking at display banding, then the restored version will have no more banding than the original image.

Ex. 13-3

Hopefully you have read the previous chapter, "Log vs Linear," as you will find many of the key concepts developed there in action here. In that chapter we found the virtues of log data to be that it retains the full dynamic range of the film and is the most efficient lossless encoding of the picture information. We also learned that log images are harder to work with. In this chapter we will find out why and what to do about it.

The issues are divided into two sections. The first is converting log film scans to linear for working in a linear compositing environment, which most studios do. The second section addresses the issues of how to perform acts of compositing, color correction, and screen operations with log images. There are also procedures on how to incorporate linear images such as matte paintings and cgi into log composites. For artists already using Cineon software to do log compositing, the explanations and procedures will mostly explain why Cineon works the way it does. For those who would work in log space without using Cineon software, step-by-step procedures are offered on how to work with log images.

14.1 CONVERTING LOG IMAGES

If you are working in linear space but have film scanned as Cineon or DPX log images they will have to be converted to linear before you can work with them. If you have composited a shot in linear space and are going to film it out on a film recorder or insert it into a digital intermediate then your linear images may have to be converted to log first. How these conversions work and how to get the most out of them are the subjects of this section.

14.1.1 Conversion Parameters

When converting images back and forth between linear and log there are three conversion parameters that need to be set correctly to avoid distorting the results. The three parameters are the white reference, the black reference, and the display gamma. This section describes what each of these parameters is and how they affect the conversion in both directions.

14.1.1.1 Black and White References

When film is scanned to a 10-bit log format the entire 1000:1 dynamic range of the film is captured. Figure 14-1 illustrates how the picture information is

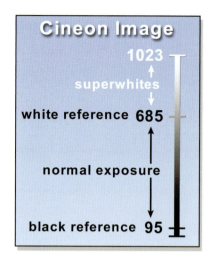

Figure 14-1 Image distribution in log space.

distributed in the log image. The superwhites are the picture content that is brighter than regular reflective surfaces. This would include things such as specular highlights, light bulbs, and the sun. Overexposed film might start creeping up into this region. The normal exposure is that portion of the picture content that contains the "normal" picture information from properly exposed diffuse reflective surfaces such as people, cars, and buildings. Here are the key points of reference that are important to the discussion of converting images from log to linear or linear to log:

White reference—because film can hold brightness ranges up to and including the sun, it is necessary to define what the maximum white value of the *normal exposure* part of the film is, and this maximum white value is called the *white reference*. This is where a 90% reflective white card should be on the negative and will have a 10-bit log code value of 685 for normally exposed film.

Black reference—the blackest black that film can have is obviously completely unexposed film. However, even unexposed film has some slight density, so an unexposed region of film is measured by the film scanner (between frames or near the perfs) and this density is called the *black reference*. The black reference is assigned code value 95. The reason it is given a value of 95 instead of zero is to leave some "foot room" for the film grain to chatter above and below this "absolute black," otherwise the blacks would have no grain.

The obvious thing to do would be to convert the entire dynamic range of the 10-bit log image to the target linear image, but it turns out that that

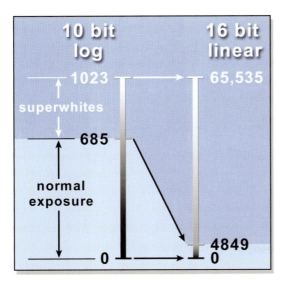

Figure 14-2 Comparison of log vs linear data.

creates a hideous problem. To understand this problem, let's watch what happens when we convert the full dynamic range of a log image to a 16-bit linear image.

Figure 14-2 illustrates the startling results of this conversion approach. The normal exposure region suddenly collapses to less than 10% of the full data range and the superwhite region expands to fill over 90% of the data space! These extreme proportions are due to the fact that the brightness values between superwhites near code value 1023 are hundreds of times brighter than normal brightnesses around code value 685.

Unfortunately, in the linear version most of the data space is now wasted on this huge superwhite range that is used only sparsely. This is one of the three reasons why log data was developed in the first place. In the log version the normal exposure region expands to fill about two-thirds of the data space, whereas the superwhites take up only one-third. This is a much better distribution of the data to the picture information. However, a "full-range" log to linear conversion does have its uses in the composite and screen operations, which we will see shortly.

If we attempted to display this full-range conversion on a monitor it would look like Figure 14-4. As we might expect from the huge drop in picture brightness illustrated in Figure 14-2, the midtones are now way down in the blacks and only the superwhite picture content is actually visible. This is the reason we must clip the log image at the black and white references—to limit brightness data to just the normal exposure range that can be displayed on a monitor. The normally clipped log to linear conversion is shown in Figure

Figure 14-3 Normal clipped log to linear conversion.

Figure 14-4 Full-range log to linear conversion.

14-3. Of course, the picture content outside the windows was above the white reference and is now clipped.

You can now see why the superwhites above the white reference are clipped out and only the "normal exposure" range is retained when log images are converted to linear. Linear display devices such as monitors simply lack the appropriate response curves and dynamic range to show the entire range of a film negative. Something's gotta give, and that is the superwhites.

14.1.1.2 The Display Gamma Parameter

Film is a carefully fixed display medium, but monitors are not. The entire film chain from film cameras to lab developing to film projectors is all very carefully calibrated and standardized for consistent color replication. When you move a film print from one theatre to another it does not suddenly change its appearance. As we all know from experience, however, this is not true for monitors. The same image displayed on three different monitors will have three different looks. The main factors that affect this are the monitor color temperature, the brightness and contrast settings, and, of course, the gamma correction of each monitor. The color temperature and brightness and contrast settings are addressed by normal monitor calibration, but because gamma correction is a matter of taste, philosophy, and religion, it varies from site to site.

The purpose of the display gamma parameter is to compensate for the various gamma corrections used on different monitors. Imagine two identically calibrated monitors but with different gamma corrections so that one appears brighter than the other. If a log image is converted to linear and then displayed on both monitors, it will obviously appear brighter on one than the other. Because our objective is to have the film image appear consistently on the inconsistent monitors, we will need two different linear images, each set for its target monitor. It is the display gamma parameter that is the "adjust-

ment knob" for creating the two versions. This is the only way that the film image can appear identically on the two different monitors.

Conversely, if you have a linear image to convert to log space, you are starting with an image on a variable display device (the monitor) that you need to convert to the fixed display space of film. The display gamma parameter is also needed here to tell the conversion process whether you are looking at the linear image on a bright or dark monitor. The problem with converting linear images to log space is that you really need a way to see the resulting log image displayed properly or you are working blind.

14.1.2 Log to Linear Conversions

Log to linear conversions are unique in the image format conversion world in that major portions of the log image are sacrificed (lost) when the linear version is clipped at the white reference and, if you are not careful, the brightness and contrast of the linear version will also be inadvertently affected. Other conversions, such as targa to tiff, simply reformat computer data between the two file formats but keep the same picture. With log to linear conversions, you don't get to keep the same picture. Studios that convert their 10-bit log scans to 8- or 16-bit linear for compositing are in fact working with a surprisingly limited version of the picture. The following examples use 8-bit image data with code values that range from 0 to 255 for illustration purposes.

14.1.2.1 Conversion Parameters

When a log image is converted to linear, two things happen. The first is that all picture data above the white reference and below the black reference are discarded as shown in Figure 14-5. The second thing is that the display gamma of the resulting linear version is set. The display gamma determines the gamma correction applied to the resulting linear version. The default conversion settings are based on the assumption of properly exposed film. The default settings for the three conversion parameters are summarized in Table 14-1.

Table 14-1 Default log to linear conversion settings

White reference	685
Black reference	95
Display gamma	1.7

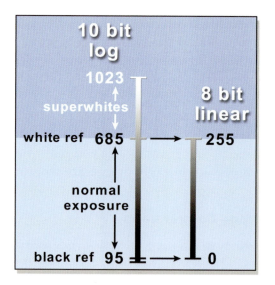

Figure 14-5 Log to linear conversion.

A very important point about lin/log conversions: if a log image is converted to linear and then back to log using exactly the same conversion settings both ways (a "symmetrical" conversion), the converted log image will be identical in appearance to the original log image, with two exceptions. The reconverted log image will not have any data values above the white reference or below the black reference because they were clipped out when it was converted to linear. The other exception is that if the linear version is 8 bits instead of 16, there will be scattered "data holes" in the darks of the converted log image. This is because the 256 code values of the 8-bit linear version were mapped back to (685 − 95 =) 590 code values of the reconverted log version and there were not enough code values to go around. Due to the nonlinear nature of the linear to log mapping, most of the missing data points become clustered in the darks.

14.1.2.1.1 The White Reference

The white reference is the maximum log code value that is preserved in the linear version and will be mapped to the maximum linear value of 255. All log picture information above this value is clipped out. If the white reference is increased to 750, for example, then more of the highlights are retained in the linear version. However, because a greater dynamic range of the log image is being transferred to the fixed dynamic range of the display monitor, the midtones are shifted down and become darker.

14.1.2.1.2 The Black Reference

The black reference is the minimum log code value that is preserved in the linear version and will be mapped to the minimum linear value of 0. All log picture information below this value is clipped out. If the black reference is increased to 150, for example, then more of the blacks are clipped out in the linear version. As more of the blacks are clipped out the midtones are pulled down and become darker.

14.1.2.1.3 Display Gamma

The display gamma setting determines the gamma of the resulting linear image and is designed in such a way that if you enter the *gamma correction* that you use on your workstation monitor it will convert the log film data to look about right on your monitor. For example, if you are using a calibrated SGI monitor and set your monitor gamma correction to 1.7, then you would enter a display gamma value of 1.7 during the conversion. Macs and PCs typically have a gamma correction of 2.2, but you may have to experiment around to find a good setting, as your application software might be over-writing the default monitor gamma correction.

14.1.2.2 Customizing the Conversion Parameters

The default settings cited earlier are designed for correctly exposed film and typical picture content. Many shots are neither. It is important to be able to adjust the conversion parameters to get the "sweet spot" out of the log image into the linear versions during the conversion process. This section offers some tips and procedures for color grading log images into linear space.

It is very important to perform as much of the color grading as possible by refining the conversion parameters during the log to linear conversion. Do not use the default conversion settings on everything and then try to color correct the linear version. Once the image is in linear space it is a lower quality, degraded image with much less color information than the original log source. Because you are starting with much less to begin with, color grading operations on this lower quality image may degrade the image further. By customizing the conversion parameters the linear version starts out much closer to the desired result and then hopefully it will need only minor refinement once in linear space. If you are working in 16 bits or float this is less of an issue.

Following are several conversion scenarios and recommendations along with problems that pushing the process around can introduce.

 Overexposed—the log image is overexposed and the linear version needs to be brought down to a normal range. There are at least two stops of headroom in the film so the picture should still be salvageable. Raise the white and black references by equal amounts. The picture will "slide down" the film response curve until it appears properly exposed. Don't alter the display gamma setting unless you want to make artistic changes to the brightness. One stop is 90 Cineon code values, so if the negative was overexposed by one stop, the white and black references would both be raised by 90 code values each.

 Underexposed—the log image is underexposed and the linear version needs to be brought up to a normal range. Lowering the white reference will "pull the image up" to compensate, but there will no doubt be a problem with the black reference. The exposed image has "slid" down the film response curve on the negative and some of it is now buried in the toe. Lowering the black reference below 95 will milk up the blacks, but will not add any black detail because it is simply not in the film to begin with. Lowering the white reference but not the black reference brightens the image but also increases the contrast. This may require lowering of the display gamma setting to compensate.

 Extended range—there might be very bright pixels greater than the white reference default of 685 that are critical to retain in the linear version, e.g., a fiery explosion with maximum pixel values of 800. There is no alternative but to raise the white reference up to 800. Unfortunately, that will push the midtones down and make them darker. You can lower the display gamma setting to increase brightness in the midtones to compensate; however, the problem with this is that it will also desaturate the linear version. You might be able to restore some of the saturation by color correcting the linear version.

Ex. 14-1

14.1.2.3 Soft Clip

The more elegant log to linear conversion utilities offer a "soft clip" option to help with the clipped highlights from the conversion. Clipping is very damaging to any image. It leaves hard-edged "flat spots" in the image that call attention to their abused nature. In addition to flat spots, it usually also introduces color shifts in the clipped regions. An example will serve to show why.

Figure 14-6 illustrates RGB values of a single pixel around the clip point, indicated by the dotted line. With the hard clip applied in Figure 14-7 the

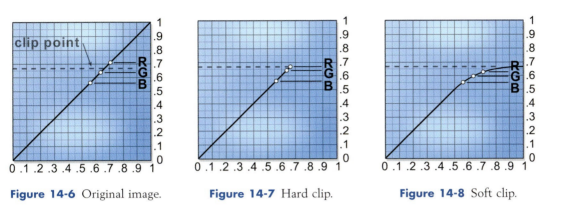

Figure 14-6 Original image. **Figure 14-7** Hard clip. **Figure 14-8** Soft clip.

red value was seriously lowered but the green and blue were not, resulting in a major color shift. With the soft clip in Figure 14-8 the spacing between RGB values has been squeezed together gently, which lowers the saturation, but their overall relationships have been preserved so that their basic color does not change. The soft clip also helps with the hard edges left around the clipped regions. The soft clip will roll the edges off gently so they are not as objectionable.

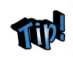 If your software can read and write log images but does not offer a soft clip when converting to linear, you can make your own soft clip with a color curve node. Simply draw a soft clip curve like Figure 14-8 that gently clips the log image to whatever white reference you will be using in the conversion to linear. After the log image goes through the color curve there will no longer be any pixels above the white reference value to get clipped during the conversion.

A good procedure is to first determine an appropriate white reference value to use for the conversion based on where the whites are in the normally exposed part of the image. Next, run statistics on the log image to find the current highest code value. Let's say you decided a good white reference would be 710 and the highest code value in the log image is 900. You now need a soft clip color curve that will gracefully pull 900 down to 710 like the example shown in Figure 14-9. However, you still want to keep the main part of the color curve linear. To do that add a locking point (shown here at 600, 600). Note that there is no need for the color curve to continue past the input value of 900 as there are no code values beyond that. You also want

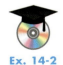 the curve to still have some slope to it as it approaches the end key point at 710 so it never goes perfectly flat. A perfectly flat region on the curve will result in a flat spot in the output image

Ex. 14-2 with no detail.

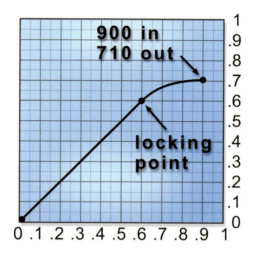

Figure 14-9 Soft clip color curve for log to linear conversions.

14.1.3 Linear to Log Conversions

There are three scenarios where you would have to convert linear images to log space:

- Your work environment is log but you have been given a linear image such as video or an Adobe Photoshop painting to incorporate.
- You worked with linear images but have to convert them to log to go to a film recorder.
- You worked with linear images but have to convert them to log for integration into a digital intermediate.

The next question becomes where to do the linear to log conversion—at your place or let the folks receiving your linear images do the conversion for you. If at all possible, you want to do the conversion to log space yourself because there can be creative decisions to make in the process and you don't want to leave those decisions to the folks running the film recorder who are unfamiliar with your artistic intent.

 The problem is that you need to be able to view the converted log image on a film-calibrated monitor. Otherwise, you are working blind and have no idea what the resulting log images will look like.

If there is a Cineon or other film-calibrated monitor available, that would, of course, be the best. Make certain that any "film-calibrated monitor" is not just converting the log images to linear for display. Failing that, you can create a conversion "wedge" by making several log versions of the same image

with different conversion settings. These test images are then taken to the destination for all the log images (e.g., film recorder or digital intermediate) and viewed on their film monitors. The best setting is then used for all subsequent conversions.

14.1.3.1 Conversion Parameters

When a linear image is converted to log, the maximum linear code value (255) is mapped to the white reference point and the minimum code value (0) is mapped to the black reference value in the resulting log image (see Figure 14-10). The display gamma setting will determine the gamma, or brightness, of the midtones in the resulting log image. The default conversions for linear to log are identical to the log to linear conversions given in Table 14-1.

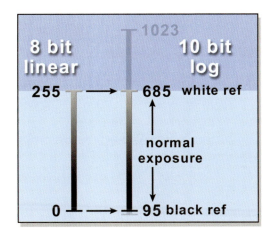

Figure 14-10 Default linear to log conversion.

14.1.3.1.1 The White Reference

The maximum linear code value (255) will be mapped to the white reference setting in the log version of the image. For the default setting, the linear code value 255 becomes log code value 685. This does not mean that the log image will contain any pixels with code values of 685, however. Suppose that the brightest pixel in the linear image was 200. With the white reference set to 685, the linear 200 would be mapped to log 550, well below the white reference value.

14.1.3.1.2 The Black Reference

The minimum linear code value (0) will be mapped to the black reference setting in the log version of the image. For the default setting, the linear code value 0 becomes log code value 95. Again, this does not mean that the log image will contain any code values of 95, however. If the darkest pixel in the linear image was 20, it would be mapped to log 200, well above the black reference value.

14.1.3.1.3 Display Gamma

The display gamma setting determines the gamma (brightness in the midtones) of the resulting log image and is designed in such a way that if you enter the gamma correction that you use on your workstation monitor it will convert the linear image to look about right on film. For example, if you set your monitor gamma correction to 1.7, then you would enter a display gamma value of 1.7 during the conversion.

14.2 WORKING WITH LOG IMAGES

Today you can get a 10-bit log image in the Cineon format as well as a DPX file. While log images represent the very best image quality for feature film work, they are difficult to work with. They cannot be viewed properly on a regular workstation monitor without special calibration and utilities, and there are several operations, such as compositing, that must actually be performed in linear space. These difficulties are largely addressed when the Cineon compositing software is used, but even with Cineon software there are opportunities to get into trouble with log images.

Most compositing packages today offer some support for the log image format but do not have the comprehensive built-in support that the Cineon software has. However, one can still do feature film work in log space with these packages given a sufficient understanding of the issues. This section provides explanations of what operations can be done in log space and what have to be converted to linear space and how to perform the conversions to avoid damaging the image quality.

14.2.1 Viewing Cineon Log Images

Kodak went to a great deal of trouble to solve a fundamental problem in digital film work, namely how to make the image on your monitor look like the projected film. The fundamental problem is that, compared to film, a

workstation monitor has a much more limited dynamic range, is the wrong color temperature, and has a totally different response curve to the image data. To get a close approximation of what the projected film will look like you must be viewing 10-bit log images on a Cineon-calibrated workstation with the following setup.

1. The monitor must first be "DAS'd" (Digital Analysis System, pronounced "dazzed") where the factory settings are adjusted to increase its dynamic range: to make blacks blacker and whites whiter.
2. The monitor look-up tables (LUTs) must be special Cineon LUTs—no simple gamma curves here. This LUT recreates the characteristic response curve of the print stock. Figure 14-11 and Figure 14-12 show the difference between a simple monitor gamma correction curve and the Cineon print film response "S" curve designed for log images.

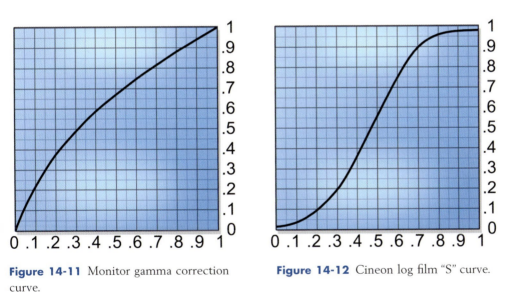

Figure 14-11 Monitor gamma correction curve.

Figure 14-12 Cineon log film "S" curve.

3. The color temperature of the monitor is altered from the typical 9000° to the film projector bulb's color temperature of 5400° in the LUT, displaying images in a warmer (redder) hue.
4. Turn off all the room lights to create a "dark surround" environment—a darkened room just like a movie theatre. With the monitor DAS'd and the dark surround, the normal contrast ratio of the monitor is boosted from a typical 50:1 up to almost 150:1, which is close to the film projected in the theatre.

14.2.2 Color Correcting

Log images are profoundly different from linear images. With linear images, the data represents image brightness numbers. With log images, the data represents the *exponents* of image brightness numbers. The same operations on these fundamentally different types of data will produce different results. Following, then, are the rules for color grading images in *log* space.

Hue shifts—for example, the image appears too cyan. Add or subtract constants from one or more color channels. If working in normalized color space, then values such as 0.03 will make a small but noticeable change. If in 10-bit mode (0–1023) then values such as 30 will make a similar change. In linear space these same color changes would be made by scaling the RGB values to about 0.

Brightness—add or subtract the same constant from all three color channels. The values listed previously in "hue shifts" will give small but noticeable brightness shifts. The image will get brighter without increasing contrast or losing saturation. Again, one stop in brightness is 90 Cineon code values. In linear space, brightness is another scaling operation, which also affects contrast and saturation.

Saturation—saturation operations will work similarly on log images as on linear images.

Contrast—scale the RGB channels to increase or decrease the contrast as you would with linear images.

Gamma correction—you can use a gamma correction operation on log images to adjust the brightness of the midtones like a linear image.

Ex. 14-3

14.2.3 Compositing Log Images

If you are not using Cineon software and simply plug log images into a compositing node, the math will be all wrong and the results truly mortifying. To composite two log images, they must first both be converted to linear, composited, and then the results converted back to log. This section describes how to set up the conversions before and after the compositing operation, where to do the color correcting, and how to introduce semitransparency into your log composites. The setups here are for a typical unpremultiplied foreground where some kind of matte has been generated, such as for a greenscreen shot. Compositing cgi images with log images have their own special issues, which are covered in Section 14.2.7, "cgi."

14.2.3.1 Converting Log to Linear

The log to linear conversion operation must be "lossless" and of the correct gamma. To make the conversion lossless, the log image must be converted to either a floating point or a 16-bit linear image without any clipping. To prevent clipping, the white reference must be set to the maximum log code value (1023) and the black reference set to 0.

The correct display gamma setting for compositing is 1.7. This gamma value is for setting up the image for a correct composite, not for viewing on a monitor. Display gamma values other than 1.7 will alter the edge characteristics of the composited image, making them darker or lighter than they should be. However, changes to the display gamma value can be done to affect the appearance of the composite for artistic purposes. The correct log to linear conversion settings are summarized in Table 14-2.

Table 14-2 **Log to linear conversion for compositing**

	Settings	Remarks
White reference	1023	To avoid clipping any superwhites
Black reference	0	To avoid clipping any blacks
Display gamma	1.7	The internal compositing default

If a log image is converted to 16-bit (or floating point) linear and then back to log with the settings in Table 14-2, the converted log image will be identical to the original. If the conversion settings are not identical in both directions (symmetrical), then the converted log image will deviate from the original. As shown in Figure 14-4, the linear versions of the foreground and background will be so dark that they are unviewable, but that does not matter here because the comp node is the only one that sees them.

14.2.3.2 The Compositing Operation

Within the comp node the foreground scaling operation must be enabled so that it will multiply the foreground layer by the matte channel because we are working with unpremultiplied images. This scales all of the pixels around the foreground object to zero black. The comp node will then (a quick review here) multiply the background layer by the *inverse* of the matte to make a "hole" for the foreground element and then the multiplied foreground and background layers are summed together to form the output of the comp node.

14.2.3.3 Converting Back to Log

The output of the compositing operation is a composited image in linear space that is so dark that you cannot see what it looks like. The last step is to convert the finished image back to log. The conversion back to log space must be done with *exactly* the same settings as the original log to linear conversions or the composited output will not match the inputs. A flowgraph of the basic log compositing setup is shown in Figure 14-13. The Cineon comp node has both the log to linear and the linear to log conversion built in. With other software you would have to add the conversions externally to the comp node as shown.

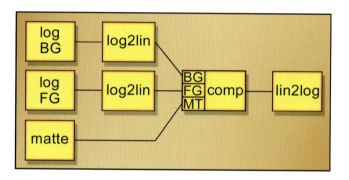

Figure 14-13 Flowgraph of composite.

Like the flowgraph in Figure 14-13 shows, mattes are never converted to log. Mattes, alpha channels, keys, or masks are all intended to define the percentage of mix between the foreground and the background in a composite or to mask some operation. They are not "images" in the sense that they represent the brightness values of light, so they must never be converted between linear and log.

14.2.3.4 Color Correction

All color corrections to the foreground and background are done in log space prior to the linear conversion. The appropriate location of the color correction nodes are illustrated in the flowgraph in Figure 14-14. The linear versions here are the full range type with the nearly black picture content so you wouldn't be able to see what you are doing if you tried to color correct them. Use the log image color correction procedures outlined in Section 14.2.2, "Color Correcting."

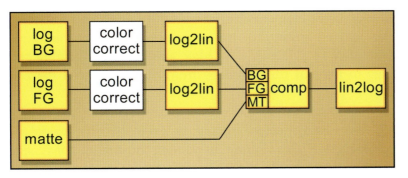

Figure 14-14 Adding color correction to a log composite.

14.2.3.5 Transparency

To introduce transparency into the foreground layer for a fade up, for example, the transparency setting within the comp node may be used as usual. The key is, of course, that both the foreground and the background layers are linear when presented to the comp node, as shown in Figure 14-13. Inside the comp node the matte will be scaled by the transparency value to introduce the appropriate transparency into the background and foreground layers during the composite. However, if your comp node does not have an internal transparency control, you can introduce your own transparency into the composite by adding the optional scaling of the matte channel density prior to the comp node, as **Ex. 14-4** illustrated in Figure 14-15.

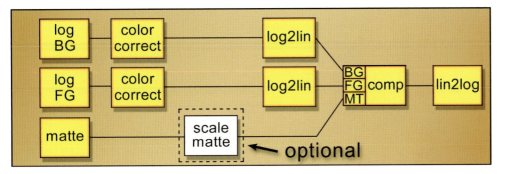

Figure 14-15 Addition of foreground fade operation to a log composite.

14.2.4 Compositing a Linear Image with Log Images

Sometimes you need to incorporate linear images into your log composites. Sources might be an Adobe Photoshop painting, a picture scanned on a

flatbed scanner, video elements, or the output of a morph package. While cgi elements are indeed linear, they have special issues so they are covered separately in Section 14.2.7, "cgi." The basic approach is to simply convert the linear image to log and then proceed from that point as if it were any log image.

The key here is to get the linear image into log space, looking as close as possible to the desired color grading to avoid abusive color corrections after it is in log space. This is done by refining the default conversion parameters, and usually the only one that needs to be adjusted is the display gamma setting. If you see banding in the log version, try adding grain or noise to the linear version before converting it to log.

Ex. 14-5

14.2.5 The Screen Operation

Many compositing packages have a "screen" operation. If yours doesn't, see Chapter 6 for how to make your own. The issue here is how to use the screen operation with log images. The answer is, you don't. Just like the composite operation, the screen operation must be done in linear space. The log images are first converted to linear, screened together, and then the results are converted back to log as shown in the flowgraph of Figure 14-16. The key here is that, like compositing, the conversion from log to linear must also be lossless.

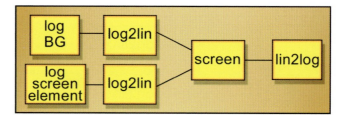

Figure 14-16 Flowgraph for screening log images.

To convert the log images to linear without any clipping, use the conversion settings in Table 14-2. With the white reference set at 1023 and the black reference at 0 there will be no clipping in the resulting linear images. And, of course, the exact same settings are used to convert the screened linear image back to log space. Again, any color correction to either image is done in log space prior to the log to linear conversions.

14.2.5.1 *Screening a Linear Image with a Log Image*

In this situation you have a log background, but an element has been created in Adobe Photoshop or perhaps rendered in cgi and you now have a linear image to screen with the log background.

The procedure is to first convert the linear element to log and then follow the procedure given earlier for screening two log images. The difference here is how to convert the linear element to log in the first place.

The trick is to map the original linear image into its proper "position" in log space and then convert both it and the log background element to linear using the procedure shown previously for screening two log elements. It is theoretically possible to leave the linear element as linear, convert the log element to linear, and screen them together. The problem is that the two linear images will not be in the same linear data range and some tricky RGB scaling operations will be needed to match them up. While it may seem like unnecessary extra steps, it's just much simpler to do the lin/log/lin/log thing. Table 14-3 shows the settings to initially convert the linear element to log for a screening operation.

Table 14-3 Linear to log conversions for a screen element

	Settings	Remarks
White reference	685–1023	Adjust to taste
Black reference	0	Must be 0
Display gamma	0.6–1.7	Adjust to taste

In this case, there are no secret underlying mathematical relationships that must be preserved as there are with the compositing operation. You can raise the white reference to brighten the highlights or lower the gamma to increase the contrast if you wish, but *do not raise the black reference*. If the black reference does not stay exactly zero, then what were zero black regions in the linear version will become greater than zero in the log version. This will introduce a light haze over the entire output image.

Like the compositing setup, color correction of the screen element should be done on the log versions of the images. Make certain that any color correction operations do not disturb the zero black background region, however. Remember the haze. A wise precaution would be to compare the log output of the screen operation to the original log background plate to ensure that no overall subtle color shifts have occurred.

14.2.5.2 The Weighted Screen

We saw how to perform the weighted screen operation on regular linear images in the chapter on compositing. The same thing can be done when screening with log images, but the scaling operation to introduce the "weighting" on the background plate must be done in linear space. The "scale RGB" operation on the linear version of the BG in Figure 14-17 is where the background plate is scaled down by the screen matte to "weight" the screening operation.

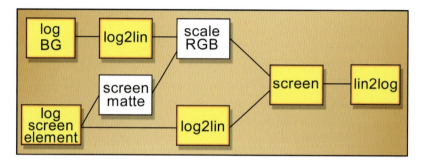

Figure 14-17 Flowgraph of weighted screen operation.

However, the luminance matte ("screen matte" in Figure 14-17) is made from the *log* version of the screen element.

14.2.6 Matte Paintings

Here we address the process of creating a digital matte painting compositing that is color matched to a log image. This usually means painting on a frame of the film to create a new version that will be used as a background plate or creating a totally separate foreground element to be composited over log images. Either way, the linear painting must end up back in log space and color matched to the other log elements.

The basic problem to overcome is that the painting must be created in linear space while the log element it is to color match is in log space. The procedure is to first convert a log image to linear as the color match reference using the default conversion settings in Table 14-1. The painting is then made to match the linear version of the image and then the finished painting is converted back to log for compositing. The key issue is to make certain that exactly the same conversion settings are used when converting the original log image to linear as when converting the finished linear painting back to log.

14.2.6.1 *Tips and Techniques*

The single most important thing you can do in this process is to the test the entire conversion pipeline from log to linear and back to log *before* doing any painting. There are problems that can only be seen in linear space on the paint station that will require revisions to the log to linear conversion settings. Other problems that can only be seen after the painting has been converted back to log will also require altering the linear to log conversion. It is best to find and fix them all before the paint artist has invested hours on a wasted paint effort. Following are some issues you may encounter and some suggestions on what to do about them.

• The log image is too light or too dark on the paint station.

If the gamma correction of the paint system is very different than the default display gamma used in the conversion, the image may be too light or too dark to work with. Reconverting it with a revised display gamma may be necessary. To make the linear version lighter, lower the display gamma. To make it darker, raise it. Another alternative is to adjust the monitor gamma of the paint station to compensate, but many painters will object to this because it disrupts the normal appearance of their gui.

• There is clipping in the linear version.

There may be times when the areas to be painted contain superwhite pixels that are above the default white reference and are clipped out with the default conversion. An example might be painting on a snow-capped mountain peak. To retain the superwhite detail, the white reference will have to be raised. If this is done, however, the midtones will get darker. If this is objectionable, a possible solution is to raise the display gamma to compensate. Don't go too far with this, as raising the display gamma increases the tendency toward banding in 8-bit paint systems.

If the superwhite picture information is not in the areas that are being painted, then don't raise the white reference. The resulting painting will have areas that are clipped at the white reference, of course, but these can be restored after it is back in log space. Just mask the superwhite areas out of the original log image and composite them over the painting to create a version with restored superwhites.

• There is banding in the painting after it is converted back to log.

Using a 16-bit paint system will prevent banding, of course, due to the increased data precision. If you are using an 8-bit paint system, there are two things you might do. The first is to add some grain or noise to the painted regions. When they lost their grain in the painting process they became "banding fodder." The second thing is to lower the display gamma from 1.7 to perhaps 1.0 when converting the original log image to linear. The higher the conversion display gamma setting, the greater the tendency for banding. The problem, of course, is that the image will appear too dark on the paint station. Changing the gamma of the paint monitor will compensate for this.

• The linear image does not look identical to the log image.

Yes, we know. Don't expect the linear version on the paint system to appear absolutely identical to the log version on a workstation with Cineon LUTs. In addition to any clipping, the linear version will appear a bit bluer, less saturated, and exhibit differences in contrast in the darks. These are unavoidable differences between the appearance of a linear image displayed on a monitor with a gamma correction and a log image with a Cineon LUT. The most that can be expected of the linear version is to be reasonably close.

14.2.7 cgi

Most studios render linear cgi images and then convert them to log for compositing with the live action. While it is technically possible to actually render log cgi images directly, it is a nontrivial process that is outside the scope of a book on digital compositing. The fundamental problem with linear cgi elements is that they look different after they are in log space. There are two places where the cgi can become abused. The first is in the initial render and subsequent conversion to log space and the other is in the actual compositing operation itself. This section first looks at the rendering and then the compositing of cgi elements with log images.

14.2.7.1 Rendering

The most common arrangement for creating a cgi element to composite with live action is to have some color-corrected frames of the background plate available to the cgi artist to do "test comps" so that the color and lighting of the cgi can be checked against the intended background. All too often, however, when the cgi is delivered to the digital artist and composited in log space serious color shifts occur, followed by frenetic color correction efforts

to put things right. While linear images are never going to look exactly the same when converted to log, with the proper setup throughout the 2D and 3D production pipeline they can be made very close.

 The starting point is the gamma correction on the cgi workstation monitor that the test comps are being done on. Set the workstation gamma correction to 1.7 and use this number for all of the display gamma settings in *all* of the lin/log conversions everywhere in the pipeline. Again, if your workstation only reports the end-to-end gamma rather than the actual gamma correction, you will need to confirm that the end-to-end gamma is 1.5, which means that the gamma correction is 1.7. With the monitor gamma correction safely set, let's step through the operations to set up a correct cgi render.

Step 1. Convert some color-corrected log frames to linear for the 3D department to use as background plates for the test comps:

- White reference = 685

- Black reference = 0

- Display gamma = 1.7

The white reference is 685 because that is default for a normally exposed negative. If the cgi must match some elements brighter than 685, the white reference can be raised higher to avoid clipping them out. However, keep two very important things in mind here. As the white reference is raised, the midtones get darker so the resulting linear image will look less and less like its log counterpart. This is not a problem in the long run because the cgi will be matched to the darker reference and then get lightened back up when converted back to log. The problem will be that it is much harder to color match with the darker colors, and small discrepancies will become magnified when the cgi is converted to log. To help with this, the workstation gamma could be cranked up briefly to check the color match in the darks.

The second issue is that whatever white reference is used here must also be used when initially converting the cgi to log at step 4. Small deviations here will have large effects on the brightness of the log version of the cgi.

Note that the black reference is set to 0 here. This is essential and is done specifically for cgi renders. The reasoning goes like this: the output of the cgi render surrounds the cgi element by a zero black field. When this is later converted to log, it must stay zero (not raised to 95) or else the blacks will pop up a bit in brightness. *All* lin/log conversion must share the exact same set-

tings; therefore the zero black reference must also be used in the initial log/lin conversion of the log background plate.

Step 2. Render cgi images and perform test comps over the converted linear background plates. The cgi elements are then delivered to the compositing folks.

14.2.7.2 Compositing

We now step into the compositing department and follow the action there. While the steps that follow may seem like we are whip-sawing between linear and log space, the sequence of operations is driven by the following unrelenting logic:

- The unpremultiply operation must be done in linear space for the math to work properly.
- The cgi should be color corrected in log space so you can see your work.
- The compositing operation must be done in linear space for the math to work properly.

Step 3. Bring the linear cgi element into the compositing flowgraph (Figure 14-18) and perform the unpremultiply operation on the linear version. See Chapter 5 for a review of this topic. Again, if you are not going to do any color correcting to the cgi element (it could happen!), you can skip the whole unpremultiply thing, leaving the cgi premultiplied. If you do, then you must turn off the scale foreground operation in the comp node at step 6.

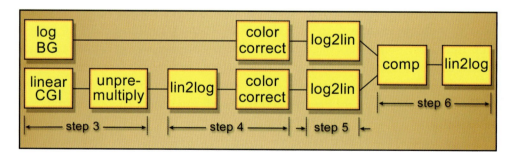

Figure 14-18 Cgi compositing flowgraph.

Step 4. Convert the RGB channels of the cgi element to log space (but not the alpha) using the *exact same settings* as used in step 1. The linear image is then "positioned" properly into log space and from this point on it has lost

all "linear identity." It is now just another log image, but one that has no code values greater than the white reference used to convert it from linear to log. We now have an unpremultiplied log element that is ready for color correction.

Step 5. For the compositing operation, convert the RGB channels of the unpremultiplied color-corrected log cgi element to linear with the following settings:

- White reference = 1023

- Black reference = 0

- Display gamma = 1.7

These are the standard settings for a lossless conversion of a log image to linear just before compositing that was listed in Table 14-2. This time we avoid any clipping by keeping the entire dynamic range of the log image when converting it to linear by setting the white reference to 1023.

Step 6. The comp node is set to scale the foreground as we have an unpremultiplied foreground image. If the unpremultiply operation was skipped in step 3, then turn off the scale foreground operation. After the compositing operation the composited linear image is converted back to log space using the same settings as step 5.

Ex. 14-6

14.2.8 Transformations and Blur Operations

Theoretically, all image transformations (rotate, scale, etc.) and blurring operations should be done in linear space. The reason is that all of these operations entail filtering (resampling) of the brightness values of the pixels. But log images are not brightness values. They are exponents of brightness values so the math does not work out right. In general, what goes wrong is that very bright pixels next to very dark pixels will get filtered down to too low a value and get darker faster than they should.

In the real world, however, pixels in the normal range behave fairly normally so most of the time you can ignore this issue and perform transformations and blurs in log space. Just keep this little insight in the back of your mind so that one day when a problem arises you can whip it out and amaze your friends by knowing exactly what the fix is. If you wind up needing to convert to linear for one of these operations, use the full range conversion settings in Table 14-2.

If you would like to see a demonstration of this issue, take a log image of a star field and give it a moderate blur. Now go back to the original log star field, convert it to a full range linear image, give it the same amount of blur, and convert it back to log. When the two versions are compared, the stars blurred in linear space will be much brighter than the ones blurred in log space.

THE ADOBE AFTER EFFECTS COLOR DIFFERENCE MATTE

We saw in Chapter 2 that the classical color difference matte generates a raw matte by finding the difference between the backing color and the maximum of other two-color channels. Adobe has developed a rather different method of generating a raw matte that is very simple and, frankly, works much better than it should. It only uses the blue and red channels, while the classical method uses all three. For a bluescreen, the blue channel is inverted then the blacks are scaled down to zero. This result is then screened with the red channel to create the raw matte which is then scaled to make a solid white core and zero black backing (the screen operation is described in Chapter 6). Let's walk through an example and see why it works.

From the bluescreen shown in Figure A-1, the blue channel is isolated in Figure A-2. Because the backing region of a bluescreen has a very high blue level in the blue channel, the backing region surrounding the foreground object is bright while the foreground itself is dark. This is reversed when the blue channel is inverted as shown in Figure A-3. The backing region is now dark and the foreground is light, which is starting to look more matte-like, but we need the backing region to be zero black and the foreground region to be 100% white. The next step is to scale the blacks down to zero which clears the backing region as shown in Figure A-4. However, there are seriously dark regions in the face area of the matte.

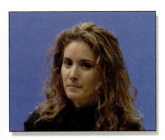

Figure A-1 Bluescreen.

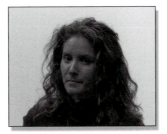

Figure A-2 Blue channel.

Figure A-3 Inverted blue channel.

The red channel is used to fill in these dark regions because there is normally high red content in things like skin and hair. Also, the red channel should be fairly dark in the backing region because that is the bluescreen area. Compare the red channel in Figure A-5 with the inverted and scaled blue channel in Figure A-4. The red channel is light in the face exactly where the blue channel is dark. We can use the red channel to fill in this dark region by screening it with the inverted blue channel in Figure A-4. The results of the screening operation produce the Adobe raw color difference matte shown in Figure A-6. The face and other regions of the foreground have now picked up some very helpful brightness from the red channel. Of course, the backing region also picked up some brightness from the red channel's backing region, but this we can fix.

Figure A-4 Black level scaled to zero.

Figure A-5 Red channel.

Figure A-6 Adobe raw color difference matte.

The Adobe raw matte now simply needs to be scaled to a solid black and white to get the results shown in Figure A-7. As when scaling the classic raw color difference matte, the scaling operation must be done very carefully to avoid over-scaling the matte which will harden the edges. Be sure to use the matte monitor described at the beginning of Chapter 3 when you are scaling any of your raw mattes so you can see exactly where you are in the scaling process.

By way of comparison, the classic color difference method was used to pull the raw matte shown in Figure A-8 from the same bluescreen. Compare it to the Adobe raw matte in Figure A-6 and you can see they produced utterly different results. However, once it is scaled to solid black and white in Figure A-9 the classic scaled matte is incredibly similar to the Adobe scaled matte in Figure A-7. But they are not identical.

Figure A-7 Adobe scaled matte.

Figure A-8 Classic raw color difference matte.

Figure A-9 Classic scaled matte.

A flowgraph of the Adobe color difference matte technique is shown in Figure A-10. The first node, labeled BS, represents the original bluescreen. The blue channel goes to an invert node which correlates to Figure A-3. The black level is adjusted with the next node to scale its backing region down to zero, then the results are screened with the red channel from the original bluescreen image. The screen node produces the Adobe raw matte shown in Figure A-6. The last node is simply to scale the matte to establish the zero black and 100% white levels of the finished matte shown in Figure A-7. Here are some variations on the Adobe color difference matte that you might find helpful:

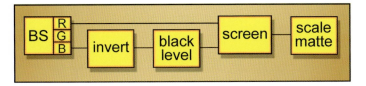

Figure A-10 Flowgraph of the Adobe color difference matte.

• Use the green channel too. After screening the red channel with the inverted blue channel, just lower the blacks to zero again then screen in the green channel. Now scale the resulting raw matte to zero black and 100% white.
• Use color curves on the blue and red channels to shift their midpoints up or down to clear out problem areas or expand and contract edges.
• The red channel can be added instead of screened. In some cases it might be better.
• If the foreground object had a high green content and low red content (such as green plants) then use the green channel instead of the red.

- Use any or all of the preprocessing techniques described in Chapter 2 to improve the original bluescreen for better matte extraction.
- Of course, this technique is easily adapted to pulling mattes on green-screens. Just use the green and red channels instead of the blue and red channels.

We now have two powerful color difference matte extraction methods, the Adobe and the classical. So which is better? The truth is, neither. As we saw in the introduction to Chapter 2, the color difference process is a clever cheat that is fundamentally flawed and riddled with artifacts. The only question is whether the inevitable artifacts will create visually noticeable problems in a given composite. Depending on the image content of a given shot, either method could prove superior.

Of course you need not choose just one method. Perhaps the Adobe method gives more detail in the hair, but the classical method has better solidity in the core of the matte. So combine them. Use the Adobe method as the outer matte and the classical method to create a solid core matte. Perhaps one method works better on one part of the foreground and the other does

better on the rest of the foreground. Roto a matte to isolate that one part of the foreground then use it to combine the two mattes. Be mindful of the edge where they meet, however, lest we see your

Ex. 2-16 seam.

Glossary

Writing a glossary for a rapidly evolving field with "unstable terminology" like digital compositing is a tricky but necessary task. It is a task that is further complicated by an infusion of terms from many other disciplines, such as conventional opticals, special effects, photography, computer science, and signal processing. However, it needs be done, so it is done here with the intent of being more helpful to the digital artist than the engineer. Many terms are very technical in nature, but the unabashedly technical definition is often less than helpful to someone trying to make a good composite than a more common-sense, task-relevant definition so the common-sense style prevails in this glossary.

Some of the words in the definitions are highlighted in **bold**. This indicates that those words are also defined in this glossary.

A

Academy aperture—as published by the Society of Motion Picture and Television Engineers (SMPTE), the rectangular area of a frame of film for cinema projection that leaves room for a sound track between the left edge of the frame and the **perfs**.

Academy center—the center of the **academy aperture**. Because the academy aperture is off center on the film frame, so is the academy center.

Add-mix composite—to use color curves to make two versions of a matte prior to composite, one used to scale the foreground and the other to scale the background. It allows fine control over the look of semitransparent regions.

Algorithm—a step-by-step procedure for solving a problem or achieving an objective.

Aliasing—the pixilated, jagged lines introduced into a computer image by failing to compute an image with **subpixel** accuracy. It results in edge pixels that are either on or off instead of smoothly blended.

Alpha—see **alpha channel**.

Alpha channel—the "matte" **channel** of a four-channel cgi image. See also **key**, **mask**, and **matte**.

Analog—a signal that is continuously variable without discrete "steps" or values.

Anamorphic—to scale an image along one axis only. **Cinemascope** frames are an anamorphic format **squeezed** horizontally on the film.

Animate—to change over time.

Anti-aliasing—the mathematical operation that eliminates **aliasing** in cgi images to give objects smooth edges. Multiple **subpixel** samples are made for each pixel to calculate a more accurate color and/or transparency value, but also increases computing time dramatically.

Artifacts—unintended side effects of some operation, usually bad.

Aspect ratio—a number that describes the rectangular "shape" of an image (how rectangular or square it is) as the ratio of the width divided by the height. It may be expressed as a proportion (4:3), a ratio (4/3), or a floating point number (1.33).

Atmospheric haze—the attenuation and discoloring of distant objects in a scene due to the color and density of particles (haze) in the atmosphere. It applies to interior scenes as well.

Axis—a straight line about which an object may be rotated or scaled. It is also the horizontal and vertical reference lines in a chart or graph marked with the units of the chart.

B

Background—the rear-most layer in a composite.

Backing color—the uniform solid color used as the backdrop in a **bluescreen** or **greenscreen** shot.

Banding—an image artifact that appears as flat regions of the same color like a contour map that is caused by too few data value steps for the display device. Instead of a smooth gradient, a series of slightly different colored bands would be seen. It is also known as contouring. See also **mach banding**.

Base layer—the bottom layer in a two-layer Adobe Photoshop blending operation.

BG—abbreviation for **background**.

Bicubic filter—performs edge sharpening as it **resamples** an image. It can introduce edge artifacts.

Bilinear filter—simply averages pixel values without edge sharpening as it resamples an image. Results look softer than a bicubic filter.

Binarize—to separate an image into just two values, usually zero and one (black and white), about some threshold value.

Bit—the smallest unit of digital data, its value is either zero or one.

Bit depth—the number of bits used to represent one **channel** of an image (or other data). A bit depth of 8 can represent 256 brightness levels, and increasing the bit depth increases the number of brightness levels that can be represented.

Black body radiation—the characteristic electromagnetic radiation emitted from a black body as it is heated. It is used to describe the color of a light source in terms of the temperature a black body would have to be in order to radiate a matching color.

Black reference—for Cineon log image conversion, the 10-bit code value (95) that a 1% reflective black surface would generate in a properly exposed frame of film.

Blend layer—the top layer in a two-layer Adobe Photoshop blending operation.

Bluescreen—(1) General; using a uniform solid primary color as the background so that a foreground object can be isolated by extracting a matte. It is usually blue or green, but can be red. (2) Specific; a shot that uses blue as the backing color for extracting a matte.

Brightness—the subjective human perception of **luminance**.

Bump matte—creating a matte from just the "bumps" of a textured surface, such as the rough bark of a tree.

C

Cadence—refers to which of the five possible 3:2 pulldown timings that can be encountered when film is transferred to video.

Camera aperture—the area of the film frame that is exposed by the camera. See also **projection aperture**.

CCD—abbreviation for charged-coupled device, a solid state electronic device that converts light into electricity for digitizing images. With the CCD cells arranged in a row it is called a linear array, and arranged into a rectangular grid it is called a two-dimensional array.

cgi—abbreviation for **computer-generated image**.

Channel—for digitized images, one of the image planes that make up the color image or a **matte**, such as the red channel or the matte channel. See also **color channel**.

Channel arithmetic—mathematical operations between the color **channels** of an image, such as adding 10% of the green channel to the red channel.

Characteristic curve—the graph published by the manufacturer of a film stock that describes how the film will increase its density with increased exposure to light. It is also called a film response curve.

Chroma-key—a matte that is created based on the color (chrominance) of an element or the use of such a matte to isolate an object from its background for compositing or other treatment.

Chrominance—the color portion of a video signal that is separated into chrominance (color) and **luminance** (brightness).

Cine-compress—the term the Flame system uses for removing the **3:2 pull-down** from video frames.

Cine-expand—the term the Flame system uses for introducing a **3:2 pull-down** into video frames.

Cinemascope—a 35-mm film format characterized by an image that is animorphically squeezed horizontally by 50% on film. When projected with an anamorphic lens the width is doubled to create a 2.35 aspect ratio image. See **anamorphic**.

Cineon—the **10-bit log** image file format developed by Kodak for digitizing feature film.

Cineon file format—a 10-bit log file format for film scans developed by Kodak.

Clean plate—a second version of an image with the item of interest gone, such as a bluescreen plate without the foreground object.

Clipping—to set any data value above an established threshold to be equal to that threshold. With a threshold value of 200, a pixel value of 225 would be clipped to 200.

Clipping plane—a flat plane that bisects a three-dimensional space and deletes (clips out) all objects on one side.

Color channel—one of the three color components of an RGB image, such as the red channel.

Color curve—remapping (altering) the color values of an image based on drawing a graph of the relationship between the input and the output values.

Color difference matte—a **bluescreen** matte extraction technique that uses the difference in value between the primary backing color (the blue) and the other two color records to create a matte.

Color grading—color correcting digitized film images.

Color record—in film, one of the three color dye layers that capture the color image, such as the red record. Once digitized, the records are referred to as **channels**, such as the red channel.

Color resolution—the total number of colors that can be produced with the available number of bits. An 8-bit image has a color resolution of 256 colors, whereas a 24-bit image has 16.7 million.

Color space—the selection of appropriate color attributes plus their units of measure used to describe a color. For example, the attributes could be hue, saturation, and value for HSV color space or red, green, and blue for RGB color space.

Color temperature—a description of the color of a light source in terms of the temperature that a **black body** would need to have for it to emit the same color. It is especially useful for describing the color of the light emitted by a monitor or light sources for photography.

Color timing—the process of color correcting each shot of a feature film. Originally done chemically in a film lab, it is now being done with computers in the **digital intermediate** process.

Component video—video that is separated into three signals: one luminance and two chrominance signals.

Composite—the process of combining two or more image layers together with the use of a matte to define the transparencies of the layers.

Composite video—video that has been compressed into a single signal for more efficient broadcast. It can be converted back into component video, but there are unrecoverable losses from the initial compression.

Computer-generated image—an image created totally in the computer, such as 3D animation or a digital matte painting, as opposed to live action images

imported into the computer and then manipulated, such as composites and morphs.

Contouring—another term for **banding**.

Contrast—the degree of dissimilarity between the brightest regions of an image and the darkest.

Control points—the points on a **spline** that control its position and shape.

Convolution kernel—the two-dimensional array of numbers used to weight the pixel values in a convolve operation. Usually a square array of odd dimensions (3×3, 5×5, etc.), the kernel is centered over each pixel in an image and the surrounding pixels are scaled by the values in the kernel and then summed together to produce the output pixel value. Different convolution kernels give very different effects, such as edge detection, blurring, or sharpening.

Cool—a general term to describe an image with a bluish cast. See also **warm**.

Core matte—a matte designed to clear stray pixels from the core (center) of a matte.

Corner pinning—a geometric transformation of an image where each corner of the image can be moved to an arbitrary location.

Correlation number—in motion tracking, the number the computer calculates to quantify how close the match is between the current frame's **match box** and the initial **reference image**.

Correlation points—for a **spline warp**, the points located on the source and destination splines that control how the pixels will be moved between them.

Crop—to make an image smaller by trimming the edges.

Cross-dissolve—see **dissolve**.

CRT—abbreviation for cathode ray tube, the image display device in a monitor or a television.

CRT recorder—a **film recorder** that uses a CRT device to display the image to be photographed by a film camera.

Cscope—short for **Cinemascope**.

D

D1 video—a digital **component video** format where the chrominance and luminance information is carried on three separate signals to maintain quality during production.

D2 video—a digital **composite video** format where the chrominance and luminance have been compressed into a single signal to reduce bandwidth for broadcast, but with a loss of quality.

Dailies—projecting film in a screening room to review new shots, or the film itself.

Darken operation—the Adobe Photoshop term for a "**minimum**" image blending operation.

Data compression—using any one of a number of schemes to reduce the size of data required to represent an image.

DDR—abbreviation for **digital disk recorder**.

Deinterlace—to use one of several schemes to convert video frames composed of two slightly differing interlaced fields into a single unified frame. See **interlaced video**.

Densitometer—a device that measures the density of negative or print film by measuring how much light they transmit. It is used to ensure that the film is exposed and developed properly.

Density—for a matte, how opaque or transparent it is. For a print film image, how rich and colorful the image is. For a film negative, the measurement of how much light it transmits using a **densitometer**.

Depth of field—the inner and outer distance from the camera lens that objects appear in focus.

Despill—the removal of backing color **spill** contamination on a foreground object in a **bluescreen** shot.

DI—abbreviation for **digital intermediate**.

Difference matte—the matte generated by taking the absolute value of the difference between two images, one with the item of interest present and an identical one without the item of interest.

Difference tracking—to track the difference in position between two moving objects in order to **track** one of them onto the other.

Digital disk recorder—a special computer disk drive with video circuitry that can record and play back video images in **real time**.

Digital intermediate—the process of **color timing** a feature film digitally. The entire feature is digitized, the scanned frames placed in editing order (conforming), color timed, and sent to a film recorder.

Digitize—to convert a continuously varying **analog** signal into discrete numbers. It also means to **quantize**.

Dilate—to expand the outer perimeter of a white matte equally all around.

Discreet nodes—simple, one function nodes such as "add" or "invert" that are combined to create more complex functions, such as a screen operation.

Display gamma—for **Cineon** log and linear conversion, the parameter that establishes the gamma of the resulting image. It is normally set to the same value as the gamma correction of the monitor used to view the linear images.

Dissolve—a transition between two scenes using an optical effect where one image is faded down at the same time the other is faded up.

Double exposure—exposing the same frame of film twice with different images.

DPX file format—digital picture exchange, a file format that can hold 10-bit log film scans as well as 10-bit linear Hi-Def video frames. A very flexible image file format, it can hold many types of images and supports extensible features.

Drop frame—a video **time code** correction that periodically drops a frame number out of the time code to compensate for the fact that video actually runs at 29.97 frames per second instead of 30. It is used to keep the time code correct for broadcast.

DV-CAM—a class of digital video formats that use MPEG-2 data compression on their images as they are recorded onto video tape.

DX—abbreviation for **double exposure**.

Dynamic range—the ratio of the largest to the smallest brightness values in a picture or a scene. A dynamic range of 100 would mean the brightest element was 100 times brighter than the darkest.

E

Edge detection—a computer algorithm that finds and creates a matte of the edges found in an image.

Edge processing—computer algorithms that operate on the edge of a matte to either expand (**dilate**) or contract (**erode**) the perimeter.

8-bit images—images that use 8 bits of data per channel, which results in a data range between 0 and 255 for each channel.

8 perf—slang for the **Vista Vision** film format where each exposed frame sits sideways on the film and spans 8 **perfs** (perforations).

Electromagnetic spectrum—the full range of electromagnetic radiation frequencies ranging from radio waves at the long end to X-rays at the short end. The visible spectrum that the eye can see is but a tiny sliver of the electromagnetic spectrum.

Electron gun—the electronic device built into the back end of a CRT that generates a stream of high-speed **electrons** to strike the screen face and excite the phosphors to emit light.

Electrons—the extremely light subatomic particles that orbit the nucleus of atoms. When displaced by voltages in conductors and semiconductors they form the basis of all electronics.

Erode—to shrink the outer perimeter of a white matte equally all around.

Ethernet—a local area network that allows data to be transferred between computers at moderately high speed.

Exposure—the total amount of light over a period of time that falls onto a frame of film.

EXR file format—Pixar's 16-bit "short" floating point representation of linear data. It supports high dynamic range image data without banding.

Extrapolate—to calculate a hypothetical new data point by projecting past the range of existing data points.

F

Fade—an optical effect where an image gradually transitions to black.

FG—abbreviation for **foreground**.

Field dominance—for **interlaced video**, whether field 1 or field 2 is displayed first.

Film recorder—a machine that exposes film using digital images rather than a live action scene.

Film response curve—the graph published by the manufacturer of a film stock that describes how the film will increase its density with increased exposure to light. It is also called a characteristic curve.

Film scanner—a machine that digitizes movie film at high resolution, typically **2k** or greater, for feature film digital effects.

Filter—to derive a new value for a pixel by evaluating it with its neighbors using one of several filtering algorithms.

Flare—the light from a bright light source that reflects and refracts through the camera lens and contaminates the image.

Flip—to swap the top and bottom of an image by mirroring it around its horizontal axis. See also **flop**.

Floating point—representing numbers with several degrees of decimal precision, such as 1.38725. It is much more precise than integer operations, but computationally slower.

Flop—to swap the left and right sides of an image by mirroring it around its vertical axis. See also **flip**.

Flow graph—the graphic representation of the sequence of operations in a compositing script that represents each image processing operation by an icon with connecting lines to indicate their order of execution.

Focus pull—to change the focal point of the lens in order to refocus on a second item of interest, such as from a person in the foreground to someone in the background.

Follow focus—to change the focal point of the lens in order to maintain focus on a moving target in a scene, such as someone walking away from the camera.

Foreground—the element composited over a background. There is often more than one foreground element.

4:1:1—video digitized by sampling the **luminance** signal of a scan line four times every four pixels but the **chrominance** only once every four pixels. When converted to an RGB image the luminance will be full resolution but the colors will have been interpolated over 4 pixels horizontally.

4:2:2—video digitized by sampling the **luminance** signal of a scan line four times every four pixels but the **chrominance** only twice every four pixels. When converted to an RGB image the luminance will be full resolution but the colors will have been interpolated over 2 pixels horizontally.

4:4:4—video digitized by sampling both the **luminance** and the **chrominance** signals of a scan line four times every four pixels. When converted to an RGB image both the luminance and colors will be full resolution.

4k—literally 4000, but in computer land it is 4096 (2^{12}).

4 perf—slang for any number of 35-mm film formats where each exposed frame on the film spans four **perfs** (perforations).

Fourier transforms—an image-processing operation that converts an image into spatial frequencies for analysis and/or manipulation.

Frame buffer—an electronic device that holds (buffers) an image (frame) for display on a monitor. It consists of special high-speed memory chips connected to video circuitry.

G

Gamma—(1) the nonlinear response of CRT monitors where a change in the input signal level does not result in an equal change in the brightness level. (2) The mathematical operation performed on image pixels that alters the brightness of the midtones without affecting the black and white points. Each pixel is **normalized** and then raised to the power of the gamma value, with gamma values greater than 1.0 darkening and less than 1.0 brightening.

Gamma correction—the opposing gamma operation applied to an image to compensate for the inherent gamma of the display device.

Garbage matte—a quick but imprecise matte that roughly isolates an item of interest from its background.

Gate weave—a frame-by-frame wobble in a scene due to the film not being securely registered with a pin through the **perforations** of the film.

Gaussian distribution—to perform a weighted average of a range of values using a distribution curve similar to the normal bell curve used by statistics.

Gaussian filter—uses a **gaussian distribution** of the pixel averages as it **resamples** an image. It does not perform edge sharpening.

Geometric transformation—an image processing operation that changes the position, size, orientation, or shape of an image. Includes operations such as **translate, scale, rotate, warp**, and **four corner pinning**.

G-matte—abbreviation for **garbage matte**.

Grain—the nonuniform "clumping" of silver halide particles and the resulting color dyes in film. The amount of grain differs between film stocks and levels of **exposure**, as well as between the three color records of a film image.

Grayscale image—another term for a **monochrome** image.

Greenscreen—using green as the backing color for a **bluescreen** shot.

gui—abbreviation for graphical user interface, the user interface to operate a computer program that uses graphics manipulated by a mouse or pad as opposed to a command line interface where typed commands control the software.

H

Hard clip—to **clip** the pixel values of an image by simply limiting them to the clipping threshold value. It produces hard-edged flat spots in the resulting image. See also **soft clip**.

Hard light blending mode—an Adobe Photoshop blending mode that combines two images without a matte.

Hard matte—to mask off a film frame with black at the top and bottom to a specific projection aspect ratio.

HDTV—abbreviation for high-definition television, a collection of high-resolution video standards characterized by a 16/9 **aspect ratio**, different scan modes, various frame rates, and up to 1080 scan lines.

Hicon matte—short for "high contrast," literally a black and white matte.

Hi-Def—slang for **HDTV**.

Histogram—a statistical analysis of an image that plots the percentage of pixels at each level of brightness. It can be for each color channel or its overall luminance.

Histogram equalization—an image processing operation that finds the darkest and lightest pixels and then adjusts the image **contrast** to fill the available data range.

HSV—a color space for describing colors based on **hue**, **saturation**, and **value** (brightness) rather than **RGB** values.

Hue—the attribute of a color that describes what point on the color spectrum it represents, separate from its **saturation** or **brightness**.

I

Image processing—using a computer to modify a digitized image.

Imax—a 15 perf 70-mm film format developed for special large-screen theatres by the Imax corporation.

Impulse filter—a filter used to **resample** an image that simply selects the nearest appropriate pixel rather than calculating some kind of **interpolated** value. It's very fast, but has poor quality; often used for quick motion tests.

IN—abbreviation for **internegative**.

Integer—a whole number with no fractions or decimal places.

Integer operations—math operations that use only **integer** numbers for input and output instead of **floating point** numbers. Computationally much faster, but results are far less precise and can introduce artifacts.

Interactive lighting—the three-dimensional lighting effects between light sources and objects as well as from object to object within a scene. It usually refers to how the lighting on objects changes over time as they move within the shared **light space**.

Interlace flicker—the rapid flickering introduced into an **interlaced video** image due to a high contrast edge being precisely aligned with a video scan line.

Interlaced video—a video scanning method that first scans the odd picture lines followed by the even picture lines and then merges them together to create a single video frame. See also **progressive scan**.

Internegative—a negative made from the color-timed **interpositive** of a feature film. Created on a high strength intermediate film stock, it is used for make the many theatrical prints on a high-speed printer.

Interpolate—to calculate a hypothetical new data point between two existing data points.

Interpositive—a color-timed positive print of the edited camera negatives of a feature film. Created on an intermediate film stock, it is used to create the **internegatives** for a movie.

Inverse square law—the law of physics that describes the falloff of light with distance. The intensity of the light is reduced by the inverse of the square of the change in distance, i.e., if the distance is doubled, the light intensity is one-fourth.

Invert—in a matte, to reverse the black and white regions. Mathematically, it is the complement (1-matte).

IP—abbreviation for **interpositive**.

Iterate—to repeat or "loop" through some process.

J

Jaggies—slang for **aliasing**.

K

k—abbreviation for kilo, which is 1000. In computer land it is 1024 (2^{10}).

Kernel—short for **convolution kernel**.

Key—the video term for a **matte**. See also **alpha** and **mask**.

Keyer—a compositing node that extracts the matte from a **bluescreen**, performs the **despill**, and produces the final composite. It is usually a third-party "plug-in."

L

Laser recorder—a **film recorder** that uses a set of colored lasers to expose the image directly on the film.

Lens flare—the colorful light pattern from a strong light source that becomes double exposed with the image due to light reflections and refractions within the lens elements.

Letterbox—to format a movie for TV that retains its theatrical projection aspect ratio by scaling the picture down to fit within the TV screen and masking it with black above and below. Commonly used to give films a "theatrical" feel when transferred to video.

Lighten operation—the Adobe Photoshop term for a "**maximum**" image blending operation.

Light space—a general term for the three-dimensional light environment of a scene within which the objects in the scene are illuminated. It alludes to the location and intensity of light sources plus their secondary and even tertiary reflection and scattering effects.

Light wrap—to blend light from the background plate with the outer edges of a foreground element to enhance photo-realism.

Linear data—like a straight line, where the difference between adjacent data steps is the same regardless of where on the line you are.

Linear gradient—a gradient with pixel values that increase uniformly across the gradient.

Linear images—images that are represented by linear data as opposed to **log data**. Each step in the data represents a uniform change of actual brightness instead of a uniform change of apparent brightness to the eye.

Linear space—representing image color values in any one of several **color spaces** that use linear data.

Locking point—in motion tracking, the point in the image that the tracked object needs to appear to be locked to.

Log—short for **logarithmic**.

Logarithmic—where the numbers represent exponents of numbers rather than the numbers themselves.

Log images—images that are represented by **log data** as opposed to **linear data**. Each step in the data represents a uniform change of apparent brightness to the eye instead of a uniform change of actual brightness.

Log space—representing image color values in a **color space** that uses log data.

Look-up table—a table of numbers that uses the value of input data as an index into the table to look up a second number for output. It is commonly used to correct the **gamma** of a monitor or to assign the colors from a **palette** to a one-channel image.

Luma-key—the matte extracted from an image based on its **luminance** (brightness) or the use of such a matte to isolate an object from its background for compositing or other treatment.

Luminance—(1) common usage to describe the brightness of an image. (2) Technically, the objective measurement of the spectral energy emitted from a surface in units such as foot-lamberts or candelas per square meter. (3) In video, the brightness part of the video signal aside from its color.

Luminance image—the one-channel image created by mixing the RGB channels in the right proportions so as to maintain the same apparent brightness levels to the eye as the original color image.

Luminance matte—a matte created from a **luminance image**.

LUT—abbreviation for **look-up table**.

M

Mach banding—an optical illusion where the eye exaggerates the boundary between adjacent regions of slightly different brightness. This makes the eye very sensitive to **banding** artifacts.

Mask—a **one-channel image** used to restrict and/or attenuate an operation to a specific region of another image. See also **key**, **alpha**, and **matte**.

Match box—in motion tracking, the rectangular box around a tracking point that is used to compare to the initial **match reference** image to find a match.

Match move—deriving the position of a moving camera and key objects in a scene. From this data a matching 3D cgi camera and objects are generated that appear to move in sync with the live action.

Match reference—in motion tracking, the initial rectangular piece of an image from the first frame of the tracking process to which the subsequent frames are compared to find a match.

Matte—a **one-channel image** used to define the transparent regions of the foreground and background elements of a composite. See also **key**, **alpha**, and **mask**.

Matte painting—a painting, usually photorealistic, that is typically used as the background for a composite.

Maximum operation—an image processing operation that makes a pixel-by-pixel comparison between two images and selects the greater (maximum) pixel value between the two images as the output. Called "**Lighten**" in Adobe Photoshop.

Mesh warp—a limited image warping method that lays a grid over an image so that deformations of the grid lines define the deformation of the image. See **spline warp**.

Midtones—the middle brightness range of an image; not in the very darks or very brights.

Minimum operation—an image processing operation that makes a pixel-by-pixel comparison between two images and selects the smaller (minimum) pixel value between the two images as the output. Called "**Darken**" in Adobe Photoshop.

Mitchell filter—performs moderate edge sharpening as it **resamples** an image. It is less prone to edge artifacts than a **bicubic filter**.

Monochrome—a one-channel image. Often a luminance image, but can be any single channel image such as the red channel.

Morph—an animation that blends one image into another by warping two images to each other while dissolving between them.

Motion blur—the smearing of an object's image on film due to its movement while the shutter is open.

Motion strobing—an unpleasant artifact where an object's motion takes on a jerky and "staccato" appearance due to the lack of appropriate **motion blur**.

Motion tracking—tracking the location of a point of interest through a sequence of moving images. It also refers to using motion track data to animate a second element to make it appear to be locked to the point of interest.

N

Negative—low-contrast film that contains a negative image. It is used for the initial photography, film duplication, and optical effects.

Node—the image processing operation represented by an icon within a compositing **flow graph**.

Nonlinear—to not have a linear relationship between one parameter and another. If one parameter is changed, the second one does not change proportionally, e.g., when doubling the first parameter the second parameter quadruples.

Normalize—for data, to scale the range of a data set so that all data values fall between 0 and 1.

NTSC—abbreviation for National Television Systems Committee, the American television standard that, among other things, specifies 30 frames per second and 486 active scan lines.

O

One-channel image—an image with pixels that have only one component, brightness, as opposed to the three RGB components of a color image.

Opacity—the attribute of an image that blocks the ability to see through it to the images behind it. It is the opposite of **transparency**.

Opaque—an object that cannot be seen through because it is impervious to the transmission of light. It is the opposite of **transparent**.

Overflow—when data exceed some "ceiling" value. For an 8-bit system that value would be 255, so any data greater than that become clipped to 255. **Floating point** systems do not clip overflow or **underflow**.

Overlay blending mode—an Adobe Photoshop blending mode that combines two images without a matte.

P

PAL—abbreviation for phase alternating line, the European television standard that, among other things, specifies the 25 frames per second and 576 active scan lines.

Palette—for indexed color (color **look-up table**) images, the predefined set of colors. For "true color" images, such as 24-bit RGB images, the total number of colors possible to create (16.7 million).

Pan—to rotate a camera about its vertical axis, which causes the scene to move horizontally in the opposite direction.

Parallax shift—shifts in the relative positions of objects in a scene due to **perspective** changes caused by a moving camera.

Perforations—holes along the edges of film where a registration pin is inserted to precisely position each frame of film.

Perfs—short for **perforations**.

Perspective—the differing appearance in size and position of objects in a scene due to their different distances and locations from the camera.

Phosphors—compounds applied to the inside of the face of a CRT that emit the red, green, and blue colors when struck by an electron beam.

Photo-realism—achieving the realism of a single photograph in a composite, making a synthetic image look realistic.

Pin registered—inserting a precision pin into the **perfs** of a frame of film to position it accurately and hold it steady while it is being exposed or projected.

Pivot point—the point in an image round where **geometric transformation** occurs, such as the center of rotation or scale.

Pixel—a digital image is composed of a two-dimensional array of many small squares. A pixel is one of these squares. In many applications the pixels are square, but in others, such as video, they are actually rectangular. It originated as a concatenation of "picture element," the smallest piece of an image.

Premultiplied—an image that has already been multiplied (scaled) by its matte channel to clear the surrounding pixels to zero black. It usually refers to a cgi image with its **alpha** channel.

Primatte—a third-party **keyer** available for some compositing packages that uses sophisticated 3D color space masking techniques to produce a high-quality **chroma-key** composite.

Print—in film, the high-contrast positive print from a **negative** that is projected in the theatre.

Procedural—to let the computer achieve an objective from a set of rules as opposed to performing the operations by hand. An example would be extracting a matte based on the brightness values of the pixels (a **luma-key**) as opposed to drawing it by hand (**rotoscope**).

Progressive video—a video scanning method that scans the picture one line at a time sequentially from top to bottom to make a video frame. See also **interlaced video**.

Projection aperture—the portion of the exposed film frame that is projected in a theatre. See also **camera aperture**.

Projection gate—a flat piece of metal with a rectangular hole cut in it that is mounted in a movie projector right behind the film to define the area of the film frame that is to be projected.

Proxies—small copies of the set of images for a shot that are used to save disk space and processing time while setting up the shot.

Q

Quantization artifact—any one of a number of **artifacts** that can be introduced into an image due to the fact that it has been digitized.

Quantize—to convert a continuously varying signal into discrete numbers. To **digitize**. Also, to convert image data from **floating point** values to **integers**, such as converting normalized data (range 0.0–1.0) to 8-bit data (range 0–255).

R

Radians—a unit of measuring angles. 2π radians equals 360°, or about 57.3° per radian.

Raster—the spot of light that scans a TV tube to draw the image on the screen.

Real time—to perform a computer operation at the same speed as the real world operation. For example, to display digital images on a monitor at 24 frames per second, the same speed as a movie projector.

Record—see **color record**.

Reference image—in motion tracking, the rectangular sample taken on the first frame to compare to the **match box** from subsequent frames to look for a match.

Refraction—the bending of light as it passes from one medium into another with a different index of refraction. This is the principle behind lenses.

Render—the computational operations that produce an image. It applies to 3D cgi as well as 2D compositing.

Repo—slang for reposition. See **translation**.

Resample—to compute new pixel values based on some kind of averaging scheme with their neighbors. It is necessary whenever an image goes through a **geometric transformation**. See also **filter**.

Resolution—see **spatial resolution, color resolution**, or **temporal resolution**.

RGB—abbreviation for red, green, and blue, the three color channels of a color image.

RGB scaling—scaling the color values of an image brighter or darker as opposed to scaling the image size.

Ringing—an artifact introduced after some image processing operations that artificially increases the contrast of the edges of objects in an image.

Rotation—a **geometric transformation** of an image that changes the orientation of the image about an axis.

Roto—slang for **rotoscope**.

Rotoscope—to draw mattes frame by frame by hand.

Run-length encoding—a lossless data compression scheme common to cgi renders that encodes picture data as a series of "run lengths" (the number of adjacent identical pixels) there are for each color across a **scan line**.

S

Saturation—the attribute of a color that describes its "purity" or "intensity" (not brightness). As a color gets less saturated, it becomes more pastel.

Scale—a geometric transformation that changes the size of an image horizontally, vertically, or both.

Scaled foreground—the foreground layer of a bluescreen composite that has been multiplied (scaled) by its matte channel to clear the surrounding pixels to black.

Scan line—a row of pixels the full width of a digital image.

Screen operation—combining two images without a matte using the formula $1 - [(1 - \text{image A}) * (1 - \text{image B})]$. See also **weighted screen**.

Search box—in motion tracking, a larger rectangular box outside of the **match box** that the computer will search for looking for a match between the match box and the initial **match reference** image.

Self-matted—an element such as smoke that is used to create its own matte, usually from its own **luminance**.

Sharpening—using one of several image processing algorithms to increase the apparent sharpness of an image.

Shear—see **skew**.

Shoulder—the top portion of the film response curve where the film begins to rapidly lose its ability to increase in **density** in response to very high exposures of light.

Sinc filter—a filter used to **resample** an image that is optimized for scaling images down without introducing aliasing artifacts.

16-bit images—images that use 16 bits of data per channel, which results in a data range between 0 and 65,535 for each channel.

Skew—a geometric transformation where the opposite edges of an image are offset from each other but remain parallel.

Slice tool—an image analysis tool that, after first drawing a line (slice) across an image, plots the RGB values of the pixels under the line on a graph.

Slot gags—using two moving hicon mattes masked together to create an animated hicon matte. This is an old film optical term.

Soft clip—to clip the brightness level of an image gradually as with a color curve instead of a single threshold value. It prevents the "flat spots" introduced by a **hard clip**.

Soft light blending mode—an Adobe Photoshop blending mode that combines two images without a matte.

Spatial resolution—a measure of how "finely" an image has been digitized horizontally and vertically. It is indicated by the width and height of an image in pixels or the number of pixels per unit length, such as 300 ppi (pixels per inch).

Spectral emissions—all of the different frequencies and intensities of light emitted by a light source.

Spectral reflectance—all of the different frequencies and intensities of light reflected by a surface.

Spectral transmittance—all of the different frequencies and intensities of light transmitted (passed) by a filter.

Specular highlight—a glint reflecting off of a shiny surface. More technically, when the angle of reflection of the light is equal to the angle of incidence, as with a mirror.

Spill—stray light that contaminates and discolors objects in a scene.

Spillmap—in the despill operation, a map of the backing color **spill** that has contaminated the foreground object.

Spline—a mathematically smooth "line" whose shape is determined by a few **control points** and their settings.

Spline warp—a sophisticated image warping method that uses splines drawn over an image to define its deformation. See also **mesh warp**.

Squeezed—an **anamorphic** image that is horizontally scaled by 0.5 for Cinemascope. See also **unsqueezed**.

Squirming—in motion tracking, a poor "lock" between the tracked object and the background so that the tracked object appears to drift around over the length of the shot.

Stabilizing—in motion tracking, using the tracking data to remove **gate weave**, camera jiggle, or other unwanted motions in a shot.

Stochastic—a random process where the next data value is independent of any previous data values.

Stop—a doubling of the exposure of the film. Increasing the exposure two stops would mean two doublings, or four times the exposure. For Cineon 10-bit log images, one stop is 90 code values.

Subpixel—literally, smaller than a **pixel**, refers to image processing operations that compute pixel values to a fraction of a pixel with **floating point** precision rather than just whole pixel **integer** values.

Super 35—any one of several 35-mm film formats characterized by using the full width of the film frame (the full aperture) with the intention of reformatting the film later for theatrical projection.

Superwhites—for Cineon images, brightness values greater than the white reference, which is the 90% white reflective surface. Includes such elements as lights, fire, glints, and explosions.

Syntax—rules that govern the terms and symbols used to construct a command for a computer program or a language.

T

Telecine—a machine that scans film at video resolution for transfer to video tape.

Temporal—having to do with time.

Temporal resolution—the number of digital "samples" taken of an event over time, such as a film camera with a shutter speed of 24 frames per second.

10-bit images—images that use 10 bits of data per channel, which results in a data range between 0 and 1023.

10-bit log—representing log data with 10 bits of precision.

3 perf—slang for a 35-mm film format where each exposed frame on the film spans three **perfs** (perforations). It saves film and lab costs.

3D animation—animation created in a computer by creating three-dimensional models of objects and then lighting and animating them.

3:2 pulldown—a timing scheme used to stretch the 24 frame per second rate of film to the 30 frame per second rate of video. Groups of 4 film frames are spread over 5 video frames by distributing the film frames over 10 video fields in the pattern 2, 3, 2, 3. It is also referred to as a 2:3 pulldown.

3:2 pullup—the process of removing the **3:2 pulldown** from film transferred to video in order to restore the frames to their original 24 frame per second rate. It is also referred to as a 2:3 pullup.

Tiled image—an image that is repeated regularly like a tiled ceramic surface. It is often a small image designed so that it does not show a seam when tiled.

Time code—running digital "clock" data embedded in the video signal off-screen to mark each frame of the video in terms of hours:minutes:seconds: frames. When printed in a window of each video frame it is called "visible time code" or a "window burn."

Toe—the bottom portion of the film response curve where the film begins to rapidly lose its ability to increase in **density** in response to very low exposures of light.

Tone—the darker or lighter versions of a given color.

Track—using a computer to find the location of a target object frame by frame so that a second element may be animated to appear locked to it. Also referred to the path itself created by the tracked object.

Tracking markers—objects deliberately placed in a scene to provide good tracking targets, usually removed later.

Tracking point—the on-screen graphic placed on an image by the operator to mark the feature to be motion tracked by the computer.

Tracking targets—features in a moving image marked by **tracking points** that are to be motion tracked by the computer.

Transformation—see **geometric transformation**.

Translation—a **geometric transformation** that simply moves an image horizontally, vertically, or both.

Transparency—the attribute of an image that allows images behind it to be visible to some degree. It is the opposite of **opacity**.

Transparent—the attribute of an object that permits light to pass through it so that objects behind it are visible. It is the opposite of **opaque**.

2D transformation—moving an image only in two dimensions, such as a **translation, scale,** or **rotation**.

2k—literally 2000, but in computer land it is 2048 (2^{11}).

2:3 pulldown—another term for **3:2 pulldown**.

2:3 pullup—another term for **3:2 pullup**.

U

Ultimatte—a **keyer** offered by the Ultimatte Corporation based on color difference matte extraction techniques that is often included as a third party module in compositing software.

Underflow—when data drop below some "floor" value. For an 8-bit system that value would be 0 so any data less than that become clipped to 0. **Floating point** systems do not clip **overflow** or underflow.

Unpremultiply—the mathematical operation of reversing the premultiply operation of a four-channel cgi image by dividing its RGB channels by its **alpha** channel.

Unsharp mask—an image processing operation borrowed from conventional photography that sharpens an image by subtracting a blurred version of an image from itself.

Unsqueeze—to remove the **anamorphic** squeeze from an image by scaling it horizontally by 2.

V

Value—the "V" in **HSV** color space, roughly translates to the brightness value of a color.

Veiling glare—the haze of light added over a photographed image due to non-parallel light rays, lens imperfections, internal reflections, and other optical anomalies.

VistaVision—a 35-mm large film format characterized by running the film through the camera horizontally rather than vertically so that the image height is the full width of the film and its width is 8 perfs. It is also known as **8 perf**.

W

Warm—a general term used to describe an image with a reddish cast. See also **cool**.

Warp—a nonlinear deformation of an image where any part of the image can be deformed as if it were a sheet of rubber.

Wedge—a sequence of film frames repeating the same image while systematically varying some attribute to find its best level. For example, a brightness wedge would have several steps of brightness from dark to light.

Weighted screen—a variant of the **screen operation** that adds the use of a matte or mask to partially suppress the background layer to increase the apparent density of the screened object.

White point—the brightest part of an image that will still be present when viewed in its final display mode.

White reference—for Cineon log image conversion, the 10-bit code value (685) that a 90% reflective white surface would generate in a properly exposed frame of film.

Witness points—markers or objects deliberately placed in a scene to be used later for 3D tracking references.

X

X—the horizontal direction.

X axis—the horizontal axis of a graph, a rotation, a scale, or display device such as a monitor.

Y

Y—the vertical direction.

Y axis—the vertical axis of a graph, a rotation, a scale, or display device such as a monitor.

YIQ—the three-component **NTSC** video signal with one **luminance** (Y) and two **chrominance** (IQ) components. The I signal reproduces orange–cyan and the Q signal reproduces yellow–green–purple. It isimilar to the **YUV** signals of the **PAL** video format.

YUV—the three-channel **PAL** video signal with one **luminance** (Y) and two **chrominance** (UV) channels. It is often misapplied to refer to the **NTSC YIQ** signals of the same purpose.

Z

Z axis—in 3D animation, the axis perpendicular to the X and Y axes. By convention, it is the axis perpendicular to the viewing screen used to represent depth into the scene.

Z channel—an additional image plane similar to an **alpha channel** but data represent depth into the scene for each pixel. It is used for 3D compositing.

Zero black—the color black represented exactly by the number zero, as opposed to one that just appears black to the eye, which might be somewhat greater than zero.

Zoom—to simulate zooming a camera into (or out of) a scene by scaling an image larger (or smaller) while keeping it trimmed to its original dimensions.

Index

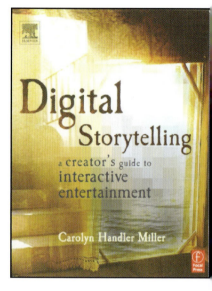